ART IN CONTEXT

ART IN CONTEXT

UNDERSTANDING AESTHETIC VALUE

David E. W. Fenner

Swallow Press / Ohio University Press • Athens

THE ART INSTITUTE OF PORTLAND

Swallow Press / Ohio University Press, Athens, Ohio 45701

www.ohioswallow.com

© 2008 by Swallow Press / Ohio University Press

Swallow Press / Ohio University Press books are printed on acid-free paper ⊗ ™

16 15 14 13 12 11 10 09 08 5 4 3 2 1

Library of Congress Cataloging-in-Publication Data

Fenner, David E. W.
 Art in context : understanding aesthetic value / David E. W. Fenner.
 p. cm.
 Includes bibliographical references and index.
 ISBN-13: 978-0-8040-1104-4 (hc : alk. paper)
 ISBN-10: 0-8040-1104-4 (hc : alk. paper)
 ISBN-13: 978-0-8040-1105-1 (pb : alk. paper)
 ISBN-10: 0-8040-1105-2 (pb : alk. paper)
 1. Aesthetics. 2. Experience. 3. Art—Philosophy. I. Title.
 BH301.E8F46 2008
 701'.17—dc22

 2007043074

B+T NR/EN

For my wife, Mynette

CONTENTS

Chapter Seven: Issues of Meaningfulness

Chapter Eight: Science and Contextualist Aesthetics

Chapter Nine: A Review of the Arguments and Evidence

Contents

PREFACE

The thesis of this book is that in many situations in which one is considering a work of art, the value of that work will increase when context is, or certain contextual factors are, taken into account. In addition to this, I make the supporting converse claim: in many situations, adopting an attitude of disinterest, an attitude of decontextualization, or a strictly formalist approach will actually decrease an artwork's value. The argument of this book is essentially inductive. From the history of art, I have gleaned tangible evidence that demonstrates the enhancement of value when a work is viewed contextually. This is the reason that the project occupies a whole book. The book's argument is really a series of many smaller ones, each focused on a particular area of value-enhancing context consideration, and each of these grounded on particular examples from the history of art. In a serious sense, this book is as much art history and criticism as it is philosophy of art.

The first two chapters provide some of the backstory for the aesthetic case. In chapter 1, I examine the nature of aesthetic experience and attempt to make three crucially important points: first, that aesthetic experience is our bedrock, with all other issues derivative from that; second, that aesthetic experience, whether by virtue of its meaning or by virtue of some a priori consideration, is not automatically characterized by disinterest; and third, that aesthetic experience is messy—there are hosts of contextual aspects in all experiences, certainly not least aesthetic ones. Chapter 2 fills in the important story about what makes art, artworks, and art experiences valuable. Without this step, my case that contextuality contributes to the value of works of art would be ungrounded. In that chapter, I reject intrinsic value accounts, as I think I must as a contextualist, and I present five extrinsic accounts, four of which are instrumental. Any of these extrinsic accounts would work well to ground my claim, but my favorite is my own noninstrumental extrinsic account.

The third chapter of this book offers a review of the history of decontextualization in aesthetic theory. This begins with a history of the disinterest theories, starting with Lord Shaftesbury and ending in the twentieth century with Jerome Stolnitz, visiting Francis Hutcheson, Joseph Addison, Archibald Alison, David Hume, Arthur Schopenhauer, and Edward Bullough along the way but taking as the most sophisticated case the one offered by Immanuel Kant. This chapter ends with a review of formalist theory.

The fourth chapter offers the context for the project's thesis. Here I briefly review the theories and theorists who advanced contextualist projects, specifically with regard to feminist aesthetics, aesthetic experience, the nature of art and artworks, and ethical, moral, social, and political contextual projects. The views of George Santayana, Roger Scruton, John Dewey, Anita Silvers, Monroe Beardsley (who has a foot in both camps), Frank Sibley, Arnold Berleant, Allen Carlson, Morris Weitz, Arthur Danto, Jerrold Levinson, Kendall Walton, Stephen Davies, Plato, Leo Tolstoy, Noël Carroll, Berys Gaut, Marcia Muelder Eaton, and Mary Devereaux are briefly reviewed.

In chapters 5 through 8, the positive case, evidenced from the history of art, for the value-enhancing power of context consideration is offered. Chapter 5 deals with issues of definition, in particular focusing on how context, and then later function, is relevant to proper classification of objects as art objects. Chapter 6 focuses on issues of artistic power and merit directly. Here I examine how consideration of particular contextual matters speaks directly to the value of the object. Chapter 7 is about the meaningfulness of art and the social, political, civil, and religious contexts that are relevant to the value of an artwork. Chapter 8 strikes out a bit, exploring the relationship between science and contextualist aesthetics.

Chapter 9 is a review of the arguments and the evidence for my case.

WORD ABOUT THE PURPOSE OF THIS PROJECT

In part, this book presents a case for the rejection of formalism, *formalism* being the position that the correct assessment and/or appreciation of an aesthetic object or a work of art, in terms of considering its value and its meaning, is had only when the agent restricts her attention to the

formal properties of the object, properties that are accessible through the senses (or derived directly and exclusively from properties that are accessible through the senses), properties that are objective in the sense of having their locus in the object. For many people (including those whose theories are reviewed in chapter 4), this is no longer a viable option. If this book were nothing more than a battle cry for the rejection of formalism, I do not think it would strike many as timely or useful, and as a result I hope that it is taken as more than this. First, the scope of this book is bigger. It is meant to offer a reasonably comprehensive treatment of the relevance of context, making rejection of formalism only one part of the argument for contextualism. Second, the argument I offer in this book is that the value *of the art object* may be enhanced in many instances through a consideration of context. I focus on precisely the same thing that the formalists were focused on: the value of the *object.* Many theories that imply or include a rejection of formalism do so while concentrating attention on the value of the experience; I want to take on the stronger case, and so I mean to be playing on the same field with the formalists, attempting to demonstrate that even with a focus on the object, a contextual approach is the better one. Third, while formalism may be a dead option for many aestheticians today, there is still a lagging sentiment that to view a thing aesthetically *means* viewing it disinterestedly. Into the heart of this unreflective sentiment I would like to drive a stake. Fourth, I locate the argument of this book within the history of art and the art world, as well as within the history of Western aesthetic theory, particularly focusing on the seventeenth and eighteenth centuries, when art museums and disinterest theory were on the ascendancy. Finally, this book is meant to take seriously the empirical nature of the investigation; the later chapters therefore deal with objects and events, while talk of theory is reserved for earlier chapters.

Mary Devereaux, at the end of an essay reviewed in chapter 4, writes, "We go to the particular cases because that is where the issue comes to life. The historical and analytical work of this essay is not mere propaedeutic to the philosophical inquiry but is inextricably bound up with the philosophical inquiry itself. This is not a new approach, but one whose *locus classicus* is Plato's discussion of Homer in Books 2 and 3 of the *Republic.*" Aesthetic experience is a messy thing, as I attempt to show in chapter 1.

Consideration of where context matters is also something for which a full consideration requires getting our hands dirty. This book is not simply a statement of the negative case for why formalism and disinterest theory should be rejected. This book also offers the positive case for where, and how, and when, and why context matters and how it lifts the value of art objects and, by extension, of art experiences.

ACKNOWLEDGMENTS

Much of this book comes from work I have done over the past decade. The research for specific sections of some of the chapters comes from papers I have written, several of which have been published previously. Parts of chapter 1 come from "Defining the Aesthetic," *Journal of Comparative Literature and Aesthetics* 23, no. 1–2 (2000): 101–17, and "Aesthetic Experience and Aesthetic Analysis," *Journal of Aesthetic Education* 37, no. 1 (Spring 2003): 40–53. Parts of chapter 2 come from "Artistic Value," *Journal of Value Inquiry* 37, no. 4 (2003): 555–63, and "Production Theories and Artistic Value," *Contemporary Aesthetics* 3 (2005). Much of the preliminary research that went into chapter 3 comes from an earlier book I did on the aesthetic attitude tradition: *The Aesthetic Attitude* (Atlantic Highlands, NJ: Humanities Press, 1996). Parts of chapter 5 come from "Pure Architecture," in Michael H. Mitias, ed., *Architecture and Civilization,* Value Inquiry Book Series (Amsterdam: Rodopi Press, 1999), 43–57. Parts of chapter 6 come from "Aesthetic Disinterest," *Journal of Comparative Literature and Aesthetics* 18, no. 1–2 (1995): 81–88. Parts of chapter 7 come from "Art and Culture," *Encyclopedia of Nationalism* (San Diego: Academic Press, 2001), 39–54. And, finally, parts of chapter 8 come from "Aesthetic Appreciation in the Artworld and in the Natural World," *Environmental Values* 12, no. 1 (2003): 3–28, and "The Aesthetics of Research Methodologies in the Social Sciences," *International Journal of Applied Philosophy* 20, no. 2 (Fall 2006): 311–30.

Much of the inspiration for the ideas in this book came from my classroom, from bright students willing to share and defend their thoughts in various courses in aesthetics and the philosophy of art. I owe a huge thank you to them; every paper I publish in the *Journal of Aesthetic Education* I can trace back to some classroom discussion I have had the privilege of leading or participating in. This book is essentially an expression of part of my life as an aesthetics teacher.

I need to thank those people who have been personally influential on the development of my thought, relative to what is included here. I thank Scott Brown, Allen Carlson, Karen Carter, David Courtwright, Marcia Eaton, Berys Gaut, Alan Goldman, Gordon Graham, Neil Gray, Kenton Harris, Julie Ingersoll, Paul Karabinis, Ellen Klein, Michael Mitias, Debra Murphy, and Edward Schuh. I ask them, if any should read this, to think well of me throughout.

Finally, I thank my wife, Mynette, and my kids, Ethan and Noah. This book is dedicated to Mynette. We have been married since before grad school; she has been around for all the research and writing—not just what went into this book but *all* of it.

Introduction

THIS BOOK REPRESENTS A SYSTEMATIC, HISTORICALLY situated, and historically evidenced attempt at demonstrating the importance of considering the context of a work of art in determining the value of that work. The central claim is that considering the context will in most cases—though I will not argue all—first, raise the value of the object and, second, raise the experience of it. By *context* I mean all those various lenses—ethical, social, sexual, emotional, imaginative, political, religious, and so forth—through which a work of art may appropriately be viewed, and by *appropriately* I mean to limit the range of lenses to those for which some good justification based in the work of art itself may be found. That one has a head cold can frame a context of appreciating a work of art, but this is not what we want to consider here.

Since this is not a book about defining what art is, by *work of art* I simply mean anything that the art world—the tradition and institution of those who create, patronize, appreciate, display, assess, evaluate, interpret, criticize, and in general just talk about art—accepts as art. The art world has a lexicographic function of specifying in some measure how we commonly use the word *art*, and that is all I mean to pick up on here.

The point of this book is not to demonstrate the importance of context to defining art, to classifying it, or to interpreting it. These are fine topics, and (as we will see in the course of this book) they overlap somewhat

with the present project, but for the most part these topics will be left aside. This book is about the value of art, about appreciating, assessing, and evaluating works of art. It is about enhancing the experiences of those who attend to works of art seeking to get the most that they can out of such works. But the book is not about those experiences themselves, not about "aesthetic experience" per se; it is about the value of works of art.

There are various steps in building the argument, and I want to cover all the necessary bases. The context of this project must thus not merely be framed within the history of western aesthetic theory (as done in chapters 1–4); the project must be positioned within the art world itself, in the history and traditions of art.

THE PUBLIC ART MUSEUM

I would like to start out by saying that I love art museums. I cannot imagine being in London for more than two days without visiting the National Gallery, if only for a couple of hours to stare at the Turners. And no trip to New York would be complete without a visit to the Metropolitan Museum of Art and one to the Museum of Modern Art. I begin this way because the research underlying this book calls into question some of the ideas that led to the creation of art museums. This book could be taken to constitute an attack on art museums, offering reasons for why they should not exist. I do not deny this aspect of my project. But as this book is about contextualizing art, one should keep in mind that the reasons offered here that are critical of the establishment and existence of art museums must be taken alongside arguments in support of them.

In 1661, the Öffentliche Kunstsammlung in Basel, Switzerland, opened its doors to the public. The Öffentliche Kunstsammlung began, as is the case with many art museums, as a family collection. The collection was then taken to a place where the public could view it—in terms of both a city and a building—and an art museum was born. As far as I can tell, this was the first public art museum. It was not the first time that art was displayed publicly, but it was the first time that a museum had been constructed for the public display of art.

One of the earliest public displays of art had happened almost two millennia earlier. Between 437 and 432 B.C., a Greek architect named

Mnesikles began construction on a new gateway to the Athenian Acropolis. This entranceway is known as the Propylaia, and it replaced the earlier Archaic Propylon. The northwest wing of the Propylaia is called the Pinakotheka (or Pinakotheke). The Pinakotheka was a space where paintings were displayed.[1]

Earlier, too, than the Öffentliche Kunstsammlung were the beginnings of the Vatican Museums. They originated as a collection of a group of sculptures acquired by Pope Julius II in the early 1500s. Although the popes were among the first sovereigns who opened their art collections to the public, this did not formally happen until the late 1700s.

In 1581, the Uffizi Palace in Florence, under the direction of the Medici family, began as a space devoted to the collection, creation, and care of art. The Grand Duke Francesco I permitted visits to the art collection, on request, in 1591. Precisely when these displays were made openly available to the public is unclear, although the collection and palace were bequeathed to the public in 1737. Given all this, perhaps the Uffizi rather than the Öffentliche Kunstsammlung should be accorded the honor of being the oldest public art museum.

To round out the picture: the Ashmolean Museum of Art and Archaeology at Oxford University was founded in 1683, the British Museum opened in 1753, the Vatican Museum was established in 1784, the Dresden Museum in 1744, and the Louvre in 1793. London's National Gallery is a relative newcomer, having been established by George IV in 1824.

The distinction between spaces such as the Öffentliche Kunstsammlung (or perhaps the Uffizi) and the Pinokotheka or Vatican Museum is important.[2] The public display of art is not the issue. What is at issue is the decontextualized nature of the space in and through which the art is publicly displayed. And so the citation of the Öffentliche Kunstsammlung as the first public art museum seems appropriate. In Basel, the space is decontextualized. It is a civic space; it is not religious, is not nationalistic (in a straightforward or obvious sense), and has no purpose other than merely displaying a collection of art for the sake of public viewing. This is the same sort of purpose evident in the Ashmolean. Although in all these cases, national pride may well have played a role in both the creation and the sponsorship of these institutions—and at that point in Europe, dissecting cleanly between national and religious-institutional purposes

may be tricky—the chief and central purposes of museums such as the Öffentliche Kunstsammlung, the Uffizi, and the Ashmolean were to display art, making it available for public viewing, and to serve as a place of education for artists.

Anyone who has ever visited an art museum knows that all sorts of efforts are taken to provide "proper framing" for enhancing art-appreciation experiences.[3] The paintings are lit well—not too brightly but in such a way that glare is minimized and viewers do not have to strain to see. Natural light is frequently available, but it is diffused. The rays of the sun are not permitted to touch the paintings and other delicate artifacts; if they touch sculptures, they do not linger for long. This is certainly for the continued health of the artworks, but it has the added benefit of providing excellent lighting for viewers: natural light is considered the "truest," and diffused light eliminates glare. The same is true of temperature. While a constant temperature (and humidity level) is essential to the continued well-being of the artworks, it has the added advantage of providing viewers a level of comfort. This level of comfort allows the viewer to avoid fanning herself or wrapping up tightly in her coat (although many art museums probably require the wearing of sweaters or cardigans). Without having to think about being too hot or too cold, the viewer can direct her attention more fully to the artworks. Art museums are traditionally composed of many rooms. Modestly sized paintings tend to be in modestly sized rooms; very large paintings regularly can be found in larger halls. Rooms have enough artworks to encourage a long stay in each, but the fact that there are more modestly sized rooms than large halls has advantages for viewing. First, the viewer is not overwhelmed by the number of works immediately available; this encourages her to take time with each room and probably added time with particular works in a room. Second, the viewer is not overwhelmed by variety. Most art museum curators group together works from the same period or works that have a similar style or national origin. Not feeling overwhelmed, feeling at ease, allows viewers to linger comfortably, considering the works for as long as they like. The rooms in art museums tend to be painted or papered or otherwise decorated in ways that explicitly draw attention to the works they contain. This is not to say that every room will be painted in a neutral color, but attention has been given to how the rooms' decora-

tions will enhance rather than detract from an art-appreciation experience. Generally speaking, the rule in constructing and decorating an art museum is to provide a venue, a context, that will substantively contribute to the art-appreciation experiences of museum patrons. This usually means that such a venue is grand enough to focus attention away from the cares of the world—the ecclesiastical correlate phrase would be "to provide a sense of the transcendent"—yet simple and neutral enough to focus attention onto the artworks. There are functions to be served in the design of art museum spaces, and what I have written above is only one viewer's sense of these functions and how they are served. All we really need is the most common sense of what art museums are like to see that such spaces are essentially spaces of decontextualization.

Human beings do little without purpose. Perhaps we do nothing outside of service to some function or other. When we go to the bother—the expense, the care of design—to create an art museum space, we do so very purposefully.[4] We work to create proper framing for art-appreciation experiences, and this proper framing may most succinctly be described as a kind of blank slate—blank not in the sense of being stark but in the sense of directing focus away from itself. Essentially what the art museum designer wishes to do is to provide an uncontextualized space or, if that is a theoretical impossibility, to provide a space where the context is all about pointing to the artworks, the artworks on their own, separate from the cares of the world, separate from their use as instruments of political reform, national pride, social commentary, sexual arousal, psychological exploration, or religious proselytism. Although the contents and styles of individual works may have effects in these categories and others, the art museum spaces in which the works are displayed are generally designed only to point to the works. Whatever viewers take away from these works is their own deal. Art museum designers mean for art museums to be decontextualized spaces. Francis Sparshott writes, "An art museum, like [a] lab, is a carefully neutral environment, with its oatmeal-colored walls. . . . [W]e are not just introduced to paintings in our museum tours, we are introduced to a specific practice of picture seeing."[5] Kathleen Walsh-Piper, a museum educator, writes, "The very existence of an institution devoted to collecting, preserving, exhibiting, researching, and interpreting works of art demonstrates the

concept of 'setting aside' an object for aesthetic contemplation. . . . The building, whether a grand temple, a spare modern tower, or an intimate historical structure, is frequently designed to encourage a feeling of separateness from the everyday world, a place in which to marvel."[6]

THE ADVENT OF ART MUSEUMS AS DECONTEXTUALIZED
SPACES AND THE ADVENT OF DISINTEREST THEORY

The timing of the main trends here is what is interesting to me. Perhaps it is mere historical coincidence, two things happening at the same time but unconnected, but I think it is more. It is interesting to consider whether the decontextualization of art exhibition spaces, with whatever social trends accompany this, moves art theorists to think in more-decontextualized ways, or whether the disinterest theorizing that aestheticians and art theorists engage in motivates the institutionalization of decontextualized public art exhibition spaces. The social trends that contribute to the rise of the importance of art include (at least) the following:[7]

1. Economically, people have more "disposable" free time and funds for the cultivation of such (presumed) luxuries as the development of artistic taste.

2. The patronage of the Renaissance broadens out; many have both the resources and the interest—and in some cases the social pressure—to commission or otherwise support works of art.

3. There is social promotion of the cultivation of taste as an overall part of a "polite" life.

4. There is greater social acceptance of art creation as a legitimate career path.

5. There is less religious restriction on who could create art and what the content of the art might be.

6. The humanities in all forms, but especially those forms that involve the exercise of taste, flourished in the intellectually and humanistically focused Enlightenment. The Romantic period only strengthened the force and popularity of the artistic life.

Out of Romanticism grew aestheticism. Aestheticism, a movement in the arts beginning in the Victorian period and experienced most in France, Britain, and the United States, held the position that art must serve no purpose other than simply to be art. The motto was "Art for art's sake." Immanuel Kant's *Critique of Judgment,* which articulates his formalist aesthetic, was published originally in 1790. Well within a century, the work of Kant—among others, but Kant was the central figure—came to influence a generation of artists who rejected all functionality that might be associated with works of art or art in general. The aestheticist's rejection of functionality is total. Not only should function play no role in art, but where it does, this counts negatively against the value of the work in question. During this period, "the fine arts" were those that fit the aestheticist criteria of art for the sake of art and for the sake of nothing else. Only one ontology of artistic value fit with the movement, and this was an intrinsic one, such that the value of an art object rested intrinsically with its internal, formal properties. Extrinsic and instrumental accounts could not be accepted, because these theories place value outside the object, with instrumental accounts placing value in the production of some psychological, cognitive, or affective subjective state. Art is for art's sake and for no other, so such instrumental accounts of the value of art would have been, at that time, quickly rejected. Aestheticism is a view about the nature of art and about the nature of artistic value, but it is also a theory about how artistic value relates to other values. From an art-for-art's-sake perspective, the only values that need to be or should be served by art are strictly artistic or, more broadly, aesthetic ones. This releases artists with this perspective from concern about the moral or social implications of their works. Both James Whistler and Oscar Wilde were aestheticists. Wilde took his adherence to this perspective as the motivating force not only behind the art he produced but also behind the artistic life he led. For the aestheticist, art elevates those who create it and those who appreciate it, as they are engaged with it, out of a humdrum existence framed by various ranges of values: economic, religious, political, moral, ecological, and so forth. Romanticism and aestheticism provided good reason for someone to take up an artistic life, as either a creator or an appreciator, and at the same time freed that person from justifying this choice through consideration of

any values external to the pursuit of art simply because it was art. This excising of the self from the ordinary world is the focus of Arthur Schopenhauer's philosophy of art. The distance from practical values and practical concern, this movement from the ordinary world to the art world, can be seen as a motivating force for the efforts of artists and appreciators, and it also can be seen as motivating the establishment of spaces—physical and temporal—where art would be appreciated for its own sake.

It is interesting to note the parallels and divergences between the ultimate views of aestheticists such as Walter Pater, Whistler, and Wilde and those of a contextualist such as John Ruskin. Ruskin's views on art, especially early in his career, focused on representation, on the artist's conveying the truth of what he meant to paint (we might say "the visual truth"), on the audience's educated and very discerning eye, and, perhaps as a consequence of all this, on the formalist elements of a work. As a result, some took Ruskin to be a devotee, even a founder, of aestheticism. This was not the case. Ruskin's focus on the discerning eye, both in the artist and in the audience, bears a resemblance to twentieth-century cognitivist views that call for the eye to be educated and informed by a wide range of considerations; for Ruskin, these considerations had to do with moral, social, and what many describe as spiritual concerns ("spiritual" being read more broadly than "religious" here). So while Pater, Wilde, Schopenhauer, and Ruskin were all interested in the elevation that could be achieved through the arts, Ruskin saw this elevation achieved not merely in the individual but in the society. His almost utopian view of the effects of careful artistic observation and the spiritual dimensions of this differ substantially from the individualist, particularist, and even isolationist views of the aestheticists. Thus, although Ruskin was interested in the formalist elements of works of art, he believed that these could be properly seen only within a larger moral and spiritual context and that this activity had social effects that were not to be shunned or ignored as the aestheticists wished but rather embraced as the core of the goodness of art.

The first theories that explicitly promoted a kind of aestheticist isolationism as the proper posture or attitude toward art—either for the sake of judgment or simply genuine aesthetic appreciation—emerged in

the seventeenth century. Perhaps the earliest was that of Anthony Ashley Cooper, Third Earl of Shaftesbury (1671–1713). Lord Shaftesbury, in trying to answer what he must have taken as the radical individualism, egoism, and moral relativism of Thomas Hobbes, adopted a sort of neo-Platonic position designed to reintroduce some ethical absolutes. In doing this, he at the same time introduced a mechanism for accounting for some aesthetic absolutes. If we will adopt a posture of *disinterest,* we can free ourselves of self-concerns.[8] A viewer who adopts such a posture eliminates whatever is personal from her aesthetic judgment. As she does this, she finds that her judgment accords with the judgments of all others who adopt a similar posture. The reason for this, said Shaftesbury, is that through adopting an attitude of disinterest, one creates for oneself a means to access what is true and real about the object under consideration. The proof for Shaftesbury's aesthetic realism, for his claim that there are aesthetic evaluative absolutes, lies in the ends that result when the means are employed. If one views disinterestedly, one will, as a matter of fact, judge as all others, similarly disposed, judge. I say a good deal more about Shaftesbury in chapter 3, but his explicit introduction of the idea of disinterest as a way to motivate correct aesthetic evaluation, along with the fact that this happened around the time that the first art museums were being founded, is quite relevant to the case that I make in this book.

Shaftesbury was followed by others who employed the notion of disinterest (see chapter 3). One is Francis Hutcheson (1694–1746), also working in the time frame that Shaftesbury did, again with its proximity to the institution of art museums. Perhaps the most famous of the champions of disinterest, especially in this vein of providing the appropriate context within which to aesthetically judge correctly, was Kant. His view (likewise examined in chapter 3) is the most mature, sophisticated, and canonical of the disinterest theories. "Aesthetic attitude theorists," particularly those of the disinterested camp, and "taste theorists," those who were working to offer accounts for aesthetic taste and, concomitantly, aesthetic realism—that there is something about the judgment and the judge that would allow for proper and true aesthetic judgment—overlapped. Most of the members of the one camp, in the seventeenth and eighteenth centuries, were members of the other.

What I find historically interesting about the fact that aestheticism and aesthetic disinterest theories were rising at around the same time as art museums were being founded is that they all seemed to be about the same thing. At the start of the disinterest theorizing—this is the case for both Shaftesbury and Hutcheson—disinterest primarily had a negative sense: if one could eliminate from one's concerns anything personal (personal advantages, personal associations and connections, and so forth), one could judge properly. Later theories, including Kant's and, into the twentieth century, that of Jerome Stolnitz, incorporate a positive element: consider the object for its own sake, on its own terms. What all these theories recommend is a removal of an object of aesthetic consideration from any contemplative context that is impure, tainted by situation, circumstance, personal psychology, function, purpose, or instrumentality. What is it that the art museum does? In large measure, the art museum provides the physical venue for encouraging precisely what the disinterest theorists recommend. Francis Sparshott writes,

> The art museum's . . . curatorial function will change from time to time (and from director to director), but for present purposes it is enough to say that a work of art is considered and treasured as the visible expression of the creative act of a creative mind: as enshrining an artistic intention. The work must then be preserved in, or restored to, a condition as close as possible to what the artist must have intended. Except, of course, that the artist may not have intended his work for a museum, but for a church altar; but we get round that by saying that the specifically artistic or "aesthetic" intention was only for the work to be accessible to perception in a certain form.[9]
>
> The museum as displayed collection really celebrates the transformation of works of art from operation to object, the divorce of the work from the worker. To associate the museum with the production of art is to confuse all relationships. And yet we know that some museums . . . do enter into institutional relations with artists, and that artists often denounce museums for falsifying the nature of art by severing the vital link between painter and spectator.[10]

Museum educator Annie Storr writes,

> Though it is not by any means the only way that aesthetic experiences occur, moments of special awareness *in the galleries* confirm that art can prove itself in moving, liberating moments. We know by now that, understood in this way, art exists for the sake of artistic experience and that the value of unburdened aesthetic creativity has been amply demonstrated. Reinforced by a cluster of related ideas and corollaries, these beliefs can be distilled down to two principles axiomatic to modern conceptions of art: (1) The assertion of "Art for Art's Sake." This is the conviction that art must not be required to meet any externally imposed criteria of justification, or, in current parlance, any "litmus test."[11]

Harold Osborne writes,

> In the contemplation of fine art we look for the sake of looking[;] . . . we direct our attention on the "formal unity and/or regional qualities of a complex whole." This way of looking, when directed upon a suitable object such as a work of art, induces an intensification and enrichment of the activity of perception itself, and it is in that that aesthetic enjoyment resides. . . . The second major function of museums today should be patronage [which] is linked to the direction of taste. . . . Without enlightened and far-sighted direction of taste, the few [art students] who are capable of great things must sink into oblivion with the rest. . . . With the failure of the museums to step in, public taste today founders without guidance. . . . [A]esthetic experiencing is the exercise of a particular skill in the sphere of percipience. It is a mode of perception which is differentiated by the fact that it is practiced for its own sake and not for the practical purposes of everyday life."[12]

Hilde Hein expresses what she sees as the museum status quo: "Museums are obliged to make depersonalized judgments that are normative. . . .

Art museums . . . purport to exhibit objects, called works of art, chiefly for their aesthetic quality, divorced from whatever historical or cultural features such works might contingently have. . . . When raised to the status of artwork, an object leaves behind its real-world associations, just as saints abandon their earthly history. . . . Detached from the volatility of personal taste, judgment acquires a seemingly independent life, befitting an exalted object and site."[13] Lydia Goehr writes, "Museum curators would take a work of art and by framing it—either literally or metaphorically—strip it of its local, historical, and worldly origins, even its human origins. In the museum only its aesthetic properties would metaphorically remain."[14]

Art museums allow the public to see works of art that otherwise would be locked away in private collections, either family collections or institutional collections. Art museums serve a public educational function. For a small entrance fee—and many art museums are free or only request a donation—the public can view great artworks. Schools near art museums take students on field trips, giving them firsthand immediate access to opportunities to have art- appreciation experiences; to appreciate the cultural world, in terms of both its products and its development and history; to inspire and prompt their own creativity; to see people who warrant respect taking art seriously; and to begin to grow their own senses of taste and discernment (to connect to the earlier point above). Schools that are not in such proximity may take summer excursions to art museums; this past summer my eleven-year-old son took such a trip to Washington, D.C., to visit the Smithsonian Institution. Public art museums do indeed serve an educational function. Arguments for increasing the funding for the National Endowment for the Arts frequently cite the importance and irreplaceability of the cultural-educational function of public art museums. To use public funds for the support of such institutions, to have public support for the use of such funds in such ways, is to demonstrate that having public art spaces is a widely (though not absolutely) shared value in America. The government does not impose American art culture on its populace; we elect people to office who represent our collective wishes (or at least this is the sometime-met ideal), and these people vote to fund the NEA and keep it alive and vital. As Americans, we democratically choose to tangibly instantiate our

shared values about the worth of art. Many other societies around the world do similar things according to similar values.

But art museums are also spaces of decontextualism. It is certainly true that there are many works of art to which the public would never have access were it not for public art museums, but it is equally true that many of the objects in art museums were not destined originally for either private collections or museums. Some of the objects in art museums today were destined for a public life of another sort.

There are some artists who create artworks without much consideration of where the work will physically end up. They may believe that the work will be subject to some sort of presentation. This accords with George Dickie's focus on presentation as a part of his institutional theory of art. Dickie writes, "A work of art is an artifact of a kind created to be presented to an artworld public."[15] This appears as a revision to his earlier, and perhaps more famous, definition: "A work in the classificatory sense is (1) an artifact (2) a set of the aspects of which has had conferred upon it the status of a candidate for appreciation by some person or persons acting on behalf of a certain social institution (the artworld)."[16] But Dickie's view is a theoretical one about taxonomy and nomenclature, and for many artists the details about how and when and where presentation will occur are left unexplored during the creative and mechanical processes of making a particular artwork.

There are other artists, however, who create works that they explicitly intend to be placed in a particular place, have a particular audience, and/or be presented during a specific time. Some of this second group of artists are working on commissions, and so they know that they work to fulfill the interests of those who commission their work. These artists know that such interests will include, and perhaps even primarily focus on, the eventual presentation of the resulting artwork. But there are other artists of this second sort who follow their own interests. These artists create with purposes in addition to "art-aesthetic"[17] ones. They may create works of art to inspire political reform. They may create works to focus religious attention. They may create works to inspire national pride or offer social commentary. These purposes tend to have intentional contexts—contexts that accompany the satisfaction of the artist's core interests—that have to do with the time and place of the

work's display. These purposes, the core ones and the ancillary ones, I refer to as the *originating context* of an artwork. And in chapters 4–7, I hope to show that artworks that have such contexts are more valuable when that context is taken into account. There are artworks that were not made for museums. This group of works stands as the greatest body of evidence for the insufficiency of a disinterest theory as a correct theory of either art evaluation or art appreciation.

For those artists whose creative purposes are simply art-aesthetic, art museums are great.[18] But for those artists who have intentions beyond simply art-aesthetic ones, art museums may function as tombs, cutting works off from the lives their artists intended for them, cutting them off from their contexts, anesthetizing and sterilizing them. John Dewey writes,

> Our present museums and galleries to which works of fine art are removed and stored illustrate some of the causes that have operated to segregate art instead of finding it an attendant of temple, forum, and other forms of associated life. . . . These things reflect and establish superior cultural status, while their segregation from the common life reflects the fact that they are not part of a native and spontaneous culture. They are a kind of counterpart of a holier-than-thou attitude, exhibited not toward persons as such but toward the interests and occupations that absorb most of their community's time and energy. . . . Objects which were in the past valid and significant because of their place in the life of the community now function in isolation from the considerations of their origin. By that fact they are also set apart from common experience, and serve as insignia of taste and certificates of special culture.[19]

Museum educator Danielle Rice writes,

> The desire to spread culture to the "uncultured" masses was one of the motivating factors leading to the foundation of art museums in the United States. Thus it is not surprising that, as institutions, museums continue to reflect this limited definition of culture as a cornerstone of quality through their collecting

and exhibiting policies. . . . Art museums today are vast store-houses of objects from a broad range of cultures. The influential philosopher John Dewey bemoaned this isolation of artworks in the museum setting, feeling that museums arbitrarily segregated the objects from the human conditions under which they were brought into being and the human consequences they engendered in actual life experience. . . . To uninformed eyes the fragments of other cultures, removed from their original settings and rituals to the visual realm of the museum, may seem mere curiosities made by unknown people whose motives remain mysterious and strange. Without interpretation these objects may be trivialized and segregated from the domain of important human experience, as Dewey noted. Because there is little else that one can actually do with the art in museums besides look at it, museums imply that all objects in their case, regardless of their initial uses, are now interesting primarily because of their aesthetic value. . . . Recent studies show that inexperienced museum visitors as well as more frequent museumgoers have little understanding of or interest in the history of art. . . . Thus one might say that within this context the role of the art educator was that of a missionary: passing on the culture of the dominant group to those natives supposedly devoid of real culture of their own. Many museum educators have become increasingly uncomfortable with playing this role exclusively. . . . [I]nstead of viewing the museum educator as a missionary, the educator should be considered more like an anthropologist, working to interpret two cultures to one another. In this new model, interpretation is reciprocal.[20]

In direct opposition to Dewey, Albert William Levi writes,

We have one more counter-argument to the stern original attack of John Dewey. For the art museum with its insularity and its isolation may in fact be the only environment in which a true aesthetic experience is possible. It is important to remember that there is one whole school of aesthetic theory which defines

the aesthetic experience as "the attitude of disinterested and sympathetic attention to, and contemplation of, the work of art for its own sake alone . . ." The concept of the art museum as an exclusive assemblage of nothing but masterpieces invites an interpretation of pure aesthetic contemplation, of a consideration of the work of art for its own sake alone. And the "purity" of the aesthetic experience . . . places the entire transaction outside of space and time.[21]

Levi's comment reinforces yet again the tight relationship that I think exists between the public art museum and motives of decontextualization.

1 A Theory of "The Aesthetic"

TO PROVIDE A CONTEXT FOR MY ARGUMENT for contextualizing art, I must first establish an infrastructure, exploring some of the theoretical suppositions that form part of the basis for my central argument. The importance of this first chapter lies in making the case that the disinterest theorists, whom I take as my chief opponents here, and I are speaking the same language. And if we are not speaking the same language, then I think I am speaking the better one, with "better" meaning closer to lived experience, closer to the raw material of the discipline of aesthetics, closer to the data that aesthetics as a discipline is meant to describe and explain.

In this chapter, I sketch out a vocabulary: what do I mean when I use the word *aesthetic*? I do this as a preemptive foil to those who would argue that the way I use the word *aesthetic* is different from the way the disinterest theorists use it. I think proponents of disinterest theory have grown so complacent about the relationship between adopting a posture of disinterest and viewing an object aesthetically (for the purpose of either aesthetic judgment or aesthetic experience) that they take the former as necessary for the latter, whether axiomatically or as an a priori truth. Since we are dealing, in the discipline of aesthetics, with explanations of experience, and since we take as our bedrock and our data those experiences that human beings classify as different from others and to

which they apply the label "aesthetic," to take the relationship between disinterest and aesthetic judgment/experience axiomatically or a priori is equivalent to making it nonfalsifiable. There is good reason not to do this, as I discuss a little later in this chapter.

DEFINING THE AESTHETIC

We use the word *aesthetic* a great deal.[1] We use the word as a modifier of *property, object, experience, attitude,* and *attention.* The word *aesthetic* is used as both an adjective and a noun, but when it is used as a noun, the word is offered as a shorthand description of an alternative, more precise description. For example, when an ordinary object is said to be "aesthetic," usually this means either (1) that the object is beautiful, elegant, balanced, and so forth, that is, has some positive aesthetic quality, or (2) that the object is such as to offer one who would attend to it an aesthetic experience that is either readily available or rewarding in some way. The word is an adjective, and so to define the word is to define it as a modifier of some noun. The question becomes, which noun?

The history of the word's usage goes back to Alexander Baumgarten, who began using the word in a philosophical context in 1735 to refer to a systemic attempt at a metaphysics or psychology of art. He believed that the foundations of the arts are "sensitive representations" that are not merely sensations but are connected with feeling. Today we tend to think that aesthetics has to do primarily (though not exclusively) with the sensuous aspects of experience. Of course, to say that aesthetics has to do with the sensuous aspects of experience gives little in the way of an answer to students who want the word *aesthetic* defined. But it does, at least implicitly, narrow the field so that some discussion may begin. To talk about the "sensuous aspects of experience" is to talk about experience. This seems an appropriate place to begin.

AESTHETIC EXPERIENCE AS BASIC

Consider *aesthetic* as a modifier of *attitude.* The philosophical tradition that focuses on understanding whether there is an aesthetic attitude and what it consists of is nestled in England and Germany of the seventeenth,

❖ A THEORY OF "THE AESTHETIC"

eighteenth, and nineteenth centuries and the United States of the twentieth. There are several aesthetic attitude theories, but certain strong trends allow us to describe the tradition as a whole without taking too many liberties. Originally the focus was on how one could go about making correct aesthetic judgments. Lord Shaftesbury, Francis Hutcheson, and Immanuel Kant believed that if one adopted the aesthetic attitude, one would be in the position to make correct aesthetic evaluations. This trend toward describing the conditions for correct aesthetic evaluation was replaced, through the work of such figures as Arthur Schopenhauer and Jerome Stolnitz, by a focus on the conditions for aesthetic experience. That is, instead of adopting the aesthetic attitude in order to make correct aesthetic judgments, the discussion turned to adoption of the aesthetic attitude in order to experience aesthetically or, better, to have an aesthetic experience. The content of that experience would be some aesthetic object or event, made an aesthetic object or event merely by the act of viewing it from this aesthetic point of view, through adoption of this special attitude.

This quick rendering of that tradition (see chapter 3 for a more elaborate discussion) allows us to understand in a sort of hierarchy some of the nouns that *aesthetic* might modify. Aesthetic attention is attention directed toward aesthetic objects, events, or properties. Aesthetic objects and events are the content of aesthetic experiences. Aesthetic attitudes or *the* aesthetic attitude (if there even is such a thing) is what allows us to have aesthetic experiences. Such an approach, even in the earlier view that adoption of an aesthetic attitude was for the purpose of aesthetic judgment, still places the having of an aesthetic experience logically earlier than attitude or judgment—that is, going on the supposition that one cannot make an aesthetic judgment in the absence of having an aesthetic experience. This leaves two items at the ground level in terms of discussing "the aesthetic": aesthetic properties and aesthetic experiences. I believe that the latter is the more basic of the two. I believe this because it seems impossible to circumscribe the set of aesthetic properties (in either an objective or a subjective way) such that a single definition would capture what it is to be an aesthetic property. This is true for the following sorts of reasons:

- The attempt to attach objective properties either to the presence of aesthetic properties or to aesthetic judgments has been

historically unsuccessful. One cannot say that because an object has thus-and-so objective properties it must because of this have thus-and-so aesthetic properties. This failure is explained, and arguments for why such connections will not be successful have been offered, perhaps most famously by Frank Sibley.[2]

- It seems impossible to identify any set of objective properties that can be called *the* set of aesthetic properties. This is a problem of inclusion, but there is also the problem of exclusion: it seems equally impossible to designate any objective property as essentially a nonaesthetic property. This is because there is no reason to exclude from being an "aesthetic property" any property that actually enters into the making of a particular aesthetic judgment. So no property that *could* contribute to an agent's aesthetic experience ought be dismissed (a priori) as a candidate aesthetic property. In determining the scope of what counts as an aesthetic property, it is not merely the internal relations that we need to be attentive to, just as it is not merely the external relations that we need to be inattentive to in experiencing an object aesthetically. Many internal relations may be superfluous to our aesthetic experience of an object. For instance, it may not be necessary to understand what motivates Iago to be such a treacherous character to appreciate his place in *Othello*. It may not even be necessary to understand that Iago *is* treacherous to appreciate the play, so long as the actions that flow from his character serve to bind the "thesis" of the play together (the jealousy that Othello feels and what results from that). Conversely, some external relations may be relevant to our appreciation of the object. In knowing something of the conditions under which Mozart composed and of the instruments that were available to him at the time, one's appreciation of his music could increase. Another example, more clearly external, might be one's motivation to view a film more closely if one knows that the film had been nominated for an Oscar. This is not an unusual occurrence. The film's nomination is not an internal relation of the object, but knowledge of the nomination might nonetheless change a particular viewer's experience of the film for the better if her

attention is colored or motivated by this knowledge. To argue a priori that some properties are not or cannot be aesthetic properties seems counterintuitive to what seems to be our goal in viewing aesthetic objects. One ought not be interested in a boundary over which we must not tread in order to gain the best experience. We should be interested in loosening boundaries so that whatever might contribute to the overall best experience might be admitted to our set of aesthetic properties. None of this is to say that we ought to pay attention to each and every one of the object's properties (such a thing is not possible). It is, however, to say that all properties ought to be candidates for attention, so that no matter how prima facie incidental or peripheral a property seems to be, no matter how detached a property is from the internal or formal set(s) of aesthetic properties, one might have the legitimate option of attending to that property given its efficacy to enrich one's experience of the object.

• Aesthetic properties seem to be hybrid properties, mixtures of both objective aspects and evaluative aspects. As such, offering a purely objective account of aesthetic properties will be impossible. Monroe C. Beardsley writes,

> The alternative that remains is to say that a distinguishing feature of A-qualities [aesthetic qualities] is their intimate connection with normative critical judgments—or, more explicitly (though still tentatively and roughly), that an A-quality of an object is an aesthetically valuable quality of that object. On this proposal, what guides our linguistic intuition in classifying a given quality as an A-quality is the implicit recognition that it could be cited in a reason supposing a judgment (affirmative or negative) of aesthetic value.... This proposal has another advantage[:] ... to give a reason in support of a judgment of a work—or of any object, considered from the aesthetic point of view—you have to cite a quality of that object or of some part of it.[3]

This connection with aesthetic value, or aesthetic values, as Alan Goldman writes,[4] places aesthetic properties in line with their most popular linguistic use: as offering a defense or a justification for a particular broad evaluative claim about a work or natural object/event (that the object is beautiful, for instance). This also ties together aesthetic properties with the meanings and interpretations of the work. A detailed articulation of the meaning of a work will inevitably cite aesthetic properties, properties that contribute to the validity of the interpretation being articulated, and given that an interpretation may well be thought of as a vehicle for enhancing appreciation of an artwork,[5] such citations will pick out aesthetically valuable aspects of the work.

- The nineteenth and twentieth centuries are filled with objects that most viewers are happy to call art objects yet whose aesthetic character lies not much at all with the sensuous but rather with the cognitive. Marcel Duchamp's readymades and John Cage's music are clear examples. Aesthetics, to encompass a discussion of Duchamp's art, cannot merely be a focus on the sensuous aspects of experience. Of course, it is also fair to say that were there nothing there to look at, Duchamp's work would not be art. An external object upon which one's attention is bent, even if that object functions simply as a trigger for cognitions of one sort or another, is necessary: an aesthetic object is necessary for an aesthetic experience. This is even true of Cage's music, and it is even true of some memory or act of imagination. There must be a content to that memory or "imagining" that acts as a focus, albeit perhaps only in a triggering way, for an aesthetic experience to occur. The point, finally, is that one cannot describe in simply objective terms the aesthetic properties of all those recent objects best labeled "conceptual art." Simple objective accounts of aesthetic properties are insufficient here.

- Finally, consider a Lockean-relational analysis of the ontology of aesthetic properties, one in which aesthetic properties are understood as Lockean secondary qualities. The relationalist believes

that (a) the basic properties of objects, such as lines, shapes, and colors, are only in part responsible for the aesthetic properties of the object and (b) the "higher" aesthetic properties, such as harmony, grace, and elegance, are not in the object per se but are found in a relationship between the basic objective properties and the attending subject. Aesthetic properties exist as they are perceived to exist. Aesthetic properties exist in a doubly indexical position: indexed to objective properties and indexed to the attending agent's subjective state. While advocates of this position do not deny that the objective properties of the object are what form the bases upon which the attender's aesthetic experiencing (appreciation, evaluation) of the object is made, it is the attending of the agent that brings these elements into actuality. Without the attending agent, the object's properties that we take to be the basis for our aesthetic experience remain in a potential state. Historically, this is a popular position; it can be found in the work of such figures as Hutcheson, Kant, and, more recently, Beardsley, with the latter writing,

> The presence of value in the object does not of course depend on it actually being experienced—even if no one ever sees the Rhodora, it still retains its capacity to provide aesthetic enjoyment. So in a sense the value is independent of anyone's experience of it. But at the same time its value is not unconnected with actual or possible experiences, for its value is in fact defined in terms of such experiences.... Setting aside transcendent beauties or ineffable intuitions, the only ground that seems to be left for attributing goodness to works of art is the sort of experience they have it in them to provide.[6]

Yet another such account is that of Michael Mitias; he writes that "*Valse Triste* has the capacity, i.e. potentiality, to occasion or actualize a musical experience which has the affective character of sadness."[7] Such accounts explain how aesthetic qualities function and how they exist. If such accounts are correct, then strict circumscriptions around the set of all-and-only aesthetic properties from an objective point of view will be impossible.

All of these arguments taken together suggest that it is not possible to say, in any objective, essentialist, noninductivist way, what an aesthetic property is. Perhaps, then, our time is better spent in focusing not on the objective but on the subjective. That is, instead of focusing on what an aesthetic property is as a property of some object or event, we should consider aesthetic properties as properties of experiences (at least in the relational way described above). We may say that aesthetic properties are those properties that importantly and relevantly make up the content of aesthetic experiences. This allows us to privilege talk about aesthetic experience as foundational to understanding what *aesthetic* means.

DESCRIBING AESTHETIC EXPERIENCE

Considering aesthetic experience as the raw data that philosophical aesthetics seeks to explain is a relatively recent phenomenon.[8] This was certainly not the focus in the seventeenth and eighteenth centuries. Aesthetic judgment was the focus of Shaftesbury, Hutcheson, Hume, and Kant: how do we make meaningful judgments—that is, we hope, real ones—about the aesthetic quality of (certain) objects and events? But with Santayana, Dewey, and Stolnitz, the focus changes. Here the interest is in the aesthetic experience: what makes those experiences we label "aesthetic" special? Why do we separate those experiences from others?

The movement from the taste theories to those focused on aesthetic experience is not a movement that is over and done with. Far from it. There is still—and I think there will always be—a tension between these two very basic aspects of philosophical aesthetics. And although I claim that aesthetic experience is the most basic thing that aesthetics studies, I recognize that this is challengeable and only true from a certain temporal viewpoint.

I recently taught a very rewarding undergraduate course in aesthetics. The reason that it was so rewarding was that the students carried the class with deep and insightful discussions, and they were not shy about challenging what was coming out of my mouth. One of the challenges that informed our entire semester focused on the tension between experience and judgment. I lectured comfortably about aesthetic experience as our raw data, and I lectured equally comfortably about how taking an aes-

thetic view of an object or event meant focusing primarily, if not exclusively, on what is available to us through simple sensory acquaintanceship with the object. "Aesthetics," I said, "is about the sensuous aspects of our experiences." And so we could, for instance, take an aesthetic view of a Robert Mapplethorpe photograph that precluded our experiences' being mired in the themes that the more famous Mapplethorpe photos take as their content. "Mapplethorpe is a great photographer," I argued, "and you can see this if you are willing to focus strictly on what meets your eye when you look at the picture." In short, I held the position that the aesthetic view is the formal one. Without saying more, what I did was conflate two different things. On the one hand, I argued that aesthetic experience is a natural part of life that aesthetics seeks to explore. On the other, I argued that appreciating something aesthetically is to appreciate its formal qualities, those qualities that one can access simply through looking, hearing, touching, and so forth. But these really are two different things.

Aesthetic experiences, if we are to treat them as raw data, must be explored without preconception, prejudice, or limitation. And, truly enough, the vast majority of aesthetic experiences are not focused exclusively, in terms of their contents, on formal or simple-sensory matters. Aesthetic experiences are, first, experiences. They are complex things, having to do with aspects as tidy as the formal qualities of the object under consideration and with aspects as messy as whether one had enough sleep the night before, whether one just had a fight with one's roommate, whether one is carrying psychological baggage that is brought to consciousness by this particular aesthetic object. In a moment, I will explore some of this complexity.

The other side of what was happening in my class, the formal focus on the sensory as the basis for an aesthetic viewing, is not the substance of "aesthetic experience" per se. It is instead the basis of what we might call "aesthetic analysis." Aesthetic analysis has to do with separating out from our aesthetic experiences one specific part. To look simply at the contrasts of light and shading in a Mapplethorpe photograph, to see the textures that the light brings out, to see the balance of the composition: these sorts of things are, to be sure, included in aesthetic experiences of (most) Mapplethorpe photos, but these are infrequently the first things that rise to one's focus when one sees a Mapplethorpe photo.

Our pretheoretical experiences tend to focus first on the photo's contents, and here in the Bible-belted South where I write this, our first experiences tend to be ones of discomfort and perhaps alarm. They initially do not tend to focus on the very deft handling of light and balance that marks much of Mapplethorpe's work.

Experiences and analyses are different, the latter being only one part of the former. So to speak of each as the basis of the philosophical exploration of aesthetics is to conflate. Once more for the record, I want to state that this tension is not a new one. The substance of this conflation goes back to an attempt to do service in the history of this discipline to the two energies, one toward judgment and articulation of the proper subjects and proper methods of judgment, the other toward the psychological, to the "raw data" of pure and complex experience that we seek to taxonomize into aesthetic experiences and nonaesthetic experiences.

AESTHETIC EXPERIENCE AS A PSYCHOLOGICAL PHENOMENON

The following is an attempt to analyze (some of) the complexity we normally find in aesthetic experience.

Formal Analysis

This is the part of the aesthetic experience previously mentioned. If we understand aesthetics as having primarily to do with the sensuous or sensory aspects of experiences—with other considerations (such as information about the object or associations the viewer makes in attendance to the object) being of secondary concern—then we understand that in some fashion these purely sensory aspects can be bracketed off from other parts of the complex aesthetic experience. This sort of thing is illustrated in the use of the rich aesthetic vocabulary we have to describe the purely sensory aspects. We talk about balance, elegance, grace, harmony, excess, order, delicacy, grandeur, simplicity, modesty, subtlety, openness, authority, gentility, charm, garishness, and vulgarity when talking about aesthetic objects, and we in most cases are not talking about the subject matter of the object but rather about how the subject matter is presented or, more simply, about the presentation itself. We use aesthetic terms to reference what immediately hits our eyes or ears (or

noses, etc.). From the basic objective properties of lines, colors, proportions, contrasts, and so forth, we develop a view of an object's aesthetic qualities, and from an aesthetic description of the object, we determine the object's aesthetic worth. This is to say, of course, that aesthetic judgments tend to take as their substance the formal qualities of aesthetic objects. This is not always the case, but it is frequently so. Aesthetic evaluations are regularly evidenced by reference to the object's aesthetic properties, and these properties are said to be present on the evidence of the presence of basic properties of line and color.

The argument still stands, however, that an aesthetic analysis is not the full story when it comes to aesthetic experience. A formal treatment of an aesthetic object is insufficient to explain fully, in the vast majority of cases, exactly what went into a particular aesthetic experience.

External Factors

Not everything objective, with regard to an aesthetic experience, has to do with a formal analysis of the object under consideration. Some objective factors play a role in the creation of aesthetic experiences; we might call these "secondary aspects." The informational and subjective factors listed below, while not part of a formal analysis of an art object, are nonetheless relevant to an assessment of its full value.

1. Informational Factors. Above I refer to aesthetic analysis as focusing on the formal characters of aesthetic objects, even as I allude to the existence of secondary factors in aesthetic analyses. There are many facts, the knowing of which alters aesthetic experiences—sometimes only a bit, but sometimes a great deal.

 A. Genetic Information: What are the origins of the work? Who was the artist, what were her circumstances? What was the environment in which the work was created? When was it created? Where? What was the context of the work? What was the society like in which it was created? What were the religious, moral, social values of that time and place?

 B. Comparative Information: What was the genre of the work? How does it relate or compare to others of its kind? What is its kind?

C. Provenance Information: What is the history of the work? Was it valued when it was first created? Who valued it? Who has owned it? How did it come to be in this museum, gallery, or collection? What awards has it won? What recognition has it garnered?

2. Subjective Factors. The analogy that philosophy of mind has drawn over the past few decades between the mind and a computer is apt here. But rather than hardware and software, the focus here is on dust, magnets, and humidity. Just as a computer can be wildly affected by these sorts of things, so too are human experiences subject to a variety of stimuli that on the surface have nothing at all to do with aesthetics but nonetheless can play a palpable role in the construction of (any) experience.

A. Psychological Factors. If one is distracted, sad, or in a silly mood, one's experience will be affected. Indeed, psychological influences have a huge effect on the way in which we take in the contents of our experiences, the way we meaningfully shape them, and the way we record them in our memories. If one is distracted enough, what might at another time constitute a very powerful experience might on this viewing constitute a minor, even a forgettable, experience. If one feels sufficiently negative or negatively critical, what might be the substance of a very valuable experience might go entirely unnoticed.

B. Physical Factors. Once when I was in college, a friend of mine, with whom I was going to see a movie, indulged in a bit of marijuana smoking. The purpose, he said, was to enhance his experience of the film. After the film was over, I asked if the goal had been reached and was assured that it had been. It does not take illicit drugs to influence an experience; I find that my IQ plummets when I am on cold medication. And, of course, too much alcohol or too much caffeine can be distracting.

In addition to this, physical factors including temperature, comfort, and conflicting events can influence one's experience.

If the theater is too cold, if the seat is too small, if the person behind you spends five minutes getting the cellophane off a piece of peppermint, then your experience of a performance may suffer for it.

C. Maintenance of Distance. Edward Bullough argued that to experience an object or event aesthetically, one must maintain a "psychical distance" between oneself and the object or event under attention.[9] "Distance" is that state in which the viewer understands that she—her person, emotions, the potential of her action—is not actually engaged directly with the object. She is out of direct involvement with the object, experiencing it as if it were "out of reach," where she cannot effect any changes that would alter the object, and the object cannot effect any changes in her. One understands, for instance, that it is inappropriate to run on stage to stop Othello from strangling Desdemona.

One way to understand distance in the theater is to consider what has been called "the fourth wall." We look onto what is happening on stage, but from the point of view of the stage, there is an invisible fourth wall that separates the audience from the players. One famous example of where the fourth wall is broken comes from Suzanne Langer.[10] During *Peter Pan,* children normally are delighted when they are entreated by Peter to become agents in the saving of Tinkerbell's life through vigorous clapping. This is a movement in the subjectivity of the audience caused by the material insistence of Peter that the audience come to Tinkerbell's rescue. The children's experience is altered, and usually for the positive.

Some aesthetic objects or events, through the way they were constructed or the way they function, invade the psychical or even physical space of the audience member. This break in distance can have a great effect on the attending individual: sometimes positive, sometimes negative. The effect, of course, is subjective, but the stimulus is an external or material aspect of the object itself. (See chapter 3 for a discussion of the relationship between "distance" and "disinterest.")

Associations

Archibald Alison, in the eighteenth century, made "association" one of the cornerstones of his treatment of aesthetics. He was writing in an intellectual context of empiricism, and he emphasized more than any other aesthetician in that tradition the importance of imagination in the construction of aesthetic experience. Imagination, for Alison, was largely a matter of actively drawing out associations in the viewer, through what he called "attentive contemplation" of the object/event at hand.[11] Imaginative associations are not matters of intellect; they are matters of psychology. The mere presentation of beauty is not enough to stimulate the spectator into feeling pleasure over the beauty; the spectator becomes a more active participant. He exercises his mind, his imagination, his attentive contemplation to more fully experience the nature of the object and in so doing experience the object as fully aesthetically as he can. Without this mindful/imaginative activity, the experience is not aesthetic but is instead one of mere pleasure. Alison writes, "The emotions of taste may therefore be considered as distinguished from the emotions of simple pleasure by their being dependent upon the exercises of imagination; and though founded in all cases upon some simple emotion, as yet further requiring the employment of this faculty for their existence."[12]

It is my experience that one of the first experiential aspects to surface in attendance to an aesthetic object is one of association. Certain forms, colors, textures, tunes, smells, tastes, and so forth can bring to our attention memories of events and flavors of past experiences with great ease and strength. The smell of diesel fuel, mixed with cigarettes and perfume—however unpleasant that combination might sound—instantly transports me back to my first visits to London and the exhilaration I experienced then. Smell is a particularly effective means of associating the present with the past, but such associations can readily be had through attendance to visual and auditory stimuli—the more usual aesthetic sensory vehicles.

These sort of associations are not purely subjective—rather, they are relational in the sense that it takes the subject's memory coupled with the objective aesthetic stimuli to bring these associations into existence—but they are purely individual and particular. They are probably temporally sensitive, too; that is, certain associations may be had on one occasion but not had, for whatever reason, on another.

The associations that Alison spoke of are not cognitive (in the sense of purposefully directed and intellectual) in type; they are imaginative. There are many different sorts of association—emotional and cognitive alike—but the point is that, first, in all cases these are psychological phenomena and, second, whenever they arise, they are as much a part of the experience as any other part. They have as much claim to being a part of an aesthetic experience as, say, the formal parts discussed above.

There is a range of associations that we may make in having an aesthetic experience. These could include

- Recollective: One recalls some past experience.

- Emotional: One associates a certain emotion with the object under attendance. This emotion could be very general ("listening to the blues makes one feel sad"), somewhat general ("Merchant-Ivory films make me feel melancholy"), somewhat specific ("I think of Scotland on very windy days"), or very specific ("Mexican ballad music reminds me of my mother's records when I was young").

- Cognitive: One makes a connection, in thinking about the object under consideration, to another object or event that shares some property with the first. This is the essence, I think, of all the aesthetic-interpretative work that goes on in considering text (whatever sort: literary, filmic, etc.) A friend of mine recently remarked that the power of Martin Scorsese's *Raging Bull* lies in how powerfully religiously thematic the film is. Another friend recently explained how Stanley Kubrick's *2001: A Space Odyssey* can be valuably understood as a tale about the Judeo-Christian story about the Tree of the Knowledge of Good and Evil. Neither of these film interpretations had occurred to me earlier. The reason for this is that these sorts of associations seem to rely heavily on the background beliefs and values of the individuals making these connections. In both cases, the interpreters were particularly religious individuals; it stands to reason that they would see, in thinking about these two films, religious themes and would explain the film's coherence in terms of religious themes. We would less expect atheists to make the same

sorts of associations, and this reinforces the point that such cognitive associations are in the largest measure dependent on the psychology of the individual making them.

Contexts

The art world of the twentieth century, if reduced to a single word, would be reduced to the word *challenge*. The early part of the century saw extensive and aggressive challenges to the very definition of art: Dada, the readymades, and Pop Art expanded academic definitions of art very broadly. The middle part of the century saw a great deal of conceptual art, art that was to be understood, that was making a point or sending a message. The last part of the twentieth century challenged our values. Robert Mapplethorpe, Andres Serrano, Richard Serra, Damien Hirst, Chris Ofili, and a host of others have presented works that confront and provoke us. They are not merely cognitive vehicles; they are strongly emotional ones, assailing our values and the contexts in which we hold those particular values.

There must be many individuals who see Mapplethorpe photographs who do not, perhaps cannot, "get beyond" the subject matter of those photos. This is understandable, to some degree or on some level, because aesthetic experiences, the raw data of experiences of viewing objects presented to us as objects primarily or merely just to be looked at, tend to include reactions based on seeing the object within a context, as seeing it as a challenge.

Surely this must be the case. Consider the many twentieth-century artworks that have very little power as aesthetic objects if considered merely in terms of their formal properties. Marcel Duchamp would hardly be mentioned in the art world today were his art objects considered merely in terms of their formal characteristics. *In Advance of a Broken Arm* (once a snow shovel) is visually very boring, as is *Fountain*. Consider John Cage's *4' 33"*. Or Robert Rauschenberg's *Erased De Kooning*. Or Andy Warhol's *Brillo Pad Boxes*. Each of these artists must have intended his work to be presented not in terms of its formal characteristics, for each of these items, taken as a formal aesthetic object, is remarkably dull. That was the point (one of the points, at least). These works were meant to issue certain challenges. And this is where their value as aesthetic objects, as art objects, lies.

A THEORY OF "THE AESTHETIC"

Message-driven art, or conceptual art, certainly falls under the "associations" category above. But it falls into this category as well, and so do its late-twentieth-century value- or sensibility-challenging cousins. The prominence of value-challenging aesthetics is undeniable. One need only open any mainstream cutting-edge magazine to see the popular legacy (or fallout) of value-challenging aesthetics in Benetton advertisements, Calvin Klein advertisements, and photos of current clothing fashions. These items are intended to rattle cages. They will offend some people. Others will embrace and champion them as tours de force of liberality and open-mindedness.

Do we take these reactions, which are part and parcel of "first contact" with so many contemporary aesthetic objects, as bona fide parts of aesthetic experiences? Given that the meaningfulness of so many of these objects rests solely and squarely on their power to provoke, the answer, it would seem, has to be a yes.

What are some of the various contexts under which we consider aesthetic objects, contexts that we bring as categories for dealing with aesthetic objects and experiencing them?

1. Social Contexts

 A. Ethnic and Racial Contexts. Many objects, perhaps all objects, today can be understood (I do not say "should"—that would be a separate argument) as conveying, overtly or tacitly, some message about matters of race and heritage.

 B. Class Contexts. The same can be said for class—of education, birth, or economic status.

 C. Gender Contexts. Does my experience of a work hold for me some significance in terms of sex or gender? Do I see Ridley Scott's *Thelma and Louise* as a feminist manifesto? Do I see Milos Forman's *One Flew over the Cuckoo's Nest* as essentially misogynist?

 D. National or Cultural Contexts. Some aesthetic objects present strong nationalist messages. In the eighteenth century, Sir Joshua Reynolds and Benjamin West produced visual works of art that celebrate and support Great Britain. In

nineteenth-century America, we find the work of Winslow Homer and Thomas Eakins (and Gerald Murphy in the early twentieth) and, in the literary arts, the work of Ralph Waldo Emerson, Nathaniel Hawthorne, and Herman Melville. Germany sees perhaps its greatest nationalist artist in the nineteenth century: Richard Wagner. In the early twentieth century, Mexican artists such as Diego Rivera, José Clemente Orozco, and David Alfaro Siqueiros painted murals that focused on cultural nationalism and revolutionary politics.

E. Political Contexts. I believe the *New Yorker* to be the best example of popular applied aesthetics today, and I usually assign a copy of it as a required text for aesthetics courses I offer. In the course I mentioned above, one student reacted strongly to being "forced" to read (part of) "that liberal rag." He pointed out that the *New Yorker* had that semester celebrated the humanity of Tipper Gore, while at the same time running an article on George W. Bush's ineptitude with the English language, and it spent a good deal of time in several issues mocking the aesthetic and moral sensibilities of New York mayor Rudy Giuliani. I had not seen these same things or, better put, had not seen these things as my student had. He was looking at the magazine through political eyes.

2. Moral Contexts

A. Religious Contexts. It is an understatement to say that Serrano's photograph of a crucifix suspended in a jar of urine (*PissChrist*), Scorsese's *Last Temptation of Christ,* and Ofili's *Madonna,* complete with elephant dung, have been considered widely from religious contexts.

B. Sexual Contexts. The line between those objects created to satisfy prurient interests and those created to satisfy aesthetic ones has always been blurry. This is not a recent phenomenon. Michelangelo walked that line, apparently. Rembrandt supposedly did, too. A good example is Edouard Manet's *Olympia,* thought to be morally reprehensible not because

the central figure was nude but owing to the defiance in the subject's face as she presented herself as a nude. In this century, the blurry line is as blurry as ever, with daily examples present in all the popular aesthetic media. The line between the obscene and the artistic is debated at both the highest and the lowest levels in this country; the U.S. Congress has only marginally fewer discussions about this topic than occur at America's dinner tables today.

C. Violence Contexts. There are those in the world whose thresholds for viewing violence are low, and there are some art objects that present deeply arresting portraits of violence (e.g., Kubrick's *Clockwork Orange*, Quentin Tarantino's *Reservoir Dogs*). When these come together, the influence of the latter on the former effectively halts aesthetic experience. Just as some people cannot see beyond the sexual content of a Mapplethorpe photo, so too are some people unable to aesthetically appreciate *Clockwork Orange* or *Reservoir Dogs* because they cannot get beyond the violence. This is not a fault in either the viewer or the object; it is simply a matter of human psychology.

3. "Taste" Contexts

A. "Good Taste." In "Aesthetic Censorship: Censoring Art for Art's Sake,"[13] Richard Shusterman argues that no case has been made against censorship that would preclude the propriety of censoring for reasons that are aesthetic in nature. Shusterman argues that aesthetic censorship would have the effect of highlighting the best work; it would not dull our aesthetic sensibilities with less-good work; and if economic constraints will necessarily act as a censor, better we censor on aesthetic grounds so that the best work is assured of receiving support.

There are a great number of artworks out in the world today that are aesthetically unmeritorious. They do not reward aesthetic attention and may even be blamed for distracting our finite attention for works that we would find

rewarding. This being said, there *are* also works out there that are aesthetically meritorious but get dumped into the aforementioned category simply because they are in "bad taste." Some artworks would reward aesthetic attention but are not granted that opportunity—their potential goes unactualized—because they are vulgar in some way.

B. "My Taste." Hume's attempt, the common wisdom holds, to balance the subjectivity and incorrigibility of taste with a realist account of aesthetic judgment fails. It fails on the probability that two equally well disposed aesthetic judges might finally disagree about the merits of a given object. This is sometimes chalked up to a difference in taste. Here we are not talking about "good taste" versus "bad taste" but about varieties of taste: some people like Mozart, some like John Lennon. Some people like David Lynch, some like David Lean. Some people like Wassily Kandinsky, some like John Singer Sargent. If it is an irreducible fact about human aesthetic sensibility that tastes vary, then this constitutes a very present and very real context through which we view aesthetic objects.

AN INDUCTIVIST APPROACH TO UNDERSTANDING AESTHETIC EXPERIENCE

If everyone has had aesthetic experiences—and this seems an uncontroversial assumption—then to some degree everyone can draw a line between those experiences she has had that are aesthetic and those that are not. This line will probably be quite vague, but that does not matter. The point is not to draw the line so solidly that it can support a metaphysical discussion (of differences in kinds of experience) but to have the line be just strong enough to apportion some experiences separately from others. Then, in as strong or as soft terms as we wish and as our arguments will support, we can begin to say what is different about aesthetic experiences and nonaesthetic experiences. The doubt that such a line can be drawn so strongly that a metaphysical distinction can be defended, along

with a general interest in ontological economy, may make the wiser choice the nonessentialist one, in which aesthetic and nonaesthetic experience lie on a continuum having fairly clear examples of aesthetic experiences at one end and nonaesthetic experiences at the other.

One philosopher who described aesthetic experience in a nonessentialist, nondivisive way was John Dewey. Dewey's account centers on what he calls "*an* experience." *An* experience is any garden-variety experience one might have that has the character of being maximally unified and highly meaningful. *An* experience is a bounded organic whole; when a moment is sufficient to itself, is individualized, this is *an* experience. In aesthetic experience, there is a heightened interest in the factors that constitute *an* experience, in the experience's "omnipresent form, in its dynamic construction, in its rhythmic variety and unity."[14]

- The difficulty with Dewey's account is that it seems to easily admit of counterexample. There are many experiences that seem to adequately fulfill Dewey's aesthetic-experiential criteria but are also clearly nonaesthetic. A nondomestically oriented spouse making his or her first grocery-buying trip might have an experience that fulfills Dewey's criteria, but this may not be the sort of experience that this individual would class with his or her aesthetic experiences. Nonetheless, there are several things that are still attractive about Dewey's account. Dewey focuses on experience and the subjective in his treatment of aesthetics. The praises of this approach have already been sung.

- Dewey does not preventively exclude any properties or states, subjective or objective, from inclusion in some particular aesthetic experience.

- He does not focus on what *ought* to be paradigmatic instances of aesthetic experiences, such as those had in galleries and concert halls. Instead, he takes the experience of "the common person" as basic.

- Dewey's account is not divisive; it does not seek to draw a hard line between the aesthetic and the nonaesthetic. Dewey believed that every event has something of the aesthetic about

it—some, of course, more than others. Even an episode of brushing one's teeth might have something of the aesthetic about it, albeit something small. This nondivisiveness is much more in line with the way that people label some experiences aesthetic and others not. There are those who have nothing like an aesthetic experience though their attention is directed at, say, a work by Warhol. There are those who have aesthetic experiences looking at the butterfly and seashell motif of a bathroom wallpaper. Dewey allows for the wideness of the range of aesthetic experience.

One of the key offerings of Dewey's account is that it offers us a deep freedom in understanding and discussing the nature of aesthetic experience. This is a blessing, to be sure. But it is also a bit of a curse because with such freedom comes the spectre of relativism, and with relativism comes the difficulty of not being able to offer any intelligible discussion about aesthetic experience. Was Dewey an aesthetic relativist? Probably. But he was no more a relativist in aesthetic discussions than any inductivist would be required to be. Different human beings have different aesthetic experiences than others, even though their attention is directed toward the same objects or events. The trick for Dewey was to describe, in the manner of a scientist, what was generally common to the ways in which common individuals labeled some experiences aesthetic and others not. This process is at heart inductivist, and so its results cannot be essential or necessary. However, his attempt to pick out a general pattern, as science does, is reason enough to listen closely to Dewey. Predictions about gravity are nonessential, but no one denies that it is better to predict that gravity will be present tomorrow as it is today. Predictions that aesthetic experiences will have the character that Dewey describes—that they will be those experiences that are maximally unified and highly meaningful—are worthy of attention.

Monroe Beardsley takes up where Dewey left off. Beardsley's reliance on psychology surpasses Dewey's. Beardsley's last (published) analysis of what constitutes an aesthetic experience is this:

My present disposition is to work with a set of five criteria of the aesthetic character of experience. . . .

(1) Object Directness. A willingly accepted guidance over the succession of one's mental states by phenomenally objective properties (qualities and relations) of a perceptual or intentional field on which attention is fixed with a feeling that things are working or have worked themselves out fittingly.

(2) Felt Freedom. A sense of release from the dominance of some antecedent concerns about past and future, a relaxation and sense of harmony with what is presented or semantically invoked by it or implicitly promised by it, so that what comes has the air of having been freely chosen.

(3) Detached Affect. A sense that the objects on which interest is concentrated are set a little at a distance emotionally—a certain detachment of affect, so that even when we are confronted with dark and terrible things, and feel them sharply, they do not oppress but make us aware of our power to rise above them.

(4) Active Discovery. A sense of actively exercising constructive powers of the mind, of being challenged by a variety of potentially conflicting stimuli to try to make them cohere; a keyed-up state amounting to exhilaration in seeing connections between percepts and between meanings, a sense (which may be illusionary) of intelligibility.

(5) Wholeness. A sense of integration as a person, of being restored to wholeness from distracting and disruptive influences (but by inclusive synthesis as well as by exclusion), and a corresponding contentment, even through disturbing feeling, that involves self-acceptance and self-expansion.[15]

Is Beardsley's account the right one? Does it accurately describe the general nature of aesthetic experience? This question, given the very approaches that he and Dewey took, may be ill conceived. No one over the age of two, since well before Sir Isaac Newton, has needed much instruction on the fact that if an unattached object is released in midair it will move swiftly and directly toward the earth. The effects of gravity are easy

to see and generally easy to predict. Though gravity itself has been explained in a number of different ways—an attraction of an object for its home, a move toward greater maturity or actuality, a field theory, a bending of space—the effects of gravity are rather uncontroversial. Does this mean, then, that we ought to cease our attempt to understand gravity and thereby cease our attempt at greater precision regarding the predicting of gravity's effects? Now that airplanes stay in the air, should we stop our inquiries into aerodynamics? The nature of science is such that it is an ongoing enterprise. Dewey and Beardsley realized that their projects were inherently inductivist and that such nonessentialist projects cannot be said to be (finally) correct or incorrect. Morris Weitz described the concept of art, the definition of art, as evolving and growing.[16] With more data in the form of new works of art, new art movements, and new art forms, the very concept of art will stretch to include those new data. This is how it must be with an inductivist approach to aesthetic experience. As a matter of course, any such account will grow and evolve to include the additional data of new human beings having new aesthetic experiences. Today empirical psychology could probably give us a more accurate account than Beardsley's, but tomorrow it could give us a more accurate account still.

LESSONS ON DEFINING THE AESTHETIC

What are the lessons to be learned about defining "the aesthetic"?

1. To define "the aesthetic" is to understand the word *aesthetic* primarily as a modifier, as an adjective. Uses of *aesthetic* as a noun are euphemisms, placeholders, or shorthand for other, more precise, descriptions in which *aesthetic* is an adjective.

2. To define "the aesthetic" is to understand why some experiences are apportioned off from others, with the former labeled as aesthetic and the latter not. This approach is more basic than attempting to understand why some properties (or states) of objects (or events) are aesthetic and some not. Such properties take on their roles as aesthetic properties only as they are involved in (actual) aesthetic experience.

3. Aesthetic experience is best understood as relational. Hume, Kant, Sibley, and many others give us good reason for thinking so. Michael Mitias writes that "any attempt to explain the aesthetic character of experience either from the standpoint of the perceiver exclusively or from the standpoint of the art work, or aesthetic object, exclusively is doomed to failure from the start—why? Because the aesthetic experience is a complex, organic, event; it is relational in its very essence. It happens, it comes into existence, in an encounter between two types of reality, a percipient and an art work; and outside this encounter this experience does not, and cannot exist."[17] The ontological account of the existence of aesthetic properties that best fits the relational character of aesthetic experiences is the Lockean one described above. Aesthetic properties are actualized in the relationship between aesthetic attender and the objective properties of the object under attendance.

4. To understand the nature of aesthetic experience without prejudice is to adopt an inductivist approach. The principal reason that this is the correct approach is that the raw data that we are attempting to understand in all this (given the discussion under category 1 above) are actual aesthetic experiences. To attempt to do this in anything but an inductivist manner is to invite inevitable counterexample. We are not, in trying to explain the nature of aesthetic experience, in the business of saying to people under what conditions they will and will not have aesthetic experiences. Rather, we must take the plethora of data with which we are faced and try to find some pattern or patterns to it. This is the naturalist, inductivist approach of Dewey and Beardsley. It is the right one.

5. There is a final lesson to be learned about defining "the aesthetic" and investigating aesthetic experience. To claim that the very meaning of aesthetic consideration (evaluation, appreciation, attention, experience) is necessarily conjoined with an attitude or posture of disinterest—"disinterest" just as any particular disinterest theorist might define it—is to miss the entire point of

open philosophical inquiry in the nature of aesthetic experience. This is the point of this chapter; it is the contribution this chapter makes to this book. Aesthetic appreciation does not *mean* disinterested appreciation. Perhaps the best way to achieve the greatest reward in those experiences that humans decide to call "aesthetic" may indeed be had through a disinterested disposition. But this is a purely empirical claim, and it is a claim that I think in many cases is false. To connect the meaning of aesthetic appreciation together with disinterested appreciation is to cut off inquiry, rendering all further philosophical challenge useless. It is to hijack the word *aesthetic.*

2 The Value of Art

IN ARGUING THAT CONSIDERING THE CONTEXT of a work of art enhances the value of that work, I am torn between whether to discuss the value of the artwork per se or the value of the experience of it. I am initially inclined to talk about the experience of it. Certainly, one experience can be better than another. This is true between experiences had by two different individuals, and it is true between two experiences had by the same person. However, in attempting to offer a justification for the judgment that one is better than the other, we find ourselves, given the inherent messiness of aesthetic experience (see chapter 1), in unsafe waters. The safer waters are the objective ones, in which the value of a particular art object is in principle accessible by everyone and open to everyone's scrutiny. This is why for the purposes of this book, a theory about the value of art needs to focus on objects and not on experiences.

I reject the view that works of art are intrinsically valuable, that they are valuable on their own, without reference to anything at all outside themselves. As a contextualist, I am bound to have this perspective. I am fairly confident that the locus of the value of art lies in the experiencing of it or perhaps more broadly within human experience. However, I am also fairly confident that if my case about art contextualism relies on the value of experiences per se, I run two risks. First, I run the risk that all sorts of psychological, associational, imaginative factors become relevant

to the constitution of the experience, and this is to subjectivize and relativize my case into triviality. Second, I run the risk of simply begging the question against decontextualist and disinterest theories that demand that certain dispositional states are necessary for the correct and proper appreciation and/or evaluation of art. That is, experiences are, it might be argued, essentially contextual, and so any theory that seeks to decontextualize experience is doomed from the start. But I do not think that disinterest theories are incoherent. I simply think that, in some cases, such theories are woefully insufficient, actually reducing the value of some works of art rather than enhancing it. This is yet another reason why my case needs to be framed in terms of the value of works of art rather than the experiences of them.

If I mean to offer a case in which the assessment of the value of a work of art is at issue, I need to be clear on just what it is that makes a work of art valuable. I need to offer, in terms modest enough for a single "infrastructure" chapter yet robust enough to ground my case and define the terms of my argument reasonably well, a theory of the value of art. I tackle this here by sketching out a variety of theories of artistic value—the only clearly unacceptable ones being intrinsic ones. Some readers may find this installment to be overkill, but for those who want the full story, including this definitional backstory, I offer this chapter.

INTRINSIC VALUE ACCOUNTS
AND ANITA SILVERS'S REVISIONISM

What does it mean to say that one work of art is more valuable, as a work of art, than another? What is it that is more valuable about an artwork when—to import my thesis—it is contextualized rather than considered in the absence of context? What is it that we judge when we assess the value of an artwork? Why are artworks valuable? I can begin to sketch answers to these questions by framing the discussion in a familiar axiological taxonomy, the language of values being intrinsic, instrumental, or extrinsic.[1]

Marcel Duchamp's artwork *In Advance of a Broken Arm* is physically a snow shovel. It was purchased by Duchamp right off the rack. *In Advance of a Broken Arm,* like the rest of Duchamp's so-called readymades,

was not originally a work of art. However, the adoption of the ready-made object by Duchamp as art, many believe, rendered the object art. At least, his act introduced the candidacy of the object to be recognized as art by members of the art world. Its candidacy has been a matter of controversy, especially early on, but generally people in the art world accept *In Advance of a Broken Arm* as art. Not everyone agrees with this verdict, of course. Some people point to the indistinguishability of *In Advance of a Broken Arm* from any one of the snow shovels left behind in the hardware store after Duchamp left with his. Someone might ask, "If the objects left in the store are not art objects, then why should one that is physically indistinguishable be art? Furthermore, why should it now apparently possess a value that the others fail to possess? Why should it be treated any differently than the others?"

If the value of this artwork is intrinsic to it—by which I mean that the value lies in properties that the object possesses that are accessible through general empirical, sensory means, separate from any subjective state, any reference to the audience member whatsoever[2]—then the question that the Duchamp detractor poses must get a second hearing: what makes the snow shovel with which Duchamp left the hardware store different from the ones he left behind? Physically the set of snow shovels is identical. We know this, because were they different from one another, Duchamp's statement in choosing the shovel to be elevated above the rest would be lost. Readymades are all essentially not physically special. If there is nothing physically special about the object, then either the object underwent some change in intrinsic value, presumably through a potential, inherent value being actualized through some action of Duchamp's, or else some value that it always had, but which had gone unrecognized, was recognized by Duchamp or by other members of the art world. The suggestion that the intrinsic value had gone unrecognized seems implausible. If the shovel Duchamp picked out had a hidden artistic or aesthetic merit, then all the shovels did. This suggestion is at odds with Duchamp's purpose in choosing an off-the-rack shovel.

The suggestion that the shovel underwent some change through the actualization of an inherent value is a possibility, but then the focus has to be on the mechanism of change. How did the shovel rise from being a mere shovel to being art? Was it through the power of Duchamp's

adoption? If so, why does Duchamp have this power while others do not? Duchamp was clearly a member of the art world; perhaps by virtue of this membership, he had the power to introduce to the art world an object as a candidate for artistic appreciation. Accepting as a supposition the position that the shovel did indeed acquire some value through its elevation to the status of art, the power to actualize the shovel's inherent value lies then in two places: in what Duchamp as an artist did in adopting the shovel for presentation to the art world, and what some other members of the art world did in accepting the shovel, now *In Advance of a Broken Arm,* as art.

Unfortunately, this sort of position is unacceptable to anyone who holds that the statement by one (elite) group that a thing is more valuable than it was before being recognized by that group is insufficient to actually make it more valuable. The academic world today is different from the academy a hundred years ago. Members of today's academy are suspicious, and probably rightly so, of moves to imbue certain objects or events, or even certain states, with greater value exclusively or primarily as a result of a powerful group's dictating by fiat the legitimacy of that move. Just because members of the art world claim that a thing is of greater value because it has been accepted as art, people who do not have such power or do not benefit from such power are not necessarily going to recognize the newly possessed value of the object. A position that may be seen to involve an undue exercise of power on the part of members of the art world suffers because of this. Furthermore, if someone were to challenge the claim that the art world is an elite group, then clearly the burden of proof would have to fall upon him. Membership in the art world, using the term in the general sense inherited from Arthur Danto (historically, traditionally) and George Dickie (institutionally), is bought through specific education, holding certain positions, or the freedom to spend time in that world.

The role of the art world in terms of accepting an object as art is a classification function. The classifying of things is something that we do as speakers of a language. A language user classifies things to communicate about his ontology meaningfully and effectively. This is why we designate some things as art. It is important to individuals with concerns about elitism that this is nearly all we do when we call a thing art. We

◈

assign a class to an object as distinct from other objects in order to talk about it as a member of a set, the set of all and only art objects. The additional respect that the object commands in view of this classification is a secondary matter, but the classification itself is merely a linguistic move. Seen in this light, the art world's function is not an exercise of power but a function of linguistics and socially necessary pattern identification. If this is the case, then the art world is not a value-conferring body. As a result, neither the position that the object had an unrecognized intrinsic value nor the position that it had an unactualized inherent value is tenable.

This is my first argument against intrinsic accounts. My second comes from Anita Silvers, from her article "The Story of Art Is the Test of Time."[3] In this article, Silvers introduces the difference between a traditionalist view of the value of works of art and a revisionist view. The traditionalist holds that the value of works of art depends on the features they had at the point of their creation. The revisionist holds that their value can vary depending on future events, that "artists are not responsible for essential properties of their creations[;] . . . as history unfolds, objects face the difficulty of maintaining their aesthetic identity while their aesthetically essential features change."[4] In her article, Silvers defends a revisionist view. She begins by talking about how objects are added to the canon:

> For a work to be canonized, it seems a truism that over time, it qualifies by:
>
> a. acquiring valuable properties sufficient to qualify it, or
>
> b. revealing previously unnoticed meritorious or agreeable properties sufficient to qualify it, or
>
> c. failing, despite systematic scrutiny, to reveal defects of disagreeableness sufficient to disqualify it.[5]

She refers to disjunct b as appealing to linear time and disjunct c as appealing to statistical time. And she writes that "neither accords sufficiently with how time actually tests works of art."[6] Silvers writes that many artworks throughout history have been subject to reevaluation. Not all good works grow steadily in admiration over time; sometimes there are peaks

and valleys. If disjunct b is the right answer, then as positive properties of works are discovered, they should endure and impede a work's declining in value (lower than where it started) later. But actual art valuation does not flow this way. Disjunct c holds that the longer a good work enjoys admiration, the less likely it is to suffer later on. Silvers states, though, that this same sort of thing actually does not happen in the case of works that are originally rejected. A work's early rejection, and its continued disfavor, does not over time increase the likelihood that it will continue to suffer a worse reputation. Disjuncts b and c are traditionalist. With their rejection, the revisionist disjunct a is left: the future history of a work counts in its assessment and its candidacy for canonization.

The best example I know in support of Silver's view is Jerry Uelsmann. Uelsmann is a photographer whose work is fairly widely well known; it has been reproduced a great deal, and even if a person does not know the name "Uelsmann," it is a good bet that she has seen one of his photographic images at some point. Uelsmann's greatest claim to fame—apart from the merit of his images—is that he was central to the reconceiving of photography from a previsualization medium to a postvisualization medium. A previsualization photographer believes that the greatest point of artistic creativity and importance is when the camera's shutter clicks. A postvisualization photographer believes that her work as an artist is done primarily in the darkroom, in the manipulation of the images captured on the negatives. Uelsmann is a pioneer of photomontage. He assembles different photographic images to create works—photographic works—combining images that could not be captured in a shutter's click. It is very difficult to look at a Uelsmann work and not immediately think that it was very cleverly and carefully enhanced digitally, that it is anything but a product of a computer process. And yet far less than 1 percent of Uelsmann's images involved such a process. He works with negatives and enlargers in a darkroom. One of the most important things, then, to know about Uelsmann's images is that they are not digitally enhanced through the use of computer software. This adds—in my case dramatically—to the admiration one feels for his images. Adobe Photoshop and other sorts of electronic visual tools were not available when Uelsmann first started working, over four decades ago. Uelsmann's case is a fine example of a contextual fact about his work being very relevant to a quality

assessment of his work, even though that fact was not even in existence when the work first began. This seems a clear case of the sort of revisionist evaluation Silvers describes.

If revisionism is true, then this is clear support for contextualism. All the events that happen after a work's creation that actually affect how it is assessed are quite clearly the sort of contextual features I discuss throughout this book. If they make a difference to the value of a work, then clearly context matters. But more to the point for this chapter, if revisionism is true, then intrinsic accounts of the value of art cannot be. The features at issue in a revisionist vision of value have little to do with the properties that the object possessed at the time of its inception, apart from the obvious way in which the assessment is about that particular object. The revisionist features are matters principally of regard, and this rests in the subject, or subjects, or the collective subject (the whole audience). These features are by definition not present in the object at its inception, so referring to them as intrinsic properties of the object makes no sense. They lie outside. They are added to the object through subjective regard.

There are, of course, other difficulties with intrinsic value accounts, problems regarding the ontological nature of intrinsic value, problems with epistemic access to such value, especially in the face of contrasting judgments. But the two arguments above are sufficient to let us leave intrinsic accounts behind us. If the value of works of art is not intrinsic to those works, then the value in question must be extrinsic in the sense that the value lies outside of the object. The next step, then, is to determine the possibilities of extrinsic value.

INSTRUMENTAL VALUE ACCOUNTS

If intrinsic value accounts are untenable, how about an instrumental account? I consider four in this section. I call these four "production accounts," given that in each account, value lies in certain subjective states that are produced through attention to the artwork. The production theories I discuss are those of Monroe Beardsley, Nelson Goodman, Leo Tolstoy, and Alan H. Goldman. The first three of these theorists represent the most popular and central production theories, those focused on, in the case of Beardsley, the value of a work of art being grounded

in its ability to produce in an audience member an aesthetic experience; in the case of Goodman, to produce in an audience member a certain cognitive experience; and, third, in the case of Tolstoy (for lack of a more current pure affective theory), to produce in an audience member a certain emotional state. The fourth account, that of Goldman, is a sort of amalgam.

Monroe C. Beardsley's Aesthetic Account

Beardsley's original account of artistic value comes from his 1958 book, *Aesthetics: Problems in the Philosophy of Criticism,*[7] in chapters entitled "Critical Evaluation" and "Aesthetic Value." There he described the three general canons of aesthetic merit in works of art: the degree of unity or disunity in a work, the degree of complexity or simplicity, and the degree of intensity or lack of intensity.[8] Each of these canons represents some quality of an aesthetic experience rather than of an aesthetic object per se, though these qualities are objectively focused, that is, focused on the formal qualities of the object under aesthetic consideration. He writes,

> First, an aesthetic experience is one in which attention is firmly fixed upon heterogeneous but interrelated components of a phenomenally objective field—visual or auditory patterns, or the characters and events in literature. . . . Second, it is an experience of some intensity. . . . But this discussion already anticipates the two other features of aesthetic experience, which may both be subsumed under *unity.* For, third, it is an experience that hangs together, or is coherent, to an unusually high degree. Fourth, it is an experience that is unusually complete in itself. . . . Because of the highly concentrated, or localized, attention characteristic of aesthetic experience, it tends to mark itself out from the general stream of experience, and stand in memory as a single experience. . . . One aesthetic experience may differ from another in any or all of three connected but independent respects. . . . I propose to say that one aesthetic experience has a greater magnitude—that is, it is more of an aesthetic experience—than another; and that its magnitude is a function of at least these three variables.[9]

The subjective focus of Beardsley's criteria comes out more strongly in his 1979 revised list,[10] quoted in chapter 1, and the instrumental character comes out strongly when he writes, "'X has greater aesthetic value than Y' means 'X has the capacity to produce an aesthetic experience of greater magnitude (such an experience having more value) than that produced by Y.' Since this definition defines 'aesthetic value' in terms of consequences, an object's utility or instrumentality to a certain sort of experience, I shall call it an Instrumentalist definition of 'aesthetic value.'"[11] The marriage, so to speak, of his chapter on aesthetic value with his chapter on critical evaluation establishes the point that Beardsley understands artistic value in terms of aesthetic value. The union is strengthened when he writes, "An artwork can be usefully defined as an intentional arrangement of conditions for affording experiences with a marked aesthetic character."[12]

Considering Beardsley's Account

The reality is that there are, especially in the twentieth century, a great many examples of works of artistic merit that have virtually nothing at all to do with a consideration of the (subjective) experience of the "heterogeneous but interrelated components" of their "phenomenally objective field[s]." While it may well be true that one can take an aesthetic perspective, in line with Beardsley's description of such a perspective, to any object (so long as that object is phenomenal or in principle sensory), it would be odd indeed if that perspective turned out to be appropriate when applied to many of the objects created within the past century. Aesthetic accounts of artistic value, when they are presented as complete analyses of artistic value, suffer from the presence of too many available counterexamples. Consider again Duchamp's *In Advance of a Broken Arm*. Objects such as this are widely accepted as works of art, yet neither their status nor their value as artworks seems dependent on the aesthetic properties they possess or on the aesthetic nature of the experience they prompt. We would most likely say of a spectator who was in the midst of appreciating the formal aesthetic properties of *In Advance of a Broken Arm* that he "really didn't get it." Most of us would find it odd to see someone studying the physical, formal properties of the snow shovel the way we would expect to see someone studying the light in a Rembrandt

or the brushstrokes in a Van Gogh. Moreover, we would say of someone who describes his experience of *In Advance of a Broken Arm* as an aesthetic experience that he was using the term *aesthetic* very liberally and not in the way that Beardsley—who, while a subjectivist about aesthetic value, was still at heart a formalist about aesthetic properties—used the term. For Beardsley's account to be interesting, it needs to circumscribe the aesthetic—properties, objects, and experiences—in such a way that it excludes some things. If one's experience of *In Advance of a Broken Arm* is an aesthetic one, then showing what sorts of experiences are not aesthetic would be very difficult.

Recent art exhibitions have only added fuel to this. Damien Hirst, one of the Young British Artists, recently found himself, with artist Chris Ofili, at the center of a major controversy surrounding the Brooklyn Art Museum's exhibition of a show entitled Sensation. The show was blasted by then–New York mayor Rudy Guiliani, who went so far as to threaten the museum's funding. Hirst's body of work includes pieces described in the following way:

> Another room contains large tanks made of glass with white painted steel frames. The tanks are filled with a kind of greenish fluid and, suspended or affixed with wire and tacks in each of the tanks, there are a series of "slices" of a cow. This is the work of Damian Hirst. You might think that it would be interesting to see the inner workings of your favorite entrée but the effect is anything but. The liquid that was used to fix and preserve the specimens has rendered the various structures a "dull gray" and so the consecutive filets looked like soggy old newspaper floating in an aquarium.[13]

If Hirst's work, or at least these pieces, has artistic value, surely this value does not lie in its potential to create in viewers experiences that are aesthetic.

To add a bit more to this point, the famed Sister Wendy Becket says, in allusion to the work of Jasper Johns, as she is discussing the conceptual nature of modern art, "What he really wants to communicate is an idea. Is this a flag or is it a work of art? A Concept? Now this conceptual

art is very popular at the moment—popular with the artworld, not with the rest of us. And often you see the stuff; you get the concept, and then you move on. You've lost interest. So here's another question: When is conceptual art great art? And the answer is: when it gives deep visual satisfaction, like Jasper Johns' flag."[14] Sister Wendy draws a distinction between conceptual art that gives "deep visual satisfaction" and conceptual art that does not. I take "deep visual satisfaction" to constitute a rewarding aesthetic engagement, using the word *aesthetic* in line with Beardsley's views. She suggests that a good deal of conceptual art does not provide any satisfaction except a cognitive one, and there is a slight suggestion that this cognitive engagement is at times fleeting, perhaps even unrewarding. The distinction that Sister Wendy points out is precisely what is at issue here.

The conclusion has to be that aesthetic experiences and art experiences—if it makes sense to use that second expression—are different things. There are many aesthetic experiences that are not experiences focused on art objects. Certainly that statement is uncontroversial. But there are many art experiences, if indeed we want to follow the art world's lead on what counts as art, that are not best viewed aesthetically, that indeed when viewed aesthetically actually lose value. This problem makes it appear that an aesthetic-experience production theory is not the whole story.[15]

Nevertheless, Beardsley did something that no other aesthetician before him was able to do. He was able to construct a meaningful amalgam of the objective and the subjective in one theory of both aesthetic experience and judgment. It is true that he was a member of a formalist circle and, for instance, believed that the meaning of an artwork could be captured simply and strictly through an appreciation of its properties, that one should not look to the artist's intention to ground interpretation; moreover, he was connected with New Criticism and with formalists such as Roger Fry, Clement Greenberg, and Cleanth Brooks. And it is true that he offers a sort of formalist analysis of what constitutes value in artworks—unity, complexity, and intensity—in a way that echoes Augustine's "unity, number, equality, proportion and order" account;[16] Thomas Aquinas's "integrity, due proportion, and clarity" account; Shaftesbury's "unity in multiplicity" account;[17] Hutcheson's "uniformity

amongst variety" account;[18] Addison's "greatness and uncommonness" account;[19] G. E. Moore's "organic unity" account;[20] and Clive Bell's "significant form" account.[21] Beardsley clearly fits in this tradition, perhaps most clearly alongside Bell. But while offering a sort of formalist analysis, Beardsley also offers a strongly subjectivist account. The formal properties he identifies as the basis of aesthetic value do not, in the straightforward objectivist sense, lie in the art objects; they are properties of the subject's experience when her attention is focused on the artwork. Bell attempted an amalgam between the objective and the subjective, but his account is not as ampliative as Beardsley's. Bell's account, for instance, suffers from charges of circularity. The depth of Beardsley's exploration of the subjective character of aesthetic experience is evident in the level of detail of the results of this exploration. In addition to this, Beardsley is able to marry together both experience and judgment in his account. The synthesizing he achieves in his vast body of work in aesthetics is astounding, but the real coup de grace is the satisfying level of intuitive comfort that his account inspires. He articulates views about aesthetic matters that seem perfectly common sense and seem to fit if not all then at least the vast majority of aesthetic objects and art objects. Dictionary definitions of *aesthetics* and *aesthetic* tend to focus on the things that Beardsley focuses on: the nature of beauty, the arts, taste, and, most centrally, the sensuous aspects of experience. Moreover, dictionary definitions of *aesthesia* focus on the ability to receive sense impressions. Beardsley captures all this in one comprehensive and satisfying package. It is difficult to think of aesthetic attention that is focused not primarily on the "heterogeneous but interrelated components of a phenomenally objective field."[22] And it is difficult to think—despite what I wrote directly above—of attention directed to works of art not primarily focused this way as well. We do in fact approach the vast majority of art objects aesthetically.

Nelson Goodman's Cognitivist Account

I take Goodman's account to come from his book *Languages of Art.*[23] In this book, Goodman theorizes that art is essentially symbolic. A given work of art functions as a symbol (or sign) or a set of symbols. Goodman differentiates between art symbol systems and non-art symbol systems through a series of distinctions.[24] This is important because there

are a great number of symbol systems that have nothing or little to do with art, and we want to be able to tell the difference between a note passed between teenagers in class and *Romeo and Juliet,* between a road sign and *Les Demoiselles d'Avignon,* and so forth. The distinctions that Goodman advances are technical, and I think that if we can stipulate to their efficacy for drawing a meaningful, substantial, and stable distinction between art symbol systems and non-art symbol systems, we can avoid the need to discuss them.

One of the first things to recognize about Goodman's theory is that it is, at heart, a representational theory. If works of art are symbols, they must refer. To what they refer is not really the point, but reference is essential: "The plain fact," according to Goodman, "is that a picture, to represent an object, must be a symbol for it, stand for it, refer to it."[25] The second thing to recognize is that symbol systems are human creations, human developments, and must be learned to be applied and to be understood, or, in Goodman's terms, "read."

Pictures in perspective have to be read, and the ability to read has to be acquired.[26] We might add that such systems do not burst forth from human minds, á la Athena, ready for battle. They are products of cultural and social evolution, in both directed and passive ways, in both purposeful and accidental ways. The third thing to recognize is that symbol systems are only understandable and useable within highly contextualized settings. The following quotations from Goodman illustrate his point:

> The myths of the innocent eye and the absolute given are unholy accomplices. Both derive from and foster the idea of knowing as a processing of raw material received from the senses, and of this raw material as being discoverable either through purification rites or by methodological disinterpretation.[27]

> Gombrich, in particular, has amassed overwhelming evidence to show how the way we see and depict depends upon and varies with experience, practice, interests, and attitude.[28]

> Just here, I think, lies the touchstone of realism: not in quantity of information but in how easily it issues. And this depends

upon how stereotyped the mode of representation is, upon how commonplace the labels and their uses have become. Realism is relative, determined by the system of representation standard for a given culture or person at a given time.[29]

Resemblance and deceptiveness, far from being constant and independent sources and criteria of representational practice, are in some degree production of it.[30]

Reference made within a context is at the core of Goodman's theory. This is somewhat different from the views of Beardsley, who was probably one of the formalists' and New Critics' best theoretic champions. From his generative article with William Wimsatt[31] to his celebration of the work of Cleanth Brooks,[32] Beardsley's focus was on the immediate connection—essentially, an immediate sensory connection—between the viewer and the viewed. Reference by a symbol of an object for Goodman, however, is heavily mediated.

Perhaps the most important thing about Goodman's theory for my present purposes is its focus not on the sensory or phenomenal but on the cognitive. Goodman writes, "The subsumption of aesthetic under cognitive excellence calls for one more reminder that the cognitive, while contrasted with the practical and passive, does not exclude the sensory or the emotive, that what we know through art is felt in our bones and nerves and muscles as well as grasped by our minds, that all the sensitivity and responsiveness of the organism participates in the invention and interpretation of symbols."[33] However, he also writes,

Use of symbols beyond immediate need is for the sake of understanding, not practice; what compels is the urge to know, what delights is discovery, and communication is secondary to the apprehension and formulation of what is to be communicated. The primary purpose is cognition in and for itself; the practical, pleasure, compulsion, and communicative utility all depend upon this. Symbolization, then, is to be judged fundamentally by how well it serves the cognitive purpose: by the delicacy of its discriminations and the aptness of its allusions;

THE VALUE OF ART

by the way it works in grasping, exploring, and informing the world; by how it analyses, sorts, orders, and organizes; by how it participates in the making, manipulation, retention, and transformation of knowledge.[34]

This clearly places the cognitive function in the center as regards both the understanding of what art is (the definitional component) and assessing whether a given work of art succeeds and to what degree it succeeds (the evaluative component).

Considering Goodman's Account

Does Goodman's account succeed? I choose not to pursue the option of criticizing the theory on the basis of its sufficiently separating art from non-art, showing that there are many symbol systems our experiences of which we commonly do not take to be aesthetic (to use the word in its very broadest sense), even if these systems seem to fulfill Goodman's criteria for an aesthetic or art symbol system. We could attempt to criticize on the grounds that not every work of art appears to refer, that even as broad a representational theory as Goodman's cannot succeed, because not all art is representational. In visual abstract art, we might well look to painters such as Mark Rothko, Jackson Pollock, Robert Motherwell, and Piet Mondrian. But perhaps already we need to leave out Mondrian: some of his best-known works are parts of series, two of which are named "Trees" and "Scaffolding," and these clearly carry with them representational references. This is probably why Pollock is known to have deliberately avoided naming his work as the style he is known for matured; he most probably wished to avoid attaching the representational to his work. Instead of Mondrian, perhaps we could include in the list the minimalists Agnes Martin and Frank Stella. If painters such as these cannot evoke interpretations that are not representational, then no visual artist can. Unfortunately for this strategy, Goodman offers a way even to understand the sort of art we are talking about here representationally. Even a given patch of color, so the view goes, *exemplifies* the particular color of which it is an instance;[35] this Goodman understands as reference. So long as the color refers, then we can understand that artwork-instantiated patch of color as representational.

Dickie criticizes Goodman's theory by consideration of the subject matter that is picked out by the art-symbol: "If cognitive efficacy is the sole criterion of aesthetic merit, then the importance of what is signified can have no bearing on aesthetic merit. For example, any two equally efficacious representational paintings will have the same value, independently of what they represent. It is at least arguable that an important subject matter lends value to a work of art."[36] This tack is not an option I want to pursue, since I mean to limit consideration to the productive or instrumental characters of the theories herein.

The reason I would question Goodman's theory as a complete account of artistic value is this. While no doubt we have all had the experience of attending to a work of art in a problem-solving or puzzle-solving frame of mind, the very fact that we can identify when our experience of art is cognitive suggests a distinction from those art experiences that are not cognitive. I can take a puzzle-solving attitude toward an art object, working out for myself the internal logic of the piece, the rules that this particular artwork instantiates and follows, and even, for good measure, an understanding of how the object refers to and represents other things. But I can just as easily, through a conscious and volitional choice, adopt an attitude of passive acceptance of what is being offered (to my senses), taking delight merely in the sensory stimulations or in how they make me feel. I am not very familiar with the technical aspects of music, so my entree into appreciating it is generally through the affective. I am more familiar with the technical aspects of dance, but I find that I can move between two attitudes, one cognitive and the other not, easily and fluidly. While a critical appraisal of the object under consideration may issue forth from the cognitive-engagement frame of mind more readily or easily than from a different frame—keeping in mind that we are considering value here—I submit that this is in large part because linguistic articulation of the value that I am experiencing flows more easily or readily when I am already cognitively engaged. Words flow a bit less fluidly when my mind-set is emotive or purely focused on the phenomenal. But I would suggest that on many occasions, the value of the work under review is heightened when considered from a noncognitive vantage point. While Goodman does not discount the emotive or the sensory—as Beardsley does not discount the cognitive—his primary focus

in accounting for artistic value is centrally lodged in the cognitive, and this seems narrow.

However, Goodman's theory addresses one thing that Beardsley's theory seemingly cannot: the aesthetic nature of literature. Beardsley writes that "an aesthetic experience is one in which attention is firmly fixed upon heterogeneous but interrelated components of a phenomenally objective field."[37] The physical vehicle for literature is the printed word; literature is physically instantiated in a series of pages with many symbolic marks on each page. Each page represents a phenomenally objective field. Each page is stable and objective. Each page can be taken in on a single viewing; few works of art are larger than may be contained in a visual field, and pages of a book are very rarely if ever members of this group. And each page, together with the marks on it, is available, in a direct and immediate way, to the senses—in this case, the sense of sight. What do we call the art form where "attention is firmly fixed upon . . . a phenomenally objective field" when that field contains symbolic, linguistic marks principally accessible and accessed visually? We call it calligraphy.

The full sentence Beardsley wrote is this: "An aesthetic experience is one in which attention is firmly fixed upon heterogeneous but interrelated components of a phenomenally objective field—visual or auditory patterns, or the characters and events in literature." And so we cannot pin on him in an overt way the ambiguity between literature and calligraphy that I want to explore here. I say we cannot pin this on him overtly, but the reality is that if Beardsley is not able to offer some reason for his inclusion of the phrase "of the characters and events in literature," this has a somewhat ad hoc feel, given the importance he placed throughout his work on the nonmediated, sensory relationship that characterizes aesthetic experience.

I own a large work of Japanese calligraphy.[38] I was able to choose the work from a collection of several dozen similar works. I chose the one I did because of the placement and flow of the ink on the paper, the movement of very black ink through very white space. I chose a work that had a great deal of white space, in part so that the movement of the ink flowing onto the paper would be emphasized. I chose the work because the symbols seemed to balance the overall work well (in the way that I, as a Westerner, am familiar with aesthetic balance), both in terms of their

fit on the field and in terms of the more "legato" and "staccato" marks on the paper. After I chose the work, I asked the artist what the word meant—but I did this only after I chose the work. She said that the two Kanji characters composed the word for "dragon." I am sorry to report that this did not increase my appreciation of the work, beyond seeing the relationship between how she expressed the symbols and a sense of their referent. "Dragon" sounded a little precious, and I was already struggling with bringing too much of my stereotypical Westernality to my choice. My calligraphic choice was made exclusively on the basis of how I immediately and visually related to the work. This same sort of dynamic is at work when I listen to opera/operatic music, as well. I find that my appreciation is much greater if the language is not English, and while some knowledge of the libretto is useful to my predictions of what sort of music is coming next, I find it annoying to try to listen to the words in a linguistically meaningful way. I do not want to understand the words, because that will just interfere with the immediacy of the relationship between my ear and the music. Literature is quite different. My imaginative and cognitive engagement is of paramount importance to me. Imaginatively, I want to mentally create, from the writer's descriptions, faces and personalities for the characters; I want to imagine the settings and the scenery, the climate and the landscape; I want to experience the subjective feel of the passage of time and the traversing of space; I want to feel the character's emotions, and I want to experience my own as they issue forth from the connections I make to the characters, their experiences, and the context of events. Cognitively, I want to chart the progress of the characters through the story, anticipating what comes next, understanding how things known to me but unknown to a character will unfold in terms of that character's psychology and his actions; I want to solve mysteries, both in the story and in terms of understanding why the writer includes what she does; I want to work out how real, how accessible and familiar, the world the writer offers is, and at the same time I want to appreciate by contrast those elements that are foreign to my life and/or the natural world around me. For any of this to happen, I have to concentrate not on how the words line up on the page, how the rivers of spaces flow through the printed type, or what the typeface looks like. I need to concentrate on what the words and phrases and sentences mean.

THE VALUE OF ART

I have to understand the referents of the symbols on the page. It is not enough to simply understand that they are symbols; I have to understand and appreciate what they mean.

Can literature be experienced aesthetically? The answer to this question has to be an unhesitating yes. Beardsley writes, "X is a literary work if a substantial role in X's creation was played by the intention to make it capable of satisfying an aesthetic interest."[39] What has to be the case, then, to say that literature can be experienced aesthetically? I think the answer is that we have to give up the notion that a necessary condition for aesthetic experience is immediacy, the idea that aesthetic experiences are the products of an unmediated relationship between the subject and the object. Goodman's cognitivist approach does this par excellence. He holds that all aesthetic relations between the subject and the object are mediated: "The myths of the innocent eye and the absolute given are unholy accomplices." The mediation that Goodman recommends is a cognitive engagement. Beardsley agrees with this:

> It is by thinking, often hard and complicated thinking, that the author shapes his plot, regulates the rhythmic variations in pace as he tells his story, selects from among the thoughts that come to him those works and actions that will most sharply reveal key traits of his characters, and, sometimes, provides us with profound visions of human life and of the universe that we are left to reflect upon. I do not mean that the process of writing a novel or a poem is purely a matter of cold calculation or problem solving; no more—and indeed much less—than most human activities is it free of sudden inspirations, feeling, and emotion of all sorts. But whatever else it also is, authoring is a mode of thinking.[40]

Beardsley recognizes the difficulty of a purely aesthetic treatment to account for literature, and he recognizes the solution that cognitivism presents:

> The line of thought just sketched moves toward what some would call a "formalist" conception of aesthetic interest, and it

has long been recognized that, of all the arts, literature is least likely, on the face of it, to make kindly to such a treatment. . . . Therefore it may be well . . . to set forth . . . an alternative kind of view. Let's call it "cognitivism," since its central emphasis is on knowledge. What we ask from literature, on this theory, and what we get a good deal of from the best literature, is knowledge—more particularly, understanding of human beings, ourselves and others. The point of authoring (and of literature) is ultimately to promote this human understanding.[41]

Goodman's approach to the value of art solves the dilemma of differentiating between literature and calligraphy, but it does a good deal more. Throughout this book, I will periodically return to his cognitivist approach—talking about problem solving and the logical structures of works of art. The theoretical bases for all that rest with Goodman.

Leo Tolstoy's Affective Account

Leo Tolstoy envisioned art as essentially a form of communication.[42] Art is meant to communicate universal emotion, which is felt by the artist and is the subject of her work and is then communicated to her audience. Without this communication, the expression of emotion through art is incomplete. Without an audience to reconstruct the emotions of the artist through the medium of her creation, there is no art. It is not enough for the artist to have felt something and produced some artifact resulting from that feeling. What has to take place, for the art to be successful, is for us to feel what the artist felt, or at least for us to feel what the artist's work can make us feel. Art is not, for Tolstoy, simply the "spontaneous overflow of emotion." Mere expression of emotion, just an outpouring of the emotion or of the articulation of the emotion of the artist, is insufficient. The rantings and ravings of an artist, if there is no communication, can result in just so many big messes (say, paint thrown wildly onto canvas, music composed recklessly). While some of the most emotionally communicative art may well have a reckless or random quality, without that recklessness or randomness communicating to the viewer the artist's emotion, it is nothing more than a big mess.

Tolstoy did not believe that art, or the viewing of art, was meant to impart pleasure to viewers. Instead, art is treated as a natural part of life, not incidental to living, as the accidental feeling of pleasure might be, but a part of life that is absolutely vital and integral. Every work of art causes the viewer to enter into a special relationship with the artist, and not only with the artist but also with everyone else who has at one time or other entered into that same relationship. The "artistic relationship" between artist and audience builds a community, a community of creator, of object, and of all those who experience the object. Without the ability of one person to empathize with the artist, to feel what she felt, and without the ability of the members of the audience to share in this experience—though they may never meet—art could not exist. The artist's job is to evoke in herself some feeling once experienced and then, once having evoked it in herself, to communicate it to her audience through some sensual medium, through colors, shapes, melodies, harmonies, figures, movements, and so on. Through the externalities of the medium, the artist transfers her feelings to others. The artist seeks to *infect* her audience with these feelings; as Tolstoy writes, "the degree of infectiousness is the sole measure of excellence in art."[43] "Infectiousness" translates into how intensely the viewer experiences the artist's emotion, how clearly she feels it, and how sincere it is.

Considering Tolstoy's Account

Problems with affective theories were known very early. Expressionist theorists Benedetto Croce and R. G. Collingwood, contemporaries of Tolstoy's, had already created theories that jettisoned the focus on pure feeling and the infectious communication of that feeling for the expression of, in Croce's case, intuitions, and in Collingwood's case, individualized emotion properly explored, contextualized, and demonstrated. However, interpretation of art that focuses on the affective is still alive and well. Consider the following from Sister Wendy:

> I'm not afraid you won't think this Mark Rothko beautiful, but what I am afraid, a little, is that somebody might think it's just beautiful. Lovely colors. No meaning. But meaning is what he was all about, and he would have been furiously angry if anyone

thought that, and told you so in suitably salty language. It was subject matter that mattered most to him. And the subject matter was the emotions. Not small, personal emotions—up today, down tomorrow—but the great timeless emotions. How we feel about death, and courage, and ecstasy. He was convinced that if you would just encounter his paintings, that emotion would be communicated to you with absolute clarity. So to achieve this he painted very large. Because in a small painting—big you, little painting—you can control it. But with a large painting, it controls you. You're taken into it. Unless of course you look at it from a distance, that killing, assessing look. So to combat that, he insisted that always the light be very dim, so you couldn't actually see the thing until you were right up against it. And then something does begin to happen. He painted with very thin mists of paint, feathering it on, breathing it on. And you are taken up, out of yourself, into something greater, something transcendent and majestic. If you can think of a religious painting without religion, this is what you experience here. It's so timeless, that when I've had this encounter, I feel to return to the world of time, I have to shake my head and bring myself down to earth again.[44]

Sister Wendy's work is as good a popular sort of art interpretation as any, I imagine, and if affective treatments such as the one she offers of, and actually ascribes to, Mark Rothko are still effective in communicating the value of a work, then affective production theories belong in this chapter.

One problem, I think, for the production-of-emotion model is the degree to which the feeling must be, to use Tolstoy's word, infected. Clearly Tolstoy's artistic aim is not simply cognitive appreciation of the expression of emotion. The emotion has to be felt by the audience. But then the questions are How? and How much? The edict to *infect* the audience with a *sincere* level of the feeling being expressed leaves one with these sorts of questions. If we see a painting depicting martyrdom, perhaps St. Sebastian's, should we feel the stings of the arrows along with the saint? Should we feel the bondage, the physical agony, and so forth? Is to feel *sincerely* to feel the emotion *completely* or merely in an abstract way?

Edward Bullough's vision of psychical distance[45] advises us to put ourselves out of direct engagement with the artwork: we understand the emotional dynamic (to focus Bullough for our purposes) but stand apart from it. We are not personally involved and should keep in mind that we are not a part of, as Goldman puts it, the "ordinary causal nexus that determines our usual practical concerns with it."[46] Bullough recommends that this is the proper posture by which to appreciate aesthetic objects. Consider the case of the murder of Duncan by Macbeth. Should we, in following Tolstoy and thoroughly feeling what is happening on stage, try to dissuade Macbeth from his treachery, or try to wrestle the knife away from him? This level of audience empathy seems excessive and out of character when considering the proper reaction to artworks. While Tolstoy surely would not have us rushing onto stage or empathetically bleeding at the consideration of the predicament of St. Sebastian, to understand just what an infection of sincere emotion is creates questions.

Perhaps the answer to the question is that we should not feel as St. Sebastian did but should feel as the artist felt as she contemplated the situation of St. Sebastian. If this is the appropriate response, then we may be met with the problem of understanding or accessing artist intentions as they constitute the source of the artist's emotions. Though we commonly expect that the artist can and probably does know her intention regarding a given art creation, and though she can communicate this to others who wish to criticize, interpret, or merely appreciate her work, the intention of the artist is often something that cannot be readily discovered. Although one can be reasonably certain of, say, Michelangelo's intention regarding the creation of the *Pietà,* a casual viewer at New York's Museum of Modern Art may be hard-pressed to explain the intention behind any one of the mature, untitled works of Jackson Pollock. The artist's intention is rather frequently invoked to either interpret a work or establish it as a work of art. However, if there is a problem with the invocation of artist intention, given the distance at which we may find ourselves from that intention, then it would seem a bad choice to relegate an object's artistic value to the speculation that the creator wished for a given object to be viewed as expressing a certain emotion. The difficulty here is a simple one. How is it that we can know that a work contains or is an expression of emotion? This may be obvious in many works, but it

becomes more difficult for formalized or highly abstract works. If one is relegated to having to fathom the intention of the artist in order to determine whether the work is an expression of emotion, one may find oneself silent. This problem renders expressive-affective theories of artistic value lacking.

However, Tolstoy's affective account may be taken to be a species of a larger project that has virtues that we would not want to sacrifice. His affective account is a species of what in this book I call "expressivism" and "expressive theory." My later review of a collection of expressive theories (see chapter 6) is intended to theoretically motivate the importance of consideration of an emotional context in a full evaluative treatment of a work of art. While Tolstoy's account may have holes, and while accounts that attempt to capture the value of art exclusively on emotional grounds may be lacking, the fact remains that emotion—its presence in works of art as an expression of the artist's emotion, what the artist meant to communicate, or what simply gets communicated—is an important part of understanding the value of an artwork.

Alan H. Goldman's Alternative World Account

Alan Goldman, in his *Aesthetic Value*, offers a production account of value. His view is broad, incorporating all three of the former perspectives:

> The value of such works lies first in the challenge and richness of the perceptual, affective, and cognitive experience they afford. Symbolic and expressive density combines here with sensuous feel. From the subjective side, all one's perceptual, cognitive, and affective capacities can be engaged in apprehending these relations, even if one's grasp of them is imperfect or only implicit. These different facets of appreciation are not only engaged simultaneously but are also often indissolubly united, as when formal relations among musical tones or painted shapes are experienced as felt tensions and resolutions and perhaps as higher-order or some ordinary emotions as well.[47]

His account is this: "When we are so fully and satisfyingly involved in appreciating an artwork, we can be said to lose our ordinary, practically

oriented selves in a world of the work. . . . It can engage us so fully as to constitute another world for us, at least temporarily."[48] He then goes on to offer not only further reasons for and virtues of this view but also many concrete illustrations of the view, all taken from the world of art.

Considering Goldman's Account

Goldman evades complaints about narrowness of scope by constructing a theory that is very broad indeed. In the production of experiences of alternative worlds, the artwork can trigger a huge range of different sorts of experiences that will be efficacious for the sake of subjective transportation. For me, a single combination of smells can invoke another whole world (as I mentioned earlier, in my case, cigarettes, perfume, and diesel exhaust put me in London instantly and thoroughly). If one has a whole book or an entire film in which to develop alternative world cues and contexts, the effect—if the book or film is good—will surely be pronounced. Just think of all the people influenced by J. R. R. Tolkien's trilogy and who, even all these decades later, have never really gotten back out of Middle Earth. If Goldman's account is so broad, and if we take it to constitute a theory of artistic value, then is there any criticism left to make of it? If the "deliverable" that Goldman promises as the instrumental product of art is so broad and can be produced in such an incredible variety and number of ways, does his account fully succeed? Perhaps. But in the next section I want to offer one more account, and I want to motivate it by raising a problem for all production theories, Goldman's included.

THE MODIFICATION PROBLEM

One difficulty for all of the accounts surveyed above, Goldman's included, concerns modification of the object under consideration. If the worth of an art object is grounded in its potential for producing aesthetic experiences of a decently high magnitude, and if better works of art are those that produce experiences of higher magnitudes (to use Beardsley's word but to think of this in terms of each of the accounts) than do lesser works of art, then it would seem that we could do artworks and art audiences a service if we modify works of art of lesser artistic quality in ways that enhance their artistic value.

In 1919, Duchamp drew a moustache on the *Mona Lisa* and named it *L.H.O.O.Q.* (or made use of a postcard that did). Duchamp did not draw a moustache on the actual *Mona Lisa,* of course, but on a copy. If Duchamp had drawn a moustache on the original *Mona Lisa,* the one painted by Leonardo's own hand, then I would wager that very few people would have been okay with that. In 1959, Robert Rauschenberg asked Willem de Kooning for permission to erase one of his drawings. De Kooning gave his permission, the erasure was made, and the erased drawing was displayed under Rauschenberg's name with the title *Erased De Kooning Drawing*. Although Rauschenberg was able to get away with this, he could do it only once—Rauschenberg was the right artist in the right context at the right time—and he did it only after securing de Kooning's permission (perhaps a necessary but not a sufficient condition). No doubt there are other cases of artistic modification, but the number is extremely small. In general, art audiences believe there is something seriously wrong about the modification of a work of art. Yet if the value rests exclusively in the productive value of the work and the "deliverable" can be increased through modification—either by the original artist at some point after the work has been presented for viewing or by another, perhaps more gifted, artist—then artistic modification should not affect us so. Indeed, in many situations, we should welcome it.

One may argue that there are at least three reasons why permission to modify artworks does not work as a counterargument to production theories. First, modification does not, as a matter of fact, increase the artistic value of modified works of art. Second, the modified work of art is no longer the same work of art as the original; it is a separate and distinct second work. And, third, the reason that we find modification of works of art objectionable is not because of considerations of artistic value but because modification actually diminishes the value of the work in other ways.

In response to the first reason, that modification does not, as a matter of fact, increase the artistic value of modified works, I would make two points. First, my argument concerning modification is a logical one, not an empirical or contingent one. Production theories allow the possibility of value enhancement through modification, and if we find modification objectionable, then we should reject production theories of artistic

value. To say that modified works are never artistically better than the original works in a way where this claim is not empirical and contingent requires a theory of artistic value, and this is precisely what is at issue. To use as evidence the facts that we do not find modified works better is to leave open the possibility that we may in some future cases.

The second point that I would make in response to this first objection is that there may be, right now, cases where we think modified works are superior. I think few people would believe that Duchamp's *L.H.O.O.Q.* is a superior work to Leonardo's *Mona Lisa,* but I am not as secure in this same intuition when it comes to Rauschenberg's *Erased De Kooning Drawing.* I do not know what the original de Kooning drawing looked like, but I know that Rauschenberg's work is, to the extent that there is any agreement about such things, a work of art of some value. Throughout this chapter, I tend to focus on paintings, but we may consider other art forms as well. It is certainly within the realm of possibility that a majority of people find colorized versions of certain films better than the originals. Ted Turner may be a member of such a majority. Younger viewers or those without much experience of black-and-white film or television may find colorized versions of films more aesthetically accessible and so perhaps more engaging. Better examples may come from music, in which variations by composers of the works of earlier composers are standard. The chances are great, I would wager, that a majority of listeners actually find Mozart's variations better than their originals: for instance, Mozart's variation on Antonio Salieri's *Mio Caro Adone.* But one may argue that Mozart's *Mio Caro Adone* and Salieri's *Mio Caro Adone* are different works, in the same way that Frank Capra's original *It's a Wonderful Life* is a different film from Ted Turner's colorized version.

This leads to the second objection, that, in the examples I offer, we are not talking straightforwardly about one work that undergoes modification but are instead talking about two separate works: the original and the modified version. This is, one may argue, why some (although not Woody Allen) find colorization of films acceptable; one is not damaging the original film in making a colorized copy,[49] one is creating a separate film. This is perhaps even easier to say in the case of musical variations. This sort of position is consonant with the view of Mark Sagoff[50] concerning artwork restoration and copying. Sagoff argues that works of art

are highly individual because they are the products of a particular artistic process. If that work undergoes a secondary process, not part of the original process of the original artist, then the resulting work is no longer the original work but a second new work. Sagoff talks about the restoration of Michelangelo's *Pietà* after it was attacked with a hammer in 1972. He praises the restorer, Redig de Campos, for taking pains to ensure that what changes Campos made to restore the *Pietà* to a condition straightforwardly visually indistinguishable from its pre-1972 state could be easily detected and easily reversed by future restorers or caretakers of the work. The 1972 lunatic changed Michelangelo's *Pietà;* to change it further, even with the intent of (perceptually) restoring it to its original state, would not be to reverse the imposition of the lunatic's "new process" but would actually add a third "process" to the history of this work. I should point out that I am in sympathy with Sagoff's ultimate point, which I take to be a rejection of Beardsley-style arguments for artistic value being a matter of production of aesthetic experiences, and with his ancillary point concerning the impermissibility of modification. The only place I part company with him is over the ontological status of the modified work. I differ for two reasons. First, while it may be readily acceptable that Mozart's *Mio Caro Adone* and Salieri's *Mio Caro Adone* are different works, this is less clear in the Rauschenberg/de Kooning case. Would we rather say that de Kooning's drawing has ceased to exist or say that Rauschenberg's work is an evolution of de Kooning's? Were I de Kooning, I would certainly prefer the latter, and it would be on that basis that I would be motivated to grant permission for the erasure to occur. My intuition is that de Kooning is every bit as important as a part of the artistic process that resulted in *Erased De Kooning Drawing* as is Rauschenberg. Rauschenberg did not erase any old thing; he erased a de Kooning drawing. The de Kooning drawing was not destroyed or made to cease to exist; it was one step of a single artistic process that resulted in the work *Erased De Kooning Drawing*. But more to the point, the "provenancial process" that led to the creation of this work did indeed include a modification of one artist's artwork (a bona fide artwork in its own right) by another artist, who, I have to imagine, was motivated to create a work of greater artistic value, greater artistic significance, than the original drawing. Based on the attention that

❖ THE VALUE OF ART

Erased De Kooning Drawing has gotten in the art world, my intuition is that they succeeded.

My second reason for differing with Sagoff is this. When an artist creates a work of art, it is the artist herself who, at some point of her own choosing, pronounces a work complete. From a nonpractitioner's point of view, I may be tempted to call this point arbitrary. The difference between a painting with one less (minute) brush stroke and one more (minute) brush stroke is, in the vast majority of paintings throughout the history of art, not significant. Certainly some paintings could not bear one stroke more or less, but this is, in art history, a small minority of works. Whether my intuition about this is shared or not does not matter; the point is this. If an artist pronounced a work complete but two days later reconsiders and puts in a few more brush strokes, it is difficult to see how this meaningfully constitutes the imposition of a second artistic process. (I wager that most writers of philosophy papers have had the experience of believing a paper to be complete but then having another thought and returning to the computer.) I contend that what this returning-artist does to her work is on a continuum with what Rauschenberg did to the de Kooning drawing. The difference is one of degree but not of kind. If this is the case, then the modification of one work that results not in a second work but rather in merely an evolution of the first original work is a possibility. If such modification is a possibility, then production theories of artistic value allow for it.

Production theories of artistic value inherently, logically, allow modification of artworks where that modification will enhance the instrumental "deliverable." If we believe that artwork modification, on the whole, is not appropriate, then production theories suffer. The embracing of modification by production theories is necessary because their very logic is predicated not on the value of the object per se but on the experience of the viewer. The better the experience, the higher the artistic worth of the object that produces it. The better the object, the better the experience.

A NONINSTRUMENTAL EXTRINSIC VALUE ACCOUNT

If we have abandoned intrinsic accounts of the value of art—accounts that locate the value in the object or event itself—and we have criticized

instrumental, production accounts—accounts that hold that artworks produce experiential states of value and so locate the value in the audience, the viewers—is there anything left? I believe that there is: an extrinsic account that focuses on the third member of the artistic nuclear family, the artist. The nuclear family of art is composed of the creator, the created, and the audience. If the value does not lie in the created and it does not lie in the audience, then the last place to look for the location of the value is the artist.

Is the value in the time, talent, skill, labor, and concentration that went into the creation of the object or in the irreducibility of the artist's expression that the object instantiates? Clearly, the respect that we have for *In Advance of a Broken Arm* is not for an off-the-rack snow shovel. If an individual is sitting in contemplation of *In Advance of a Broken Arm,* then she most likely is cognitively focused, perhaps concerning Duchamp's wit, or the challenge that Duchamp offered the art world, or the challenge offered by readymades, by the Dada movement, or by the twentieth century in general. The respect she has for the work is a cognitivist one, and probably in this situation, the respect she has for *In Advance of a Broken Arm* is for the artist and what had taken place in his thoughts. Is this valid for all art objects? If we reject production accounts as insufficient to explain all instances of an artwork's value, perhaps an account that is focused on the audience's respect for the value of the artist's labors is more in keeping with the way we actually value. The point is not to localize and classify the value of the object in any final way but to explain the position that many of us share with regard to art objects possessing a value simply in terms of being art.

Consider how we value objects of decoration. People who create decorative objects for commercial purposes do not sign their works. They generally do not offer their works directly to the public but wholesale the objects out to retailers. They are not at all invested in the future of their works, and the works are usually produced in volume, one after the other. In a focus on the artist as the reason for our care of art objects, there is little cause for us to have such care for decorative objects. There is no artistic investment, no expression, and only some instantiation of talent and skill (and this, only to the level that most human efforts involve some talent and skill).

A host of objects are situated on the line between art and decoration; perhaps it is finally best not to search for a hard dividing line but to think simply of a continuum between the artistic and the decorative. Numerous objects bought at craft fairs are signed and one-of-a-kind. Perhaps they are art, although most times our intuitions move in the other direction. Grandmother's handmade quilt that hangs in my hall is signed, but most quilts are not signed. There is plenty of gray area. But the shades of gray may be explored in terms of the respect that we bear the creator's efforts. A quilt bought from a department store is owed less respect than Grandmother's quilt. A craft object constructed of seashells bought from a craft fair is owed more respect than a seashell craft bought from a souvenir shop along a Florida highway. However, once the distinction between the two shell-crafts is removed, they will fetch the same price. When there is no proximity between the buyer and the origin of the two objects, there is no reason to respect the unknown creator's efforts of one more than the other. It seems clear in this case that respect is borne in terms of the origins of the objects, borne in terms of the creator's efforts. Once the creator becomes anonymous, the creation loses its capacity to command any more respect than a similar creation with less noble origins. Assessing the worth is then simply a matter of assessing the object in terms of its formal properties alone. We assess the worth of decorative objects in terms of their origins, when we know them. While this may be a matter of sentimentality, it does not alter the fact that origins are key to our assessment of the objects.

A focus on origins has as much to do with the assessment of art objects as with decorative ones. Once a work is discovered to have been created by a more impressive artist than was once assumed, the work jumps in value. Perhaps this is not an increase in aesthetic value, although that can be argued, but the work jumps in monetary value and, for our purposes, in terms of the respect it commands. The increase in respect is warranted in terms of the enhancement of our respect for the talent, skills, and depth of expression of the newly discovered artist. While there will be formalists who decry the enhanced respect as aesthetically disingenuous, the happy news is that we do not have to answer them. The enhanced respect is a psychological fact, and the explanation of that fact is all that concerns us here (in this chapter). Psychologically and

factually speaking, provenance counts, as does the award of an Oscar for a film or a Newberry prize to a children's book. These things influence our assessment of the value of objects.

The respect we bear for art objects wanes the less proximity, spatial or temporal, we have with the artists. The best illustration of this is the test of time. Massive numbers of works of art are being produced today and have been over the past centuries. The claim might be made that this increase is a product of the Enlightenment and the general promotion of free expression, or alternatively that people simply have more time on their hands, but the point is that the numbers are huge. If the past is any indication, most of the works will not survive the test of time. Recently created works of art, for the most part, receive good care. The best explanation for this is that since we do not know today what will pass the test of time and what will not, it is better to save as much as possible as fodder for the test. This is a good explanation, but whether such an academic reason actually motivates the saving is not clear. The full explanation might well involve our general sense of respect for the individuals who created the works we save. Someone who receives from a loved one a birthday, Christmas, or Bar Mitzvah gift not to his liking is required, under the rules of civility, to express appreciation for the gift and to continue to show appreciation for a suitable period of time, usually measured in years. Only people with a radical devotion to honesty do not believe that this expression of appreciation is required. As there is less proximity to the gift-giver, the requirement lessens. At some point, if enough time has passed or the gift-giver has died, the person may discard the gift. The key is proximity. The same seems true of art. Once the proximity between the possessors of the art and the artists has duly lessened, the respect by the possessors for the art will also have lessened.

Much the same can be seen in how we treat the deceased. If a dead body is five thousand years old, we are happy to find it, and we move it for display in a museum. If a dead body is five hundred years old, we dig it up and examine it, but we probably do not display it, and we may return it to its resting place. If a dead body is one hundred years old, and we accidentally unearth it, we generally take pains to return it to its resting place quickly. If a body is a week old, and we unearth it, we are accused of grave robbery. It is a hard case to make to say that these

differences are somehow in respect of the body itself. The dead body has no interests. Barring a case involving offense to the dead body's spirit, the reason for the differences has everything to do with proximity. The interests we are meeting in respecting the differences belong to the deceased's loved ones and, perhaps, ourselves. If an individual desecrates the body of a person recently dead, he may well offend the deceased's family or friends. In addition, such a desecration has a Kantian dimension: if we desecrate a recently dead body, we open up the possibility that it is permissible for our body, once dead, to be so desecrated. We take great pains, as a society and probably as a species, to dispose of the recently dead according to their wishes. We respect the interests of people who have interests in treating the recently dead well, whereas we do not violate interests in digging up and displaying the remains of the long-dead, because we do not know that there are any interests. In some sense, this is how we handle art as well. Does the respect we bear art objects survive once the artist is gone, once the artist has lost an interest in the future of her works? Unless the art object has benefited from the effects of the test of time, then as the proximity wanes, so also does the respect.

If an object that is much like objects that we uncontroversially call art has lost its provenance, or at least its origins are unknown, this does not render the work not-art. The object for which we lack knowledge of its origins is classed with other art objects on paradigmatic grounds. It shares in common with such objects certain formal characteristics or contextual factors that, while perhaps not necessary or sufficient to establish a case for its being art, are enough to substantiate its classification linguistically. Moreover, the respect it is accorded is also parasitic, as was its classification, on paradigmatically central art objects. Art in general should be treated in a certain way. Everyone with a passing acquaintance with art knows in general that art should be handled appropriately. If an object is classed alongside objects that command this delicacy of treatment, then it will command the same treatment. This will be the case, in the absence of the knowledge of its origins, at a minimal level. If its origins are later discovered, then it may be treated better, but unless the discovered origins reveal that the object was never meant to be an art object, then it will be treated no worse. If the object was not meant to be art,

then the object's treatment will revert to whatever treatment objects of its new designation, or classification, enjoy.

Understanding the value as subjectively focused on respect for the artist's efforts—her talent, skill, time, expression—renders the value relative to the valuing individual. In the descriptions of the value of art objects we have considered, there are shifts in the value that each object has relative to the valuer, to her proximity to the object and to the artist, and to her knowledge of the object's origins and provenance. Different people will respect the same artwork, as a matter of fact, in differing degrees and ways. For instance, someone may give very clear and careful instructions to framers when she hands over a print or a painting to them. She may always ask the framers how they will process the work and how they will protect it while it is in their custody. She may do this because she is certain that the work means a great deal more to her than to them. Different people value differently, but as long as there is a general movement from less value to more in the assessing of non-art objects to art objects, then that is enough upon which to found a discussion like this one. Furthermore, to protect the art object appropriately is sufficient. A minimal level of treatment in accord with a minimal level of respect is enough. We may expect and hope that the average in terms of treatment and respect is higher than minimal, but minimal treatment and respect is fine. Minimal good treatment includes prevention of any aesthetic modification of the artwork; protection from the natural threats of time, the elements, or neglect; and avoidance of handling the object in such a way as to harm it. We are not required to frame it or buy it a pedestal. We are not required to arrange for its display, exhibition, or performance, or to retain it. We can sell it or donate it if we wish.

I realize that in this chapter I have not offered a strong argument against modification; indeed, to some degree I celebrate the modification by Rauschenberg of de Kooning's drawing. The case against the general modification of works of art essentially rests on very widely shared intuitions. It is indeed the rare individual, even the rare libertarian capitalist, who would believe that once he owns a work of art, it is really his to do with as he wishes. Owners of artworks are caretakers of something whose full value cannot be measured on the same scale or in the same terms as the scope of their ownership. The modification problem is a species of a

larger problem, and that concerns the way in which we actually do value art. We build it museums and galleries, and industrialists pay millions of dollars for a single piece of it. But we do not do this for any other objects or events that possess or deliver the value(s) that production theories claim for art. We do not build such houses or pay such prices for purely aesthetic objects, or purely cognitive objects (the closest would be an arena for chess matches—puzzle museums do not count), or purely emotive objects (the closest is a movie theater, but that is only if the film—either the particular film or film in general—does not count as art). If we understand the "symptoms" of real-world valuing in terms of money and care, then works of art have a value that far surpasses the price of pigment and canvas (etc.) in the actual world. For us to say that their value lies in producing certain experiential states (or, really, producing anything) should be to say that we would pay and care equally for non-art objects that produce those same sorts of states, but in reality we do not. To chalk this up to our being acculturated or socialized to take care of art, without regard for these philosophical considerations of its value, is not to do service to the fields of everyone reading this.

It seems to me that even if we reject object-intrinsic artistic value accounts, this leaves us not just with instrumental accounts but with *extrinsic* accounts, of which instrumental accounts are a species. I recommend that we consider, as an extrinsic account of artistic value, a focus not on the audience but on the artist. The value of a work of art is located subjectively in individuals who respect the art object as the product of the artist (reflecting the artist's time, talent, skills, labor, concentration) and perhaps above all as the instantiation of the artist's valuable and irreducible expression. The respect we accord a given art object is borne out of a respect for the artist's efforts. There is no need to offer a separate account of the acquisition of intrinsic value by an object upon its achieving the status of art, and there is also no need to appeal to the potential of the object for contributing to positive aesthetic experiences to explain why, commonly, respect is paid to art objects qua art. This extrinsic account jibes well with the actual way we—perhaps we as Westerners—value art. We tend to understand and appreciate art in terms of who it came from, who they were, what their influence was, and so forth. This may not be a good thing—it may be snobbish and elitist and impure

and all the rest—but it explains our ordinary experiences with art. It explains why the industrialist will pay millions for a Monet. It explains what we choose to house in the Louvre, the National Gallery, the Tate, and the Museum of Modern Art.

One last set of caveats. This extrinsic account is most probably a version of an expressivist account. The focus is on the artist, and while there is in this theory a focus on the audience's appreciation of the work—and expression—of the artist, the main focus is on the artist. I also believe that there are instrumental elements in this account, since value lies in the subjective uptake of the importance of the artist's work. But unlike in production theories, the subject's involvement here is not additive. The dynamic is one of inherency. The subject actualizes the value that is present in the work *as a result* of the artist's efforts and expression. The audience member is the locus of value, but this is only because the value has to be located somewhere, and if it is not intrinsic to the object, then there are few options left. Locating the value in the artist would be very odd unless she created the work merely as an expression (and whatever therapeutic benefits resulted) or as an object only for her own viewing. So the value must be located in the audience member, hence the characterization of the value as a matter of respect.

LESSONS ON VALUE ACCOUNTS

For a chapter essentially concerned with "infrastructure," this discussion has gone on a while. The purpose behind this discussion, and thus the justification for engaging in it for so long, concerns the importance of establishing a baseline against which to make claims about objects being more valuable as works of art given one set of considerations rather than another. This is important if I want to argue that in some cases consideration of the context of a work of art enhances the value of that work.

The first stage of the case offered in this chapter concerns the reason we need to focus on the value of the art object itself and not on the experience of that object. The second stage, the longer discussion, consists of reviewing various theories of the value of art. The point of this offering is to come out with something useful. Rejecting intrinsic accounts seems nowadays simply to make me one of the crowd, even though in-

trinsic accounts of the value of art allow for value to be assessed through a generally objective process focused on (1) a formal analysis of the object and (2) information about the object that is in principle accessible by anyone, that is, "part of the public record." But the bottom line is that a contextualist project cannot rely on an intrinsic account of value. To do so seems to beg the question against the very case I mean to be offering. If the value of a work lies in its intrinsic properties, features that are objective and do not rely in any substantive way on the subject, then the right way to approach art assessment seems the formalist route. But this is what I deny. I trust that the two arguments offered in rejection of an intrinsic value account are sufficient to ground my rejection of that approach without begging the question against it. Having dispensed with that approach, we can go on to consider approaches that are both extrinsic and friendly to a contextualist project. Above, I describe five extrinsic accounts, four of which are straightforward instrumentalist accounts—which I refer to as "production accounts." Along with a review of each, I include some criticism, primarily to motivate moving on to other accounts, not the least of which is the noninstrumentalist extrinsic account that I offer at the end. (Although this extrinsic account still incorporates a subjective element, it relies less on the subjective than do other nonintrinsic accounts. In recommending my extrinsic account, I want as much of my cake as I can possibly have—as much of an objective basis for art evaluation as is possible—while eating it at the same time—that is, jettisoning intrinsic value accounts.) The bottom line must be that any of these five extrinsic accounts of the value of art would work perfectly well to ground my claims about the importance of context. The only accounts that do not work are intrinsic ones.

3 Disinterest Theory and Formalist Theory

DISINTEREST THEORY AND FORMALIST THEORY—
along with the more art-historical movement of aestheticism and "art for
art's sake"—are essentially theories of decontextualism. Decontextual-
ism,[1] for my present purposes, can be defined in one of three ways: (1) the
very nature of aesthetic attention is disinterested and focused contempla-
tively and exclusively on the formal features of aesthetic objects; (2) aes-
thetic attention produces the best results when it is disinterested, with the
"best results" couched in either objective terms (the object of attention,
the aesthetic object, is more valuable) or subjective terms (either the ex-
perience is more valuable, that is, richer and more rewarding, or some
other, nonaesthetic, purpose is achieved); or (3) disinterest is necessary for
achieving objectivity in aesthetic judgment. Jerome Stolnitz, Roger Fry,
and Stuart Hampshire believe definition 1. I attempt in the first chapter
of this book to obviate this approach, but toward the end of this current
chapter, I briefly return to their specific claims. Definition 2 is the em-
pirical correlate to definition 1. Arthur Schopenhauer and Edward Bul-
lough believed definition 2. Lord Shaftesbury and Francis Hutcheson be-
lieved definition 3. Immanuel Kant believed a combination of definitions
1 and 3, though *objective* is not the right word to apply to Kant's theory.

My plan for this chapter is to lay out the opposition's case as cleanly
and sympathetically as I can. The rest of the book, following this chap-

ter, is a refutation of these various positions, all captured by the umbrella term *decontextualism*. This being the case, I will not spend much time in this chapter in critique of these opposing positions. The exception to this practice is where a given theory has unique points that need to be addressed in a specific fashion.

DISINTEREST AS THE BASIS FOR AESTHETIC JUDGMENT

The historical foundations of disinterest theory lie in two places. The first is Britain of the late seventeenth and eighteenth centuries. Those who contributed to the establishment of this tradition are known as the British Taste Theorists. By and large, they worked in a spirit of growing empiricism in Britain. The first of these was Shaftesbury. He was followed by Hutcheson, Joseph Addison, and, writing at the same time as Kant, Archibald Alison. To a lesser extent, David Hume, Edmund Burke, and Alexander Gerard contributed to this history.

The second place where disinterest theory began to grow was in Germany in the latter part of the eighteenth and early nineteenth centuries. Immanuel Kant was motivated to determine how it is that aesthetic judgments can be true or false while still accounting for the problem, raised by Hume, that judging is a subjective phenomenon. Kant determined that the key to correct aesthetic evaluation lay in two things: (1) that human beings each have the same faculties for understanding the world, and (2) that if each aesthetic evaluator were motivated in his evaluation by an appreciation of the object merely as it is an object of contemplation, he would—insofar as he would be judging disinterestedly—be judging the object just as every other properly disposed aesthetic evaluator would judge that same object.

The other German thinker who contributed heavily to this history was Arthur Schopenhauer. Schopenhauer's theory of the Will, as a domineering and unhappy force that enslaves all, led him to look for escape. His escape took two forms: one permanent, the other transitory but more accessible. The permanent escape was to deny desire, to adopt asceticism and take up the life of pure contemplation. The second escape was through art. Through art, the individual could understand not just the phenomenal world but also the world of Platonic Ideas. In rising to this

higher level of understanding, one divorces oneself from desire. To release oneself from desire, the individual must appreciate the artwork from a disinterested viewpoint, contemplating the object for the object's sake and for no other end. Schopenhauer was primarily interested in disinterest not as a means to motivate appropriate aesthetic judgment but rather as the proper posture for aesthetic experience. In the second section of this chapter, I review his theory along with those of Edward Bullough and Jerome Stolnitz, both of whom worked in the twentieth century.

Lord Shaftesbury

Lord Shaftesbury (1671–1713; the Third Earl of Shaftesbury, Anthony Ashley Cooper) is credited with being the first to utilize the notion of disinterest in a way comparable with later theorists.[2] Shaftesbury's motivation in working out his theory was twofold: first, he was met with the extreme relativism that he took Hobbes's ethical theory to contain, and he wished very much to address and refute this relativism; and second, in the attempt to address the relativism, he adopted a neo-Platonist position, holding that there are absolutes and that they exist extra-mentally, separate from subjects. Hobbes presented Shaftesbury with a challenge. If Hobbes were correct, then value judgments might be nothing more than reports of certain self-interests. Shaftesbury, like many of the aestheticians who followed him, was interested in capturing what seemed to be common experience: a standard against which to measure whether value judgments—in this case, aesthetic judgments—were correct. He was originally, as a matter of fact, interested in creating an ethical system to refute Hobbes. The interest here, though, is in his aesthetics, about which Shaftesbury wrote,

> Could we once convince ourselves of what is in itself so evident, That in the very nature of things there must of necessity be the foundation of a right and wrong taste, as well in respect of inward characters and features as of outward person, behavior, and action. . . . [A man of breeding] inquires which are the truest pieces of architecture . . . the best paintings. . . . He takes particular care to turn his eye from everything which is gaudy, luscious and of a false taste. . . . A man of polite imagination is let into a great many pleasures that the vulgar are not capable of

receiving. He . . . often feels a greater satisfaction in the prospect of fields and meadow, than another does in the possession. It gives him, indeed, a kind of property in every thing he sees, and makes the most rude uncultivated parts of nature administer to his pleasures: so that he looks upon the work, as it were in another light, and discovers in it a multitude of charms, that conceal themselves from the generality of mankind.[3]

Disinterest, at this stage of the tradition, has only a negative or privative meaning: "not motivated by self concern."[4] *Interest* was at times a synonym of *advantage;* at others, a synonym of *concern.*[5] This is perhaps apparent given the Hobbesian influence. It is this negative sense of *disinterest* that forms the cornerstone of the way in which the term was used from Shaftesbury on to today. But understanding that the term had a positive side as well is equally important. Disinterest does not mean "uninterest." Disinterest allows for an interest on the part of the agent, only that interest is not motivated or informed by issues relative only to that agent.[6]

For Shaftesbury, there was a need to show that some way existed of accessing the absolutes that he thought existed. The means was to develop a system that made use of disinterest as a way of gaining this access. With the adoption of a posture of disinterest, the agent could assure himself that he would judge just as any other person would, or so Shaftesbury, and others who followed him, concluded.[7] This access to the absolutes that grounded the identification of right and wrong judgments was accomplished by the initial attitude of disinterest on the part of the agent. Viewing without considering possession or self-interests with regard to the object would allow the agent the pure vision she needed to clearly see in the object the appropriate qualities.

This access took the form of the agent's having and exercising what Shaftesbury called *Moral Sense,* an inward eye that grasps harmony in aesthetics and ethics and does so immediately and directly. Perceptions of beauty, Shaftesbury thought, are immediate and are accessed by the Moral Sense in much the same way that simple base properties of objects are accessed by the senses. Just as one sees that the object is red and not blue, so one as quickly sees that the object is beautiful and not ugly. The Moral Sense was for Shaftesbury the faculty of taste.[8] In aesthetic

judgments, this inward eye would identify, or be inspired by, the objective property of *Unity in Multiplicity*. However, the work must first be a candidate for the agent to see the Unity in Multiplicity—the correct posture must first be taken on the part of the agent. This is accomplished by the initial attitude of disinterest. And this is essentially how the object is transformed into an aesthetic object. In this way, disinterest is biased toward a more "catholic and inclusive concept of the aesthetic."[9] Not only could any object be viewed aesthetically through the initial attitude of disinterest, but also this posture could be adopted by anyone and at any time. This is important because it marks the nature of disinterest not as a state that is brought about through the object's effect on us but as something that is purposefully entered into to promote aesthetic viewing or the ability to properly judge aesthetically. One should note, however, that the state of disinterest arises not automatically or in a vacuum, but out of a voluntary and conscious wish to view the object in a certain way, that is, in the aesthetic way.

Francis Hutcheson

Francis Hutcheson (1694–1746) was to some extent a mirror of Shaftesbury. This is especially the case with regard to disinterest.[10] There are, however, significant differences between the two. First, Hutcheson was not ontologically a neo-Platonist; he was a relational realist in the Lockean sense that I describe in chapter 1. While he thought there was a real property of beauty and that one could be right or wrong in one's ascription of beauty to any given object, he thought that the seat of that real property was in the relationship between the object and the subject. This is, perhaps, the statement for which he is best known. He retained the realism to provide for the universality of judgments, that is, to accomplish the end of having aesthetic judgments be not merely a matter of subjective whim but such as to be correct or incorrect as tested by the judgments of everyone, universally, who was properly disposed to judge, that is, disinterested. But instead of attributing the property of beauty to a removed realm or to the object itself, Hutcheson located the property in the relationship between the attending agent and the object.

This sort of position led to another difference between Hutcheson and Shaftesbury. The universality that they both sought was not for Hutche-

son grounded in the object or in some objective property; it was instead grounded in the judging ability of the individual, in his faculty of taste, as Hutcheson noted: "We find our selves pleas'd with a regular Form. . . . We are conscious that this pleasure necessarily arises . . . from some uniformity, order, arrangement, imitation, and not from the simple ideas of Colour, or Sound, or Mode of Extension separately considered. . . . [O]ur Power of perceiving the Beauty of Regularity, Order, Harmony, [we call] an INTERNAL SENSE."[11] The faculty of the *Internal Sense* was for Hutcheson as real and present as any other faculty. "Taste" was of the same kind as "eyes-for-seeing" and "ears-for-hearing," though one could not physically locate any taste organ as one can locate the eyes or ears. He thought that the presence of the Internal Sense was established by experience: "That there is some Sense of Beauty natural to Men; that we find as great an Agreement of Men in their Relishes of Forms, as in their external Senses, which all agree to be natural."[12] As one sees yellow and agrees with all those with working and practiced senses that the color is indeed yellow, so it is that when one sees in objects that which triggers the Internal Sense, that individual agrees with all other judges that the object is indeed beautiful. Two points to note: first, for Hutcheson what triggers the Internal Sense is *Uniformity among Variety,* as a counterpart to Shaftesbury's Unity in Multiplicity. Second, to agree that an object is beautiful, more than a disinterested eye is required; also required is a practiced eye. The more practiced one is at identifying beauty, the greater and more precise is one's sense of taste: "This greater Capacity of receiving such pleasant Ideas we commonly call a fine Genius or Taste."[13]

What is in agents is not the beauty per se; what is in agents is the innate ability to sense beauty. What is in the object is not the beauty per se, either; what is in the object is Uniformity among Variety, and this is what triggers perception of the beauty.[14] "Beauty" is a relational quality, and Hutcheson is quick to point out that all beauty is relative to the mind perceiving it.[15] The argument Hutcheson offers for the existence of this innate faculty is that there appears to exist a universality about judgments that is known through experience of the world, through custom, education, and example, and this universality would not have existed if there had not been at the start some mechanism for its existence. So the Internal Sense of taste must indeed be present in all of us.

Disinterest as the Basis for Aesthetic Judgment

Hutcheson thought that obstacles could get in the way of experiencing beauty, just as obstacles can get in the way of experiencing yellow. Just as the lighting might be influential, just as a room or gallery might be dark, just as there might be some saturation of some color other than yellow stuck in an observer's head, so too could the sensation of beauty be disturbed by interests. One must first be properly disposed to seeing the aesthetic object before that aesthetic object acts upon one by triggering the Internal Sense and providing one with an aesthetic experience, which Hutcheson casts in terms of aesthetic pleasure. And it is the disinterested stance of the spectator that affords her the opportunity to experience beauty. This stance seems not to be "entered-into" for Hutcheson. He rather describes it as something that can be "exited-from" by means of taking on (practical) interests in the object.

Joseph Addison

Joseph Addison (1672–1719) reacted to Hutcheson's claim that there was such a thing as a special faculty that accounted for the universality of taste, that one would judge the same as another if each were properly disposed for judgment.[16] Addison based his theory of taste not on Platonic entities or special faculties but on science. In a sense, Addison's theory is an attempt to demystify Hutcheson's position. Hutcheson's faculty of taste might simply be an ability to discern and appreciate or enjoy beauty, if the ability is present, which might be understood or described without need of positing this new faculty. This is a clear road-sign that empiricism was becoming more strongly influential in the minds of the British Taste Theorists. Addison's study revealed that there are three qualities that, when in the object, give rise in the spectator to a favorable aesthetic judgment, and these he characterizes, as did Hutcheson, as arising from the feeling of pleasure: "Those Pleasures of the Imagination, which arise from the actual View and Survey of outward Objects: And these, I think, all proceed from the Sight of what is Great, Uncommon, or Beautiful."[17] Addison's qualities are different from the triggers that Shaftesbury and Hutcheson described. Addison's qualities do not give rise to the sensing of beauty, but beauty is one of the qualities.

Presumably, if one were correct in attributing to Addison a commitment to empiricism, one would not have attributed to beauty an existence

that is extra-mental and extra-particular. However, Addison clearly did not think that beauty is purely subjective. Beauty is an objective property. Addison offers two tests for determining the correctness of assessment or judgment of an aesthetic object: the test of time,[18] and whether one is pleased with the proper qualities of what one is perceiving. "If a Man would know whether he is possessed of this Faculty," Addison observed, "I would have him read over the celebrated Works of Antiquity, which have stood the Test of so many different Ages and Countries. . . . [H]e should, in the second Place, be very careful to observe whether he tastes the distinguishing Perfections, or . . . the Specifick Qualities of the Author whom he peruses."[19] What is of primary interest is the second criterion, that the spectator be pleased appropriately, with the pleasure taking as its true ground the qualities in the object that one ought to appreciate if appreciating the object aesthetically. But how is the spectator to know when it is beauty that is arousing him, and if there is a special state of the mind that renders him particularly receptive to the beautiful?[20] Addison answers that it is just the disinterest of the spectator that assures him that he is judging properly. He is appropriately disposed to react not out of his own concerns and interests but out of a pure appreciation of the object, an appreciation characterized by disinterest: "A Man of a Polite Imagination is let into a great many Pleasures, that the Vulgar are not capable of receiving. . . . He meets with a secret Refreshment in a Description, and often feels a greater Satisfaction in the Prospect of Fields and Meadows, than another does in the Possession. . . . So that he looks upon the World, as it were, in another Light, and discovers in it a Multitude of Charms, that conceal themselves from the generality of Mankind."[21] Again, this stance is what allows one to assure oneself that it is the appropriate qualities that make the experience aesthetic and pleasureful. The initial posture of disinterest is that mechanism, under the subject's control, that allows her to ensure that her attendance to the object will be aesthetic. With this attitude, she may know that she is attending to the appropriate properties and in the appropriate way to experience the object aesthetically.

Archibald Alison

Archibald Alison (1757–1839) wrote at about the same time as Kant. He stressed disinterest more than Addison did, and he expressed it in a way

that is still closer to the way that it is used today by theorists such as Jerome Stolnitz.[22] Alison, coming chronologically closer to Hume, was more prone than his predecessors to the influence of empiricism. His position was focused on the subject, certainly more than Shaftesbury's or Hutcheson's, and more than Addison's as well. Alison thought that it was imagination, or certain imaginative associations, that made for aesthetic experiencing. The mere presentation of beauty is not enough to stimulate the spectator into feeling pleasure over the beauty. The spectator becomes a more active participant. She exercises her mind, her imagination, her attentive contemplation to more fully experience the nature of the object and in so doing experience the object as fully aesthetically as she can. Without this mindful, imaginative activity, the experience is not aesthetic but one (possibly) of mere pleasure, Alison argued: "The emotions of taste may therefore be considered as distinguished from the emotions of simple pleasure by their being dependent upon the exercises of imagination; and though founded in all cases upon some simple emotion, as yet further requiring the employment of this faculty for their existence."[23] This suggests two things. First, it strengthens the subjectivist bent of Alison's program, for though the objective properties that each person sees (hears, etc.) are the same, what she does, in her imagination through association, with these properties is what determines her aesthetic experience. Second, it suggests that one must be disposed in a certain way to experience aesthetically (I include Alison in this first section on judgment for reasons I will discuss below).

The object's importance, however, is not diminished. First, Alison clarified that the object's qualities per se are what cause more or less use of imagination, and this provides for some objects being aesthetically better or worse than others. Second, the object's qualities are those that give rise to the experience in us, that experience which mirrors those objective qualities. Objects whose character is sad will make one feel sad, and those whose character is joyful will make one feel joyful. The importance of the object in Alison's account is, in this regard, closer to the work of Shaftesbury than to that of Hutcheson or Addison, whose accounts are more focused on the subject. However, the account is, at heart, more subjectivistic, because the level of aesthetic experience and the judgment of that aesthetic object focus strongly on the workings of the spectator's mind.

In all this talk about the subject's associations, is there room left for disinterest? Yes. What Alison meant by "associations" was the activity of the imagination, similar to the way Kant was interested in the interaction of the imagination and the understanding. Alison's commitment to disinterest[24] is found most obviously in his view about how one judges and evaluates aesthetic objects, but it is also found in his view about how one experiences aesthetically. If one is encumbered by personal or practical interests, this will interfere with the depth to which one can contemplatively attend to the object and with the experience of beauty.[25] This was important because of the widely subjectivist character of Alison's theory. He needed a vantage point from which to ensure that aesthetic judgments did not become purely subjective, with diminished hope for comparison between judgments. Given total subjectivism, judgments about beauty could not have a claim to universality, he thought.

All in all, Alison moved still further in the refining of the concept of disinterest. The ideal state of the mind, he says, is to be "vacant and unemployed."[26] With the addition of any practical or personal concerns, for furthered ends involving the object, the experience of beauty may be lost or at least severely curtailed. Again, the use of the term *disinterest* has had, throughout its use by these empiricists, a negative or privative meaning. Throughout, each has emphasized a need for the agent to divorce herself from her common concerns.

David Hume

Hume concentrates on the possibility of knowing whether something is beautiful or not. He begins with sentiment. If one favors a certain object, if the appreciation of that object brings one pleasure, then how can one be wrong about that? That is, one cannot be talked out of liking what one likes. One may be able to inquire into the causes of feelings or likes, but one cannot, through simple rational discourse, affect those feelings or likes. Hume writes that "all sentiment is right; because sentiment has a reference to nothing beyond itself."[27]

But this is not how it is with saying that something is beautiful or aesthetically good, because when one says that something is beautiful or good, one is not merely declaring that one likes it; one is asserting a certain judgment. When one says, "That object is beautiful," one is saying

something that is supposed to make reference to the way the world really is, to a matter of fact: whether the object is indeed beautiful. Though one's feelings are pertinent in aesthetic judgments, they are not the whole story. The whole story also must include that when one makes an aesthetic judgment, one means to be saying something that is true or false, that is correct or incorrect, that is up for discussion and revision. "Amidst all the variety and caprice of taste," Hume argues, "there are certain principles of approbation or blame, whose influence a careful eye may trace in all operations of the mind. Some particular forms or qualities . . . are calculated to please, and others to displease."[28] There are patterns to what are commonly taken to be beautiful objects, and there are properties present in these objects that lie at the heart of these patterns. However, once that is said, Hume might be expected to offer a formula, a set of objective, formal properties of an object such that when the object possesses this set, it is beautiful. He does not. Instead, he begins to develop what he calls a *Standard of Taste,* a set of rules of judgment that are found through experience. The rules, if they are discoverable through experience, are found in the judgments of individuals. What Hume seeks to understand are the patterns of common sentiments. If we all like or dislike similar things, then it is these patterns that require investigation.

Hume captures these subjective patterns in his articulation of the *true judge.* For an object to be a beautiful and/or aesthetically good object is for it to provoke aesthetic sentiment in appropriately disposed competent critics, in true judges. Hume suggests that true judges have at least the following qualities: "Strong sense, united to delicate sentiment, improved by practice, perfected by comparison, and cleared of all prejudice, can alone entitle critics to this valuable character; and the joint verdict of such, wherever theories are found, is the true standard of taste and beauty."[29] Judges who have (at least) these characteristics are the judges, then, to whom one may appeal in the determination of whether some object is really beautiful or not. If they are inspired by the object, given their backgrounds and special natures, then the object is indeed beautiful. Hume writes that "the joint verdict of [true judges] . . . is the true standard of taste and beauty."[30]

It is in the idea that judges must be properly disposed to view objects aesthetically and render correct judgments that Hume may find kinship

to the disinterest tradition. The proper disposition is for Hume more complicated than we find in earlier disinterest theories—this can be explained by the level of sophistication of his treatment of the subject. Nonetheless, the consideration of "free of prejudice" may be a correlate to disinterest. It entirely depends on how one understands what Hume means by "free of prejudice."

Hume is widely credited with offering us the standard version of the test of time;[31] he writes,

> The same Homer, who pleased at Athens and Rome two thousand years ago, is still admired at Paris and at London. All the changes of climate, government, religion, and language, have not been able to obscure his glory. Authority of prejudice may give a temporary vogue to a bad poet or orator; but his reputation will never be durable or general. When his compositions are examined by posterity or by foreigners, the enchantment is dissipated, and his faults appear in their true colours. On the contrary, a real genius, the longer his works endure, and the more wide they are spread, the more sincere is the admiration which he meets with.[32]

If Hume is right about the mechanism of the test of time being useful for identifying the value of works of art, then it is logically necessary that objects have future existences if they are to be subject to the test. This is, as I discuss below, radically different from the strategy that Kant employed to ensure universal aesthetic judgment; the difference lies primarily in the way in which Kant described disinterest. There is a tension between Kant's disinterest theory and Hume's test of time theory, and perhaps even between Hume's test of time and—if he is to be seen as a participant in the tradition of disinterest—a certain reading of his recommendation that a true judge be free from prejudice. My inclination at this point is to say that no such tension exists within Hume, that his recommendation for impartiality is closer to a recommendation for openness, honesty, and a recognition of the limits of one's own taste or of one's societal context. This is more in keeping with the spirit of what he wrote in "Of the Standard of Taste." Read this way, Hume is not properly identified as a

member of the disinterest tradition. But, again, it all depends on how one understands what Hume meant by "free of prejudice."

Immanuel Kant

Kant's position in aesthetics, much like his position in metaphysics, may be understood most fully against the backdrop of Hume's position. Hume's view attempts to capture the authority and diversity of the subjective aesthetic judgment while also attempting to account for the belief that some judgments are true and some are false. The antinomy Hume builds is his point of departure, and it may also be seen as Kant's. Through the mechanism of the true judge, Hume attempts to account for the universality of principles but also for the importance of the subjective sentiment and the diversity of judgment, with the expectation that true judges will judge alike. Kant took his departure from this point, exploring in greater depth the subjective case for convergence of aesthetic judgment and, with convergence, a case for aesthetic realism.

The key, Kant thought, to securing universality was twofold. First, it is important to recognize that each person has the same mental structures for understanding the phenomenal world and that the aesthetic judgment is not primarily a matter of sentiment but rather a matter of free play between the understanding and the imagination (mental structures we each possess). Second, it is important for the aesthetic judge to be properly disposed to making a correct judgment. Proper disposition is for the agent to be disinterested. Given disinterest on the part of the judge and given similar faculties for understanding the world, we would all judge similarly—at least we would all judge similarly in singular judgments, that is, in each instance of judging ("this particular rose is beautiful").

Kant's view, as expressed in the *Critique of Judgment,* begins with the notion that insofar as humans are aware of it, or understand it, nature is formally purposive; things appear to uniformly work toward some structure or end. This is not an objective quality of nature per se, at least not so far as one can be aware. Rather, this is a matter of how human beings naturally see the world. It is a subjective maxim, a rule about us. When one judges an object aesthetically, the faculties of imagination and understanding engage in free play, finding a harmony in the mental presentation of the object. For reasons I mention in the next paragraph, this free-play

judging requires judging without bringing the object under any concept. Because of our human mental faculties for experiencing the world, we seek to find the purposes of objects. We seek to see them as connected to other objects and to their past and future states as objects. Because, however, the free play that Kant talked about requires us not to bring the aesthetic object under any category, not to regard the object as connected to other objects or states, the purposefulness we find in aesthetic objects is a purposeless sort. That is, we see the object as if purposefully designed—we see it as structurally sensible, formally "right," an object to be understood—but given the disconnect with other objects and states, this purposefulness cannot and does not connect to any actual purpose: hence, purposeless purposefulness. Again, this purposiveness does not find its seat in (external) nature but is grounded subjectively.

Kant's view of disinterest, of proper subjective disposition under which to judge an aesthetic object, is closely tied to his view that the object must be understood as an object of contemplation and not as an existent object. The first and central indication of what Kant meant by "disinterest" is the first sentence of section 2 of Book One: "Interest is what we call the liking we connect with the presentation of an object's existence." He continues, "In order to play the judge in matters of taste, we must not be the least biased in favor of the thing's existence but must be wholly indifferent about it."[33] Existent objects have pasts, futures, and relations to other objects.[34] If they have futures, then we can take an interest in their future states. If they have relations to other objects and futures, then we might take an interest in their instrumental natures, in their functions. But in a judgment of taste, Kant told us, we must attend only to the contemplative object, the object out of relation with everything else. This means that any actual purpose the object might serve is out of bounds for our consideration. This is a more sophisticated view than his predecessors had. This is more than a Humean call to avoid prejudice or a call from Shaftesbury to avoid personal, self-interested considerations. This is a point about the nature of the exercise of taste itself, intimately connected not merely to the prior conditions—to the prior disposition, to disinterest—but intimately connected with the very notion of beauty itself. For an object to be beautiful, the delight we take in it must be insular and isolated.

Disinterest is, for Kant as for his predecessors, more a negative idea than a positive one. He says, "There is no better way to elucidate this proposition . . . than by contrasting the pure disinterested liking that occurs in a judgment of taste with a liking connected with interest. . . . All interest ruins a judgment of taste." Kant defined the two ways of being: (1) liking what is agreeable (or merely pleasant to the senses); and (2) liking what the object is good *for*, that is, liking the object as a means to some end.

> Both the agreeable and the good refer to our power of desire and hence carry a liking with them, the agreeable a liking that is conditioned pathologically by stimuli, the good a pure practical liking that is determined not just by the presentation of the object but also by the presentation of the subject's connection with the existence of the object; i.e. what we like is not just the object but its existence as well. A judgment of taste, on the other hand, is merely contemplative, i.e. it is a judgment that is indifferent to the existence of the object: it [considers] the character of the object only by holding it up to our feeling of pleasure and displeasure. . . . Hence the agreeable, the beautiful, and the good designate three different relations that presentation have to the feeling of pleasure and displeasure. . . . *Taste* is the ability to judge an object, or a way of presenting it, by means of a liking or disliking *devoid of all interest*. The object of such a liking is called *beautiful*.[35]

One must endeavor, then, as mentioned, not to allow oneself to regard the object for any instrumental good. One must also not allow oneself to regard the object merely pleasurefully as an object of sensation. One must find pleasure in the object not as it happens to be agreeable but as it is the object of the free play of the imagination and understanding in the appreciation of its "purposiveness without purpose." As Israel Knox observes, "It is not strange that Kant should have made disinterest the sine qua non of aesthetic contemplation. Disinterest is liberation from interest, and interest is pleasure dependent upon the idea of the phenomenal existence of an object."[36] This free play of the imagination and understanding, this purposiveness-without-purpose, and this contem-

plation of the relationless object imply that there are no rules under which one can judge, objectively, whether an object is beautiful. One cannot appeal to a rule or principle to convince another judge that her divergent judgment is incorrect. One can appeal only to one's personal experience of the object, given one's regard of the object in the appropriate way: disinterestedly. No principles of taste can be articulated. As Kant said, they are not a matter for the logician. When disputes arise, these are, in Kant's view, to be attributed to a failure on the part of one of the judges: either he is not judging disinterestedly, he is not exercising a judgment of taste (only a judgment of agreeableness), or he is judging not freely but dependently. That is, he is placing the object under a category of similar objects and judging it against the standard of the set.

Kant's view of disinterest was meant to escape the empirical scrutiny given to a position that holds that convergence of judgment is only (contingently) possible through adoption of disinterest. His view of disinterest seems to have been based on two things. First, it is based on the a priori considerations of how human beings understand the world and the faculties they use (and must use, given the a priori foundations of the argument) for understanding the world. Second, it is based on his view that to exercise a judgment of taste is to engage in this particular mental activity but to do so with the object of this activity being an object out of relationship with every other object or state. Surely, the pure intuitions of time and space apply to these objects, but nothing else does. We view the object as an object of contemplation alone. This is what it is, according to Kant's definition, to judge whether an object is beautiful. These two elements—the a priori case for the specific aesthetic operation of the mind, and the definition he offers of what it is to judge beauty— make disinterest an integral, central aspect of what it is to judge aesthetically. This level of intimacy and the sophistication of Kant's case make his view the most formidable of the lot of disinterest theories.

DISINTEREST AS THE BASIS FOR AESTHETIC EXPERIENCE

The previous section deals with what may be the more obviously motivated basis for disinterest: articulating the conditions necessary for correct aesthetic judgment. This section deals with a different motivation. The

three theorists discussed here—Arthur Schopenhauer, Edward Bullough, and Jerome Stolnitz—adopt disinterest theories that provide the basis through which one simply can have an aesthetic experience. In some sense, then, the task for these historically later theorists is more basic than was the task for the earlier theorists. In another sense, the task of describing the proper posture for aesthetic experience had to wait until interest in aesthetic experience qua aesthetic experience became an issue. During the time of the British Taste Theorists and Kant, it really was not seen as an issue. This is not because it was not seen as problematic but rather because it simply was not seen. The nature of experience was largely something ushered onto the philosophical stage by the problems that Hume set up and the wide-ranging theories that Kant produced. So even though Kant talked about judgment, one may fairly say that it was largely through his epistemological work that philosophical interest was generated in the nature of experience per se.

Arthur Schopenhauer

In the same manner as Kant's background included Hume and British Empiricism, Schopenhauer's background included Romanticism. Romanticism was anti-Enlightenment, anti-intellectual, and predominantly interested in the emotive response viewers had to aesthetic objects or that artists experienced either in or prior to the creation of an artwork. Romanticism was less interested in thinking or action and more interested in feeling and expression of feeling. The Romantic movement was influential on Schopenhauer's thought, as was the work of Kant. In Schopenhauer's theory, the role of emotion is present but not in the positive light in which Romanticism portrayed it. For Schopenhauer, emotion contributes to the drives of desire, and desire is what fuels what he called the Will.

Schopenhauer's influences, though, extended further back than Kant. He began with the Ideas, or Forms, of Plato. Like Plato, Schopenhauer believed that these Ideas are more real than what one is phenomenally presented with. That is, the Ideas are real; the phenomenal world is but a copy or representation of those Ideas. Schopenhauer expressed the hope that "after what has been said there will be no hesitation in recognizing the definite grades of the objectification of the Will, which is the

inner reality of the world, to be what Plato called the Eternal Ideas or unchangeable Forms. . . . The Eternal Ideas, the original Forms, can alone be said to have true being."[37] The world is just a mirror of the Platonic realm. Like Shaftesbury, Schopenhauer sought to establish absolutes. These Schopenhauer absolutes were not, however, for the purpose Shaftesbury had in mind. While Shaftesbury needed absolutes to have a standard against which to judge, Schopenhauer's absolutes were more in line with the Platonic Forms. Schopenhauer's absolutes were permanent, unchanging ideas whose existence would allow one to realize that there is a means of escape from the Will. Through access to the immutable Forms, one may escape the Will.

What characterizes the phenomenal or natural world, for Schopenhauer, is the Will. The Will is the will-to-live; it is desire for the necessities and comforts of survival. Although the Will itself is unknowable (it is supersensible), the Will manifests itself in all want, deficiency, and suffering. It objectifies itself in every action one takes, for every action is geared toward one's own survival and satisfaction. But the irony is that one can never be satisfied. In the phenomenal world, the rule is *want,* and the more one tries to evade want, the less one is able to do so. To struggle is to reinforce the Will as the harbinger of unhappiness and strife in one's life.

Schopenhauer's metaphysics is not, however, hopeless. Schopenhauer made provision for gaining access to the world of Ideas, which is the Will-less world. He identified two ways by which this may be accomplished. The first way, the most drastic, is to consciously deny desire, to become an ascetic and cease the struggle for gain. Tied into this is the admonition to take up philosophy, to focus on contemplation to the exclusion of bodily desire. The connection to Platonic theory is obvious. In the same manner as Plato counseled that one ought to contemplate the forms to rid oneself of ignorance and lack of goodness, Schopenhauer advised contemplation of the forms, that is, taking up philosophy, to escape rampant desire and the pressures of the Will.

The second way of escape from the Will is not as permanent as that of asceticism. Schopenhauer recommended focusing on the aesthetic, and if one does so in a way that is devoid of will, one can escape the Will and gain access to the Ideas, which are captured to some degree in aesthetic objects, since these objects incorporate elements or aspects that are

universal. Here the influence of Aristotle is perhaps apparent. Aristotle believed that art was essentially a matter of representing natural objects— but in representing them to show their best, most general, most universal qualities. Schopenhauer's suggestion that one attend to aesthetic objects in order to appreciate in them the Ideas, and to escape the Will, shows how aesthetic objects do indeed have more of a claim to universality than do mere natural objects. In any event, though, Schopenhauer's ontology is strictly Platonic, not Aristotelian.

All knowledge of Ideas can only come through alienation from the Will. And this Will-less contemplation of aesthetic objects is characterized by disinterest. Any conception of beauty one might have comes from a posture of disinterest in viewing aesthetic objects. Through aesthetic objects, one is able to rise above the "particular" and contemplate the forms.[38] In art, one is presented with the "permanent essential forms of the world and all its phenomena."[39] Since the idea is timeless, it releases one from subjectivity and takes one to pure Will-lessness, wherein one loses both individuality and the pain that comes from desire. Disinterest is alienation from personal desire and gain (here again is a primarily negative characterization of disinterest).

In the *World as Will and Idea,* Schopenhauer wrote,

> A man relinquishes the common way of looking at things. . . . [H]e thus ceases to consider the where, the when, the why, and the whither of things, and looks simply and solely at the what[;] . . . gives the whole power of his mind to perception. . . . [H]e loses himself in this object. . . . [T]he object has to such an extent passed out of all relation to something outside it.[40]

> It lifts us out of real existence and transforms us into disinterested spectators of it.[41]

But this is not to say that the onus is on the object to trigger the subject's disinterest. It is the action of the subject, initially motivated to escape the Will, that transforms the object into an aesthetic object. As with others before, Schopenhauer's account includes the traditional hallmarks of subjective control *and* an explicit account of how the object in question is

transformed into an aesthetic object. The transformation "takes place suddenly ... by the subject ceasing to be merely individual ... as if raised by the power of the mind."[42]

Like all of his predecessors, Schopenhauer utilized the notion of disinterest as focal in his account of aesthetic viewing. Disinterest was treated by Schopenhauer as being such that it is entered into by the subject to bring on aesthetic experiencing, being such as to transform the object-in-the-world into an aesthetic object, and being such that it allows the subject, by his own power, to rise above the particularized phenomenal world.[43] While Kant may have been interested in a logical exploration of disinterest as a precondition of the universality of judgment, Schopenhauer was interested in the psychological state(s) of the individual.[44]

Edward Bullough and Psychical Distance

The notion of *psychical distance* was popularized in "'Psychical Distance' as a Factor in Art and as an Aesthetic Principle," written by Edward Bullough in 1912. Bullough's article has enjoyed enormous influence. It has been written about and read about in scholarly journals, of course. But beyond this, Bullough's term *psychical distance,* or its diminutive "distance," has been incorporated into everyday speech. The idea of distance has, though relatively young, enjoyed a more pervasive effect than has the more time-honored notion of disinterest, that is, since the time Bullough wrote the article. One may not uncommonly hear someone in a gallery or while discussing a film or a play speak of needing to achieve or maintain some distance from the object or event to appreciate it correctly. No doubt part of the reason for this is the nature of twentieth-century art, which invites controversy over meaning or message or whether it is even art in the first place. Distance is commonly invoked as a prescription for an unenthusiastic viewer to become a bit more receptive to the object he is attempting to experience aesthetically. Granted, sometimes the advice might be to gain *physical* distance—as one might advise with an Impressionist or a Mark Rothko painting—but on many occasions, the advice to acquire distance is synonymous with advice to acquire objectivity.

Bullough's theory begins with the suggestion that to experience an object or event aesthetically, the subject must distance herself from the object: "Distance ... has a negative, inhibitory aspect—the cutting out of

the practical sides of things and of our practical attitude to them—and a positive side—the elaboration of the experience on the new basis created by the inhibitory action of distance. . . . Distance appears to lie between our own self and its affections. . . . Distance is obtained by separating the object and its appeal from one's own self, but putting it out of gear with practical needs and ends."[45] Gaining clarity on the notion of distance from Bullough's definition is not so simple a task. For the moment, though, one might define distance as being a state[46] such that the viewer understands that she—her person, emotions, the potential of her action—is not actually engaged directly with the object. She is out of direct involvement with the object, experiencing it as if it were "out of reach," where she cannot effect any changes that would alter the object and the object cannot effect any changes in her. Her experience of the object may result in changes in her (heightened awareness, sadness, joy, rage, etc.), but these changes are only possible as states over which she retains control, which her attendance allows. This "detached affect" definition of psychical distance seems, given the psychological source of the notion, a fairly accurate one.[47] If distance is an attitude that is empirically found to be the state in which people are when they are most obviously attentive to (what are determined to be) the aesthetic features of a work, then the definition must be capable of empirical confirmation.[48]

A second aspect of the theory is that Bullough's conception of aesthetic experiencing admits of degree. One can be more distanced or less: "Distance may be said to be variable both according to the distancing power of the individual and according to the character of the object."[49] This is important because Bullough explained that to be distanced is in itself not sufficient for aesthetic experiencing, at least aesthetic experiencing of the most robust sort. Bullough introduced what he called his *antinomy of distancing:* for the fullest or best aesthetic experience to take place, one must seek not only to distance oneself from the work but also to keep that distance to an absolute minimum. Though distance is necessary, the least possible amount is optimal for the best aesthetic experiencing: "What is therefore, both in appreciation and production, most desirable is the utmost decrease of distance without its disappearance."[50] Bullough called this an antinomy, and aptly so. The least amount of distance might logically seem to closely approach having none at all, but Bullough's view

requires that one maintain at least some. The way that this is accomplished, though, Bullough did not explain in great detail.

Most of Bullough's examples come from the theatre, and his demonstration of the antinomy is no exception. Bullough suggested that the viewer imagine that he is at a production of *Othello*. To properly appreciate it, he must understand that running on stage to stop Othello from strangling Desdemona would be inappropriate. This understanding is an instantiation of distance between the viewer and the play. However, simply to be distanced is not sufficient. One also must be attentive and sympathetic to the play, attempting to understand it and feel the emotions that are appropriate. One must be not only distanced but also sympathetic to the play. One must attain the distance, but one ought to attain the least amount of distance without losing it. So it is appropriate to feel despair when watching Macbeth receive the news of his wife's death; it is appropriate to feel sorrow when Lear finds that Cordelia has been killed; it is appropriate to feel frustration when Juliet hears that she is to marry Paris.

Bullough's classic example of psychical distance is that of appreciating a thick fog at sea. Although there is imminent danger, a sailor is still able to appreciate the qualities of the fog as a fog—for example, appreciate the milky whiteness, the thickness, the perhaps sublime nature of the fog—by distancing himself from the danger, from practical concerns, by attending to the phenomenal qualities of the fog and not to the peril that it brings, that is, not to the practical situation in which he finds himself.

Another interesting example concerning distance comes from Suzanne Langer.[51] Langer recalls that as a child she saw a production of *Peter Pan*. In the story, there comes a point where the fairy Tinkerbell drinks some poison to prevent Peter from drinking it. Tinkerbell becomes very ill and is close to death. Peter, in desperation, appeals to the audience to assist him in saving Tinkerbell's life; if they would clap vigorously and proclaim their committed belief in the existence of fairies, it would help her to recover. At this intrusion, Langer reports, she was horrified and miserable, because the magic and illusion of the production was ruptured when the distance with which she was attending to the production was lost. This supposedly shows that distance is necessary to proper aesthetic viewing. However, the support is lost when Langer admits that of all the children viewing the play, she was the only one who did not respond

enthusiastically and joyfully. Langer's full testimony may constitute a criticism of Bullough's theory of distance. Because the vast majority of the children were not disturbed by Peter's entreaty, to claim that some distance existed between themselves and the production becomes ludicrous.[52] Clearly no such distance existed, or it was not necessary to the full aesthetic experience, as is evidenced by the children's delight in the illusion of the play. While counterexamples such as these may seem an unsophisticated criticism of psychical distance, such criticism is appropriate. There are many examples of artworks, bona fide artworks, that call for the inclusion of the spectator as participant in the fulfillment of the aesthetic object as aesthetic object. Counterexamples, as in the *Peter Pan* case, can be found aplenty. One example is Peter Weiss's play, *Marat/Sade*, in which a play-inside-the-play about the murder of Marat is directed, at an asylum, by the Marquis de Sade. The following is included in the play (the brackets indicating stage direction): "Marat: [speaking to audience] Now it's happening and you can't stop it happening."[53] The audience is pulled in, as it is in *Peter Pan,* by being made to feel some moral responsibility for what is happening on stage. Another example is *Cats.* In the theater, when the cats are not dancing or singing on stage, they roam around the audience, soliciting the audience to interact with them as with real cats. When one is petting an actor, it is hard to imagine oneself as distanced from the production; petting actors is to be involved.

A second genre of counterexample to psychical distance is when the object, instead of involving the audience through negating distance, creates an overdistancing between itself and the spectator. An intriguing example of this is Tom Stoppard's *Real Thing,* in which the production begins with a play inside of the main play. During the beginning of this performance (in characteristic Stoppard style), members of the audience do not know that the play they initially see on stage is a play-inside-the-play. When they realize this, they are taken aback. One founds oneself at a great distance from the original play, the play-inside-the-play.

Another example might be Henry Fielding's *Tom Jones,* in which the author frequently addresses the audience as a storyteller might address his: "Reader, take care. I have unadvisedly led thee to the top of as high a hill as Mr. Allworthy's, and how to get thee down without breaking thy neck I do not well know. . . . We are now, reader, arrived at the last state

of our long journey. . . . And now, my friend, I take this opportunity of heartily wishing thee well."[54] A third example is found in *M. Butterfly*. In this play, the principal character, Pinkerton, continually breaks from the action of the play to explain to the audience what is going on, in both the sequence of events and his own mind. During this time, he might change costumes and the famous Chinese Property Men might change the set. The audience finds itself overdistanced from the actual play in listening to Pinkerton and watching the set-changers.

Perhaps simpler examples of purposeful overdistancing come from television: in the old ABC sitcom *Growing Pains,* the son asks the father, "How often do I bring my problems to you, anyway?" and the father replies, "Every Wednesday evening, eight, seven-central."

These cases, the instances of both underdistancing and overdistancing, are all intentional on the part of the author. These breaks from distance are included to add to the cleverness of the object; if successful, the cleverness or breaking of distance can heighten the aesthetic enjoyment of the object.

The parallels between distance and disinterest are many. Each account includes similar conditions: attention, sympathy, and disconcern for practical matters. Each has similar points of support, and the twentieth-century formulations, those of Bullough and Stolnitz, each take the aesthetic experience as the goal of adopting distance or disinterest. Differences, however, are present, too. Bullough's program is meant to be more precise than those of the disinterest camp, that is, more in line with the empirical scrutiny of what the adoption of an attitude of disinterest would cash out as. But his program is then susceptible to criticisms, such as those made by George Dickie, that question how one might even instantiate distance between oneself and, say, chamber music. Kant, Schopenhauer, and even Stolnitz advance positions more philosophical in character than Bullough's; this leaves Bullough's account more susceptible to the onslaught of recalcitrant experience. It seems plausible to view distance as an empirical cognate, a psychological stepchild, of disinterest. Given this interpretation, Bullough's program is susceptible to all the criticisms of the notion of disinterest. But this is not a symmetrical relationship; the criticisms advanced against distance are not so clearly criticisms of disinterest, and the central reason for this is the narrowness of Bullough's program.

Within the past three or four decades, the banner for disinterest has been most prominently carried by Jerome Stolnitz. Stolnitz sought to expose the way in which aesthetic experience could be had, either at all or most fully. The goal of aesthetic experience is, for Stolnitz, a goal worthy of achievement on its own. With Kant, the motivation to achieve the goal is epistemic in nature; with Schopenhauer, the motivation is ontological. With Stolnitz, the motivation is aesthetic: simply having an aesthetic experience on its own or for its own sake. That people are motivated to seek out aesthetic experience for its own sake seems to be a common experience. If one asks a friend to go to a gallery or concert, the friend does not question why; she recognizes that aesthetic experiences are good things.

Stolnitz begins his account by noting that attention is selective. The viewer focuses routinely, either consciously or not, on different aspects of what she senses, and she dismisses, again, either consciously or not, those aspects or properties that are not relevant to the purpose of viewing. If one's purpose is to mow the lawn, then the focus is on the function of the lawn mower, on whether it is gassed up, blades are sharp, and so forth. If the purpose is to fix a broken lawn mower, then the focus is on the internal combustion engine, paying attention to wires, valves, and plugs. In the absence of purpose, then, the focus is on the lawn mower not as a lawn mower, given that the name itself implies a function. The state in the absence of purpose is such that one focuses on the object as an aesthetic object, paying attention to its immediately perceptible properties and to nothing further. "It is the attitude we take which determines how we perceive the work," Stolnitz states. "An attitude is a way of directing and controlling our perception[;] . . . an attitude organizes and directs our awareness of the world. The aesthetic attitude is not the attitude which people usually adopt. The attitude which we customarily take can be called the attitude of 'practical' perception."[55] Stolnitz defines the aesthetic attitude as "disinterested and sympathetic attention to and contemplation of any object of awareness whatever, for its own sake alone."[56] He takes "disinterest" to mean that one does not look at the object for any purpose it may serve. Attention to the object is solely directed at the object's properties intrinsically, not instrumentally. One is not interested in

what the object, or its properties, can do or accomplish. One is simply interested in the object on its own: "Disinterested means that we do not look at the object out of concern for any ulterior purpose which it may serve. We are not trying to use or manipulate the object. There is no purpose governing the experience other than the purpose of just having the experience. Our interest comes to rest upon the object alone, so that it is not taken as a sign of some future event, like the dinner bell, or as a cue to future activity, like the traffic light."[57]

A further notion that needs clarifying is that of sympathy. Stolnitz argues that if one is to appreciate an object, one must accept it on its own terms. That is, to experience the object unpurposefully and aesthetically, one must be willing to focus attention on the immediately perceptible features in a serious way, not haphazardly or nonchalantly. One must be sympathetic to the work, else "disinterest" might well mean "lack of interest," which is exactly what is at issue. It sounds like a paradox, that one must be interested in the work in order to maintain a disinterest in the work, but the fact is that if one does not have some initial interest in the work, then one is not at all in the position to appreciate the work, or, more precisely, to experience the work aesthetically. The paradox is lifted, Stolnitz states, when "interest" is understood as "sympathy," and "disinterest" as "the absence of purpose."

> The word "sympathetic" in the definition of aesthetic attitude refers to the way in which we prepare ourselves to respond to the object. When we apprehend an object aesthetically, we do so in order to relish its individual quality, whether the object be charming, stirring, vivid or all of these. If we are to appreciate it, we must accept the object on its own terms. . . . [A]ny attitude whatever directs attention to certain features of the world. But the element of attention must be especially underscored in speaking of aesthetic perception. . . . [I]n taking the aesthetic attitude, we want to make the value of the object come fully alive in our experience. . . . [T]o savor fully the distinctive value of the object, we must be attentive to its frequently complex and subtle details. . . . [A]s we develop discriminating attention, the work comes alive to us.[58]

Stolnitz also carries into the twentieth century from Schopenhauer that it is the posture taken by the spectator that transforms the object from an object-in-the-world to an aesthetic object. As stated earlier, this does not mean that the object undergoes an ontological change, that it becomes a different kind of thing. What is meant instead is that the object's properties that would lead to a full aesthetic experience (its phenomenal qualities of lines, shapes, etc., giving rise to the experience of its balance, symmetry, beauty, etc.) are hidden until the aesthetic attitude is adopted by the spectator toward the object.

Viewing the object without regard to purpose is not to say that any knowledge of the object (such as genetic knowledge, interpretation, and criticism) is irrelevant. Stolnitz says, "'Knowledge about' is relevant under three conditions: when it does not weaken or destroy aesthetic attention to the object, when it pertains to the meaning and expressiveness of the object, and when it assists the quality and significance of one's immediately aesthetic response to the object."[59] The inclusion or allowance of knowledge-about further emphasizes the point that the aesthetic attitude is adopted to promote to the greatest possible degree the aesthetic experiencing of the object by the spectator.[60] However, Stolnitz allows for agent autonomy in allowing the spectator and her experience of the work to dictate, at least for her, the depth or range of the aesthetic qualities of the object. If the critic disagrees, nothing follows; the spectator has no reason to change her view in the face of disagreement. This is not a surprising twist. Although Stolnitz is not interested in rendering the critics redundant, he is interested, as the majority of aesthetic attitude theorists are, in putting the focus on the actual phenomenal experience of the spectator. One reason for disagreement might come, Stolnitz believes, from a difference in focus. In the same manner as attention may be focused on different aspects of an object according to the purpose of the spectator, so too might the attention on different aesthetic aspects of the object when viewing purposelessly. And it is here that the critic and knowledge-about are important, to open up the spectator to further areas of focus, so that her experience of the work is greater or richer.

Before ending this discussion, I want to take a moment to consider the relationship between the views of Stolnitz and Bullough. Stolnitz is quite certain of the influence of the notion of disinterest, and he holds

that the concept of psychical distance put forward at the beginning of the twentieth century was simply a variation on the theme of disinterest. That is, Stolnitz takes Bullough's account to be another exploration of disinterest as a candidate for the aesthetic attitude.[61] There is reason to agree with Stolnitz, and as well as having many of the same points of support in common, the two accounts also have susceptibility to similar criticisms. Bullough seems essentially to say that necessary and sufficient conditions for experiencing aesthetically are (1) that one is distanced, (2) that one attends to the object, and (3) that one does so with the least amount of distance. Stolnitz's conditions are essentially (1) that one is disinterested, (2) that one attends to the object, and (3) that one does so sympathetically, taking the object on its own terms. The parallel here is striking. Not only are the distancing and the disinterest similar, as was Stolnitz's claim in making psychical distance a child of the parent disinterest, but the instruction to view with the least amount of distance and the instruction to view sympathetically are similar as well. Stolnitz mentions that it is important to note that aesthetic viewing is not instantiated in a cowlike stare, and Bullough's account gives fundamentally the same view. It is necessary, as explored in the treatment of Stolnitz, that this sympathy be included. Inattention to, or apathy toward, an object can render the experience of that object either completely nonaesthetic or of a very low aesthetic quality. The cowlike stare for Stolnitz is comparable to what Bullough calls overdistancing. Say a group of people each with very little exposure to the art world visited New York's Museum of Modern Art. While the members of the group might show the appropriate signs of aesthetic experiencing (looking at the paintings, looking at them closely, perhaps discussing them with other group members), it is doubtful whether their appreciation of the paintings would be consistent with that of one who was familiar with the gallery experience. Having seen, say, only craft objects, and while perhaps being quite good at judging these objects, they might keep the new objects in the gallery (painting, sculptures) at such a distance from themselves that they are not able to experience the objects aesthetically, or at least not very aesthetically. It is a question of receptivity. A child might well be able to appreciate abstract artworks without ever having come in contact with them before, but one who develops a prejudice about what constitutes art

(perhaps excluding some objects regularly found in the Museum of Modern Art) might be guilty of overdistancing.

In the section on Bullough, after presenting his view, I briefly reviewed criticism of it. I will not be doing the same for Stolnitz, and I did not do the same for Kant, either. Psychical distance is not finally the same as disinterest theory, and so a fuller review of it in this chapter seems warranted. In contrast, I take disinterest to be the historical, institutional, and canonical manifestation of decontextualism. Because the rest of this book is devoted to praising contextualization, I will save criticism of disinterest, including the disinterest theories of Kant and Stolnitz, for the chapters that follow.

DISINTEREST THEORY SUMMARIZED

What are the common themes and threads among the various disinterest theories? Is there a set of claims that can be articulated that either capture what is common to all disinterest theories or capture the general nature of disinterest theory?

From Shaftesbury we get the most basic sense of disinterest: "Not motivated by self-concern." We also get from him the idea that "disinterest" does not mean "uninterest." From Hutcheson we get an ontology and a greater rationale for adopting disinterest. We also get from him the notion that disinterest implies being free of obstacles. Addison moves the trend toward greater empiricism along, and Alison moves it still further along. Both adopted positions that are more amenable to empirical scrutiny, to confirmation and disconfirmation, than their predecessors. Part of Alison's contribution is a greater emphasis on the subject and her active participation. He also explores, from a psychological perspective, the effects of adopting a posture of disinterest. From Hume we have the continued focus on the subject; his focus on the subject is the greatest thus far. Instead of recommending object-focused criteria for judgment, Hume offered a subjective standard of taste. And although he did not use the term *disinterest,* he may have contributed to the tradition by including in his standard of taste the condition that the subject be "cleared of all prejudice." Kant gave us perhaps the most expansive and sophisticated version of disinterest. He made this an integral

part of his treatment of the subject. Disinterest and the common faculties of the human mind are all that is necessary for rendering a true and universal aesthetic judgment. Kant connected disinterest to a regard for the object's existence, along with the recommendation that consideration should be given solely to the contemplative object. He completed this by discussing the difference between a judgment of taste, properly motivated by disinterest, and judgments of agreeableness (or dependent, as opposed to free, judgments). He also gave us the recommendation that the object be considered under no categories. This is, as we discussed, richer than the recommendation to avoid considering the object instrumentally. Like Hutcheson, Schopenhauer gave us an ontology, though a decidedly different one from the one Hutcheson offered. In doing this, Schopenhauer was able to cast light back on the object, on how taking a posture of disinterest enables us to see what is most essential and lasting in the object. He talked about the loss of the subject's individuality and desire, "lifting us out of real existence." Bullough emphasized the emotional detachment. He balanced this with a recommendation to maintain that detachment but to maintain the least amount of it possible. This is for the sake of attentiveness to and sympathy with the aesthetic object. From Stolnitz we get a reaffirmation of the importance of aesthetic experience itself, along with his insight concerning the selectivity of attention. We also acquire an emphasis on sympathy; in a more novel insight, we gain an acceptance of relevant "knowledge about" the object.

Given all this, I believe that disinterest theory can be summarized in the following way. One must be properly disposed either to practice proper aesthetic evaluation or to have a true aesthetic experience, and that proper disposition is characterized by the agent being disinterested, with disinterest understood as having the following character:

1. The agent suspends all consideration of how the object (or event) could serve some functional or instrumental purpose beyond merely being an aesthetic object. This includes the premise that the agent suspends all consideration of how the object or its existence could provide a benefit or advantage to the agent, except in its role as aesthetic object.

2. The agent suspends all consideration of the object under any category. The agent exclusively considers the object as an object out of relation with any other object, state, or property.

3. The agent includes in her consideration of the object those factors, and only those factors, that either are transcendentally or psychologically unavoidable or constitute factual knowledge-about. She makes herself an "everyperson" with regard both to the subjective and to the objective aspects of the experience.

4. The agent is sympathetic to and interested in the object as a focus of attention and consideration.

Item three has an interesting relationship to the work of John Rawls, specifically his concept of the veil of ignorance.[62] Behind the veil of ignorance, judges are obliged to evaluate principles solely on the basis of general considerations. They do not know the particulars of their circumstances. Of course, Rawls is talking about developing a theory of justice (in particular, of economic justice), but as he credits this idea partly to Kant's treatment of ethics, it is a small step to think of the idea in relation to aesthetic disinterest. Removing knowledge of the particulars of one's circumstance surely contribute to the ability, as Kant recommended, for one to view the object without concern for its actual existence. Having only the most general knowledge will contribute to the judge's considering the object out of relation with other objects, states, and properties. It renders the sympathy one generates for the object pure, based on common human interest and emotion, removed from any particular associations or psychological contexts.

I want to end this section by coming back once again to my position that disinterest, especially in the form in which Kant describes it, is the historical soul of decontextualism. To view disinterestedly is to view without any regard for context. And, similarly, to consider an object removed from context is to adopt a posture of disinterest as it has been described here.

FORMALISM

Formalism, conceived in one way, is the object-focused correlate to the subject-focused disinterest theories (especially as disinterest theory and

taste theory overlap). Formalism is the position that the correct (1) assessment of, or (2) appreciation of, an aesthetic object and/or a work of art is had when the agent restricts her attention to the formal properties of the object, properties that are broadly accessible through the senses (or immediately derived from these), properties that are objective in the sense of having their locus in the object or are objective in the sense of being entirely dependent for their existence on nonaesthetic, "base" properties such as, in the case of paintings, line, color, texture, and so forth. Melvin Rader describes the formalist in Aristotelian terms: "The contemplator or critic should not concern himself with the efficient and final causes of the work of art since these are external to it, and therefore not esthetically relevant to it; he should be concerned solely with the material and formal causes: with the artistic medium and the materials grasped in their esthetic immediacy; with the artistic form judged in terms of its internal characteristics as contrasted with its external references."[63] As I point out in the introduction to this volume, for many (though certainly not all) aestheticians today, formalism is not a live option. But for many working in the nineteenth and early twentieth centuries, this was not only live, it was canonical. Noël Carroll writes that "no other human activity, the formalist alleges, has the exhibition of form as its special or peculiar province of value.... What is special about art above all else, according to the formalist, is its concern with discovering formal structures that are designed to encourage our imaginative interplay with art works."[64] Formalism, as the leading principle behind aestheticism and the art-for-art's-sake movement, elevates art and aesthetic attention by separating them off from the rest of human activity. Art does not serve a function other than as a source of pure, relationless contemplation.

The history of formalism may be divided broadly into three common arenas, generally historically located in separate eras. The first arena—with theorists from ancient Greece (Aristotle),[65] medieval Europe (Augustine[66] and Aquinas[67]), and seventeenth- and eighteenth-century Britain (Shaftesbury, Hutcheson, and Addison)—focused on judgments of beauty and aesthetic merit. Theories in this arena advance formulas, sets of necessary and sufficient objective conditions that, if met, render the object in question beautiful or aesthetically meritorious. Before the seventeenth-century taste theories, the focus was exclusively on the object. With the

advent of the Scottish Enlightenment and the beginnings of British Empiricism, the focus shifted a bit. The ontological story is mixed; both the object and the subject have roles to play. But nowhere is the objective thrown over for the subjective: the viewers must employ certain faculties and adopt certain attitudes, but the formulas consist in objective properties only.

The problem for those in this first arena is that no formula, no set of aesthetic principles, has ever been offered that has not either met with a preexistent apparent counterexample or has had an apparent counterexample created soon after that defeats it. Whatever formula is advanced must fit all of the objects in the world that are determined without benefit of the formula to be beautiful. Whatever formula we offer must fit our intuitions of what is beautiful, and the set of objects we believe to be beautiful might be a very large set indeed. Once a formula is put forward, historically it has always met with either some artist's creation that we believe to be beautiful but apparently fails to meet our analysis or else some object that apparently fulfills the criteria completely but fails to be beautiful. In a real sense, we must know what it is for an object to be beautiful, because without those intuitions, there is nothing against which to test formulas. The trick is to come up with some analysis of what it is to be beautiful that can capture all of our intuitions about beauty, but after the eighteenth century, this endeavor was abandoned.

The second arena follows the subjective turn that was initiated by David Hume and Immanuel Kant and was codified into canon by Frank Sibley (see chapter 4). Instead of offering objective-criteria formulae—as a means to establish aesthetic realism, the holy grail that formalists up to that point were consumed with—Hume and Kant focused on the qualities of the subject that make one a good judge. Hume and Kant opened the door for other subjective accounts of aesthetic goodness, but the real investment in subjective accounts came in the twentieth century and was provided by a plurality of aestheticians (with Sibley being perhaps the most famous), who argued that reductions of evaluative aesthetic claims would never result in arrangements of objective properties. Sibley first identified aesthetic concepts and aesthetic terms as ones that necessarily include taste in their application. In justifying the application of aesthetic terms, however, we naturally seek out a basis that does not refer

to taste. We look for the "objective" basis for our application of such terms, and we commonly expect to find such bases. Unfortunately, this flows in only one direction. While we may naturally look to nonaesthetic features to ground our ascriptions of aesthetic ones, we cannot, no matter how full an account we offer, ever say that, owing to the presence of given nonaesthetic features, an aesthetic feature must certainly be present; indeed, according to Sibley's argument, anyone who says that (upon following a rule stating that a certain aesthetic feature can be created by inserting certain nonaesthetic ones) would be suspect. We would say that such a person is not exercising taste and, moreover, does not really understand the aesthetic term at issue unless he can correctly apply it in instances where citing the rule is not an option.[68]

In this second arena, we find theorists with decidedly mixed ontological accounts, accounts in which the subjective, the experiential, takes priority over the objective. Of the formalist aestheticians in this second arena, the most famous is Clive Bell, with his theory of Significant Form."[69] Bell wrote, "To create and appreciate the greatest art the most absolute abstraction from the affairs of life is essential."[70] Perhaps less famous, but still deeply influential, are the theories of G. E. Moore,[71] Eduard Hanslick,[72] José Ortega y Gassett,[73] Roger Fry,[74] and Stuart Hampshire.[75] As I mention in the previous chapter, Monroe Beardsley was a kind of formalist.[76] William Wimsatt, Clement Greenberg, Cleanth Brooks, André Levinson, and Heinrich Wölfflin were theoretically minded formalist critics and art historians. Oscar Wilde and James Whistler were famously formalists. Wilde and Whistler, and many other artists of the day, were aestheticists; they argued for "art for art's sake," denying that artistic motives should occupy at any time an area subservient to ethical, social, political, or any other concern of context, concerns beyond the scope of the art taken strictly on its own. Formalism of this period developed as a means of escaping the metaphysical and intentional commitments that came with the earlier theories of Romanticism and Expressionism; it continued to develop as a means of escaping those who wished to constrain art according to varieties of external considerations. Aestheticism celebrated art on its own terms, and so the focus on the art itself, freed from irrelevant externalities, was all the sharper and more intense.

During the time of this second arena, one avenue along which formalism traveled focused on the audience. Analyses of this sort are called "reception" theories, referring to how the audience receives the artwork or experiences the artwork. Bell's version is sometimes referred to as an "arousal" theory, given that the artworks arouse in the viewer some state. If the audience is affected in a certain way, based in this case on how and what the object actually is, what properties it objectively possesses, then the work is truly art. Furthermore, how the audience is affected is much more accessible to aestheticians and critics than is the intent of the artist in creating the object. One is then not in the position of having to access some private individual artistic intention. According to the New Critics, what a work represents, what is in the mind of the artist, what the religious or moral climate is, what the history of the presentation of the work is, what others have said about the work—all these items are necessary neither to determine the status of the object as art nor to determine its value. The only elements necessary to determining the status are contained in the work itself. These are completely accessible to any viewer of the work (anyone with working senses), regardless of her previous knowledge or her religious, moral, metaphysical commitments, and so forth. The work itself, standing alone, is the key to its constitution as art and the assessment of its value.

New Criticism was popularly supported through a paper written by Wimsatt and Beardsley called "The Intentional Fallacy."[77] This paper deals neither with the establishment of a thing as art nor with the assessment of its value. Instead, this paper concerns understanding the meaning of an artwork. In the paper, Wimsatt and Beardsley state that it is entirely unnecessary to know what was in the mind of the artist when she was creating the work in order to correctly interpret that work. We ought not appeal to the intentions of the artist to explain the meaning of the work; instead, we ought to consult the objective features of the work. Through an examination of the properties of the object, its formal relations, we will come to a clear understanding of what the object means. So the meaning of *The Sound and the Fury* by William Faulkner is what is found in the text itself. The words and the rules that govern language give rise to the meaning. The intention of the artist is unnecessary for fixing the meaning of the work. Kendall Walton and Stephen Davies disagree; in

DISINTEREST THEORY AND FORMALIST THEORY

the next chapter I consider their views on the nature and classification of art. Another theorist who disagrees is Jenefer Robinson. In examining the concept of individual style—the style of an implied author as constructed out of relevant recurrent features in literary works—Robinson places the author (or at least the implied author) in a logically and aesthetically much more central and important place than where Wimsatt and Beardsley leave him.[78]

A second avenue along which formalism traveled in the second arena focused more on the object—though, since the accounts of Hume and Kant, there were few if any theories that focused exclusively on the object. Theorists in this camp discuss the aesthetic or art object merely as a construction, and they focus on the properties of the object and the internal relationships of those properties but only insofar as these are able to be perceived through simple sensory contact with the object. Roger Fry and Stuart Hampshire are good examples of theorists on this path. Fry writes that the aesthetic emotion

> seems to be as remote from actual life and its practical utilities as the most useless mathematical theory.[79]
>
> Art is an expression and a stimulus of this imaginative life, which is separated from actual life by the absence of responsive action. . . . That disinterested intensity of contemplation, which we have found to be the effect of cutting off the responsive action . . . that clear disinterested contemplation . . . is characteristic of the aesthetic attitude.[80]

In "Logic and Appreciation," Hampshire describes the differences between moral judgment and aesthetic judgment. Moral judgment is purposeful; it is constructed through the appeal to theory to solve a problem related to conduct. It is an application of the general to the particular for the sake of charting action. This is very different from aesthetics. In aesthetics, there can be no appeal to the general to answer the problem posed in the particular. First, there is no "general"; there is no theory to which to appeal to chart whether the object under consideration is aesthetically worthy or not. Second, there is no problem. Aesthetics, says Hampshire, is not about whether one ought to do this or that, or even whether one

ought to regard a thing in this way or that. "Oughts" as action-focused are matters of ethics, he says; "There are no reasons why some object is ugly in the sense that there are reasons why some action is wrong."[81] Instead, to consider a thing aesthetically is to "attend ... for the sake of their own intrinsic qualities, and disregard the purposes which lie outside; and so regarded, the [art object] becomes gratuitous.... Nothing but holding an object still in attention, by itself and for its own sake, would count as having an aesthetic interest in it.... What pattern or arrangement of elements is there to be seen, when one attends to the thing carefully and disinterestedly?"[82] Hampshire's central claim is either (1) a variant of something I attempt to diffuse in chapter 1 or (2) a consequent of Kantian theory. If option 1 holds, then what makes Hampshire's view more substantive than an appeal to the intuition that aesthetic attention is disinterested attention—a position Stolnitz may be argued to have taken—is the added weight of his argument that aesthetic judgment is essentially particular, essentially gratuitous, essentially indefensible (or perhaps "a-defensible," in the sense of not being a matter for which one offers a defense), and essentially has nothing to do with solving problems or with charting actions. His views seem to turn on a theory of value that is broader than either aesthetics or ethics. When I talk about an art object being more valuable when viewed within a certain context, I assume that we are all interested in both having experiences that are richer and more rewarding and increasing the wealth of our ontologies by increasing the value of the objects populating those ontologies. These things strike me as two means by which one can live a more valuable life than one would otherwise be living. "Living a good life" is a both a key and a common feature of both aesthetics and ethics. To minimize aesthetics as non-action-oriented and gratuitous is to place it outside the scope of what may contribute to a good life (not to mention outside the scope of common critical practice). If it is the moral thing to do to live the best lives we can, and if aesthetic objects enrich our lives, then in some sense our pursuit of them has an unavoidable ethical dimension. I believe that Hampshire would reject my view, however; his division of value would entail such a rejection.

In speaking this way, my view parallels the view of John Ruskin. As I mention in this book's introduction, Ruskin's focus on the discerning eye, both in the artist and in the audience, is a call for the eye to be edu-

cated and informed by a wide range of considerations, considerations that have to do with moral, social, and spiritual concerns. Although Ruskin was interested in the formalist elements of works of art, he understood these as properly seen only through a larger moral and spiritual context, and he saw that this activity had social effects that were not to be shunned or ignored as the aestheticists wished but rather embraced. Ruskin was driven to what I think of as a contextualist position because of the effects he understood to come from interacting with art. Such interaction is elevating; it contributes to the betterment of the individual life as it brings the individual to a spiritual understanding of the truth— the visual truth in the case of paintings—that the artist sought to capture on her canvas. As spiritual elevation occurs, this has implications for the moral development and insight of the individual, and as this development occurs in the individual so it also occurs in the collection of individuals, in the society. The effects of art, for Ruskin, are not only palpable but also deeply important. Aestheticist theorists such as Walter Pater who sought to divorce art from any of its wider connections were working on motivations distinctly different from those of Ruskin. Perhaps both motives were worthy, understood in terms of the values they meant to serve, but Ruskin's understanding of the values of art lie in a more experientially and inductively grounded vision of how art as a matter of fact has effects, spiritual and moral, on individuals and on society. To argue as Hampshire does is to see the values of an artistic life narrowly. This narrowness Ruskin would think both unnatural and in denial of sources of value.

If Hampshire is following the Kantian path—option 2 above—then the rest of this book, as so much of it is focused on rejecting Kant's disinterest theory, will of necessity address Hampshire's view as well. The bottom line is that if the thesis of formalism is meant as an a priori claim about the nature of aesthetic attention, it falters on the grounds that, as an a priori claim, it is based on appeals to intuition that do not take their proponents very far. If it is meant as an empirical claim, it is subject to recalcitrant evidence; I have several chapters of this sort of thing ready to go. Kant's situation is somewhat unique. He offers an a priori claim backed up by an argument about the nature of aesthetic judgment and the nature of aesthetic subjectivity. The second part is a matter of metaphysics,

so let us focus on the first part. If Kant's true goal is universality about aesthetic judgments, with the key aspect being that one can judge that a particular aesthetic object is actually aesthetically meritorious, then it would seem that if I can show that an object increases in value through following theoretical considerations in contrast to his own, he would be obliged to listen. If Kant's goal is to construct a means by which to demonstrate that an object is aesthetically good, then if I can, using a construction different from his, show that that object is even better than he was able to show it was, there is reason to question his views. This, then, is precisely what I mean to do in the rest of the book.

The latest formalist on the scene is Nick Zangwill.[83] Within the past few years, Zangwill has revived interest in aesthetic formalism. His definition of a formal aesthetic property begins with "[t]he intuitive idea that formal properties are those aesthetic properties that are directly perceivable or that are determined by properties that are directly perceivable."[84] He defines a formal property in this way: "Formal properties are entirely determined by narrow nonaesthetic properties, whereas non-formal aesthetic properties are partly determined by broad nonaesthetic properties."[85] And he defines a narrow nonaesthetic property as follows: "The word 'narrow' includes both sensory properties, non-relational physical properties, and also any dispositions to provoke responses that might be thought of to be partly constitutive of aesthetic properties."[86]

Zangwill occupies the third arena, the current one, although the dividing line between what I identify as the second arena and this third one is blurry. I take as a hallmark of this third arena that the ontological debates are by and large left behind. The focus is not on the source, location, or stability of aesthetic properties; the focus is on properties themselves and on what counts as an aesthetic property and what counts as a nonaesthetic property, what properties are relevant to an aesthetic description of an object and so what properties are relevant to its status as an aesthetic object, its place as an object of aesthetic experience, and the judgment of its merit as an aesthetic object. The number one concern of contemporary aesthetic formalists must be to advance arguments that would delineate in tight and enduring ways what counts as an aesthetic property and what does not. Zangwill agrees with this: "I assume as a fundamental principle that aesthetic properties are deter-

mined by nonaesthetic properties. . . . Once we admit this thesis, there is then an issue about *which* nonaesthetic properties determine aesthetic properties. . . . Which nonaesthetic properties are aesthetically 'relevant'? This is where the issue of formalism should be located."[87] In "Feasible Aesthetic Formalism," Zangwill makes use of the Kantian model of free and dependent beauty as a means to divide formal aesthetic properties from nonformal properties: "We can best understand non-formal aesthetic properties in terms of dependent beauty, and formal properties in terms of free beauty. . . . I would like to recast Kant's distinction as a point about the *property* of beauty rather than as a point about the *judgment* of beauty."[88] In invoking the Kantian distinction, Zangwill is not, I think, arguing that formal aesthetic properties should be divided from nonformal aesthetic properties according to this distinction. Instead, he invokes the distinction in the capacity of a definition or explication of the two terms. His argument lies in applying this definition to considerations of works in various art forms and then considering the virtues of such an application. In talking about representational painting, Zangwill carves up the inherent aesthetic properties into ones having to do with the representational nature of a painting and those that have to do only with "a sense of form and color and a knowledge of three-dimensional space" (Zangwill quoting Bell). Although Bell takes this as a sufficient condition for aesthetic viewing, Zangwill takes it only as a necessary one. But in its necessity lies the virtue of the formalist view. Zangwill says that without this, "we cannot appreciate a work of visual art."[89] In discussing architecture, he writes that "formal sculptural properties are architectural values that have waxed and waned in perceived importance relative to other architectural values. But formal values should not be ignored altogether. An ancient Egyptian temple or a Selchuk mosque may have artistic values, including aesthetic values, which depend on its specific function. But they also have formal values that we can appreciate in blithe and perhaps blissful ignorance of the deeper meaning of what we see. An immaculately proportioned building delights the eye, immediately."[90] Zangwill goes on to talk about literature and about music; concerning the former, he recommends a tactical retreat from formalism. Music, however, is the clear case, and if the music in question is "absolute," then it is easy to buy that "moderate formalist is the right approach."[91]

Zangwill hereby shows two things: first, defining formal aesthetic properties as different from nonformal aesthetic properties is intuitively comfortable; and second, focusing on formal aesthetic properties is intuitively central in focusing aesthetic attention on some aesthetic object or event (or we could go further and simply say "some object or event"). One conclusion to be drawn is that approaches that are contextualist in the extreme—deconstructionism is perhaps the best example—are intuitively problematic. What Zangwill ultimately wants to do, it seems to me, is to establish two things: first, the indispensability, the necessity, of a formal aesthetic description of every aesthetic object (for which he does not want to invoke "tactical retreat"); and second, the centrality of such a description to every aesthetic account, be it descriptive of an experience or evaluative.

Formalism of the first arena was well intentioned. It sought to explain why some objects and events are beautiful or aesthetically meritorious and why others are not. Perhaps this is anachronistic, but it was also the straightest path to aesthetic realism: if we can show that certain nonaesthetic objective properties are present, then we can know whether our claims are right or wrong. Aesthetic realism was the holy grail of seventeenth- and eighteenth-century aestheticians, and for many aestheticians today, it continues to frame the most central issues of aesthetics worthy of attention. Unfortunately, all the formulas offered failed at the advent of counterexamples either existent or soon to be. Kant and Sibley explained to us why. So we abandoned the most robust formalist path, and we proceeded along a more subjective one.

Formalism of the second arena was also well intentioned. Although there are many players, if we understand this arena to be primarily focused on aestheticism and art-for-art's sake, on making the access to art and to other sorts of aesthetic experience dependent not on knowledge of externalities but on a simple sensory acquaintanceship between viewer and viewed, then the motives of the aestheticist are laudable both in their egalitarian spirit and in the freedom such motives encouraged in artists, in audiences, and even in critics.

Formalism of the third arena—it, too, is well intentioned. If I am correct that one thing Zangwill demonstrates is that a consideration of the formal aesthetic features of a work of art or an aesthetic object is almost

inevitable in any description of an aesthetic experience or in any justification of an aesthetic claim, and that in the vast majority this enjoys a predominant focus, then aestheticians spend their time well exploring this—why it is and what it means.

The intimacy of the relationship between traditional disinterest theory and more recent formalist theory is perhaps best illustrated by the dual membership in both camps of so many theorists. The sorts of statements made by Fry and by Hampshire go a long way toward cementing the connection. These two theories make up the popular theoretical ground of decontextualism. Aestheticism and New Criticism were the art world's manifestations of the influence of disinterest theory and, more explicitly for the time, formalist theory. All this is the case for the opposition. In the next chapter, I begin the case for contextualism.

4 Contextualist Theory

THE ARGUMENT AT THE CORE OF THIS BOOK has a very simple form: most works of art are more valuable when considered within appropriate contexts. The progress of this argument largely depends on advancing a theory of the value of art and then empirically testing whether in fact many works of art are more valuable when considered within appropriate contexts.

In chapter 2 I offer a range of extrinsic value accounts, most of them instrumental, any one of which I feel the overall argument could be based on. Of course, particular sorts of examples of the value-enhancing power of context-consideration are stronger or weaker depending on exactly which value theory one is using at the time, but given that all of the value accounts focus on particular aspects of a subject's experience of an artwork and that consideration of works in appropriate contexts changes the subject's experience of the work—and my thesis is that this is in the vast majority of cases for the positive—then a certain latitude in terms of specifying which value theory the book's argument will rest on is not only not a problem, it is a virtue insofar as the rejection of one value account does not send the roof caving in for the book's argument. Let me add, again, that the case for the enhancement of the work's value, while located in the value of the subject's experience, is not focused on aesthetic experience. Chapter 1 explains what I mean by this and offers the

reasoning for why the value in question is that of the work of art itself, albeit located subjectively in experience.

The rest of the work of the argument, then, is in looking at classes or sets of examples of works of art, and sometimes art forms, that serve to evidence the thesis. This work is inductive and essentially empirical, so much of the book is taken up with offering examples and exploring the worthiness of using them as evidence.

This chapter, however, I devote to exploring other arguments in support of contextualism. The literature of Western aesthetics from the past two and a half millennia has many such arguments; there is no way that in a book, much less a single chapter, we can engage any of them with a hope of doing them justice. The point of this exercise is to frame a context—a history of theory context—for the book's primary project, as this is described above.

The theories reviewed in this chapter represent challenges to disinterest theory, to formalism, and, broadly, to decontextualism. By and large, the theories here are not constructed as attacks on decontextualism. Instead, they advance positive claims about the value enhancement that is gained through considering contextual factors. These claims imply a rejection, broadly, of decontextualism and, specifically, either of disinterest theory or of aesthetic formalism. This chapter is divided into discussions on three types of theories preceded by some observations on aesthetic perspective:

1. Theories that focus on the importance of context-consideration for the enhancement of aesthetic experience. This discussion includes notice of the theories of George Santayana, Roger Scruton, John Dewey, Anita Silvers, Monroe Beardsley, Frank Sibley, Arnold Berleant, and Allen Carlson.

2. Theories that focus on the importance of context-consideration for understanding the nature of works of art—in some cases for identifying an object as an art object—and through this understanding gaining a perspective through which a work of art may be regarded in its truest and (usually) most valuable sense. This discussion includes notice of the theories of Morris Weitz, Arthur Danto, Jerrold Levinson, Kendall Walton, and Stephen

Davies. Nelson Goodman would fit here, too, as of course would George Dickie.

3. Theories that focus on the importance of considering the moral, ethical, social, or political features of works of art. This discussion includes notice of the theories of Plato, Leo Tolstoy, Noël Carroll, Berys Gaut, Marcia Muelder Eaton, and Mary Devereaux.

It may strike some as obvious that what is missing here is any mention of theories focused on the meanings of works of art and how audience members interpret works of art. Although I do take up issues having to do with "meaningfulness" in chapter 7, the focus there is not on meaning or interpretation in the straightforward sense. Nonetheless, I say a few words about meaning/interpretation at the start of that chapter.

ON AESTHETIC PERSPECTIVE

Feminist Aesthetics as "Meta-Aesthetics"

In "Kantian and Contextual Beauty," and in other places, Marcia Eaton credits feminist aesthetics for contributing to what she calls the "contextualist turn" in aesthetics. "Feminist aesthetics" is neither feminist criticism nor feminist art history. Feminist aesthetics deals with broader issues, issues concerning traditional questions in aesthetics and the philosophy of art. What makes feminist aesthetics unique is that these traditional questions are addressed through the perspective of gender, in terms of both how answers to these questions are framed and constructed (and so with a focus on theory) and how art experiences and aesthetic experiences may be understood (and so with a focus on lived experience and the content of those experiences). Carolyn Korsmeyer is one of the most central theorists working in feminist aesthetics today.[1] Korsmeyer and others advance theories that demonstrate both the historic place of women in the discipline of aesthetics and what approaches to various questions in aesthetics and the philosophy of art would consist of, had the historic place of women in the discipline enjoyed greater prominence, that is, had the perspective not been "gender-neutralized" by instituting the male perspective as *the* (only and so neutral) perspective.

Feminist aesthetics is inherently and essentially contextual. Once we understand (1) that the employment of such things as disinterest and

universal intersubjectivity are not essentially neutral but rather a set of views coming from a set of theorists all of whom shared in common their gender and ethnicity (especially as the *locus classicus* of these views is eighteenth-century Europe), (2) that shared perspective is not the same as universality, and (3) that twentieth- and twenty-first-century women (not to mention all of the other groups I mention in the next chapters) may have different, competing perspectives, the only conclusion available is that disinterest theory, formalism, and constructs such as ideal agents with ideal tastes are themselves matters of perspective and so matters to be understood contextually. The point of feminist aesthetics as I understand it is to locate traditional projects in aesthetics alongside projects of other perspectives, thereby eliminating the presumption that such a thing as a neutral view is possible. The elimination of this assumption not only opens the doors to perspectives that are gendered but also opens the doors to perspectives that focus on ethnicity, class, nationality, and so forth. The point is not for any one to establish dominance; the point is to accept the variety as a fact. Sarah Worth writes, "By starting with the assumption that art and the way we experience it are gendered, feminist aesthetics acknowledges the different kinds of experiences art can produce, and hence can take more varied kinds of experiences into account."[2] Of the importance of context to feminist aesthetics, Worth writes,

> Denying an art work its context can deprive it of important cultural, personal or political significance that need not be lost. . . . Feminist aesthetics wants to allow art works to remain in their context, rather than isolating them and putting them on display separately in a museum. . . . Feminist aesthetics also challenges the notion that a pure, disinterested state of contemplative attention characterizes ideal aesthetic appreciation and the appropriate apprehension of art. . . .
>
> Conversely, feminist aesthetics emphasizes the connection between art and life. . . . [It] suggests that aesthetic value arises in conjunction with the moral and epistemological and not in opposition to them. . . . According to feminist aesthetics, the perceiver focuses on the relationship of art to artist, culture, nature, and ultimately to its context. Adopting this approach

allows one to take into consideration religious, political, social, and economic considerations that are important to the context, in additional to other formal characteristics. . . . Feminist aesthetics takes on the task of making us aware of the gaze which we use to look at, interpret, and judge our world. This is part of the context in which art works are made, and it is part of the context in which we need to understand them. . . . Feminist analyses attempt to link aesthetic judgment and the resultant implied meaning and value of works of art to beliefs and desires in everyday life. It is only here, in the complicated nexus of social circumstances surrounding the creation of art, that we can fully understand its significance.[3]

While Worth addresses one traditional question from traditional aesthetics here—the question of the approach that should be taken when considering works of art—feminist aesthetics can be seen as pursuing a larger project. By saying that approaches both to theory and to aesthetic experience are inherently perspectival, the feminist aesthetician advances a claim not merely about problems within aesthetics but rather about the nature of aesthetic inquiry itself. While the feminist aesthetician does aesthetics, as we see above, the feminist aesthetician also offers a position on how aesthetics ought to be done. Seen this way, feminist aesthetics is a "meta-aesthetic," in the manner of metaethics.

The thesis of this book echoes cleanly and closely the position advanced above by Worth, but if feminist aesthetics can and does pursue a larger project, indeed, if thinking of feminist aesthetics as a meta-aesthetic is correct, then, given the nature of both the feminist aesthetic project and the breadth of its import, for the feminist aesthetician contextualism would seem to be not merely the conclusion of a line of argumentation but an inexorable feature of all aesthetic argumentation. Surely the feminist aesthetician can argue for contextualism, but in a sense this is unnecessary; the very approach of feminist aesthetics implies the correctness of contextualism.

The project of this book is more modest than would be the construction of a meta-aesthetic. I do not take it as an axiom that decontextualized approaches are wrong, nor do I take this as an implication of the

way I do aesthetics. If I take disinterest theory and formalism, as specific programs of decontextualism, as coherent and possible, then my project is more "local" than that of feminist aesthetics.

The View from Somewhere

Before moving ahead, I would like to consider one of the implications of understanding feminist aesthetics as a meta-aesthetic: that all views are views from somewhere, that all views are contextualized in terms of the perspective—the perspectival location—of the viewer.

In the late nineteenth century, Alois Riegl developed a relativistic theory of the value of art based on his notion of the "Kunstwollen," the *artistic volition,* the will or drive of the artist to create. The artistic volition is not the same for each artist in every generation; rather, it is a product of a time and place and of a historical progression. Consequently, to understand the artistic volition is to understand it as contextualized in its historic period. The artistic volition is a part of both a cultural and a temporal context; since it is through understanding a period's Kunstwollen that we can understand why it is that artists were moved to create and to create as they did, the result is a strong contextualism.

Riegl believed that the only way to understand a work of art, to understand its significance and its value, is first to understand the artistic volition that brought it into being. This, of course, means that the value of an artwork is relative to its time and place, to the temporal and cultural context that is responsible for a particular artistic volition, which itself is responsible for the creation of this artwork. There are no universal standards by which to judge any work; all are contextual. Riegl's work is a foundation for those who would study art history broadly, not privileging one period over another, and it is a foundation for those who would study the production of art or artlike objects and events beyond the bounds of, say, Europe. To understand an art object and its value is to understand these things in context, and so while the value of a given work of art is relative, Riegl's theory does not admit of anything like radical subjectivism. Instead, it demands careful art-historical scholarship, motivated by a sympathetic egalitarian spirit.

If there are such things as universal aesthetic values, aesthetic values that are unchanging and stable, they should be seen, as the history of art

unfolds, as driving in a positive direction the recognition of the worth of those objects that embody or at least include these virtues. The test of time is meant to connect to this, such that as time progresses, only those objects with lasting value will continue to enjoy consistent appreciation and praise. But someone like Riegl might object, regarding the test of time as we understand it today to be contextualized to a particular time and place. That is, the test of time may work over a period of several hundred years, with the art objects produced during this time having obvious connections to all the others of this time. But how might the test of time be used in the service of distinguishing the value between European art objects and, say, Chinese art objects? Or between European art objects and Aztec ones? Or between contemporary French works and the objects on the cave walls at Lascaux? Given enough of a paradigm shift—measured perhaps in centuries or in ocean-sized spaces—the test of time cannot function as it is meant to.

If Riegl is right, aesthetic values are shaped by historical, cultural, and perhaps other contextual forces every bit as much as they in turn shape a culture and are involved in the evolution of that culture's art products through time. Too often, we may miss the influence of the times and places on the development and ascendancy of particular aesthetic values, but trends in what art objects are valued, and what kinds of art objects are valued, and from whom these objects come can be tracked in concert with other social values. The same may be said about aesthetic theory; it, too, may be tracked alongside sets of values that seemingly have little to do with art theory but nevertheless have a substantive effect. This in large measure is the core of the claim I investigate in this book's introduction: the connection between theories of decontextualization and the rise of the museum as a decontextualized space. I would amplify that claim a bit more here, suggesting that it is unclear which exercises primacy over the other. It is likely true that each exercised force on the other. Evolution concerns itself not merely with changes in a species but with changes in that species' environs. Coevolution may well be the case, if Riegl's theory or some theory close to his is right.

Riegl's work strikes me as consonant with overarching themes in feminist aesthetics, that all views are from somewhere. If feminist aesthetics and Rieglian aesthetics can be seen this way, they recommend that the

claims of those who advanced theories purported to capture universal aesthetic truths must be reviewed in light of the particular temporal and cultural conditions under which these theorists labored. If there are no transcendent or universal aesthetic absolutes, then we need to be mindful of the implications that flow from theories built on the inclusion of such absolutes. It is possible—I think likely—that as disenfranchisement can be the result of purposed exclusion, it can also be the result of unintended exclusion where theories privilege particular perspectives and even particular audiences.

Does a theory that sets up parameters either for correct assessment of art or for correct appreciation of art privilege those capable of such disposition and so exclude those incapable of, or simply indisposed to, adopting such an approach and its parameters? It is a truism that exclusion breeds elitism. Those accounts—and this is the majority of the taste theory accounts—that construct sets of parameters that only limited numbers of viewers can meet will result in a kind of elitism. Why "limited"? In those accounts where one of the following situations occurs, "limited" is the only way to describe the number of those who have access.

1. Accounts that require that an individual have certain traits— traits such as delicacy of taste, being well practiced and well versed at comparison, being educated. These accounts will exclude potentially large numbers of viewers from the achievement of the proper disposition.

2. Accounts that require the adoption of a (perhaps unnatural) posture with which a possible viewer has no experience. Despite Shaftesbury's frustration with Hobbes's moral theory, Hobbes's moral psychology has had, for many decades, receptive audiences. Many people seem to live out their lives in purposeful pursuit of the goods they believe they need to survive and flourish. And where these people dip into the pool of altruism, it is difficult to see why they would suspend attention to their own interests without some interests, those of the beneficiary of their largesse, being met. Attending in the absence of purpose, in the denial of consideration of self-interest, may be so alien to some people that they are de facto prevented from achieving

what we are told by disinterest theorists is the proper posture for aesthetic appreciation.

If the correct posture is not available—and this cannot be a theoretical point; it must be a practical one—then those for whom it is unavailable are cut off from, to use the Scottish Enlightenment term, "polite" society; they are unable to have true aesthetic experiences. To the extent that decontextualized approaches to art appreciation, as a matter of fact, limit access to the conditions for proper disposition, they are to be held suspect.

My point about the elitism connected to traditional aesthetic attitude theories parallels the points of others concerning the elitism involved with museums and with the establishment and sustaining of art canons. Edward Sankowski writes, "Without testing, challenging, and supplementing, it seems to me, the dominant canons, fortified by the prestige and practices of influential museums, contribute to the imposition of illegitimate authority. . . . It should be said immediately that the unjustifiably marginalized artists, and the groups whose sensibility they often express, are definitely among those whose autonomy is damaged."[4] And in connection with a discussion about John Cage's work, Stephen Davies writes, "Moreover, to the extent that the paradigms it sets out to debunk are ones endorsed by politically powerful, wealthy minorities who take their taste and standards to be superior to others, its message also is political, not narrowly academic."[5]

One might claim that discrimination is precisely what is at issue. What the taste theorists meant to secure was the ability to correctly and truly discriminate—not between persons but among artworks of varying worth. Taste is a skill, an ability, a matter of education and exercise, and it is a worthy goal, worthy of effort and mastery, because it comes at a cost and with a substantial reward.[6] Such an enterprise is to be applauded and supported, as public education should be. But this only works as a justification, in a social/political setting, if two things are already in place. First, the opportunity to master this skill and achieve this ability must be open to everyone, and open in a practical and not merely theoretical way; and second, this opportunity must not be imposed upon the "hoi polloi" as an external value but must be embraced freely

CONTEXTUALIST THEORY

by those to whom the opportunity is offered. This speaks directly to that situation in which an individual believes that she is having rewarding art-aesthetic experiences already. If she believes, on the basis of her consideration of her own experiences, that she is having bona fide art-aesthetic experiences, then it is verging on elitism to suggest to her that she is not. If, however, the proponent of a decontextualized approach can offer her something more than what she already has, in a way such that she intuitively sees the value of investing her energy and time in the achieving of this new skill called "taste," then my condition for avoiding elitism is met.

AESTHETIC EXPERIENCE

As I state in chapter 1 and have echoed once or twice since then, my focus in this book is on the value of art and not on the value of aesthetic experience. This is slightly messy, since the extrinsic accounts of the value of art that I employ necessarily reference the experience of the aesthetic subject, the "attender." But given that this is a discussion already had and brought up as a caveat here, I feel free, as part of constructing a picture of the historical, theoretical context for the book's project, to move on to talk about those theorists who discussed aesthetic experience in contextual terms.

George Santayana

I begin by talking about perhaps the most ardent subjectivist in the history of aesthetics, George Santayana. Santayana's subjectivism is comprehensive. The unique way in which he expresses the subjective nature of beauty places him very centrally among those theorists who believe that what psychological features the subjects brings to her experience of beauty, what subjective contexts she brings, will be not only relevant to but actually definitive of the sort of experience she has.

Santayana suggests that beauty rests entirely on human feelings and human interests.[7] He says that the one element that is always present is our attraction to beauty, and this attraction can be described as a feeling of pleasure in regarding beautiful objects. Santayana believes that beauty is pleasure objectified. He says that "beauty is pleasure regarded as the quality of a thing."[8]

Santayana explores what beauty is by addressing what is felt—what is actually felt—in the presence of beauty. Aesthetics, for Santayana, is comprised of the investigation of values that are dependent, either directly or indirectly, on emotional consciousness, on appreciations, preferences, and appetites. This makes Santayana's claims, including the central one concerning the relationship between beauty and pleasure, empirical and inductive. As I argue in chapter 1, this seems a wise and warranted approach to me. But it comes, of course, at a price; the claim will buckle under the pressure of recalcitrant experience. The question now has to be "Do my aesthetic experiences have the quality of pleasure?" This can be answered in a variety of different ways, but the first move should be consideration of the question. Perhaps the better question, given Santayana's explicit words, is "Do my experiences of beauty have the quality of pleasure?" I have had many aesthetic experiences that I would not consider pleasurable in a straightforward way. Watching Francis Ford Coppola's *Apocalypse Now* or Stanley Kubrick's *Clockwork Orange* or viewing much of Francisco Goya's work is not an experience I would call straightforwardly pleasurable.[9] But in actuality, these are experiences that I am very pleased to have had, experiences that I return to try to repeat from time to time. In some basic sense, I find value in these experiences, and this value is not merely cognitive or intellectual in nature. So it seems fair to say that I am experiencing, at some level, a kind of felt psychological pleasure.

Roger Scruton

Roger Scruton is a defender of pleasure as a necessary part of aesthetic experience.[10] Scruton argues that aesthetic attitudes are those one holds in the expression of preference for and against objects of aesthetic interest,[11] and he characterizes the first condition of the attitude as follows: "the aesthetic attitude aims at enjoyment of and satisfaction with an object."[12] Enjoyment of the object, or pleasure felt in connection with attention to the object, is not as commonly agreed upon as one might think.[13] It seems harmless to say that one enjoys attention to aesthetic objects and the experience, both intellectual and emotional, that one has in this attention. Why else should one wish to go to galleries, plays, concerts? Why would one want to read a novel or a poem if one were not going to enjoy engaging in the activity? It seems hard to imagine attend-

ing to aesthetic objects and activities in the face of no good feeling, again, both intellectual and emotional, connected with the experience. Scruton writes, "It is odd to say 'I cannot stand the sight of an elegant horse,' or 'It is a beautiful novel and I never want to read it again,' or 'I like the look of that—it is the most hideous suit I have ever seen.' Only in special circumstances would these locutions make sense at all. This leads us to suspect that aesthetic appreciation involves enjoyment of, or pleasure in, an object. Enjoyment and pleasure occupy a central place in the aesthetic attitude."[14]

Santayana's focus on psychology is unmistakable, and Scruton's is almost as visible. Pleasure is a psychological state, influenced by a great number of subjective features. If we seek pleasure in aesthetic experience, we seek out a state that is necessarily thickly wrapped up in a particular psychological context. It is impossible to discuss pleasure as a feature or as a goal of aesthetic experience in the absence of discussing the subject's psychology.

We see in Santayana's analysis a strong anti-Kantian and anti-eighteenth-century bent. We ought *not* be disinterested. Quite the opposite: to explore aesthetics, we must acknowledge our vital and deep interests in aesthetic objects. Aesthetic objects are not to be held at arm's length or be divorced from our attachments. They should be considered as part of what we indeed are most interested in. It is meaningless to say that what is beautiful to one person *ought* to be beautiful to another. The claim to universality rests on the mistake, Santayana tells us, that beauty is an objective property. Beauty is, Santayana argues, a subjective, psychological, contextual phenomenon.

One more word about Santayana before moving on. The project that warrants Santayana's inclusion in this chapter and in this book is not the one that is at the core of his theory or the project that I invoke Scruton in connection with. Many disinterest theorists would have no hesitancy in saying (1) that pleasure is not in the slightest at odds with disinterest and (2) that if to be pleased with a thing is to be interested in it, then I have trivialized the notion of disinterest. The reason Santayana is included here is his focus on a psychological context for considering and appreciating aesthetic objects. It is the imposition of the psychological context that is at odds with Kant and other disinterest theorists.

John Dewey

Another theorist devoted to discussing aesthetic experience in a way suffused with subjective context was John Dewey. Dewey's account of aesthetic experiencing focuses on experience as an interactive relationship between the perceiver and the object.[15] Dewey uses the term *experience* in two ways: the first is to indicate the interactive relationship between the individual and the world around her, while the second is to indicate a special sort of the first kind—or, perhaps better said, this second way picks out experiences further along the continuum. This special sort Dewey calls "*an* experience." *An* experience is any experience that principally has the characteristic of being unified and complete. Any experience, regardless of whether it is *an* experience or just a garden-variety experience, is aesthetic to some degree, specifically, to the degree that it incorporates unity. But not every experience is as aesthetic as every other experience. Not even every unified experience is as aesthetic as every other, because the degree of unity will vary from experience to experience. Those experiences that are most clearly aesthetic in character are those experiences that fit into his classification of *an* experience. Those experiences that are maximally unified are most clearly aesthetic experiences. When a moment is sufficient to itself, is individualized, this is *an* experience. These are typified by viewing paintings, listening to symphonies, reading novels, and so forth.

The judgment of whether an experience is *an* experience is made solely on the basis of the felt, lived experience of the individual perceiver. Only in her experience can the object in question be judged to be aesthetic; the aesthetic quality of the experience is thus something that is very personal, very individual. On the face of things, this makes for a very subjectivistic account of aesthetic judgment. Dewey avoids the danger of going too far and thereby sacrificing comparability between aesthetic objects. In gaining insight into an aesthetic object, a person is able to appreciate the aesthetic properties, understand and appreciate their relation to one another, and then understand and appreciate the relation of the work to herself as subject and the relation the object bears to others of its kind and its environment. In working through all of this, the subject comes to have an experience that is not only momentarily pleasurable or even aesthetic. She comes to build a structure that will allow for more frequent

and greater appreciation of this object, of objects of its kind, and, conse-
quently, of aesthetic objects in general. The individual experience is what
is at the heart of aesthetic judgment. However, it follows from this ac-
count that the great works of art, or, we might say, the most enduring
aesthetic objects, are those that provide the richest aesthetic experience,
or create most frequently *an* experience. In this way, the autonomy of the
individual can coexist with the regularity that we perceive in the history
of art and in the general consensus about what sorts of things make for
good aesthetic objects (sunsets, flowers, whales' sounds) and what sorts
of things generally do not (dirty dishes, coughing). According to Dewey,

> The task is to restore continuity between the refined and inten-
> sified forms of experience that are works of art and the everyday
> events, doings, and sufferings that are universally recognized to
> constitute experience.
>
> By common consent, the Parthenon is a great work of art. Yet
> it has esthetic standing only as the work becomes an experience
> for a human being.
>
> No contemporary [of Plato] would have doubted that music
> was an integral part of the ethos and the institutions of the
> community. The idea of "art for art's sake" would not have been
> even understood.
>
> Life goes on in an environment; not merely *in* it but because
> of it, through interaction with it.
>
> Art is the living and concrete proof that man is capable of
> restoring consciously, and thus on the plane of meaning, the
> union of sense, impulse, need, and action characteristic of the
> live creature.
>
> The enemies of the esthetic are neither the practical nor the
> intellectual. They are the humdrum; slackness of loose ends;
> submission to convention in practice and intellectual procedure.[16]

In formulating his view, Dewey is careful to make focal the experience of
the common person. Dewey is careful not to dictate which experiences
are aesthetic and which are not; instead, he allows for the decision of the
common person. Dewey's interest is in the ordinary. If he can capture
what occurs in the ordinary experience of aesthetic qualities, then he will

have formulated a theory that takes the empirical description of what occurs as basic. In this regard, Dewey's program is similar to Santayana's. As we saw with Santayana, when the common experience of humans is taken as basic, the focus is not on the divorce from interest in the objects believed to be aesthetic—quite the reverse. Dewey shows a common person who is vitally interested in the objects that he experiences aesthetically, and the interest and attention with which he invests the objects are just those characteristics that lead him to experience the object aesthetically. The experience is aesthetic because it captures his attention and interest so vividly. He is enraptured with the experience.[17]

Dewey would have found eighteenth-century disinterest theory anathema to his focus on the ordinary, everyday nature of aesthetic experience. It is inherent in his views that he would have found a disinterest characterization of aesthetic experience both unnatural and elitist.

Anita Silvers

When people attend to works of art, they seek out some sort of rewarding experience. Different people seek out different things, and perhaps no one theory captures this adequately. But what they all have in common is that every art viewer, everyone not forced to be there by a parent, teacher, or spouse, is there to get something out of being there. The viewer is looking, if you can excuse the economic analogy, for a return on her investment of time, energy, and attention. To the extent that she is seeking such a reward, she is actively engaged in finding value. While some attend to art objects purely as an intellectual exercise—for the purpose of understanding the nature of art, art creation, art viewing, art classifying, or art criticism and the evaluation of the work under consideration—these purposes are had by the minority of art viewers. The "natural" approach holds as the purpose of viewing art to come away with something—some experience, insight, mood, emotion—of value. As it is natural for people to be perspectival, as it is natural for viewers to consider works as they "immediately" find them, as it is natural to find works in psychological, social, and political contexts—with the most "immediate" approach being one that brings with it context—so it will be natural for viewers to seek their rewards as broadly and widely as they will.

CONTEXTUALIST THEORY

The decontextualist, certainly the disinterest theorist, will disallow this as an improper approach. The Kantian variety of theorist will object that true judgment given such natural contextualism is impossible; if this complaint stands, it demonstrates that Kant's relevance is relegated only to those whose sole purpose is evaluation. The Stolnitzean variety of disinterest theorist is in more trouble because she will have to create a case that says that the reward the "natural" viewer finds in attendance to the works she considers is not an aesthetic sort—aesthetic reward being reserved for properly disinterested viewers—but some other kind. This is a tough case to make if we take the subject's report as bedrock and if the subject professes that her experience was rewarding. To suggest that her experience was not an aesthetic one requires either that we find something more basic than subjective experience and subjective testimony or that we redefine the word *aesthetic* from its common usage to make it incorrectly applied by the "natural" viewer.

Anita Silvers, in "Vincent's Story: The Importance of Contextualism for Art Education,"[18] relates an experiment she conducted on a group of pre-secondary-level students. She told them, while showing them a set of slides of works by Van Gogh, an apocryphal story in which Van Gogh is portrayed as a kind of con artist. Silvers reports that the students, who had up to that point been offering positive responses to Van Gogh's work, suddenly began saying negative things. At this point, Silvers revealed her deceit. But, she reports, the students did not go back to their original positive reactions to Van Gogh; even though she revealed the falsity of the negative stories about his life, the students had already internalized them, and their observations of his work were now, to some degree, permanently colored by the false stories. Despite what the hedonic utilitarian may think about Silver's contextualist experiment, its strength is very interesting; she generates empirical proof of the fact that what we hear about art strongly affects how we perceive it. This is the natural situation. To attempt to bracket off such external relations of works of art is to attempt something artificial.

Monroe Beardsley

I want to return, once again, to considering the views of Monroe Beardsley, particularly as they can be seen to amplify and build on the work of

Dewey. Beardsley's views are discussed in chapter 2, so instead of spending time repeating them here, I want to explore just the most context-focused aspects of his theories. An important caveat to remember is that while there are contextualist elements in Beardsley's work, there are strong formalist elements as well. Beardsley does not fit into one camp or the other cleanly or absolutely.

Like Dewey, Beardsley makes the aesthetic experience focal in his treatment of aesthetics. Beardsley suggests that one is having an aesthetic experience if one is focused on the form and qualities of an object and this experience is unified and pleasurable. The particular qualities that we are looking for in the form of the object are intensity, complexity, and unity, all tied together with pleasure. The aesthetic experience is had through paying attention to these items in the object and having the experience of these aspects of the object be re-created in the experience of the viewer. Beardsley suggests that experiences that are broadly aesthetic are parasitic in some sense on experiences of art. This is not to say that the appreciation of a flower or a sunset is only had after one has experienced some work of art. Through consideration of art, however, we focus on what items make us most aesthetically pleased. So it is these aspects that we seek out in natural aesthetic experience, in experiences of flowers and sunsets. The appreciation of art allows for a more precise definition or exploration of what it is that we are looking for in natural aesthetic experiences. Beardsley's last published list of common aspects of aesthetic experiences is cited in chapter 2; this list does not grow out of philosophical speculation but out of an empirically based accounting of what people look for in aesthetic situations.

Beardsley's search—following similar paths to those followed by Santayana, Scruton, and Dewey—is broadly psychological. This is because psychology provides a naturalistic, scientific approach to the study of subjective phenomena, and as for Santayana and Dewey, aesthetic experience was a subjective phenomenon for Beardsley. In some sense it may be trivial to say that experience is subjective. Of course it is; what else could it be? But the point here is to cast light on the fact that Santayana, Scruton, Dewey, and Beardsley all considered aesthetic experience not through an exclusive focus on the content of that experience— the aesthetic object, art object, or properties of the object. Instead, they focused primarily on characteristics of the experience itself. This cannot

help but be a contextual enterprise, since individual psychologies will provide different contexts for experiences, with the result that we can only understand the differing experiences of different subjects in terms of the context of that subject's psychology.

Frank Sibley

Frank Sibley adds an important element to the tradition of including the subject in aesthetic experience. His focus, as we saw earlier, is on the identification of the presence of aesthetic properties, specifically as this identification leads to claims about the aesthetic merit of the object under consideration. Sibley argues that reductions of evaluative aesthetic claims will never result in arrangements of objective properties. Looking for the "objective" basis for our application of such terms is the sort of project that Aristotle, Augustine, Aquinas, Shaftesbury, and Hutcheson pursued. They sought to establish a formula, a set of formal, objective properties—what Sibley calls "nonaesthetic features"—that when present in an aesthetic object render that object aesthetically good or beautiful. This was meant by these earlier theorists to be biconditional. If the object is aesthetically good, then it certainly has the formal properties the account prescribes. If the object has the formal features the account prescribes, then it is certainly aesthetically good. Moreover, we use as evidence for our judgments that certain objects are aesthetically good the facts that they possess these certain formal properties. Unfortunately, as we saw, such an account flows in only one direction: we may look to nonaesthetic features to ground our ascriptions of aesthetic ones but cannot ever say that the presence of given nonaesthetic features means that an aesthetic feature must certainly be present.[19]

Sibley talks about the importance of engaging taste in ascribing to objects aesthetic properties. I think we can take one step out from this and, starting from his work, consider other taste contexts that seem very relevant to assessing the value of art objects. First, there is the matter of "good taste." As we saw earlier,[20] Richard Shusterman argues that censoring for aesthetic reasons would have several benefits (see chapter 1). The aesthetically unmeritorious artworks that exist today do not reward aesthetic attention and may even detract from works that would be more rewarding if created or highlighted. I do not want to minimize my earlier claim about the elitism involved with traditional conceptions of taste,

but I do not think I endanger that earlier claim by saying that some works are indeed artistically better than others. To judge these requires the involvement of a subjective context, the engagement of a set of skills on the part of the audience member. This claim does nothing to further an attack on traditional taste theorists or disinterest theorists. They never claim that the subjective context of taste is ever appropriately held back—quite the opposite, of course. But the point remains that if all aesthetic evaluative activity requires taste and the exercise of taste is "subjectively additive" to the artwork under consideration, then aesthetic judgment is in its very nature a contextual matter.

One may say, given the theories of artistic value offered in chapter 2, that we must have a valuer for an art object to have value. And perhaps art evaluation is inherently contextualist in the sense that it requires the "additive" of the subject's taste for any evaluation at all to be made. This is a possibility, and it is consistent with Sibley's work. But if this were the case, then formalism should have entirely passed away with the advent of his work. Again, let me say that I do not take formalism to be either incoherent or dead; in fact, I think there are times when a formalist analysis is preferable—is more value-enhancing—than a contextualist approach. The upshot is that if formalism survives the notion that all aesthetic evaluation requires the inclusion of taste, then what taste does is to actualize an objective potential; what it does not do, if formalism is to survive at all, is to "additively" include subjective contributions, aspects of the subject essentially external to what is given in the art object or event.

But there is more to be said. In addition to "good taste," there is also the taste of a particular individual. Hume's attempt to balance the subjectivity of taste with a realist account of aesthetic judgment fails because any two valuers do not necessarily agree about the merits of a given object: they have different taste in music, in visual art, in literature (see chapter 1). If it is an irreducible fact about human aesthetic sensibility that tastes vary, then this constitutes a very present and very real context through which we view aesthetic objects.

Arnold Berleant

Returning to the central theme of this section, I want to discuss the nature of aesthetic engagement by focusing on work in environmental aesthetics.

Arnold Berleant, one of the foremost environmental aestheticians working today, clearly prefers the Deweyan approach to describing the conditions for aesthetic experience. Indeed, he extends the model to say that the greater the sensory engagement and involvement—he uses the word *synaesthesia* (in a positive way) for the complete union of sensory modalities[21]—the greater the depth of appreciation, identity, and recognition of interconnectedness. And it is these things that will ground the deepest motivation for protection and defense. "Environmental appreciation cannot be directed toward an object for there is none. Appreciative engagement must replace the customary contemplative admiration,"[22] Berleant argues. "The boundlessness of the natural world does not surround us; it assimilates us."[23] Berleant's paradigm of environmental aesthetics is a sort of participatory aesthetic in which the lines between human and nonhuman nature are blurred to erasure. The model of separation, with all the good that such noninvasive, noninstrumental models bring, is inferior to an embracive, connective model. An attitude that seeks to find kinship with the natural context will afford experiences that are more genuine, deeper, and more motivating. When all of my sensory modalities are engaged, and when my thoughts and feelings are likewise engaged, then I am totally immersed, I can have the deepest, richest, most highly unified experiences I am capable of. And these experiences Dewey and Berleant call aesthetic.

Berleant's approach emphasizes real-world, real-psychology, felt experience. It does not seek a gulf between the viewer and the viewed; it instead celebrates an intimacy between the two. The greater the intimacy, the greater the experience. The more the viewer is able to invest herself in the viewed—both qualitatively in terms of the richness of the experience and quantitatively in terms of the amount of time she can rewardingly spend with the viewed, the number of sensory modalities engaged, and the intensity of that engagement—the greater will be her aesthetic experience. The subject's involvement in the object of her experience is key here. If the subject attempts to maintain a distance from the object, her experience of it will fade.

Allen Carlson

Fellow environmental aesthetician Allen Carlson agrees with Berleant on this point. He writes that nature appreciation is different from art

appreciation in that while the aesthetic object in the case of art is lo-
calized and (almost always) distinct from the appreciator, the object of
nature appreciation is all around the appreciator, encompassing one,
forming a living and dynamic context for one's appreciation, changing
as one moves through it, with the appreciator not as distinct from the
environment but as part of it. "We must experience it not as unobtrusive
background, but as obtrusive foreground,"[24] Carlton states. To further
this point, nature appreciation is not like art appreciation in terms of the
number of sensory modalities that are engaged. Carlson writes, "Certain
complexities make it even more difficult to develop an aesthetics of en-
vironment than of art. For one thing, environment involves perceptual
categories that are wider and more numerous than those usually recog-
nized in the arts. No single sense dominates the situation; rather, all the
modes of sensibility are involved."[25] The norm in art appreciation is that
only one or two senses will be used in appreciation of the object (usually
this is either sight or hearing or both). Nature appreciation is different
from most of our art experiences because of the sensory envelope it cre-
ates around us. In addition, whereas in art appreciation we typically pick
out formal qualities both as a focus of our attention and as evidence for
our judgments, we cannot do the same in nature appreciation. Part of
the reason for this is that nature can only be framed artificially. "With-
out imposing a frame on the natural environment, it is not possible to
see it as having formal qualities," Carlton points out. "The natural envi-
ronment . . . has a certain openness and indeterminateness that makes it
an unlikely place to find formal qualities."[26] The kind of engagement
Berleant and Carlson are talking about is not merely about the plurality
of senses involved; it is about how one's senses are involved.

A walk through the woods is immediately present. There is nothing
more than the woods and me. I have to constantly negotiate my way
through branches and over terrain. I have to deal with mosquitoes, ticks,
and snakes. I have no idea whether I will see an eagle, a bobcat, or an
alligator. I might not, but I might. I am alert. I look at the trail before me,
at my footfalls, at the shrubs and trees around me. I hear the branches I
step on, the birds overhead, occasional rustles in the brush nearby. I
smell the pine; I once smelled a skunk. I taste the air and the occasional
saltiness of my own sweat. I feel heat around me, then a breeze, then a

mosquito bite. My heart is pumping, and I am sweating. I keep my balance on inclines, down slopes, on narrow trails, on slick mud—all negotiations on my part. This is my somatic engagement. I think about my vulnerability here. I see a raccoon washing a meal, and I think about which plants I could ingest without harm. I look for wildflowers, rare birds and animals, particularly large or old trees. I feel free from e-mail. I hear no cars. I think about my place here and now. And I think about my place in the natural world. I think of my size in relation to what is around me: not just my physical size, but my temporal size and the size of my influence. I see myself, as a natural thing, in contact with other natural things. And, with luck, the dividing lines between me and my context disappear. This is a part of my psychological engagement.

It stands to reason that in the face of such depth of experience will flow the most genuine concern for those contexts. The most highly motivated environmentalists I encounter are not academics, or at least not the cloistered sort all too familiar in the academic world. The environmentalists who most deeply feel their call and commitment to the protection of nature are those who spend regular and sustained "quality time" out in the woods, in the mountains, on the rivers. Preference of a model of aesthetic engagement over a model of detachment is the right one for environmental aesthetics.

Berleant's view is at odds with the view of Bullough; the degree to which he is at odds with other disinterest theorists will depend on how we define *sympathy* (to use Stolnitz's word). But at least Berleant will be at odds with those with whom Santayana and Dewey are at odds; for Berleant, the inclusion of psychological context in accounting for the worth of the aesthetic object (in his case, the natural object) counts positively.

Carlson is well known as a cognitivist in environmental aesthetics; he believes fundamentally that correct aesthetic assessment of a natural object or area will depend on how scientifically informed the evaluator and the evaluation are. Being scientifically informed may jibe with being "sympathetic" and being open to "knowledge-about." But being scientifically informed seems clearly at odds with Kant's formulation of disinterest if we understand the Kantian position on contemplation of the aesthetic object to include taking the object separate from all relations it bears to others and to a future and a past; this is distinctly nonscientific.

Much more could be said about Carlson, especially about his rejection of formalism.[27] But that will have to wait. (I return to Berleant and Carlson in chapter 8.)

THE NATURE OF ART AND ARTWORKS

Twentieth-century antiessentialists contend that there is no single feature that all works of art share in common and that is common only to works of art. This is their negative claim: that there is no single essence of art. However, antiessentialists do not make only the negative claim but also make positive ones. Three possibilities present themselves. The first is that there are many definitions of art, all equally legitimate, such that if any object falls under any one of the definitions, then it is art. Second, there is no single feature shared by all art objects, but various art objects share in common with other art objects certain features, making a family out of art. Third, art is a concept that is open and must evolve, so that while there may be, say, disjunctive definitions of art that we might offer today, these same disjuncts may not hold tomorrow.

The trend toward antiessentialism may have begun with Ludwig Wittgenstein. Wittgenstein's theory of family resemblance does not specifically address the problem of defining "art." His theory was about essences in general, not specifically about the essence of art. However, his general philosophical interest in the prospects and possibilities of essentialism in all forms is what gave rise to a "family resemblance" kind of antiessentialism as a theory of art. Wittgenstein did not believe that patterns, resemblances, general common features, and so forth cannot be found among differing objects all apparently correctly labeled as (say) "art." The problem is that when any single one of these patterns or common features is explored as a possible definition of art, counterexamples are always found. A single commonality is impossible to find. Perhaps, though, artworks share no single feature all in common but share a group of features, like members of a family, each instance of art having some of the features common to other artworks but missing some features that other artworks have.

If art is considered in this manner, then we may see some art objects as falling under one definition of art, while other works might well fall

CONTEXTUALIST THEORY

under other definitions. Perhaps there is a large set of definitions under which an object is determined to be art. This is to offer a disjunctive definition of art. For an object to be an art object is for that object to be A or be B or be C or be D, and so forth, until the list of possible definitions is exhausted. Thus, there is the possibility that the list will be exhausted, given that there are a finite number of artworks and there always will be a finite number of artworks. However, the list could potentially become very large, and with its growth the possibility of identifying all the A's, B's, and C's (etc.) included in such a definition becomes increasingly difficult.

Morris Weitz

A sort of disjunctive definition is offered by Morris Weitz. He suggests this not primarily because of the wealth of counterexamples that seemingly can be leveled at any given definition but because art is a concept that continues to grow and change. It continues to evolve. If we attempt to place boundaries on what constitutes art, we set ourselves up for refutation, because in attempting to install a boundary, we do nothing but construct something artificial and alien to the nature of art. Simply put, in constructing a boundary, we today do little but offer a challenge to tomorrow's artists to defeat that boundary. Art changes and grows, so any definition we might assert would need to change and grow as well. It is the evolutionary aspect of increasing disjuncts that restrains interest in developing and specifying the content of each of the disjuncts. Though one may, with careful art-historical study and careful identification of patterns, be able to construct a disjunctive definition of all art up to the present, art is still being created. Weitz's work firmly establishes the dependence of the philosopher of art who seeks to define art on the art objects themselves, on the context of the art world, and especially on the artists.

Arthur Danto

The tradition of antiessentialism may be seen as the motivation behind "art world theory." Art world theorists such as Arthur Danto argue that while we may not be able to identify an objective feature of works of art that is common to all (and only all artworks), there is nonetheless something

that is common to all artworks: their position in the art world. Danto suggests that artworks are principally vehicles for aesthetic interpretations. For an object to be an artwork, it must be seen to be an artwork. What makes, he asks, the *Brillo Pad Boxes* that Andy Warhol created—created to imitate exactly the Brillo pad box found in any supermarket—art, while the supermarket box is not art? What accounts for the difference between the Warhol box and the supermarket box, Danto suggests, is a theory of art. Without a theory of art, without a theory of how to identify art, the Warhol box and the supermarket box would not be different. The Warhol box is interpreted as a work of art. The supermarket box is not. It is the interpretation as art that makes the Warhol box art. This goes for Brillo pad boxes as well as for portraits. The interpretation transforms or, as Danto puts it, transfigures an object into art.

The interpreter, for Danto, is not a single subject but a sort of collective subject. The art world is a living, changing tradition, in part composed of a subjective collective, consisting of artists, critics, patrons, audiences, art historians, curators, producers/directors, art guild members, aestheticians, and probably sociologists and anthropologists, and so forth. But the art world is also the interpretative tradition itself, a historical progression, an institution made up not merely of people and objects but also of time and history. Danto's vision is extremely contextual; it would not be hyperbolic to say that for Danto whether an object is art is an entirely and exclusively contextual matter. This is the only path open that he sees, given the breadth of kinds of objects presented as art recently.

The formalist Clive Bell's view is that for an object to be art, it must possess (and then subsequently inspire the aesthetic emotion corresponding to) "significant form." For Bell's theory to succeed, he would need either (1) to show that Brillo pad boxes, urinals, shovels, and a host of other such objects do actually possess significant form, or (2) to reject as art all these sorts of objects. The first option is not realistic; it would diminish the challenges offered by Warhol, Duchamp, and many other modern artists. The second option is only viable if the philosopher of art is willing only to occupy a position hierarchically distinct from the rest of the art world, the sort of position in which the philosopher pronounces what makes an object art and the artist gets in line with that pronounce-

ment. If the philosopher of art means to describe what artists and other members of the art world are doing, creating, and accepting—if the philosopher understands her role as descriptive—then she will be forced to give up a formalist definition of art just as, with the advent of non-representational art, we had to give up a mimetic definition, and just as, with the advent of pure abstract art, we had to give up an expressivist definition. We cannot return to a time prior to Weitz; we live with an art world that cannot be described formally anymore. This is not to make any recommendation except that the mission of the philosopher of art should not be to exclude what the rest of the world accepts as art.

Jerrold Levinson

Jerrold Levinson mines in the vein begun by Danto and, more explicitly, by George Dickie. In a series of papers beginning with "Defining Art Historically,"[28] Levinson argues that for something to be art, it must be produced with the intention of being regarded in the way or ways in which previous works of art have been regarded (that is, as they were regarded *as* works of art). Levinson's theory is still art-historical and, we might say, even art-sociological in nature. But it avoids some of the messiness found in both Danto's and Dickie's accounts; Levinson's account turns on an individual intention, the intention of an individual artist, and so he is not obliged to try to circumscribe—however loosely, as we see in Danto, or however tightly, as we see more in Dickie—the community or institution (or tradition) of the art world. Individuals make art, and for Levinson, it is the individual's intention that is key to establishing that the things she makes is art (or a work of art). The other half of the equation is that the artist's intention must have a particular content: the creation in question must be regarded in the way or ways in which previous works of art, qua works of art, have been regarded. It is this content that places Levinson's work alongside Danto's and Dickie's, but more importantly for us, it is this content that identifies Levinson's work on the nature of art as highly contextualist. For a thing—an object or event—to be a work of art, it must be intended to be regarded as past works of art have been; for any thing to be a work of art is for it to stand in a relation with the history of art, with all those works of art that came before it.

I now wish to turn my attention from general theories of definitions or characterizations of the nature of art to theories of how historical and comparative relations actually work to provide proper contexts under which works of art should be considered. I begin with the most central theorist here: Kendall Walton. In "Categories of Art,"[29] Walton rejects the "intentional fallacy." The intentional fallacy, presented in a paper by William Wimsatt and Monroe Beardsley[30] (mentioned in the preceding chapter), states that to correctly interpret a work, one need not know what was in the mind of the artist while creating the work. Rather than seeking the intentions of the artist to explain the meaning of the work, we ought to consult the work's objective features and, by examining the properties of the object, come to a clear understanding of what the object means.

Walton believes that Beardsley and Wimsatt—and other formalists such as the New Critics—go too far. Walton suggests that critical questions about works of art cannot meaningfully be separated from questions about their histories. Not only are factors such as origins important, but also important are the relations that the work bears to others of its kind. If one hears a work of music that uses the tonal styles associated with J. S. Bach and Antonio Vivaldi, she may believe that the work is Baroque. In part, she may evaluate the work against how good a piece of Baroque music it is. For instance, she might say that a certain liveliness is characteristic of Baroque compositions, and the presence of this feature shows the mind-set of the Baroque composers. Suppose, however, that she discovers that the piece she is listening to was composed just a few years ago. Her consideration of the work, then, most likely would change. She would look for some reason why such a work would be composed now, for most recent compositions do not sound much like classic Baroque music.

Walton suggests that the full consideration of an artwork involves inspecting its relational properties under three categories: standard, variable, and contra-standard. A property is standard if the possession of that property by an object works in placing that object in a certain group of works, each of which has that hallmark property. A property is variable if the possession of the property does not alter the status of the grouping of that object with others. And a property is contra-standard if the possession of that property by an object would tend to disqualify it from

a certain grouping with others. This schema is clearly contextualist. For an artwork to be considered accurately, to be perceived correctly, something about its history must be known to a subject, but more than this, the subject must know something about a lot of artworks. That is, she must be able to place the work in a context of other works.[31]

Walton provides a means of understanding works of art that are new, novel, and original in view of these (decidedly contextual) features. A theorist who relies solely on what is presented, perceptually and formally, in the features of an object will not be able to appreciate the new or the original within the artwork. Categories that depend on seeing a work in the context of a progression of artworks and art styles will not be available to the theorist who understands disinterest to involve considering the object a-temporally. Those who hold such a view are out of sync both with common critical practice and with a popular and usually illuminating means of judging the value of a work of art.

Stephen Davies

Stephen Davies advances a line of argument, similar to Walton's, in relation to how musical works are appropriately regarded. In "Musical Understanding and Musical Kinds," Davies explores what it may mean for someone to (truly) understand a musical work. Through a detailed and richly informed consideration of a Mozart work, Davies demonstrates that true understanding of a work really means more than simple structural knowledge of how a work is put together as it was; to understand a work is to know why it was put together as it was.

> This latter question, asked as one about function, involves a consideration of how the particular work differs from others of its kind, and that in turn requires a grasp of what it is that distinguishes one musical kind from another.
>
> The important question is not "how is it put together," but "why is its being put together this way rather than that significant to its being a concerto as opposed to being a symphony?"[32]

Davies makes a further point, one that concerns the connection between understanding a musical work and enjoying it. He writes, "The arguments I have developed above suggest to me that many music lovers are

mistaken in equating the enjoyment they experience with the pleasure afforded by the deeper levels of understanding."[33] This point is taken up again as Davies considers the correct approach to take in appreciation of John Cage's work 4'33".[34] For the purposes of this book, this final point is gratifying insofar as it connects correct classification of a work of art—in Davies's case musical ones—with one aspect of the value of such works, the pleasure and enjoyment of the experience of not only listening to but also understanding music. This echoes the cognitivist account of artistic value found in the work of Nelson Goodman and the cognitivist account of aesthetic value found in the work of Allen Carlson. A work of art understood within the context of its correct (historical and comparative) classification may, as Davies suggests, be taken as a work of greater value than it otherwise would be.

Internal and External Rules for a Given Work of Art

At the start of this section, I talk about general theories of characterizing the nature of art; just above, I talk about theories of how understanding a work of art in proper relation to the history of its form and to others of its kind is important. Finally, in this section, I narrow my focus even further by talking about the individual work of art and its internal logic.

Art criticism is a species of critical thinking. If critical thinking means seeking out and being able to advance reasons for the adoption or holding of a position, and this requires the logical skills involved with correct argument formulation and the epistemic skills involved with quality evidence gathering, then art criticism is essentially critical thinking applied to a certain content: art. Art criticism, I think, involves four things. First, it involves describing the art object. Ideally, this description will function as a cache of evidence for claims about the work's value and about its meaning, so trying to be as objective—in the simple sense of focusing on objective features of the work—as possible is important. Value-ladenness at this stage can interfere with the use of this description as evidence for value and meaning claims later. Of course, a purely value-free description is impossible; value is involved subjectively in the very selection of those items the critic chooses to mention and those she chooses to ignore, but the point is that the description phase is not the evaluation phase, and to the extent that the former is meant to be used

CONTEXTUALIST THEORY

in support of the latter, the description should be kept as uncontroversial as the critic can manage. Second, the critic commonly offers information about the work. She may talk about its origins, its relations to other works, the artist, what awards it won, what show it is part of, and so forth. This is the most obviously contextual phase of criticism; in a sense, it is pure context building. Third, the critic interprets; the critic advances a view or views about what the work means. The final stage is evaluation. Is the work good? How good? This stage is only complete when the critic offers a full account, complete with argument and evidence, for her position regarding the value of the work. Without giving us the argument and evidence, the critic is merely delivering her own opinion qua opinion, and while there may be value in this—to the extent that the critic opines in a way that serves us (being consistent, being very experienced, that sort of thing)—generally the critic worth reading is the critic who offers the full case. This is the critic being a critical thinker. It is certainly what academics expect of other academics who criticize works of art.

Critical evaluation happens in two arenas. First, there are the sorts of considerations that theorists such as Walton and Davies point to. These are, of course, matters of context. And while there are plenty of formalist theorists who recommend avoiding this arena and settling instead for straightforward, essentially objective, formalist analyses, the common reality today is that these sorts of obvious contextual matters are included in full evaluative cases. The second arena is the one internal to the work itself. This is where the formalist concentrates. An approach that favors this second arena has a great obligation to produce a quality description of the art object, because that description will constitute the entire body of evidence for the ultimate evaluation. The formalist critic will most likely appeal to the conceptual definitions of aesthetic properties in citing those properties as present in the artwork—this is something we all probably do in rendering a formal analysis of a work, regardless of whether we stop there or add more. But if this were all there were to it, human consideration would hardly be required; a good computer would do a better job of it. Sibley and Beardsley argue that the citation of aesthetic properties requires more than seeing whether certain objective properties fit certain contextual definitions, the way we check to see whether a chimpanzee is a monkey or an ape. Citation of aesthetic

properties requires the exercise of taste, as is discussed above. But I think there is more to be said here. What the critic—we are talking about all critics but especially about formalist ones—does in the exercise of taste is to work out the internal logic of the work of art in a way that is irreducible to any rote or mechanical operation. This is the true worth of a good critic; she can see through to the internal structure of the work and then articulate that as a part of her description of the work, with the consequence that the work's own logic is the basis for her ultimate evaluation of the piece.

This problem-solving, puzzle-solving approach to understanding not merely the meaning of a work of art but its value as an artwork is popular today. In large measure, it is a part of a general cognitivist approach to aesthetics and the philosophy of art, and perhaps it finds its heritage more in the work of Nelson Goodman than anywhere else. In chapter 2, I review Goodman's theory of the value of art. It turns on the production of valuable cognitive activities in us, occasioned by consideration of the work. I have no hesitation in getting behind Goodman on the point that there is an internal logic to works of art that prompts in us valuable cognitive activity. (Where I disagree with him is on the sufficiency of this for explaining the value of art entirely.)

Works of art have sets of internal rules, knowable by considering the work alone. But implicit in understanding how this set of internal rules functions in the object is knowing another set of rules, a set of external rules. I am not returning to the obviously external and contextual matters discussed by Walton and others. I think there is a more intimate set of external rules that are inescapably part and parcel of a full consideration of the internal rule or logic of a work of art.

Let me give an example of this from soccer. I have two sons, both of whom play soccer for neighborhood teams. My older son is a good, all-around player. He knows the rules and the object of the game. He is a good sport and a good team member. My younger son—six years old as I write this—is a less good player. He has certain ethical sensibilities that require of him less than full participation if he believes to any degree that his team is outmatched by the opposing team. But he is good at playing the *context* of the game. He knows how to wear his uniform. He knows the rules of the game. He knows that when one is on the bench,

one drinks Gatorade. But the object of the game—scoring goals, or at least pursuit of and assistance with scoring goals—seems something with which he has less than full acquaintance. Playing the context of the game is not really playing the game, a fact that his mother and I know from the pleasant, condescending remarks of fellow moms and dads. The internal logic of soccer involves knowing the rules and object of the game and acting in accord with this knowledge. The external rules of soccer have to do with sportspersonship, team-membership, and perhaps issues such as strategy. On the periphery are external rules about how one wears one's uniform and what one drinks when one is waiting on the bench.

Artworks are like this. They have an internal logic, but in addition, they have an external set of rules as well. To know the externalities without knowing the internalities is fairly useless, but—and this is my claim—one cannot competently understand the internal structure, logic, or rules of a work of art without at the same time understanding the external logic to which this particular work's internal logic is related and perhaps even embedded. Consider a second example. Susan Haack illustrates the nature of "coherence" with the crossword puzzle. In a crossword puzzle, one is keen to fill in the blanks with letters of words that meet the conditions set either in the clues or in the theme of the puzzle (for example, if the puzzle is only about state capitals, this takes the place of a written set of clues). The letters that one can put into the blanks are constrained by the number of squares, by whatever letters are already in some of those squares, and by the placement of those filled squares. But these things act not only as constraints but also as clues. It is easy to know when one gets the right answer because of the fit of the new word with the intersecting words and with the clues. The new word fits the blank. This fit is a beautiful illustration of coherence. Back to the point about rules. The internal rules governing crossword puzzles have to do with candidate answers fitting clues, fitting squares, and fitting with preexistent letters. The external rules here include the following: that crossword puzzle clues regularly involve puns and slight deceptions, that the puzzle creator probably offers a hint as to the sorts of deceptions employed in the clues in the title the creator gives the puzzle, that the new word will be a word in the same language with the rest of the words, that, generally

speaking, the more intersections the more clever the puzzle, that longer sets of blank squares generally are harder to solve than shorter ones (so start with the shorter ones), that longer sets of blank squares will intersect with more words (so the investment in trying to solve a longer word first sometimes pays off well), and so forth.

As is true with the internal logic, the external rules are knowable only in the particularity of a given work, just as the external rules of playing soccer are, in their substance, unique to the game of soccer. So to derive examples of external rules for art, we must turn to particular works of art.

- One can know about Michelangelo's *David* that it was originally · designed to be placed high up, to be seen from below, and one can know this in two ways. One is straightforwardly informational; we have a record of this intent. But another way to know this is, first, to see the features of the statue, which, taken as a good representation of a normally proportioned young man, are out of proportion and then, second, asking oneself under what conditions these proportions would make sense. That is, under what conditions would the representational qualities of this statue be perfected?

- One can know that Franz Schubert's *Unfinished Symphony* is unfinished because, first, the word is in the title; second, the symphony has only two movements and this is a contra-standard property to the work, à la Kendall Walton; or third, the work comes to an end in an aesthetically unsatisfying way. If one is a strict formalist, she will take this as a fault in the work. If one is an enlightened formalist, she will judge the work against a standard generated by two things, the work's quality so far as it goes and the knowledge that, by virtue of its unsatisfying end, it was not completed.

- One can know that the sounds of the guitarist's fingers as they slide up and down the strings in classical guitar playing are not an aesthetic part of the object. One does not need to be told this; one can judge it with but a little experience of classical guitar and a consideration of the true aesthetic properties of the work.

- One can know that the droplets of ink that are splattered in a grass-style work of Japanese calligraphy are not an aesthetic part of the object. They are produced as a consequent of the speed at which the brush moves and must move in that particular calligraphic style.[35]

- One can know that the "Chinese Property Men," individuals who move scenery on stage as the curtain is up and the play's action is proceeding, are not a part of the play, not a part of the world of the play. To use a term from film, they are nondiegetic. Figuring this out is not difficult despite having little former experience of it.

These are only a few simple examples, but I claim that every work of art has some features that are at the same time inherent in the work and still contextual. It is not my intention to dissolve the distinction between the formalist and the contextualist. My point is that even the enlightened formalist will recognize that some contextual aspects are unavoidable; she cannot maintain her position in its purest form.

MORAL, ETHICAL, SOCIAL, AND POLITICAL CONSIDERATIONS

While there are many contexts under which a work of art may be appropriately considered, none has received more attention recently than moral and ethical contexts. I want to broaden out the discussion slightly by including social and political contexts, as well.

Plato

Discussion of such contexts is by no means new. It goes all the way back to Plato. For Plato, the artist in creating an imitation of a natural object is in fact creating an imitation of an imitation, if we think as Plato did of natural objects as imitations of the forms in the heaven of Ideas. Such removal from reality, from the essences of things, prompted Plato to negatively assess the value of art. True reality consists of the forms, or essences. Natural objects are imitations of these essences. Art, then, consists of imitations of imitations. Art, instead of bringing us closer to reality, pushes us away. In art, there is no reality and so there is no

possibility of knowledge. Imitative art provides no knowledge, and inso-
far as the goal of humans is attainment of knowledge of the truth, art
serves contrary purposes. If art has a value at all, to restate Plato's theory,
it is the power to strengthen the relationship between the citizenry and
the state. If art has value, then its value is patriotic or as propaganda. Art,
for it to be valuable at all, must celebrate the virtues of the heroes and
the gods. It must demonstrate strength and bravery, never show undue
emotion or weakness. If it fails to support the state, then it presents only
copies of copies, not truth, and may actually hurt the morale of the cit-
izenry. Plato believed that art that did not support the state should be
censored. Plato is not the only person who believed this. In chapter 7,
I consider the views of Karl Marx and Mao Tse-tung. Both of these the-
ories are nationalist; both insist that art should be purposeful and that
the proper purpose of art is in support of the state as a political entity.

Leo Tolstoy

Perhaps the next loudest voice when it comes to considering the social
context of art is that of Leo Tolstoy. In chapter 2, I review Tolstoy's the-
ory of the value of art. In this chapter, I want to concentrate not on what
makes art valuable but rather on one aspect of it that is both essential,
for Tolstoy, to all good art and essentially contextualist. Tolstoy believed
that for an object to be a good work of art—or, more basically, a work of
art at all—it must be an infectious form of communication of sincerely
felt universal emotion and invoke sincere feeling in its audience. Beyond
the level of communication and the level of sincerity in the infectious-
ness, the artist must also, said Tolstoy, impart to the audience a true sense
of the moral and religious attitudes of the society. The artist must com-
municate not only feelings but those feelings as they accord with the re-
ligious context in which the work is made. Tolstoy saw art not in support
of the state as a political unit but in support of the society as a moral and
religious unit. Art should reflect the real and vital values of the society
as a whole. It should not merely be a reflection of the artist's individual
values and vision. The artist is only one person. The viewers, however,
are numerous. To create a work that celebrates cowardice or faithlessness
would, it seems, be anathema in any society. To create a work that cele-
brates resolve, courage, strength, and order is to create in the best tradi-

tion of the Greeks. To create a work that celebrates compassion, spirituality, love, and hope is to create a work that fits well into the religious environment of Abrahamic societies (Judaism, Christianity, and Islam).

Tolstoy's critics have pointed out that a common ingredient in much art, especially lately, is that instead of supporting the religious climate, it challenges this climate. If we dismissed objects that purport to be art on the grounds that they do not accord religiously with the societal environment, then a large number of objects that we all apparently correctly refer to as art would not truly be art.

Recently, the work of Chris Ofili, as I mention in chapter 2, was at the center of a major controversy surrounding a Brooklyn Art Museum exhibition. Ofili created an eight-by-six-foot painting called *The Holy Virgin Mary*. The depiction of Mary is surrounded by very small pictures of genitalia, and her breast is three-dimensionally constructed of elephant dung. The mayor, Rudy Giuliani, threatened to cut off the gallery's seven million dollars of funding from the city and have the museum evicted from its space. He called Ofili's work "sick" and "blasphemous." He said that his threat was not censorship but rather a correct use of public funds. Ofili's piece continued to be a lightning rod of controversy even after Guiliani's interest in the show subsided. A devout Roman Catholic man, Dennis Heiner, attacked the painting, smearing the canvas with white oil paint squeezed from a tube. He covered the facial features and the body of the painting's dark-skinned Mary (although he left the elephant dung and genitalia photos intact). He called the work "sacrilegious." It should be noted that the painting was restored quickly and put back on display. It perhaps also should be noted that the show that features Ofili's work (along with the work of several other Young British Artists, including Damien Hirst) has been the most popular in the museum's history.

Several years before this, Andres Serrano suspended a plastic crucifix in a jar of urine and photographed it. The photograph is called *PissChrist*, and it fueled two controversies. First, Serrano's work was being funded by a grant from the National Endowment for the Arts. Second, the work was found by many people to be irreverent and sacrilegious. These two controversies are, of course, related. The outcry against funding such works with public dollars was explicitly fueled by the irreverent nature of the photo and the title Serrano gave it. Were it not for the fact that this

work offended the religious sensibilities of many people, the U.S. senators who used it as evidence for threatening the funding of the NEA would not have so used it. They cried out that such a work offended the general, common religious and moral (note the purposeful conflation) sensibilities of those people saw their tax dollars as being misused for such a purpose. In short, these senators, along with the many others making similar arguments, were marching in precisely the same line as Tolstoy. And so, even though in the absence of immediate controversy and in the comfort of an academic consideration we might find religious censorship anathema to the free and open developments of the cultural and art worlds, we might feel differently were we in a slightly different context, with slightly different sensibilities. There but for the grace of the insulation of the academy . . .

My point is not to hammer one side or the other of this debate (although I for one am pleased that religiously challenging artworks are available and encouraged). My point is to show that Tolstoy's vision of art was strongly contextual, and the context was the common religious sensibilities of the society in which the art is being created. One may argue that his contextualization is virtually laughable today, but cases such as those of Ofili and Serrano suggest that we live in a much more Tolstoy-friendly society than we might think.

Noël Carroll

Within the past few years, there has been no theorist more prolific on the subject of the moral consideration of works of art than Noël Carroll.[36] Carroll's treatment of the subject is both highly systematic and very insightful. His approach generally has been to identify and articulate the positions of those who believe, or would believe, that moral considerations matter little or not at all to the appropriate consideration of works of art. In answering their objections, he outlines reasons for why moral considerations are not only possible but usually very fruitful, contributing to the value of works of art. The chief opponent to moral contextualism is the view he calls "autonomism" (which he also refers to as aestheticism), the view that the moral and the aesthetic are separate spheres of regard. The autonomist is interested in maintaining a hard dividing line between the two, and where he accepts that moral consid-

erations may be proper, he separates these off from aesthetic considerations, maintaining that moral considerations do not affect aesthetic ones. One argument put to the service of autonomism is what Carroll calls the "common denominator argument": that whatever is relevant to the value assessment of a work of art must be present in all works of art. Carroll concedes that such an argument may demonstrate that not all works of art should or can be assessed in terms of their moral dimensions, but he firmly rejects that this goes for all works of art. Many, he shows by solid example, are valuable or even ultimately only understandable when viewed within a moral context. Another argument in the service of the autonomist is the "banality argument" (or cognitive triviality argument): that whatever moral lessons are present in artworks, they are ones that anyone with the ability to appreciate the artwork will already have learned much earlier. This argument is augmented by the "nonargument argument": that artworks do not teach their lessons in reasoned ways, by the use of the offering of argument; as such, they should not presume to say that they *teach* at all. This argument is augmented by the fact that artworks trade in fictions, so they can hardly count as providing evidence for a given moral insight or lesson. A final argument in the service of the critic of moral contextualism is the "anti-consequentialist," who argues that if artworks have moral lessons to teach, there is scant evidence that by reading, viewing, listening to these works of art, ethical behavior increases. Through the offering of powerful counterexamples, Carroll demonstrates that these arguments lack teeth, but while he rejects autonomism handily, he is more circumspect when it comes to "moderate autonomism," the view mentioned secondarily above: that while some works of art are appropriately considered from moral perspectives, moral features of artworks have nothing to do with aesthetic features. Two answers to the challenge of moderate autonomism are ethicism—a view offered by Berys Gaut (and discussed below)—and Carroll's own view, called "moderate moralism." Moderate moralism is the position that in some cases, moral defects in a work of art count as aesthetic defects; ethicism, he says, makes the stronger claim, that they always do. Moderate moralism also says that moral virtues in works can sometimes also be aesthetic virtues of those works. In addressing the epistemic arguments, the ones concerning the usefulness of

works of art for moral instruction, Carroll offers what I think is his most powerful argument for moral contextualism (what he calls "ethical criticism"), the "clarificationist view":

> In mobilizing what we already know and what we already feel, the narrative artwork can become an occasion for us to deepen our understanding of what we know and what we feel. Notably, for our purposes, a narrative can become an opportunity for us to deepen our grasp of the moral knowledge and emotions we already command. . . . Clarification does not claim that, in the standard case, we acquire interesting, new propositional knowledge from artworks, but rather that the artworks in question can deepen our moral understanding by, among other things, encouraging us to apply our moral knowledge and emotion to specific cases. For in being prompted to apply and engage our antecedent moral powers, we can come to augment them. . . . We may possess abstract principles, like "All persons should be given their due," and abstract concepts, such as "Virtue is what promotes human flourishing," without being able to connect these abstractions to concrete situations. For that requires not only knowing these abstractions but understanding them. Moreover, it is this kind of understanding—particularly with regard to moral understanding—to which engaging with narrative artworks may contribute.[37]

Berys Gaut

In the same book as that containing the quote directly above can be found an essay by Berys Gaut entitled "The Ethical Criticism of Art."[38] Gaut writes, "This essay . . . defends a view I term *ethicism*. Ethicism is the thesis that the ethical assessment of attitudes manifested by works of art is a legitimate aspect of the aesthetic evaluation of those works, such that, if a work manifests ethically reprehensible attitudes, it is to that extent aesthetically defective, and if a work manifests ethically commendable attitudes, it is to that extent aesthetically meritorious."[39] Gaut's essay is constructed systematically, moving from advancing his

thesis to defending it against objections, to another advance, followed by dealing with more objections. One of the earliest objections he deals with is that aesthetic consideration is characterized by an attitude of detachment. To this he responds,

> The step from the claim that the will is disengaged and therefore that ethical assessment has no role to play does not follow: there is similarly no possibility of altering historical events, and we are in this sense forced to have a detached or contemplative attitude toward them, but we will ethically assess historical characters and actions. If it is objected that we are ethically engaged in history because we hope to draw from it lessons for our current practice, the same may be said of the lessons we can draw from fiction, such as the psychological insights that Freud discovered there.[40]

It is this lesson-drawing that forms the basis of his argument for ethicism, which he credits in part to the work of Martha Nussbaum on morality and literature (Nussbaum would fit nicely into this section on art and ethics, as might Iris Murdoch).

Gaut's argument for ethicism is the "merited-response argument." If a work of art recommends a response in us that is morally suspect, the work is, to that extent, less aesthetically good than a work that recommends a response in us of which we can be proud. The work's value is diminished in the former case not because it recommends something unmerited but because in catching ourselves and not following the recommendation, the work has failed in one of its aims. This is an aesthetic failure of the work.

Marcia Muelder Eaton

Marcia Muelder Eaton offers a wide-ranging treatment of the relationship between aesthetics and ethics in her *Aesthetics and the Good Life*.[41] Her approach is perhaps best characterized as holistic; she reviews with approval those theorists throughout the history of aesthetics who sought to combine consideration of aesthetic sensibility and ethical virtue in an account of the good life.

The deep connection between aesthetic and ethical value proposed in this chapter reinforces the claim I made in earlier chapters that the aesthetic cannot be understood in isolation from other human concerns and experiences. What delights or repels us aesthetically, what we believe, and what motivates or offends us morally influence and interfere with one another. . . . Someone who leads an immoral/aesthetic life harms others directly. Someone who leads a moral/unaesthetic life may also deprive others. . . . Failure to recognize the integration of the aesthetic with other aspects of human existence leads also to impoverished theory. Theories that keep the aesthetic separate from other areas of human life provide no way of resolving crucial conflicts. Once the aesthetic and the ethical (and the practical, etc.) are seen as contributing to an overall meaningful life, there is a way of [integrating] them.[42]

This is the path I followed in criticizing Stuart Hampshire—and in celebrating John Ruskin—in the previous chapter. Against theorists such as Hampshire, Eaton argues for the relevance of ethical considerations in considering a work of art. She writes that "it is often necessary to weigh aesthetic concerns against other kinds of concerns."[43] In "Serious Problems, Serious Values: Are There Aesthetic Dilemmas?"[44] Eaton explores whether there are aesthetic dilemmas in the way that there are moral dilemmas, that is, if indeed there are moral dilemmas. In this paper, she finds aesthetic dilemmas that meet the tests—logical and emotional—that characterize moral dilemmas.

Referring to . . . formalism as "radical autonomism," Noël Carroll has recently argued that it fails to recognize that a great many works of art become intelligible only when the audience provides appropriate moral emotion and evaluation.[45]

My own prejudices go in the direction of the contextual. That is, I am rather confused when someone claims that no knowledge or moral stand at all is involved in the judgment that something is beautiful.[46]

Our experiences, our encounters with and in the world and the decisions we make as a result, do not typically come in separate *packets,* with the moral, aesthetic, economic, religious, scientific, etc. serving as viewing stands distanced from one another so that we look at the world first from one and then from another standpoint.[47]

Mary Devereaux

In an essay called "Beauty and Evil: The Case of Leni Riefenstahl's *Triumph of the Will,*"[48] Mary Devereaux presents a detailed case study of one of the most disturbing questions that contextualized aesthetics must face: what do we do with an art object that at the same time is both beautiful and evil? Riefenstahl's film *Triumph of the Will* is a documentary of a massive political rally sponsored by the Nazi Party in Nuremberg in 1934. The film is best described as more than a documentary; it is a work of political propaganda, celebrating the themes and agenda of National Socialism and serving as an invitation to support those themes and that agenda. Hitler loved the film and worked with Reifenstahl on its design. Reifenstahl's claims, after the war, that the work was either a pure documentary or a pure exercise in the creation of a beautiful film are unbelievable given the film's history, Reifenstahl's history, the impact the film had, and the very content of the film itself, in terms of both its substance and its form. The trouble this film creates for aesthetics is that, Devereaux points out, it is at the same time evil in its deep and abundant celebration of evil and beautiful in its filmic structure, its photographic elements, and the celebratory form itself. These two things cannot be cleanly dissected from one another. To take a formalist view of separating the aesthetic elements of the film from the nonaesthetic context of it, Devereaux argues, "requires us to ignore the essence of the film."[49] She continues:

> The second option broadens the concept of the aesthetic beyond its traditional boundaries. It says that we are responding to a work of art "aesthetically" not only when we respond to its formal elements or to the relationship between its formal elements

and its content, but also whenever we respond to a feature that makes a work the work of art it is. (These features may include substantive as well as formal features.) On this second option, the aesthetic is understood in such a way as to track the artistic, however broadly or narrowly that is to be understood. . . . It is this second route that I recommend. . . . But it does recommend that there are areas where these domains overlap and that certain works of art, especially works of religious and political art, fall within this overlapping area.[50]

Devereaux examines the fallout from this position, noting that there is, in the enjoyment of the beauty of *Triumph of the Will*, an opportunity for moral corruption, given that one of the goals of the film is to make the audience receptive to the doctrines of National Socialism. She ends her essay with an exhortation for aestheticians and other thoughtful viewers to experience the film—given, for aestheticians, its power to spotlight a disturbing question and its presentation of an opportunity for thoughtful viewers in general—to "understand more fully ourselves as human beings." I am left wondering, however, what impact this film, given a less-than-academic setting, has. Watching this film divorced from its context would require sustained concentration, and this is something Devereaux clearly recommends against. The majority of people who watched this film in the 1930s watched it in context. This is where its power lay.

DISINTEREST THEORY UNDER ASSAULT

Let us take a moment to reconsider disinterest theory in the light of the contextualist work of the theorists represented in this chapter. Disinterest theory says that one must be properly disposed either to practice proper aesthetic evaluation or to have a true aesthetic experience and that proper disposition is characterized by the agent's being disinterested, with disinterest understood as having the following character:

1. The agent suspends all consideration of how the object (or event) could serve some functional or instrumental purpose beyond

CONTEXTUALIST THEORY

merely being an aesthetic object. This includes a suspension of all consideration of how the object or its existence could provide a benefit or accrue an advantage to the agent, except in its role as aesthetic object.

2. The agent suspends all consideration of the object under any category. The agent exclusively considers the object as an object out of relation with any other object, state, or property.

3. The agent includes in the consideration of the object those factors, and only those factors, that are either transcendentally or psychologically unavoidable or constitute factual "knowledge-about." The agent thus becomes an "everyperson" with regard to both the subjective and the objective aspects of the experience.

4. The agent is sympathetic to and interested in the object as a focus of attention and consideration.

Item four remains uncontested. There is no theory of aesthetic attention or approach that recommends against sympathy to and interest in the aesthetic object. But what of the other three?

Item one is rejected. The theories of Plato and Tolstoy require the object's purpose to be taken into account: works that do not serve specific purposes are not as good as those that do. In fact, works that fail to serve these purposes may well be candidates for censorship. Carroll's, Gaut's, and Eaton's treatments of the importance of ethics in aesthetic assessment are directed in large measure at the subject, at the influence the object has on her moral character; Devereaux's work speaks to the same thing (in scarier and more exigent terms). These theories imply a rejection of a position that says that consideration of the purpose or function of an object should be bracketed off and ignored. At least to the extent that these theories warrant, purpose must be taken into account.

Item two must be rejected by Walton and by Davies. Classifying a work of art properly is key to understanding its place as art. A rejection by Walton and Davies may be complemented by a rejection by Danto and Levinson, too, who construct theories in which objects' relations to other objects and events are key to establishing them as art in the first place.

Finally, the theories in the first section of this chapter imply a rejection of item three. To include ourselves as "experiencers," with all that may mean—with its focus on our individual psychologies, with its implications for inductive exploration of what aesthetic experience is really about, with its inclusion of the individual memories, associations, modes, and so forth that we bring to experiences, that we filter experiences through—all of these imply a rejection of item three.

Critics have complained that John Rawls's veil of ignorance is too artificial to accomplish the work he described for it. Leaving aside the worthiness of Rawls's work in political theory, where at least there is a motivation for adopting an original position, there is no correlate motivation in aesthetics. What the aesthetic subject is attempting to capture are the best aesthetic experiences she can have. This is the primary goal. If her real-life felt experiences are better (as she judges them) by including her own subjectivity and psychology as part of the experience, then why would she want to adopt an artificial, unnatural posture of disinterest? What would be the motivation? Of course, the earlier goal of disinterest theorists is to achieve meaningful aesthetic judgment, and no doubt Hume's advice to avoid prejudice seems unassailable. But arguments such as those offered by the theorists reviewed here explicitly recommend to us the inclusion of certain contextual factors in our judgment of works of art.

5 Issues of Definition

WHAT IT IS FOR A THING TO BE A CERTAIN KIND of thing depends most times on matters of context. This is true for many things, among them some art objects and some art forms. In this chapter, I examine three cases in which definition—that is, defining an object as art or as a member of a certain kind of art form—requires us to consider relations or properties external to the object. As I state in the introduction to this book, issues of definition, classification and interpretation were not a part of this project, but sometimes these issues overlap with issues of value, this book's primary focus. This chapter represents an occasion on which issues of definition and issues of value mesh. This chapter's relevance to the overall project is not for the sake of ontology, however, but instead because some art objects either (1) only take on their true value as art or (2) have their value as works of art substantially enhanced when understood under a particular definition. So to discuss "issues of definition" in this way is not to leave behind talk of the value of art—quite the contrary.

MODERN ART

Early in my career, I gave a series of lectures on defining "art." As is my usual practice, I first tried to offer some reason for why attempting a

definition of art is useful. One student, however, was unconvinced by my appeal to common sense that *of course* there are objects and events in the world that are art and others that are not. She objected that by her lights "art is anything one says it is." Her objection was hardly unusual. I answered her challenge by pushing my appeal to common sense. I wadded up a sheet of paper, placed it on the lectern, and asked, "Is this art? Can you, should you, consider this the same sort of object as the *Mona Lisa?*" (Sometimes this is enough to silence the objection—either the added strength behind the intuition or the intimidation that a teacher can muster in confronting a student individually.) However, in this case, the student did not back down but repeated her claim that art is anything one regards as art, and one might just as well call the wadded-up paper art as call painted canvasses or snow shovels, urinals, or Brillo Pad boxes art.

Part of my response to this student was to point out that the claim that something is *not* art can be a very strong claim. One makes a strong critical statement about an object in saying that it is not art. Moreover, this reaction is, in some measure, the sort of response someone like Andy Warhol might have expected. Warhol stretches our collective concept of art, perhaps even stretching our understanding of the nature of art. Brillo Pad boxes, ones that are indistinguishable from Warhol's, exist in the supermarket. Of course the point of his creating his *Brillo Pad Boxes* and presenting this as art is precisely because we do not as a routine matter see Brillo Pad boxes as art. And this "routine matter" is part of what makes Warhol's presentation so evocative.

The question, What is art? is an old one. There has been plenty of time for an assortment of different theories to be advanced. The oldest is mimetic theory. Athenians in Plato's day believed that the character of art was to imitate nature. Works of art resembled, in simple sensory terms, objects in nature. A statue of a man looked like a man. A painting of a tree looked like a tree. Of course, a *painting* of a tree probably resembled another painting more than it resembled a tree, and this may be part of the reason that mimetic theory evolved into representation theory. Today, when aestheticians speak of representation, they are not necessarily speaking of a resemblance relationship between the art object and the natural object it represents. The relationship between these two objects may be symbolic, with the artwork standing as a sign of the object

it represents. After mimetic theory came a set of theories focused on expression. At the start of this period, the expression at issue was the expression of emotion. This evolved through stages that considered whether the emotion was particular or universal to theories that held that what was being expressed was not necessarily an emotion: it was an intuition. Furthermore, the emphasis was less on what was happening with the artist, with the expression of her emotion, and more on communication, on how what was being expressed was being received by the audience. Formalism was thus the third big wave.

In the early twentieth century, attempts to define art began to deteriorate. Antiessentialists such as Morris Weitz—discussed in the previous chapter—challenged the very possibility that art can be defined. Antiessentialism was to be expected, and those following the trends in both philosophy and the art world no doubt saw it coming. The trend in philosophy was initiated by Wittgenstein and his general skepticism about all things essential, including essentialist definitions and, by implication, essentialist definitions of art. The trends in the art world were blatant. Postimpressionism, Cubism, Abstract Expressionism, Surrealism, Dada, Marcel Duchamp's readymades, Warhol's Pop Art, and postmodernist trends in general were on the scene or coming on the scene, and theorists such as Weitz had the natural reaction that with each definition, each attempt to circumscribe what counted as art, came a succeeding challenge, and so the most reasonable position to take was to say that art was open and evolving. Either that or say that the majority of works being created in the twentieth century and making their way into galleries, museums, private collections, and critical reviews were actually not art, given some earlier art-theoretical decision about what counted. Antiessentialism is where Danto comes in. Danto's focus is on what is going on in art, and he takes his cues for the development of his art world theory from such things as Warhol's *Brillo Pad Boxes*.

In chapter 2, I discuss Duchamp's *In Advance of a Broken Arm* and his *L.H.O.O.Q.*, as well as works by Damien Hirst, Jasper Johns, Mark Rothko, Robert Rauschenberg, and Willem de Kooning. For bigger works, we could include Richard Serra and Christo; to move beyond generally static visual works, we could include Ingmar Bergman, John Cage, Tom Stoppard, and Martha Graham. All of these twentieth-century artists created or

create works of art that, to be appreciated in any serious and honest way, require us to test our ideas, to work through some cognitive puzzle, or to reevaluate the boundaries of our concepts of what counts as art. Except for obvious aspects of "plain old" sensory beauty, which we certainly find in the works of several of these artists, to deal with their works formally is to miss the boat. One must engage on an intellectual level, working through imaginative, problem-solving, challenge-testing, associational contexts. Their works mean so much less without this, but more to the point, the art objects themselves are far less valuable without such a context. *In Advance of a Broken Arm* is an off-the-rack, hardware store snow shovel. Duchamp's *Fountain* is an even more boring object. The large, color-field works of Rothko I think are beautiful.[1] But if there were nothing more to them than their formal qualities, many audience members might be inclined to mention that objects created by their preschool children elicit similar responses and evaluations. Bergman's *Fanny and Alexander* is an extremely beautiful film, and one could watch it with an eye simply on its formal elements and come away with a great experience, although not a perfect one. Formally, there are both narrative and visual elements within the film that do not make a lot of sense taken at face value. It may be that narrative elements always require cognitive attention, and if this is so, then I am begging the question. But we can take narrative features formally—or, to make the point, formalistically—in such a way that their explanation does not require us to bring anything to them. Biblical literalists claim to be able to do with this with scripture, gathering the meaning (*the* meaning) in an interpretative exercise that is dependent on absolutely nothing but the words before them and the disposition of reading those words under supernatural direction. Given that such direction is univocal, each literalist would or should end up with the same, single meaning. Approach such as this could be taken toward *Fanny and Alexander,* but then I am back to the claim that there are narrative elements, when approached this way, that make little sense. Again, I do not want to delve too deeply into issues of interpretation, but I stay on my own ground in saying that the worth of *Fanny and Alexander* as a film, despite its visual beauty, is dependent for its full measure on the members of the audience bringing to it some cognitive, imaginative, and associational activity of their own.

Modern art is generally—though Weitz and others have taught us not to say "universally"—like this. It requires the audience member to move beyond what is presented to the senses. It requires the audience member to move even beyond what may be gleaned in any objective fashion; by this, I mean information about the origins of the work, its historical position and relations, and the relations it bears to other works. These works require cognitive, imaginative, and associational work on the part of the audience member. Without this, they are of very little value—like snow shovels, urinals, and exact replicas of Brillo Pad boxes—or their value is reduced, as is the case with the beautiful works of Johns and Rothko, and with Bergman's *Fanny and Alexander.*

For the viewer to assess the full measure of the value of individual works, many works of modern art require consideration of various contexts:

- To understand the place of a modern work in the history of art. I am no aesthetic fan of the mature work of Jackson Pollock, but I can certainly appreciate his place and the importance of that place in the history of art, in the history of modern art, and in the history of American art. American art would seriously miss Pollock were he not in its history; indeed, understanding the historical progression of twentieth-century art without the New York School and Pollock's work may be impossible. Pollock is, as much as anyone, essential to the face of American modern art.

- To understand that a challenge is being offered. Knowing the detail of the circumstances of Duchamp's challenge with *Fountain* makes this work engaging. Just knowing that his works represent a challenge can make them engaging. The same can be said when the challenge is more localized. The works of Adrian Piper, for example, present stunning social challenges to how we confront and personally manage racial differences and stereotypes. Spike Lee films and Billie Holiday blues do, too.

- To understand that the viewer's reflection is necessary. One must deal with the challenges, both academic (or art world–oriented)

and personal. One must work through the problems and the puzzles. One must work out interpretations that enhance the value of works—note that I am not getting into how this is to be done; the very fact that modern art requires it is a contextual matter in respect to its nature and value as art. (For those who might believe that a cognitive approach is compatible with a formalist one, I would add that part of the intellectual work in question is associational—in one's particular experience but also in the taxonomical terms that one must bring to bear in cognitive consideration—and this surely involves invocation of both a subjective dimension and a taxonomical dimension at odds with any formalist approach.[2])

For an object to be a work of modern art requires a range of considerations, most of which make little sense from a formalist perspective, most of which require intellectual engagement and association (imaginative and taxonomical), and all of which require appreciation of context as well as a basic appreciation of the relevance of context. This is not a new lesson. It is one we learned from Arthur Danto. This puts Danto's work, which I review in the preceding chapter, in a very central position with regard to any effort to define art or to define an object as art or as a member of an art form in any way that is coherent with what is currently going on in the art world, in any way that is both descriptive and honest, and, finally, in any way in which twentieth-century works of art are truly valuable.[3]

Returning to the exchange I mentioned at the start of this discussion, my answer to the student—why some objects are works of art and why some are not—turned on an analysis of what it means to define art, what it means to consider some objects to be art and some objects not to be. But when asked for the particulars, when asked how one, concretely and practically, made the decision whether a given object was art or not, my recourse was to the contextualist theory of Danto. Could the wadded-up piece of paper be art? Sure, it *could*. But the fact is that it was not. And the difference between the wadded-up-paper as art and the wadded-up-paper as not-art depended entirely on context, on how the object was received and interpreted within the traditions and history—the context—of the art world.

There are many different kinds of functional art, that is, art whose objects have obvious functions, serve in obviously instrumental ways. Ancient objects from Africa, Asia, Europe, and the Americas—the 500-year-old Aztec calendar stone disk, the 2,200-year-old Xian terra-cotta warriors, the 2,500-year-old Parthenon, the 3,300-year-old coffin of Tutankhamun, and presumably the 17,000-year-old Lascaux cave paintings—are all treated as art (or artlike) objects today. Though the boundary between art objects and functional objects may be a relatively recent phenomenon, and while some mileage may be garnered from the fact that this mode of classification is so recent, the bottom line seems to be that there are many art objects that are also, or once were, functional objects.

We might divide up functional objects as consumable objects and nonconsumable ones. The ones mentioned above are clearly nonconsumable, and these objects present the greatest challenge to those who contend that all consideration of function is anathema in art assessment and appreciation. Recently there has been some scholarship on the aesthetics of food and drink.[4] It is fairly easy to imagine aesthetic appraisals of food and drink. A restaurant receiving Michelin stars receives them partly on the basis of an aesthetic assessment of the food. Wine drinkers are generally familiar with their particular and in some ways peculiar aesthetic glossary, the vocabulary they employ when they aesthetically assess wine. Single-malt Scotch whisky drinkers have a similar one; it is common among single-malt drinkers that connoisseurs expect to be served their whisky in "nosing glasses," a reference to smelling the Scotch. When I reflect on the aesthetic merit of food, I think about two things: first, the gustatory experience; and second, the visual presentation. For visual presentation, it is difficult to beat sushi and sashimi. Too many Western foods are beautiful when they reach the table, but they require the diner to immediately demolish whatever formal structures carry the visual beauty in order to eat. This is not the case with sushi. The beauty diminishes as there is less on the plate, but it is not, in a swift, preemptive motion, destroyed at the start. In fact, traditional Japanese diners are known to work to maintain the aesthetic merits of their dining area by hiding away whatever elements are destined for discarding. And sushi

connoisseurs know that, because of unpleasant associations to other events, pieces of sushi are to be ordered in pairs. These sorts of aesthetic and ritualistic considerations are part of the overall aesthetics of sushi consumption.

But it is not primarily on visual grounds that the claim that food is art is advanced. To get to the heart of the matter, the case must be about food qua food, and so the claim must be about the gustatory and not primarily the visual. The strategy of those who consider whether food is art, and then in some cases advance the claim that it is, tends to take the form of an apologetic. Theorists take on the possible objections against food being art and attempt to answer them. Objections include the following: that taste and smell are lesser senses than sight and hearing, capable of much less discrimination;[5] that food cannot achieve the levels of complexity or structuring that fine art forms can;[6] that food is essentially temporal, that one must destroy it to experience it;[7] that food cannot have "meaning" in the way that other art forms can (along with the notion that it cannot have the emotional content or impact that "real" art can);[8] and that it is essentially functional and art is essentially appreciated in the absence of regard for any instrumental purpose it might serve.[9] Although dealing with these objections here would be interesting, our focus needs to be limited to the functionality of food. Ideally, for the purposes of this book, I would craft an argument that proceeds like this: on the basis of the fact that food is an art form, and on the basis that food is essentially functional, then some art forms are essentially functional and thus their value as art is connected to their functionality. (I make such a case later, but that case is not about food.) The first premise in my argument above, that in fact food is an art form, is at issue; the very fact that it is at issue is why the strategies of those who write about it take the apologetic form they take.

But let me say a couple of words about the functionality of food. Certainly food is nourishing, and certainly we eat food to stay alive. But these facts have little to do with the gustatory experience, with tasting food. When we talk about the aesthetic character of food, only the rare theorist[10] attempts to connect the nutritional value of food to an aesthetic characterization of it. Generally we save talk about the aesthetic nature of food for the events that are located in our mouths; once the food is

swallowed, it is not really a matter of sensation, and so aesthetic descriptions of it from that point on generally are not forthcoming. (If there is someone who derives some sort of sensuous pleasure from food passing down the esophagus, then I stand corrected.) The aesthetic character of food has to do with taste, and taste has little to do with nutrition, as anyone who sits at a gourmet meal counting calories and vitamins can easily attest. The nutritional function does not commonly come into play in an aesthetic characterization of food, and so to say that food-as-art is primarily or essentially functional in respect of nutrition is to say something unfocused and probably wrong.

But there is a deeper claim that I would like to make about the functionality of food. So many of the food-as-art apologetics take on the problem by playing on the other guy's playing field, and this seems unnecessary to me. The apologist may say that because art qua art is functionless— as aesthetic contemplation ignores all practical or instrumental concerns— and food is, after all, nutritiously functional, this is a reason why food may not be capable of being an art form. But art qua art is not functionless; as I show below, in talking about architecture, some art forms cannot be understood as art forms at all without a very present and central focus on their functionality.

In this part of the chapter, I want to look at the most central case that I can imagine of functional art, the case of architecture. If architecture is an art form and its function must be accounted for in any treatment of it as an art form, then here is a class of cases in which consideration of context is crucial. Architecture is essentially associated with function. Because of this, there can be no such thing as "pure architecture," in the sense that the art object, to follow Kant here, is brought under no category.[11] If architecture is inherently connected to functionality, then a work of architecture, considered as an art object, cannot be pure. I argue that thinking of architecture absent its function is impossible. The argument rests on a definition of the term *architecture*. Let us begin with a very broad definition of architecture and then move in more narrowly.

D1 *Architecture is primarily the three-dimensional spatial (or perhaps four-dimensional spatial-temporal) manipulation of matter.*

One must start so broadly in part because there are a great many objects and forms to be included. The media through which architecture can be instantiated, through which space can be manipulated, are virtually unlimited. One can manipulate space using wood, rock, metal, glass, bricks, cement, sod, compacted dirt, leaves, and so forth. One can manipulate space using fabric, paper, plants, water, and even light. To declare that any one of these media is inappropriate as a medium is only to invite challenge—challenge, I would wager, that would prove successful.

Objects that are works of architecture using this first definition include the following:

- Houses, office buildings, hospitals, schools, and so forth. These are uncontroversially labeled as (potential) architectural objects.

- Chairs, tables, desks, bookshelves, park benches, and so forth. For those who believe that "furnishings" such as these are not works of architecture, I would hasten to bring up the case of Frank Lloyd Wright's work. Wright designed not only buildings but also furniture. If we take the works of the architect Wright, when he was creating what he took to be works of architecture, to be works of architecture, then furniture (or certain pieces of furniture) created by him should also count. If this is correct, it disallows a narrowing of a proper definition of architecture to cover only those spaces that are inhabitable or are, in a general sense, enclosed. Chairs are not (normally) spaces that can be occupied in the way that buildings can, yet if (some) chairs are architectural objects, then "occupation" or "enclosure" is not correctly a part of a definition of architecture.

- Sculpture. The creation of a work of sculpture is a three-dimensional spatial manipulation of matter. Is sculpture architecture? Is Michelangelo's *David* a work of architecture? On an objective or formal view, I think the answer is yes. That is, finding some essential physical difference between objects that are popularly labeled sculpture and those popularly labeled architecture is impossible. In this sense, works of sculpture are works of ar-

chitecture and works of architecture are works of sculpture. To attempt to force a distinction on objective or formal grounds is to invite frustration.

Nevertheless, we commonly label some objects "sculpture" and others "architecture." We think of these objects differently and regard them differently. Since this distinction cannot be made on objective grounds, there must be something that accounts for this distinction that is essentially subjective, having to do with how these sorts of objects are regarded.

Stolnitz says that to consider an object aesthetically is to consider it without regard to any external purpose the object might serve. For Stolnitz, this is both necessary and sufficient (that is, along with a sympathetic attention) for aesthetic experience. Sculpture is frequently considered in this way. Instead of thinking of the *Venus di Milo* as a giant great doorstop, we tend to regard this work for its own sake, only as an object of attention. This is generally not how we regard works of architecture. On these grounds, we can carve out a distinction between works of architecture and works of sculpture. Sculptural works are frequently regarded with disinterest or, better, regarded as pure aesthetic objects. Architectural works are not. Architectural works are usually regarded as works with purposes beyond mere pure contemplation or attention. We live in houses, work in office buildings, recover in hospitals, learn in schools, sit on chairs, eat on tables, write on desks, store books on bookshelves, and rest on park benches. In each case where the objects in question are popularly labeled as (at least potential) works of architecture, we have some purpose in mind for their use. In other words, we regard them functionally. Gordon Graham writes that "the architect's products are essentially functional[;] . . . even aesthetic functions in music and painting can be abandoned without loss to their essential character as worthwhile objects of aesthetic attention. And the same can be said for sculpture, drama, literature and so on. But the same cannot be said for architecture. Whatever else the architect does, he builds, and this means that he necessarily operates under certain functional constraints. A building which fails in the purpose for which it is built is an architectural failure, whatever other merits it may have."[12] To use my terminology, pure architecture is

sculpture. So we might now introduce a new definition for architecture, one that seeks to capture the common distinction between architecture and sculpture.

D2a *Architecture is the three-dimensional spatial manipulation of matter where regard for the resulting object is considered purposively or functionally.*

D2b *Sculpture is the three-dimensional spatial manipulation of matter where regard for the resulting object may be purely formal.*

If one wishes to consider works of architecture as architecture, one must consider their functions. However, it is too simple to say that the greater the function of a given architectural object, the greater its aesthetic value. There are some objects that are highly functional yet fail to contribute to aesthetic experiences of any serious quality. And there are some architectural objects that are—considered as works of sculpture, considered without concern for function—of high aesthetic quality yet are functionally suspect. Francis Sparshott writes that "the more beautiful [buildings] are, the easier it is to overlook what a nuisance they have become,"[13] but he also writes, "If a building has a function, judgment of its form cannot be divorced from judgment of its function."[14] The key, then, to considering works of architecture as architecture lies in finding the balance between form and function, between how beautiful, elegant, balanced, and so forth the object is *and* how well it serves its purpose.

Example One: Wright's Barrel Chair

I own a copy of Frank Lloyd Wright's famous Barrel Chair. When guests come to visit, they frequently notice the chair and remark on its beauty. At this point, I invite a guest to sit in it. Invariably, the delight on the guest's face evolves into a puzzled look; sometimes the guest will ask, "Am I sitting in this the right way?" While Wright's Barrel Chair is a beautiful chair considered as an object to be admired visually (or "sculpturally"), it is the most uncomfortable chair in the house. As a chair, the Barrel Chair is dysfunctional. This limits the aesthetic quality of the chair. The reward on the investment of attention in the chair as a work of architecture, considered with its function in mind, is low.

Example Two: Automobile Styling

Although I have never driven a Lamborghini, I believe that they are cars of extraordinary performance. Yet I find the Lamborghini Diablo to be an ugly car; it looks squashy and buglike to me. One car that looks good is the old Auburn. Although by today's standards the Auburn cannot be considered a high-performance automobile, it held its own by the standards of its day. The sleek, long, motorboat-like styling of the Auburn contributed to its performance. In the Auburn, we find a marriage of form and function. As an architectural object—if a car can be an architectural object—the Auburn offers to my eyes a very rich aesthetic experience.

Example Three: Theater Design

For works of architecture to be considered as architecture, their purposes, their functions, must be taken into account. A beautiful office building in which no one can work is aesthetically questionable. A stately bookcase that does not hold books well or prevents ready access to them is aesthetically questionable. I say "aesthetically questionable" on precisely the same grounds that theorists such as Noël Carroll, Berys Gaut, Marcia Eaton, and Mary Devereaux find moral qualities in works of art relevant to their aesthetic character and in their aesthetic appraisal.

An excellent final example of this comes from the appreciation of theaters. A theater is a unique sort of space in that while its primary purpose is to serve as a venue for artistic performances, its secondary function, as a venue, is to motivate appreciation of those performances by its very design and decoration. I want to briefly talk about four theaters: two in Miami and two in London.

The Guzman Theater in Miami is the site of performances of Edward Villela's Miami City Ballet. The Guzman is an older theater in Miami's downtown. It is fairly ornate, perhaps even baroque, and this seems appropriate for Miami. As students my wife and I would attend the ballet, and as students we tended to sit fairly high up in the theater. The Guzman, although not shaped like an amphitheater, has an amphitheater feel to it. I felt, sitting high up, not only that I could reach out and touch the ceiling (complete with twinkling lights) but also that if I leaned too far forward I would go careening into the orchestra pit, several miles below.

Before the curtain would go up, my attention was more focused on my sense of height than on my anticipation of the night's performance.

I have also attended ballet performances in Miami Beach's Lincoln Road Theater. There I was not much worried about my looming death from a fall. However, each time I visited the theater, I wondered how long it must have taken the theater staff to remove the airplanes before opening the doors for the performance. The space is enormous, and while there is a clear benefit in terms of the numbers of patrons able to experience the performance, there is an equal loss in terms of the intimacy of the viewer with the performance.

Covent Garden's Royal Opera House is another very large theater, and in the past I have tended to sit high up there. However, the height and the enormity of the theater are softened by the design. Many theaters in London seem to share the same design, which wraps the stalls on the floor with a series of embracing balconies. This design contributes to a sense of intimacy while still allowing a great number of viewers to be present at once. The sense of height is also softened, because unlike in the Guzman where one has a clear view of all the levels of seats, extending into the depths, carrying the eye ever lower, the view of the balcony viewer toward the stage in the Royal Opera House is mediated only by air or the few rows of seats directly adjacent.

My favorite theater in London is the Barbican, where the Royal Shakespeare Company plays. Although in an ideal theater world the Barbican might be located more centrally in the West End, everything else about the theater is comfortable and engaging. The seats on the floor, while numerous, are designed to offer the patron a sense of personal space. The slope upward is gentle, yet unlike in many theaters the floor is sloped to allow patrons in the rear visual access to more than just the patron immediately ahead. Each row has its own exit door, so interior space is not "wasted" on stairs. One has a sense that the main balcony is floating over the floor, yet it does not sit above the floor invasively, blocking one's view of the top of the stage's arch. As in older theaters, there is the sense that the balcony embraces the floor, yet unlike in older theaters, all seats face the stage. The sense of intimacy with the performance is exceptionally high (in fact, in a particularly bloody scene in *Macbeth,* my wife felt that the intimacy level was a bit too high).

This exercise in theater criticism is meant to demonstrate that the functionality of the theaters described in terms of their roles as venues for artistic performances has a great deal to do with the potential of appreciation of performances. To consider a theater merely as a space, that is, to consider only its formal qualities—and many theaters have formal qualities that clearly lend themselves to being considered from such a perspective—is to miss what is ultimately of greatest importance in a theater. To go a step further, I would modify this last phrase to say "what is of greatest *artistic* importance."

If all other art forms, as far as we can tell, can be "pure"—that is, considered simply in terms of their formal properties—and architecture cannot, does this constitute a reason to think that architecture is either not an art form or less of an art form than those art forms that can be pure? Arnold Berleant writes, "In many respects, architecture is a paradigm of art in the traditional sense. It offers singular objects, striking in size and appearance, that stand apart and dominate their surroundings. Such structures are awe-inspiring, and their reverential power is transferred by association to the individuals and institutions associated with them."[15] In contrast, Stephen Davies argues that architecture is not an art form on the grounds that this would render most buildings, as art, poor works of art, and architects should not be saddled with being forced only to design art.[16] The question of whether architecture is an art form, while interesting, stands behind a still-more-interesting question: is it possible to experience architecture aesthetically? Consider again disinterest theory, a necessary condition of which is that those objects that cannot be considered from a disinterested perspective cannot be aesthetic objects. If pure architecture is properly sculpture, then architecture is an object-form that cannot be considered from an aesthetic point of view. Sculpture can, but architecture, since objects so classed cannot be so classed in the absence of a consideration of their functions, cannot. The punch of why this is so shocking is that all aesthetic attitude theories, of which disinterest theory is one, hold that all objects can be aesthetic objects if only they are viewed in the correct way; this is apparently not the case with architecture regarded as architecture. But architecture, we commonly wish to argue, can be regarded from an aesthetic point of view. Must our aesthetic attendance be characterized by disinterest in

order for us to have aesthetic experiences or to properly judge aesthetically? The answer has to be no. While we can reasonably hold that works of architecture as defined earlier are (potentially) aesthetic objects on the grounds that considerations of function in aesthetic attention and aesthetic evaluation may be appropriate at times, we may still hold that disinterest is the best understanding of purity when it comes to aesthetic attention and experience. Architecture, to be considered as architecture and to be considered aesthetically, must include attention to the functions of those spaces and the furnishings of those spaces that we class as architecture. To discount those functions is to treat architecture as sculpture. This is of course permissible. But it is not recommended. To understand architecture is to see it as a balance between form and function, between formal qualities and purposeful ones. That is the power and uniqueness of understanding architecture as art. The value of a work of architecture as a work of art is inextricably bound up with appreciation of the work's functionality, and the greater that functionality (inter alia), the greater the value of that work of art.

Consideration of works of architecture from noncontextual perspectives would, in most cases, leave the attender unengaged and with a flat experience. Nowhere, I want to suggest, is that more the case than it is with architecture. Among all potential aesthetic objects, works of architecture may well have the most complex contexts. Works of architecture are, unlike most works of art, usually permanent. Of course, some works of art, such as installations, are permanent; others, including particular works of sculpture such as Richard Serra's *Tilted Arc,* are meant to be permanent. But most works of art are quite mobile. Canvases, throughout their lives, are moved from patron to patron, gallery to gallery, wall to wall. And the very nature of allographic works of art is to be (again, potentially) instantiated at various times in various places. While there is no a priori reason to think that works of architecture must be permanent—indeed, if we include Wright's furniture in the list of architectural objects, then we have empirical reason to think that all such works need not be permanent—it is the general case that the most paradigmatic instances of architectural works are relatively permanent.

As such, their designers and creators must take pains to ensure that they fit their locations well. Indeed, this was the primary complaint of

those who sought and ultimately were successful in the removal of *Tilted Arc:* not that the sculpture was bad sculpture but that it was in the wrong place.[17] A good example of the careful choosing of a location and the careful fitting of a building into a location is the Getty Center in Los Angeles. First, it was decided that the center would be placed in a space unto itself. That no other buildings would be in the center's vicinity allowed the architect to create as a single architectural work not a single building but a small collection of buildings. Yet the center is not a collection of works; it is one work, and this was made possible only because the center was set apart from the rest of Los Angeles. Second, the center was placed some height above the rest of Los Angeles. This meant that the center would be visible from greater distances, that it could make more use of light and more use of large forms. Third, the center was not entirely white, the attested preferred color of the architect; it was instead a light-tan rock color. This decision was made to protect the continuity of color from the hills upon which the center was located through the center itself. (Note, however, that reference to a building's contextuality does not limit one to citing continuities between the location and the building. Continuity between site and building is strongly the case, and strongly to be valued, in Wright's work. However, medieval cathedrals, for instance, were designed to present a contrast to nature and the corporeal.)

All of these decisions, and no doubt hundreds more, were made concerning what the Getty Center would be like from a contextual perspective. Just above I describe visual fit and impact, but the reason that I say "hundreds more" rather than "dozens more" is that visual fit is only one of the host of contextual perspectives to which architects generally attend. How a building sounds, how a building smells, how it feels in terms of temperature, space, stability, lightness—and this is not even to begin to discuss cultural contexts.[18] B. R. Tilghman writes that "to understand that a building works and how it works we much understand the human activities it is intended to shelter and those activities in turn must be understood as part of a larger cultural context."[19]

The "problem-solving" aspect of creation of a work of architecture is much more complicated than it is with other works of art. All works of art can be viewed as solutions to problems, as answers that artists express to whatever prompted them to create. This is one way in which the search

for the meaning of a work of art can be approached. Yet whereas in most works of art the problem and the solution expressed can be explained relatively briefly, this is not at all the case with works of architecture. The problems to be solved with architecture are highly varied and very numerous. But the happy news is that they are generally more accessible to the casual attender than are the problems sought to be answered on a canvas. And here I am not merely speaking about engineering problems, though certainly they are a part. With architecture, problems of fit, of function, of scale, of cultural permanence abound.

Disinterest is reductionistic. To have an experience of architecture that even begins to tap the available wealth is to adopt more than a single perspective. In "Architecture and Continuity," Berleant says that "a growing force in the twentieth century has been the recognition of different ways in which beauty and use are inseparable,"[20] and "the architectural structure is bonded, on the one hand to its inhabitants, and on the other to its site, its neighborhood, the town or city, the region, and eventually, by the influences that range from the climatic to the cosmic, to the world."[21] Architecture presents the opportunity to engage a range of one's sensory modalities in an integrative way, whereby sight, sound, and so forth meld into an organic experience. Berleant's work is about all environments, natural and otherwise. (Good) Works of architecture present complete environments, and they may readily engage many or all of the senses of an attender, especially if that attender is inside the structure. They present whole microworlds. Tilghman writes that "a work of architecture can bespeak an entire way of life."[22] One need only consider the *chickee* of the indigenous people living in Florida's Everglades. Chickees are built in concert with the life expectations of the Native Americans who use them. For instance, they are not built to be permanent or to withstand hurricanes—consider what it would mean to build a hurricane-resistant structure in the Everglades out of available materials. That goal is seen as ludicrous, and so chickees are designed otherwise.

Alan Goldman's account of aesthetic value focuses on the ability of engagement with an aesthetic object to provide one with an aesthetic experience characterized by the sense that one is in another world, another place and time, in a different set of world circumstances than one's everyday world.[23] If Berleant and Goldman are correct, then this makes

works of architecture potentially the most powerful (artifactual) aesthetic objects. Not only should works of architecture, defined with regard to their functionality, be considered legitimate art objects, but they also may well be considered among the best. Taking disinterest as the model of aesthetic purity is sound. Taking the pure approach to attendance to works of architecture is unsound. Aesthetic reductionism fails as a rewarding approach to most works of art, but it is entirely wrongheaded as an approach to works of architecture. Works of architecture are richly functional and richly contextual, and they reward attendance through a plurality of sensory modalities.

DANCE

When is a dance not a dance? This is not meant as a riddle; it is meant as the organizing principle of this section of this chapter. Architecture is an aesthetic form that, as a matter of definition, must be considered contextually, and in particular with the context of functionality and purpose in mind. This is not the case with dance, however. In fact, it is because dance critics differ on how to regard certain objects that a treatment of dance in this chapter is interesting.[24]

In 1994, Bill T. Jones, an influential and respected choreographer and dancer, and his dance company, the Bill T. Jones/Arnie Zane Dance Company, founded by Jones and his partner Arnie Zane in 1982, premiered *Still/Here* at the Brooklyn Academy of Music's Next Wave Festival. *Still/Here* is a set of two dances connected by a common theme and incorporating spoken narrative alongside dance movement. The common theme is death and dying, and the spoken narratives were delivered by people who were in fact suffering from life-threatening conditions. Jones's partner, Zane, had died from AIDS in 1988, and *Still/Here* was, along with a set of other dances and a set of workshops he conducted, in part manifestations of how Jones was dealing with death.

John Coulbourn, writing for the *Toronto Sun*, describes the dances:

> As its title implies, *Still/Here* is two separate but thoroughly co-joined works, in which Jones' 10 member dance family—these people are far too connected to be dismissed as a mere "corps"—

deal with some very tough issues. In *Still*, moving to the music of Kenneth Frazelle and the voice of Odetta, the dancers—male, female, gay, straight, tall, short, black, white, thin and Rubenesque—gently and stylistically re-shape the horror of a death made imminent. Using taped excerpts from Jones' survival workshops and videos of participants, they weave an intricate tapestry of vulnerable humanity on Gretchen Bender's elegantly conceived set. Slowly, they explore the shape of individual mortalities and sketch outlines of bridges of mutual support. In *Here*, with music by Vernon Reid of *Living Color*, those bridges are given form and substance as they are built in living flesh. Arrayed in shades of blood red, instead of Still's silky creams, the dancers create a world where any and every moment of life is cause for celebration.[25]

Ramsey Burt writes, "I remember going to see 'Still/Here' at the Edinburgh Festival in 1995. . . . Aesthetically, I felt at the time, 'Still/Here' was quite mainstream. Its subject, like that of the Last Supper, was radical and contentious, but compared with the more experimental work of the 1980s, it relied on a strong spoken and sung narrative text to make its point while using dance either as an illustrative support or to create a sense of feel good communal interdependency."[26]

Bill T. Jones was born in Florida in 1952, the tenth of twelve children. He was raised in Wayland, New York, a predominantly white agricultural community. In 1979, after successfully choreographing a variety of pieces for the American Dance Asylum, Jones and his partner Arnie Zane settled in New York. By the mid-1980s, Jones had "emerged as one of America's preeminent dancers and avant-garde choreographers. Rooted in the postmodern experimentation of the 1960s, his work often combines speech, song, dance, and mime, as well as spontaneous movement. He infuses his art with candid autobiographical details in an effort to challenge audiences' ideas about tolerance, sexuality, death, and interracial romance—issues he has dealt with as a gay black man diagnosed in 1985 as HIV-positive."[27] Jones has won numerous prestigious awards for his work; he has garnered the positive attention of many of the country's most celebrated artists, Maya Angelou and Jessye Norman among them;

and he has choreographed for such companies as the Alvin Ailey American Dance Theater and the Boston Ballet. Although Jones's work may be at times controversial in both substance and form, Jones is not by any stretch of the imagination on the fringe of the dance world. The reason that Jones and his work warrants this introduction is because, in the mid 1990s, *Still/Here* could be found at the center of a major controversy in the world of dance.

Arlene Croce is one of this country's foremost dance critics. She wrote for the *New Yorker* for many years. She is a good writer and an insightful critic. (It is important for this discussion to keep in mind that neither Jones, Croce, nor any of Croce's critics are amateurs or hacks.) In 1995, in an article in the *New Yorker*, Croce wrote about *Still/Here*. More precisely, Croce wrote about writing about *Still/Here*. She said that she could not do it. She could not review the work, because the work was, in her view, "victim art," and she felt uncomfortable putting herself in the position of writing critical words in part about participants in *Still/Here* who were in fact facing life-threatening conditions. In an article called "Discussing the Undiscussable," Croce examines her decision not to review *Still/Here*.[28] She writes, "I have not seen Bill T. Jones's *Still/Here* and have no plans to review it. In this piece, which was given locally at the Brooklyn Academy, Jones presents people (as he has in the past) who are terminally ill and talk about it. I understand that there is dancing going on during the talking, but of course no one goes to *Still/Here* for the dancing. . . . If I understand *Still/Here* correctly . . . it is a kind of messianic traveling medicine show." She says that as a critic, she has four options. First, she can see the work and review it. Second, she can see it but choose not to review it. Third, she can choose not to see it. Fourth, she can write about what she has not seen. Concerning this fourth option, Croce writes that it

> becomes possible on strange occasions like *Still/Here,* from which one feels excluded by reason of its express intentions, which are unintelligible as theatre. I don't deny that *Still/Here* may be of value in some wholly other sphere of action, but it is as theatre, dance theatre, that I would approach it. And my approach has been cut off. By working dying people into his act, Jones is

putting himself beyond the reach of criticism. I think of him as literally undiscussable—the most extreme case among the distressingly many now representing themselves to the public not as artists but as victims and martyrs.

Part of Croce's case for not being able to review *Still/Here* rests on the need she perceives for maintaining an emotional detachment. She says that she "can't review someone I feel sorry for or hopeless about." She relates that she has avoided dancers whose physical states impede her ability to be candid in her evaluation of their dancing, dancers who are overweight, old, or with physical deformities "who appear nightly in roles requiring beauty of line." Croce writes, "In quite another category of undiscussability are those dancers I'm forced to feel sorry for because of the way they present themselves: as dissed blacks, abused women or disenfranchised homosexuals—as performers, in short, who make out of victimhood victim art. I can live with the flabby, the feeble, the scoliotic. But with the righteous I cannot function at all." Croce says that what she terms "victim art" began with the "arts bureaucracy," with funding agencies both governmental and private that have expressed a "blatant bias" for "utilitarian art," that is, art having a social activistic component. By the late eighties, Croce says, arts funding had been placed in jeopardy by those who required art to demonstrate its usefulness.

> When even museum directors can talk about "using art" to meet this or that social need, you know that disinterested art has become an anathema. (Disinterested art: you have to understand that there's no such thing.) . . . Many writers who discovered dance in the 60s and 70s felt as if they'd stumbled into the golden age of the art. All the way up and down the line, the most wonderful dancing, the most brilliant choreography were all about dance. What happened to politicize it? The promotion, for one thing, of the new arts-support networks, which began to stress the democratic and egalitarian aspects of nonformal movement. Academics, teaching newly-accredited dance-history courses, also laid heavy stress on these aspects. By the eighties, when the culture wars got underway and the N.E.A.

was targeted by pressure groups left and right, it had become painfully clear that New York–centered, disinterested, movement-game, do-your-own-thing, idealistic postmodern dance was doomed. It was elitist. It had no audience. It produced no repertory. Most fatally, it did not establish itself in the universities and influence the coming generations. The sixties, it turned out, had been not the golden dawn but the twilight of American modern dance.

In the case of federal funding, taxpayers in the Reagan years grew increasingly interested in seeing the benefits they derived from the funds the government took from them. If benefits could not be demonstrated or articulated, then the object of funding was held in suspicion. Art for art's sake clearly falls into this category of suspicion. If art is only for art's sake, then the artist—and the critics—will not feel obliged in the least to demonstrate or articulate why art should be funded. "Art for art's sake" is wonderfully liberating; it promotes artistic and expressive freedom, and it encourages experimentation and novelty. But when it requires funding from sources that then demand some account of the good that their money is doing, its practitioners fall silent.

To survive, artists—both individual ones and ones who have companies—must secure funding. Selling the products of their art, either through commissions or through postcreation sales, is the traditional means of artistic support. But large-scale artistic companies today—symphonies, operas, ballets—all produce events that cost more than ticket receipts can support. As with state colleges and universities, where the cost of tuition is but a percentage of what it takes to deliver to students the educations they receive, were ticket prices for large-scale artistic performances set at their true rate, set at the point at which ticket receipts could support such performances entirely, far fewer patrons could afford seats. Fewer patrons means less revenue. Less revenue means higher ticket prices. And pretty soon such large-scale performances disappear.

So in the interest of supporting the arts and cultural aspects of a society, members of that society contribute taxes that governmental agencies distribute according to that purpose: the purpose of endowing the nation's artistic and cultural efforts and, in retrospect, legacy. This is

the traditional answer when one asks about the purpose of the National Endowment for the Arts or the National Endowment for the Humanities. The answer is educational and cultural. But that is where the traditional answer generally stops. Non-arts-inclined citizens have a vague sense of how a cultural life and heritage are important for a nation, and this vague sense is usually enough to keep them relatively comfortable with the government taking their money and giving it to artists. But this only works as a justification so long as the citizens are comfortable. Once there is some suspicion that the government is supporting art gratuitously or supporting art that detracts from the reputation of a nation's culture, accounting by the government is called for by the citizens. Once this happens, the government turns the questions over to the artists: What are you doing with the citizens' money? Can you show that this is worthwhile? Can you show the value you are contributing back to society?

Art-for-art's-sake-style artists will be hard-pressed to answer such questions. Their very orientation to art creation precludes them from developing the sorts of answers required by the government and the suspicious citizenry. Some artists give up public funding. They go it alone. But this does not work well in the cases of large-scale performance companies and institutions such as museums and major galleries; they require public support to survive. So what has happened generally is that the directors of such companies and institutions begin to craft answers to the questions, and they tend to craft these answers out of microcosmic aspects of the traditional answers. "Art should be supported because a nation's cultural life is important." This is the big answer, and directors carve out of this big answer answers that are more focused and localized. They focus on the educational values they serve within their local communities. Educational services are part of social services generally, and so it has become common to hear directors sing the praises of how their companies or institutions meet all sorts of social needs. This is what Croce is complaining about. The production of art is not justified on artistic grounds; it cannot be, if by "artistic grounds" we mean aestheticist or formalist grounds. Justification must connect to other values, and once this door is open and this strategy proven successful, then the articulated justification and the need to evidence it mean a different sort

ISSUES OF DEFINITION

of operating structure and philosophy for those companies and institutions. Meeting social needs and social activism become not only legitimate as a goal but also centralized. Formalized arts take a back seat to art forms that can appeal to these broader goals. Dance as therapy, dance as social commentary, dance as a means of bringing in those who are marginalized or disenfranchised in some ways becomes more prevalent and popular—at least in terms of who is getting public funding—than the formalized arts. But Croce is a formalist. She practices formalist criticism about a very rarified art form—ballet—which presents, par excellence, an opportunity to appreciate and experience formal aesthetic features.

What Croce calls "victim art" is one species of art that she sees—rightly, I think—as being cut off from a pure formalist assessment. What she has been attacked for is that the sort of dance today that is being produced with formalist goals in mind occupies a minority of the overall dance that is currently being offered. More than this, it occupies a minority of the sort of dance that is being studied—not merely in amateur and professional companies but in colleges and universities, too. Croce is right to complain about "disinterested" dance not establishing itself in universities, but her complaint as she articulates it is driven by externalities that she feels free to disparage: the non-arts-inclined, money-clenching public and their reluctance to fund anything they fail to see benefiting them in a more or less direct way. There is another side, another force driving dance to evolve in the way it has, and that concerns the general trends of postmodernist art and the greater sensitivities toward inclusion of the disenfranchised, an inclusion justified in part on the same sorts of economic grounds upon which artists and arts communities call for funding. It is easy to complain about the government and a greedy but abstract citizenry. It is more difficult to see actual impoverished people, people impoverished through marginalization, and to claim, in seeing them, that arts funding should in some measure enjoy equal funding consideration. The only recourse is for the art world to back off, and this is precisely what Croce did in respect of reviewing Jones's work. She backed off:

> For me, Jones is undiscussable, as I've said, because he has taken sanctuary among the unwell. Victim art defies criticism not

only because we feel sorry for the victim but because we are cowed by art. . . . I do not remember a time when the critic has seemed more expendable than now. Oscar Wilde wrote that the Greeks had no art critics because they were a nation of art critics. But the critic who wishes to restore the old connection between the artist and his audience appeals in vain to readers who have been brought up on the idea of art as something that's beneficial and arcane at the same time. People for whom art is too fine, too high, too educational, too complicated, may find themselves turning with relief to the new tribe of victim artists parading their wounds. They don't care whether it's an art form. They find something to respond to in the litany of pain, and they make their own connection to what the victim is saying. Of course, they are all co-religionists in the cult of Self.

This is the etiology of the matter, but there are more lessons, lessons about formalism and about the nature of dance, to discuss.

"When is a dance not a dance?" Croce's answer seems to be this: when it does not present its audience with the formal features necessary—and only those formal features—to take it, on its own and distinct from external considerations, as a basis for pure and disinterested aesthetic contemplation. Is *Still/Here* a work of dance? I am not referring to whether the spoken narratives were more central to the work as art than was the movement. I take Jones and the director of the Brooklyn Academy's word for it that the work, if it was art, was dance. But I also take Croce at her word when she says that she will review, or at least see, any dance performance. An implication of Croce's position, which I would characterize as strongly formalist, is that if there is no means by which to attend to an object with emotional detachment, then there is no way to approach it critically. If it cannot be criticized, then it lacks one condition—namely, formal properties that are accessible by the disinterested viewer—that render it capable of producing an aesthetic experience, and for formalists such as Croce, Monroe C. Beardsley, and the New Critics, the object's inaccessibility as an aesthetic object results in its also not being an art object. If a formalist critical treatment requires accessibility to formal properties for an object to be an aesthetic object and *Still/Here*

does not, because of its content, permit this, then it cannot, for the formalist, constitute a work of art. If this is right, then Croce's claim could have been more powerful. It is not that *Still/Here* is a work of "victim art." It is that *Still/Here* is not a work of art at all. And, as such, Croce was not in the least obliged to review it.

I think Croce is right when she says that *Still/Here* did not provide her with the formal features, and only the formal features, to constitute it a work of dance, given her formalist perspective. Where I think Croce is wrong is in her outmoded insistence on a formalist definition of dance. Deborah Jowitt, a writer for the *Village Voice,* wrote on January 10, 1995,

> She's not alone in feeling her critical prerogatives and her power hobbled by art that prompts pity for artists because of social oppression or the precarious state of their health. I've talked to other critics who are troubled about how to preserve—to what degree to adjust—their aesthetic standards in reviewing highly politicized work or work grounded in special communities. . . . Croce is, in part, championing the kind of abstraction or formalism or obliqueness that distances us from subjects like death or personal rage. I like that coolness too. But I can live with not always getting it. Am I naive in thinking that the critic's main tool remains the ability to *see* what a work is and is not, and to criticize it accordingly? . . . That dance these days tends toward narrative and political statement seems to me part of a cycle, not the end of dancing as we know and love it. If we don't watch and comment frankly on it, are we not turning dance itself into a victim?[29]

Context makes a difference in definition. Although Croce says, provocatively, that "there's no such thing [as disinterested art]," it is disinterest in the classical philosophical sense that informs that ideal she says that museum directors hold as anathema now as they talk about "using art to meet this or that social need." Croce celebrates the purity, to use the term both as she does and as I do above in talking about architecture, of the aesthetic object—in her case, the dance event. She sees this as crucial to her work as a principled dance critic. If she assesses a

dance on the basis of an art theory that is inherently expressive, mimetic, or otherwise contextualist, she endangers her craft by necessarily including in her assessment items that she, subjectively, judges to be relevant. The safer ground by far for one who like Croce pioneers the construction of the professional dance critic is the generally objective ground of criticism rendered only on those public aspects of the object: the formal properties of the aesthetic object and the public information that obviously concerns the object's existence as art, including genetic, historical, and object-relational information. This is especially the case for Croce, as dance has not received the same warm welcome in the world of fine art that painting, sculpture, and poetry have.[30] Her formalism is not only understandable, it was probably necessary.

But with works such as *Still/Here* growing in popularity, in terms not only of their attraction of audiences but also of the frequency of their production, Jowitt's concerns about the future of dance criticism in the hands of the formalists must be taken to heart. If the formalist has an "out" in terms of holding certain events even to be dance (art) events, then it is likely that, given current trends, the dance world will leave the critics behind. No doubt there were several critics who did not give a second thought to Duchamp's *Fountain* or to Warhol's *Brillo Pad Boxes*. These objects lacked the required basis for being taken seriously: they lacked the formal features that for the formalist are necessary for aesthetic assessment. Clive Bell and Roger Fry certainly would have rejected these objects as art. For the formalist, the equation is simple: no aesthetic nature, no art. Jowitt has a legitimate concern about refraining from criticism of dance as an art form. To the extent that it is legitimate, it also signals a reason to leave formalism behind in favor of more contextualist approaches. On formalist grounds, on those grounds that require a disinterested consideration, *Still/Here,* in the way that Croce describes it, is not art.

The case of Croce and Jones is an extreme, of course. The point in exploring this case is to spotlight the importance of taking into account the appropriate classification of a dance when appreciating it. This is not only a point about definition, and it is not only one example in support of the theory that Kendall Walton advanced. This is a point about appreciation, too: a member of a dance audience will find a work of greater

value by rejecting a purely formalist consideration of the movements of the dancers on the stage and instead adopting a view informed by an appreciation of the *sort* of dance he watches. His experience becomes more valuable, but more basically, the dance event itself takes on its true value. This is important for many kinds of dance, particularly for the majority of contemporary modern dance. Unless the audience member brings a contextual understanding for the kind of dance the event is, the event may well be of little value, if any.

6 Issues Concerning the Power of Art

THIS CHAPTER WILL BE ABOUT ISSUES concerning how context affects the value of works of art in respect of how powerful they are and thus how powerful are their effects both in terms of their capacity to inspire in us great experiences and in terms of the content with which they populate those experiences.

EMOTION

Both J. R. R. Tolkien and Peter Jackson make strong use of emotional elements throughout the original literary version and the epic film version, respectively, of *The Lord of the Rings*. While reading the books and watching the films, I felt suspense, repulsion, fear, elation, relief, inspiration, and many other emotions. I wager that there are few people who can make it through the last hour of the films' nine hours without feeling some fairly strong emotions; I also wager that there were not many dry eyes in theaters during the last twenty minutes. The emotions that Jackson arouses are inherent to the story that he delivers in these three films. They are not tacked on; they are not themselves a focus; there is no overt plan on Jackson's part to craft a work the purpose of which is to arouse emotion. This is, of course, not the case with all artworks, and there are entire classes of films that are so designed. *Terms of Endearment, Steel*

Magnolias, Love Story, and *Kramer vs. Kramer* are all tearjerkers, so dubbed because their purpose is in part to arouse certain powerful emotions of sadness and sometimes sudden or powerful relief from that sadness. *Nosferatu, Night of the Living Dead, Halloween, The Exorcist, The Shining,* and *The Silence of the Lambs* are all designed to arouse fear and, if Noël Carroll is right, disgust.[1] *Psycho, The Birds, Rear Window,* and *North by Northwest* are designed to arouse feelings of suspense. Jackson's *Lord of the Rings* is not exclusively or principally a vehicle for emotion arousal, as are several of the films listed above, but clearly Jackson's films—and Tolkien's books—are in part powerful because we develop emotional engagements with the characters and we sympathize with their plights and successes. The emotions we feel are part and parcel of the power of the aesthetic (or art) object in many cases; without that aspect, the object would be less powerful and, so, less valuable.

Although I am focusing on film here, the same sorts of claims are commonly made about literature (I mentioned Tolkien), music, stage plays, dances, and opera. Such claims are made about art forms beyond the literary and performing arts—several of Francisco Goya's pieces, for example, inspire fear or repulsion, while Claude Monet inspires deep calm, and so forth—but connections with emotion arousal are more commonly found where the audience's engagement with the art object takes time. Through time, one can be brought into certain moods that allow certain emotions to surface. Through time, the artist can craft a rhythm to inspire stronger and stronger emotional states. I also realize that so far I have focused more on what we might call negative emotions: fear, repulsion, sadness, and the like. The reason for this is that these emotions tend to be more palpable and generally stronger, both in terms of how audience members feel them and in terms of how they can be inspired, than are positive emotions or more-complex emotions. In short, it is a lot easier to scare someone and get a big emotional response than it is to move someone as powerfully or quickly into feelings of happiness or elation. I will not continue to focus on negative emotions in this chapter, but the introductory point about the power of emotions seems easier to make with this negative focus.

I need to be clear here that the inclusion of the emotional content of art objects is not in contrast to or a contradiction of disinterest or psychic

distance theories. Edward Bullough and Jerome Stolnitz explicitly include in their theories the importance of positioning oneself to be receptive to feeling emotions (see chapter 3). This is the core of Bullough's antinomy of distance, that one should seek out the least possible distance while maintaining some. It is through the least possible distance—or through what Stolnitz calls "sympathy" with the art object—that we allow ourselves to feel as fully as the art object can move us.[2] Since this book is not merely an attack on disinterest theory and/or formalism, the inclusion of a chapter that deals in part with emotion is fitting. Emotional contexts are a large part of what it means to understand art in context.

Jenefer Robinson offers a comprehensive introduction in "The Emotions in Art."[3] She begins by defining "emotion":

> There is widespread agreement among emotion theorists that emotional responses occur when our wants, goals, and interests, and/or those of our kin or social group, are perceived to be at stake. . . . I think of an emotion primarily as an episode, albeit one that involves more than a change in facial expression and which typically lasts for more than a few seconds. . . . On this conception, an emotion is a response by a person to some particular situation or events in the environment, which is registered as significant to that person's wants, goals, and interests.[4]

She goes on to talk about the social contextuality of emotions: "Emotions clearly have a biological basis, yet they are also highly dependent on social and cultural norms."[5] She is joined in this endeavor by two others: Arthur Child[6] and Marcia Eaton.[7] Eaton writes, "Understanding emotions requires not just a study of individual bodies and minds but of language, moral systems, social functions, rituals, and other sociological and anthropological phenomena."[8] The sorts of responses that we make to art have much to do with environmental and historical influences. We learn responses both in the aesthetic arena and in the emotional one. Except, perhaps, for a few basic responses, the sort that we would commonly describe as instinctual, our responses are mediated by what we have gathered through the modeling of others and through environmental influence. If this is a fact, then it places emotion, as we experience it as a

response or mode of engagement when we attend to art objects, in a central position with regard to our overall contextualist thesis. If this is a fact, then it makes emotion an essentially contextualist matter with regard to attending to art.

Emotions are not only the results of educational forces. Robinson (and Eaton, as we have seen) describes them as the means of education as well. Robinson writes, "Not only is it possible to respond emotionally to works of art; for very many works it is mandatory to respond emotionally if we want to understand the work as fully as possible as well as the 'lessons' for our own lives. . . . How do works of art 'teach us about life'? One way that novels and movies are often said to do this is by enlarging our emotional range. . . . The kind of education that novels offer is a *sentimental* education. It is an *experiential* education."[9] Clearly, most times, emotion is an important aspect of aesthetic and art experiences. Taking this as a given, I want to explore, in the rest of this first section, specific instances of where it is important and also where the contextuality of emotion as a response to art is pronounced. Before getting into these specific examples, however, we may benefit from a brief review of the collection of art theories called Expressivist, since it is within these theories that emotion takes center stage.

Expressivist Theory

Chronologically, the second art-theory wave to come along after mimetic theory was romantic theory. Romanticism followed the Enlightenment, but Romanticism was anti-Enlightenment in a strong sense. Whereas the Enlightenment promoted intellectual endeavors, Romanticism focused both on the passionate or emotional and on the individual (the latter clearly a positive influence of the Enlightenment). Romanticism saw art as essentially the outpouring of the individual's passionate nature, of one's personal feelings. One theorist of this period was Friedrich Nietzsche. Nietzsche conceived of art as a synthesis of two separate *energies* that are found in nature and burst forth from nature: the Apollonian and the Dionysian. Apollo represents artifactuality, individuation, labor, structure, symmetry. Dionysus represents the antithesis of Apollo; he represents the death of individuation and structure, the freedom of expression, revelry, excitement, spontaneity, liveliness, perhaps even recklessness. It is

through the reconciliation of these two energies, the one toward form, the other toward expression, that the best art is created. This reconciliation happens through the artist and his creative processes. Tragedy arises, as with the best art, through this synthesis of the Apollonian and Dionysian. Tragic art, through an imposition of structure, through what Nietzsche calls the "Apollonianization of the Dionysian," makes us aware of and able to cope with the harshness of reality. In this way we can understand the world. Tragedy exists not to depress us, not to make us resign ourselves to the negative in life, but to help us affirm life, with all its pain.

It will be difficult to state very clearly at the outset the difference between Expressivism and Romanticism. Instead of stipulating a difference that might seem arbitrary, we can understand Expressivism as a more recent version of the essential element of Romanticism: expression of vital emotion. The difference that seems noteworthy at this stage is that the Expressivists are much more concerned with the communication of emotions to the viewers. This may be indicative of their being less metaphysically inclined and more specific about the mechanics of expressing vital emotion. Perhaps a bridge between Romanticism and Expressivism, as chronologically distinct versions of emotion-inducing, or arousal, theories, is the famous statement by Wordsworth that all good poetry is the spontaneous overflow of powerful feelings. Tolstoy was an Expressivist (for a discussion of his views, see chapter 2). Benedetto Croce, the Italian idealist who lived at the end of the nineteenth century, was also an Expressivist.[10] Croce was less concerned with details such as sincerity, infectiousness, and religious climate—those things that were central for Tolstoy—than with an investigation of the actual mechanics of expression. How does an artist express through artistic creation? What does she express? "Feeling" was much too ambiguous a term for Croce. Art could not be a matter of mere expression of emotions. What were expressed were not feelings but intuitions—more specifically, lyrical intuitions. For Croce, aesthetics was the science of images or intuitive knowledge. When we are conscious of the world, we are first conscious of what Croce called raw sense impressions. When we clarify these, they become intuitions. And these intuitions are the building blocks of artistic expression. To express these intuitions successfully is to create art. Unsuccessful art is not a fault of the expression of the intuition. Rather, the failure is due to the intuition's

not having been developed fully from the sense impression. Art is intuition, said Croce. What he meant by "intuition" is an inner vision of an image. It is an immediate knowledge through the contemplation of that image by the imagination of the perceiver. It is the most basic and most fundamental operation of mental activity. Since art is so closely tied to the expression of intuition, it follows that the work of art per se is not the physical object but the expressed intuition. The work of art is not a physical thing but a mental re-creation. The physical work is merely a medium of communication, merely the vehicle for transmitting the expression. However, the artwork is not something supersensible. Instead, Croce tells us that the artwork is the conscious consideration "in all its concreteness." This is to say that the artwork is the deliberate contemplation of an image of something, with the image being contemplated in its most basic form. Moreover, the intuition could not be expressed in any way other than through the artist's creation. It is ineffable. The expression of that intuition could exist only through that particular artwork which expresses it.

Following closely behind Croce was the English philosopher R. G. Collingwood. Collingwood's theory is less theoretical in tone than Croce's theory of art as expression. Collingwood agreed with Croce that it is naive to say that an artist merely expresses emotion, but he returned to treating emotion more centrally in his expressivist theory than Croce ended up doing. Collingwood saw the expression of emotion as having definite elements, some of the necessary ones being (1) that the emotion is not simply mentioned to the audience but is demonstrated to them; (2) that the emotion is individualized, is this emotion here and now, not just one of a species, say, of happiness or sadness; and (3) that the expression is not simply for the arousal of emotion, for the expression of emotion that is art is not manipulative. The artist must be sincere and candid with her audience. Without complete honesty on the part of the artist, the expression can be nothing other than merely manipulative or, worse, simply without feeling. However, the artist must handle the emotion that she is expressing delicately. She must not rant and rave (Collingwood accused Beethoven of this). She must not preach but must gently and subtly communicate the specific, unique emotion that she wishes to express. The expressivism that Collingwood describes is a familiar one. Expressivism typically does not focus on the receptivity of the audience; it focuses on the artist and the

processes of creation. However, for the expression in the art to be fully successful, the audience and the communication of artist to audience seem to both be necessary ingredients. The best artists will produce works out of a construction of emotion in some artistic medium and will produce them so that they do communicate to us, so that they touch us.

Theories that focus on the expression of emotion do not have a great many adherents today. Problems have included the following. (1) Is true communication possible? It may be that in all communicatory or relational definitions of art, where the audience members need to understand what it is that is being communicated or expressed to them, we cannot accurately or even adequately be sure that we are correct. If this is indeed problematic, then we are without a means of knowing whether or not we are being communicated to effectively. Are we getting the right message? The success of the expression is key to determining whether the art is good art and, more basically, whether it is even art at all. (2) Another apparent problem with the re-creation of what the artist wishes to express is the following: what about those cases where the artist really does not know what she is attempting to express? There are Freudian, Jungian, and other psychological critics who suggest to us that the artist may not be fully in conscious touch with what actually does get expressed through the artwork. Perhaps one may be willing to acquiesce, saying that it does not matter whether the artist is fully and consciously in touch with the emotion or intuition that is being expressed, so long as there is adequate and honest expression. This is plausible, though it suffers from the fact that no one, not even the artist herself, is in a position to know what actually is being expressed. (3) What about the work that seems to reveal no expression of emotion whatever? If there are art objects that were not intended to express emotion and do not in fact communicate any emotion, then this is a problem for expressivism (consider purely formalized music). But for all the problems of expressive theory, one of its chief virtues lies in capturing what we take to be a familiar part of art experiences: the fact that art regularly moves us.

Inspiration

I think that many academics, when asked which of Shakespeare's plays is their favorite, name either *Hamlet* or *King Lear.* My answer to this ques-

tion is *Henry V. Henry V* has, I believe, the most emotionally powerful speeches of all the Shakespearean plays. Henry's speech at the gates of Harfleur dwarfs the levels of aggression that even Quentin Tarantino reaches. I imagine that Elizabethan audiences were shocked. But the level of aggression in Henry's speech is quite purposeful. If he can scare the inhabitants of Harfleur enough, he may be able to save many lives and much mayhem. So he pours it on. This speech is not the greatest of the play. The greatest is the St. Crispin's Day speech, given just before the Battle of Agincourt. Shakespeare puts words into Henry's mouth that would move the least brave to heights of patriotism and valor. Henry V is widely regarded as England's most military king, and Shakespeare's delivery of such a patriotic speech finds its most appropriate setting in the character of Henry and just as the English were to take on overwhelming numbers of French. The only speech that rivals the St. Crispin's Day speech is that of Winston Churchill during World War II in which he describes England as a sceptred isle. This is significant, of course, because these speeches occur in similar circumstances.

Plato would have been pleased, and I feel sure that Plato would have agreed with me that Shakespeare's greatest play was *Henry V.* Although Henry V does not come out of *Henry V* pure and godlike, in the way that perhaps Wagner treated some of his heroes—one might think of the desperate deal Henry offered God on the eve of battle—there is a great deal less exploration of the foibles, vices, and shortcomings of human beings in *Henry V* than in *Hamlet, Lear,* or many of the other plays. *Henry V* is the most patriotic of Shakespeare's plays. It rallies audience members to greater sentiment about their native land—for the English, this would be England to be sure, but the emotions that Shakespeare inspires are fairly easily transferable to one's own country. I spent a number of months in the mid-1990s living in St. Andrews, Scotland. St. Andrews, a small town, is home to Scotland's oldest university, founded around 1411. The town retains its historical character, and there are reminders of its medieval past, especially its ecclesiastical past, both in medieval terms and in terms of the Reformation. I mention all this because St. Andrews is a very Scottish town. When I was there, St. Andrews had one cinema, which had two theaters. And while I was there, for the entire time, both theaters played one film: Mel Gibson's *Braveheart.* Perhaps even more significantly, I was

never able to see it there; whenever I went to buy a ticket, they were always sold out. Again, I think Plato would have been pleased.

Plato's views (as I discuss in chapter 4) principally concern what art does and whether what it does is of value. Art is of little or no value if its purpose is to convey knowledge. Art is removed from reality, from the forms, so far that it takes us in the opposite direction from knowledge. Art as a copy of a copy is unstable and impermanent. Insofar as the chief goal of humans is attainment of knowledge of the truth, art serves contrary purposes. If, however, art has any value, it is the power to strengthen the relationship between the citizenry and the state. Essentially, if art has value, its value is patriotic or as propaganda. Art, for it to be valuable at all, must celebrate the virtues of the heroes and the gods. It must demonstrate strength and bravery, and it must never show undue emotion or weakness. If an art object wallows in emotionality of any negative sort, it harms its audience and thus harms the city's citizens; better that it not exist at all. Yet art can be quite valuable if it serves its patriotic purpose, at the same time ennobling its audience and inspiring greater positive sentiment between that audience and the state—its history, its heroes, its value. But seeing that value strictly in terms of the virtue of its function is important.

Henry V, Braveheart, Victor Fleming's *Joan of Arc,* John Ford's *Young Mr. Lincoln,* and Gibson's *Patriot* are all films that Plato would have received with approval. They inspire in straightforward national-celebratory ways. In the next chapter, I examine nationalist and propagandist art contexts, but the point to be made here is the one focused on emotion. These films, and certainly many other artworks from a range of art forms, arouse sentiment, a greater and deeper emotional engagement with the object represented. As they do this, they create the conditions for audience members to be inspired. The audience members take this inspiration with them when they leave the theaters, galleries, and libraries. Plato believes that this makes them better people and certainly better citizens. For Plato, art that achieves this, or occasions the achievement of this, is valuable. For Plato, it is the only art that is valuable; even those of us who disagree with Plato's thesis can at least see that art that achieves inspiration is valuable to the extent that it does this. Moreover, inspirational works of art are more valuable as the level of inspiration rises. *Henry V,* especially

as compared with other popular patriotic Shakespearean plays such as *Macbeth* and *Richard III*, is my best example of this. *Henry V* is a better play than it would otherwise be specifically because of the inspirational efficacy of its patriotic dimension. On the one hand, this thesis is not at great odds with the descriptions of disinterest offered by theorists such as Stolnitz and Bullough. On the other hand, if an artist means for her work of art to inspire patriotism (or inspire anything), and she takes pains to construct her work to achieve this, then this functional element of the work is out of bounds to the disinterest theorist, that theorist who says that emotional connection is appropriate but consideration of function is not.

Catharsis

Catharsis is commonly thought to be the purging, purifying, or exorcizing of emotions through attention to some art object that exhibits and arouses these specific emotions. Aristotle, albeit briefly and slightly ambiguously, describes this in connection with comedy and tragedy, with music and poetry. He says that the purposes of music can be understood as educational, for entertainment and relaxation, and for catharsis, for the attainment of healing. In the last of these two, the result is pleasure. Aristotle (or one of his commentators) writes, "The potentialities of the human emotions that are in us become more violent if they are hemmed in on every side. But if they are briefly put into activity, and brought to the point of due proportion, they give delight in moderation, are satisfied and, purified by this means, are stopped by persuasion and not by force. For this reason, by observing others' emotions in both comedy and tragedy, we can check our own emotions, make them more moderate and purify them."[11]

In chapter 4, in connection with Santayana, I discuss pleasure as the point and purpose of aesthetic attention. One of the mysteries of theories that relate pleasure and aesthetic attention together so intimately is how we describe attending to aesthetic objects for which our immediate felt reactions are not pleasurable, are not any stripe of positive emotion, but instead are negative emotions including fear, terror, revulsion, disgust, and discomfort—either as the whole of our reaction to a work or as an integral part. A traditional answer to this mystery—"why attend to something

which makes you feel bad"[12]—is one that focuses on catharsis, on purging strong emotion. The consequence of such a purging or purifying is pleasure. This answer allows us to retain our theories about the intimacy between aesthetic attention and pleasure while at the same time understanding why we are attracted to aesthetic objects that arouse in us negative emotions. We understand that aesthetic pleasure need not be a matter of an immediate felt reaction to a work; aesthetic pleasure can be a second-order sort, one that comes about through engaging with negative emotions but then coming out of the other side, feeling that (first-order, immediately felt) pleasure that comes through attending to such works.

Over the past three decades or so, the cathartic dimension of films seems to have grown more and more complex. Film has the unique situation of never existing without film criticism existing alongside, and the vast majority of film viewers—perhaps because as an art form, film is very accessible in all sorts of ways—usually have more-developed critical and historical appreciation of the development of film than is enjoyed in other art forms, and they probably have this even in the absence of any sort of academic training or discussion. In the early days of film, during the silent film era, it was common to find emotionally negative themes. F. W. Murnau's 1922 film *Nosferatu* is a perfect example. This film is gothic and creepy; Count Orlok is repulsive and scary; people are in supernatural jeopardy and generally helpless. Yet many people have been drawn to this film; even now, this is most probably the most popular silent film, the one that silent film viewers today might grab from the rental store for a Saturday evening. Two other films, Verner Herzog's 1979 film of the same name and Elias Merhige's 2000 film, *Shadow of the Vampire,* were spawned from the Murnau project. Early films with negatively emotional contents, going right up to the cold war, almost always had a denouement that was upbeat and morally and cognitively satisfying. The bad guy got his just deserts. The story's twists were all wrapped up. And whatever mysteries existed were by and large solved. If anything remained, it was highlighted as remaining meaningfully (is the monster *really* dead?). Puzzles were solved and ethical sensibilities were appeased. Alfred Hitchcock's films are well known for (almost) always reaching a comfortable moral equilibrium at the end (except for *The Birds*). But over the past few decades, moral, cognitive, and emotional

ambiguities have not only been tolerated but also are, in some cases, very central aspects of films. As we learned in "slasher" or "splatter" films, the monster almost never really dies, and although we may take the industry standard from a higher class of films than these, the point is a simple one: whatever cathartic processes are at work in us as audience members are not so simply tied to the actual objects and events presented in the film as they once were. Situations in which identification is made between the audience and the bad guy, in which deep moral and emotional ambiguities are left unresolved, in which depressing events mount and are never brought to closure are common now.

I find certain films utterly disturbing. Francis Ford Coppola's *Apocalypse Now*, Stanley Kubrick's *Clockwork Orange*, Martin Scorsese's *Taxi Driver*, and Stephen Frear's 2000 film *Liam* are four. *Liam* is the most depressing film I have ever seen, and although I have not returned to watch it a second time, I own a copy. I plan to see it again. I have seen the other three films in this list numerous times, and I anticipate watching them many more. I cannot call what I feel as a result of watching any of these "comfortable equilibrium." They disturb me, but in that disruption I find some kind of value worth returning to—not as a cognitive endeavor, not as an exclusively intellectual problem-solving event, but as an emotional one. In this, I think I may be on a different track than that of Noël Carroll. His take on why we seek out and return to horror films is cognitivist. We appreciate and enjoy intellectually working through the overall narrative complexity and resolving the problems, both of the characters and of the overall story/plot. Our fear and disgust are not directed at concerns for ourselves but rather at the characters on the screen; we feel for them. The evidence of my own reactions is a more emotionally charged and emotionally responsive one; while I clearly appreciate plot complexity and that appreciation is an intellectual one— and so I think Carroll is correct in this regard—my felt experience is primarily emotional. Although I find "slasher"/"splatter" films not very scary, this is not due to their lack of any serious creative efforts at plot development; it is instead due to the fact that the writers and directors take almost no care in creating a context for me to enter an emotional state of any appreciable magnitude. In contrast, Hitchcock does this extremely well, and anyone with a fear of birds should probably stay away

from *The Birds* even though the story is great fun, intellectually/cognitively speaking. I think of what I experience in viewing these sorts of films as a sort of catharsis,[13] resembling the kind that Aristotle and his commentators discuss. I do not believe that human beings are getting more psychologically complex—perhaps we are, but I doubt it. I believe that filmmakers are now able to develop artworks that speak to us at deeper levels. In some sense, I think that film is becoming a more sophisticated art form, and I see this development as on a par with the developments of much older and more-established art forms.

The point of talking about film and the evolution of what catharsis may now mean to us is to highlight the fact that catharsis, as a species of emotional aesthetic response, is a contextual matter. It depends on the object and its properties, certainly, but it also depends on the development of the art form, preparing us for greater subtlety and greater complexity. It depends on audiences being properly prepared, in terms of being both psychically prepared to be open to these sorts of experience and educated through personal experiences with the development of film. Whether in the final analysis there is such a thing as catharsis is a matter of subjective testimony and psychological and social-scientific inquiry. But I believe there are two things to say here. First, it is a fairly common testimony. A great many people report gaining cathartic experiences through aesthetic attention, and they report this as a common part of their lives. Second, as I sketch out above, this is one of the most intuitively comfortable explanations of why we seek out and return to experiencing art objects that involve and arouse decidedly negative emotions in us. Whether this explanation ultimately survives as the reason we attend to such objects is less the point than its plausibility as an explanation. The very plausibility means that individuals will commonly appeal to it to explain their attraction to such negatively emotional experiences. The commonality of that appeal serves to place catharsis in a central position in terms of one more context that audience members may consider in assessing the worth of such emotionally arousing works of art.[14]

Humor

Of the three areas of the aspects of emotional arousal in this section, humor is the most subjectivistically contextual of the lot. Jokes, comedy,

and wit all require that the audience "get it," and "getting it" requires a more complex set of events than the sort of "getting it" that characterizes a priori intuition, that is, how one "gets" that Socrates must be mortal if he is a man and all men are mortal, or how one "gets" that two plus two makes four, that single planes can contain only one color at one time, that something can, in a single context, be or not be, but not both. Humor is more complex than this, and that complexity turns on the subject's preparation for "getting the joke."

In all cases of humor, there is some cognitive work that must be done. There is a puzzle to be worked out, a problem to be solved. Much humor turns on the incongruous or the unexpected.[15] The audience member then needs to work out the fit: how these unexpected and/or incongruous aspects fit coherently with the object as its own internal logic would have dictated. All art objects have such a logic. They have their own internal structure. This, I think, is a lesson we learned from Kant: it is a subjective maxim that we look for the purposiveness, the intellectually accessible and gratifying structure of an object or event. Events that have such structure we call experiences (here is a bridge between Kant and Dewey). Objects that have such structure are attractive; we look to understand the structure—and perhaps, relatedly, the objects' meanings—and we take pleasure in finding and appreciating that structure. Indeed, the richness of the aesthetic vocabulary that is employed by those who work with pure intellectual structures—such as math and logic—suggests that forms and formal elements are indeed matters about which we can get aesthetically worked up. Rhythms, logics, and structures allow for prediction, and prediction allows for expectation, even in those cases in which predictions are not overtly articulated.

By humor involving the "unexpected," I do not mean necessarily explicitly so. Mel Brooks's *Young Frankenstein* bills itself as the "funniest comedy of all time." Anyone familiar with the writing styles of Brooks and Gene Wilder knows generally where the jokes will fall. The logic of *Young Frankenstein* is a logic of comedy. It has a familiar rhythm, and so the humor is not, in a straightforward or explicit sense, unexpected. By "unexpected," I mean that were the characters in full knowledge of their circumstances, their psychologies, and their use of language, and were the events that ensued simple and easily predictable physical things, there

would be nothing to find humorous. With full knowledge and full consistency, there is nothing funny. Except of course perhaps that. We live in a world without full knowledge and full consistency, so this itself becomes an unexpected and thus humorous object.

We take pleasure in working through a joke, in "getting it," and this pleasure seems on a continuum with the pleasures we find in solving puzzles (such as crossword puzzles), seeing for the first time the way that certain laws of logic, physics, and metaphysics work, working out the meaning of an art object, or simply being able to extract a well-designed structure from an art object. The more challenging the puzzle, the more delight we take in working it out. And it is not uncommon to find that the more we have to invest in getting a joke—that is, the more cerebral a joke, the more prepared we have to be for it, the more esoteric it is—the greater still our delight is. Preparation can involve our being open to the presentation of a joke. It can involve our being intellectually prepared for the challenge of solving the puzzle. It can involve our knowing a great deal of background information that forms the context for the joke. But in most cases, it involves our seeing the incongruity and unexpected nature of the joke. Humor is only humorous when it is "gotten," else it is just a waste of time and effort. And being "gotten" is a matter of subjective context. John Morreall writes,

> There are variations, also, in what individual adults in a single culture at any given time find humorous; one's educational level, social class, profession, sex, etc., can all make a difference here. As any after-dinner speaker knows, the jokes that would go over big at a meeting of academics might not go over at all at a meeting of a labor union. And there is a noticeable difference between the cartoons in, say, the *New Yorker* and the *National Enquirer.* There are even differences in what individuals find funny based on their unique personalities and perspectives.[16]

My six-year-old finds hilarious things that my eleven-year-old and I do not, things such as slapstick and "mugging." My eleven-year-old and I find funny things that bore my six-year-old. And I think I am the only one in the house who regularly finds *New Yorker* cartoons funny. This all has much less to do with the objects than with subjective preparation.

Teaching a film course that enrolls very broadly has given me an opportunity to do a little amateur aesthetic sociology. I find Hal Ashby's *Harold and Maude* poignant, sentimental, and nostalgic. But mostly I find it hilarious. When I require students to view it—as my "black comedy" selection—reports back are quite mixed. Some students find it, as I do, hilarious. Some, perhaps generally half the class, do not find it very funny—except for the more obviously funny parts such as the Eric Christmas speech. The reasons they do not find it funny have to do with preparation, with subjective context.

- Some do not find it funny because they cannot place the jokes in a familiar context. They cannot relate to the strong 1970s pop context of the film. Without this, they cannot predict what is supposed to be funny and what is supposed to be a normal part of that world. The more obviously funny things about the film, such as Harold's action while meeting his "first date," come off as adolescent and dull because those events cannot be placed on a continuum with the more subtly funny things about the film.

- Some students do not find it funny because they cannot relate to the progression of events in the film. They may be able to take the work as a sort of period piece, but they find the sequence of events, as driven by such unusual characters with such unusual psychologies, unbelievable. The more outrageous this becomes, the more distanced—to use that word as Bullough would—they become. With hyperdistance comes a lack of interest in trying to solve any puzzles or find the underlying structure of the sequence of events.

- Some do not find it funny because they cannot work out the logic of black comedy; they are unprepared to find things at once both pathetic and humorous. Without this preparation, they cannot resolve this puzzle, this incongruity.

- Some students do not find it funny—or as funny as I find it— because their acquaintanceship with preparation for comedy has only been of the less subtle forms, the forms with which, not to put too fine a point on it, my six-year-old is familiar. If a

student does not know that he or she must pay close attention, must work to find the incongruities and puzzles, then such passivity is rewarded with boredom.

The other side of my amateur sociology I find equally interesting: when students find films funny that I, outside of the point I am trying to make here, would argue are clearly not funny. I have had a student laugh his way through *Casablanca* and *Raging Bull*. I have had students who find *Harold and Maude* funny but for reasons radically different from mine: they find it funny because they find it quaint. This is what makes them laugh at classic horror films and classic science fiction films. I experience an unpleasant personal reaction to this. It makes my blood pressure rise. It is the same reaction I have when I am working feverishly to get a student to see the progress of a series of premises down to a conclusion, and the student simply cannot get it. "Get it." Again, "getting it" is a matter of subjective context, and were I to internalize my own point better, I would have more patience with my students. When students cannot find a ground upon which to relate to a film, that is, when the events, the setting, the characters, and so forth are alien to them, they cannot construct for themselves a means of prediction. This is the case with all films, but it is particularly the case with comedies because all but the most basic slapstick films require some cognitive engagement (even good slapstick—think of the Marx Brothers—requires some cognitive engagement). Students unprepared for the form of silent films cannot relate to the contexts of these films. Students unprepared for films of more than two hours have a tough time maintaining their engagement with *Lawrence of Arabia* or *Fanny and Alexander*. Students unprepared for pre-CGI (computer-generated images) or pre–George Lucas–style special effects cannot relate to the clunkiness of earlier effects, and so they find *The Birds* funny rather than terrifying. Nowhere is preparation more crucial than it is with humor.

The reason I discuss film again in this section on humor is that it is the most popularly accessible art form. For art forms that are less popularly accessible, the preparation stakes just go up. Humor in the fine arts is not common, and where it occurs, it usually requires a great deal of investment. One works to find it; one works to understand it. But then the delight is usually greater, given the investment. The ability to make

the investment is, once again, a subjective matter. To find something funny is a matter of context. This context is essentially a matter of subjective preparation, but it is also, as the examples above show, a matter of the joke being placed and delivered correctly, against a backdrop of predictable regularity and appreciable structure. Design and delivery are the artist's responsibility, and her exercise of talent in this regard can be judged by how rewarding the puzzle solving is for the audience member. Of course, it is up to her as to what level of audience preparation she wishes to anticipate. There are probably a huge number of jokes out there in the art world that go undiscovered, "un-gotten." Given a broader context and more preparation, we might find the aesthetic world more humorous than we do.

IDENTIFICATION

There are several ways in which audience members typically identify with works of art or parts of works of art. First, it should be said that the sort of identification we are talking about, the sort common to talking about engagement with artworks, is usually made person to person. So the first sort of identification I talk about below is where the connection is made between a particular person and a particular character in a work. After this, I talk about broader connections, where the audience member identifies with themes in works that focus on gender, on sexual orientation, on ethnicity, on religious identity, and on nationality, politics, or class.

Personal Identification

Two nights after watching the first film in Peter Jackson's *Lord of the Rings* trilogy, my son reported having a dream. He started out his recollection by saying, "I was Frodo . . ." He then moved swiftly into telling me the plot of the dream, not lingering to explain how he could be someone else. He took it for granted that I would find it common that one could dream that one was someone else.[17]

Personal identification between a particular person and a character—who is also meant to be a particular person—in a film is common. Part of the reason this is so common is the nature of mainstream American film. Classic Hollywood cinema is characterized as having a focus on

individual characters as causal agents who advance the story through seeking out the satisfaction of their desires. This is a narrative form, a form driven by a series of events, causally connected, forming a more or less coherent story. The most common sort of causation in these types of films tends to be psychological, that is, with psychological causes motivating the narrative events. As the characters realize, will, or pursue something, the story progresses. Classic Hollywood style, then, allows its audiences plenty of opportunities to identify in a personal way with the characters it puts on the screen. Most times we identify with the protagonists, sometimes with the antagonist, and sometimes with supporting players. The reason we most times identify with the protagonist is that the filmmaker tends to create this character with more care, making him or her more true-to-life and more sympathetic. This is also the character who probably spends the most time on the screen, and it is usually that character's psychology, in the sense mentioned above, that drives the film's story. None of these precludes identification with other characters, of course. Depending on shared psychological and physical characteristics, identification can be had with any developed character. My son reported that in his dream he was Frodo. This is canonical, as Frodo is clearly the central protagonist of *The Lord of the Rings,* and apart from the separately developing stories of some of the supporting characters, Frodo's journey—his physical one and his psychological one—take center stage. But my son could easily have reported that he dreamed he was Legolas the elf. In Tolkien's books, Legolas is a somewhat mystical character, kept at a bit of an emotional distance, as is the case with all of Tolkien's elves. In Jackson's films, Legolas retains a bit of that mystical nature, but it is complemented with a good deal of what I can only think to call teenaged bravado—both bravado and the skill to carry it off. Clearly, Jackson's target demographic includes, along with those of us who grew up with Tolkien's books, our adolescent and preadolescent children, whom we no doubt drag off to these films as a rare location of common interest. Our children are rewarded by an action-adventure film, complete with high-powered special effects, that moves more swiftly in form and content than Tolkien's books do. My son's favorite character from the films is Legolas, and I believe that this is because Legolas gets to do the coolest stuff in the films. He is not as fully developed a character as is Frodo (or Aragorn,

Sam, or Gollum), but identification is a matter of a subject's finding familiar (or inspiring) the properties of one particular character, and so this will differ from subject to subject.

In his book *What Is Cinema?* André Bazin writes that "Tarzan is only possible on the screen."[18] By this, he does not mean that you cannot rig up a stage with enough vines and trees to make Tarzan believable. Many more fantastic things than Tarzan stories are done on theater stages. Bazin means that in theater, we experience the actor on stage as a real person, separate and distinct from ourselves as theater patrons. But in cinema, we experience the actor on the screen as a form (what Bazin calls a "tracing" or a "mold") into which we can pour ourselves as the content. I can identify with the cinematic Tarzan in a way that I cannot relate to the Tarzan on stage. The Tarzan on stage is a real live, breathing person. This Tarzan has a full personality, I believe, even if it is not revealed entirely during his time on the stage. The personality and character of Tarzan on the screen, in contrast, extend only so far as the development that the film incorporates. Beyond this, he is everyman (or everyperson; I feel sure that some women identify with Tarzan, especially if the only other options are Jane or the chimp). What is unrevealed on the screen of Tarzan's personality can be filled in with my own. This means that so long as the parts of his personality that the film reveals are items to which I can relate, there are no hidden aspects that I need worry about in terms of my finding those aspects to be things to which I am unable to relate. Bazin's point is meant to say something about cinema as an art form, and especially as an art form distinct from theatre, but in showing this distinction he also captures some of the nature of the mechanism that allows person-to-character identification.

The points that are made here positively could as easily be made negatively. When we identify with an antagonist, to the degree to which that identification is with an antagonist and not with the more protagonistic of his or her qualities—that is, we identify with the negative characteristics rather than the positive—we do the same as in the Tarzan case. We do not allow ourselves to fill in the rest of the character's personality with something alien to ourselves. We fill in the blanks with ourselves. This allows a stronger relation, a stronger reaction, and a stronger identification. In cathartic ways, this is wonderful. It allows us to examine in

a crucible those aspects of ourselves that we would aspire to be rid of. They can be taken in isolation, given that they form the explicit connection between oneself and the character with whom one identifies, and they can be studied from that vantage point. This allows for the possibility of surgical excising. From the perspective of catharsis, identification with an antagonist qua antagonist may be more beneficial to us as psychological creatures than the positive identification we might make with heroes. However, positive aspiration may achieve similar results and come at less of a personal price.

Personal identification can happen in other art forms, of course, beyond film. Literature is the obvious example, but anywhere you have the development of a character can lead to identification between a particular audience member and that particular character. Opera is a good example. More than one audience member has felt empathy for the longing and ultimate despair of Madame Butterfly. More than one person has related to the jealousy and rage of *Carmen*'s Don José. Story-driven dance, as is the case with much of ballet, is not as good an example. I am sure that there are each year at Christmas many children who identify with Tchaikovsky's Clara. Perhaps a better example is the identification that one can make with the main character in George Balanchine's *Prodigal Son*. An artwork with a well-crafted character, capable of inspiring sincere empathy, given an audience open to and capable of forming an identification bridge, is a more valuable work than it would be were such identifications not readily available.

Gender and Sex

The other sort of identification I want to discuss is a broader sort: the identification that one can make, through artworks, with various general themes or abstractions. What I have in mind here is identification with aspects of a work of art that convey, symbolize, or stand for a particular aspect of gender or sexual identity.

Frida Kahlo's work has been described as portraying deep insights into experiences not uncommon to women. I want to say that these insights are into the feminine, but Kahlo's work seems to transcend whatever connotations may come along with "feminine." Kahlo's work is largely autobiographical. She painted many self-portraits, all expressing some

particular sense of herself. These senses are frequently roles in which she sees herself cast. Many of her self-portraits, perhaps most, communicate complexes. One understands feelings of pain, of resignation, of frustration, of absurdity, of being cast in roles that one would not have sought out on one's own. Kahlo's work communicates to me in hints of what it was like to be her, with an emphasis on *her*. While I understand to some small degree what it was like to be Frida Kahlo, I understand also, again to some small degree, what it is to have faced the life she led as a woman. Kahlo's work, seen from this perspective, has contributed immensely to its popularity but also, what is more important, to its power as art.

John Steinbeck gives me some sense, through the character of Tom Joad in *The Grapes of Wrath,* of what it is to be a man faced simultaneously with inescapable familial obligations and an inability to figure out a way to meet them. J. D. Salinger, in *The Catcher in the Rye,* and Anthony Burgess, in *A Clockwork Orange,* both give me a sense of what it is to be an adolescent male in a certain societal setting. Virginia Woolf, in *To the Lighthouse,* gives me a sense of what it is to be Mrs. Ramsey, a wife and a mother. Art can illuminate aspects of gender and sexual identity, and we can identify with these aspects—their portrayal and their development—in characters in paintings, in books, on the stage, and on the screen. Conversely, we can look at a great number of artworks through lenses designed to filter out this aspect, to hold it in isolation for study, so that we can learn whatever lessons are there about gender and sexual identity. I am sure that when I, as a rather docile adolescent, read *A Clockwork Orange* for the first time, my thoughts were on the formal crafting of a very cleverly written book and on metaphysical and physical issues about free will. Now I see in it a broader topic about what it is to live out one vision of the fully realized adolescent male life. To see such things in such works is to see them as having a greater significance than they would have were they simply particular stories about particular people and events, regarded atomistically. Their power lies in part in the greater stories they tell.

Ethnicity

I can think of no artist who more powerfully and aggressively portrays issues of ethnic identity than Adrian Piper. I can think of other artists who

may have more-lasting effects or broader audiences, but Piper's style of communication leaves no holds barred. In 1991, I saw one of her installations in New York's Museum of Modern Art. It was a full room, painted starkly white, with bleachers on all four walls. Viewers were invited to enter and sit on the bleachers. In the middle of the room was a column with four sides. Near the top of the column were four television monitors, each facing a different way. Displayed in the monitors was what could be taken for the head of a single person standing inside the column. The head would periodically move to face a different wall, with the sides and back of his head facing the other walls. The head was that of an African American male who was speaking in short sentences of the attributes that he did not possess. All these attributes came from negative stereotypes of African Americans, particularly males, and they were not abstract in nature; they were concrete. I am Hispanic, but my own minority membership did not for a moment relieve me of the sense of discomfort at being a member of the demographic in whose history can be traced the origins of such stereotypes. This discomfort was not the result of didactic means. Piper was not, in the straightforward sense, preaching. She was simply setting up a context in which ethnic identity, both that of the man whose head was on the screens and that of the occupants of the white bleachers, would be spotlighted (either positively or negatively, depending on who was occupying the bleachers). Very powerful. This was not the first time I had seen Piper's work, but this piece has stayed with me more than others.

On the far end of the continuum is the work that Mary Devereaux discusses in her essay "Beauty and Evil: The Case of Leni Riefenstahl's *Triumph of the Will*" (see chapter 4 for my discussion of this film). Riefenstahl's work is a celebration of national and political identity, of course, but it is more than that. Such national and political identity is made richer and more plausible because of the ethnic message of the film. The film celebrates German virtues and German history in a way that allows its original viewers, and perhaps even some today, to take the step of believing that a certain vision of national and political identity is the best means to continue that ethnic tradition.

I want to compare nothing to Riefenstahl's film, and I want to put very little near it on my ethnic-identity continuum. However, I do need to

make the point that the ethnic identification that audience members make through attention to works of art is more generally a celebration of that ethnicity than an indictment of one's own ethnicity or attacks on the ethnicities of others. Today, for many reasons, we are more cautious about characterizing ethnicities in ways that may lead to stereotyping. Where we err, when we err, we err on the side of noncritical celebration of the ethnicities of others. This is an error easily forgivable, I think, and it may have the utilitarian/educational effect of inducing even greater openness to ethnic difference. This is a good thing. But my ethical sensibilities notwithstanding, the point of all this is to focus on the fact that through many works of art we identify with ethnicities, our own and others. Again, works that tell bigger stories are more valuable as artworks than are ones that tell necessarily particularized stories.

Nationality and Politics

The next chapter is on meaningfulness and communication, and I spend a good deal of time talking about nationalism and political propaganda there; thus, little time need be devoted to the subject here. However, highlighting the distinction between nationalist or political communication and nationalist or political identification is important. There are a host of artworks that have as part of their foci national identity that do not mean to communicate any message about it. Monet's focus on France does this, as does Paul Gauguin's focus on Tahiti. Jasper Johns's iconic use of the American flag does this. The fact that Damien Hirst and his contemporaries are collectively referred to as Young British Artists does this. Works produced by these artists are not works that are meant to convey particular political messages. That Johns decided to use the symbol of an American flag has more to do with the iconic nature of that flag than it does with a particular celebration of nationalism. Presumably, the arrow goes in the other direction: Johns used the American flag because it was already popularly celebrated, not because he meant to add to its iconic nature. These artworks and many others promote a recognition of their national originating contexts. There are many people who would own a Jasper Johns work well before they would consider hanging any other product of modern art on their walls. Some might feel that they are missing the point, but for my purposes, they provide good evidence of

the point I am making here: they find value in national identification qua national identification.

Class

Charles Dickens must be the king of artists creating works with a focus on class distinctions, distinctions of birth, of circumstance, and of wealth. Shakespeare was pretty good at this, too, many times keeping separations between plots and subplots localized to different classes. In both cases, the goal seems to be to give an accurate characterization of the climate of the time. If artworks have both elements that strike us as new and novel and elements that provide a backdrop of reality, a basis upon which the new and novel can be spotlighted, then many artists (perhaps more working before the twentieth century than afterward) have seen class as part of the reality backdrop. This is fine, and it is purposeful, because only against the familiar are we able to really consider in depth the new and novel. This is a point made above in connection with humor.

On occasion, the spotlight is placed on class distinction itself. Margaret Mitchell's *Gone with the Wind* shows a woman consumed with the accouterments of class who, by the end of the book, has reduced class down to functionality, keeping only those trappings that help her survive. Edouard Manet's *Olympia* features two women. One woman, the woman of the higher class, is reclining on a bed, nude except for one shoe, jewelry, and a hibiscus flower in her hair. The other woman, the woman whose role it seems is to serve, is fully clothed, perhaps overclothed, given the amount of fabric that Manet paints for her dress. She is holding a pillow in front of her, and embroidered on this pillow is a collection of modest flowers. From the expressions on the faces of both women, from their choice of garb, their choice of flowers (if "choice" is right), and their postures, one gets a sense that they have very different sensibilities. As has been the subject of prior discussion, it is not clear which sensibility is the (morally?) better of the two. The serving woman looks more than concerned; she looks nervous. With the addition of a scared small black cat at the foot of the bed, which I have always associated more closely with the woman on the bed rather than the serving woman—whose house and pets are these, anyway?—we get the sense that the woman on the bed is worthy of inciting nervousness. In many artworks, the moral

sensibilities of members of various classes are compared, with the more common theme being that privilege can corrupt. Consider Evelyn Waugh's *Brideshead Revisited*, Tennessee Williams's *Cat on a Hot Tin Roof*, or Mary Shelley's *Frankenstein*. Beyond the portrayals of class as background reality and as a basis for moral commentary, we find a good many works of art that focus on class transition. Dickens famously works on this in *Great Expectations*. Sometimes class-transcending experiments are rewarded and characters are elevated. Sometimes the lesson of the story is that one should be content with one's station in life. But, as occurs with the other contextual issues related to identification above, as these artworks spotlight class, they illuminate broader themes that those in whom such themes resonate will value.

Religious Identity

It is easy to see how religious works of art are driven in their creation, their provenance, and their celebration by adherents of the religion that forms their context. Leonardo, Michelangelo, Bach, and Handel created great works of art, many of them most easily understood in Christian contexts. Religious identification can function in a variety of ways. I present three effects of religious identification below.

First, religious identification can lead to offense when audience members find themselves faced with a particular work that they find sacrilegious or blasphemous. In previous chapters, I discuss the responses to Chris Ofili's work and Andres Serrano's work. Viewed outside the context of religion (or Christianity or a particular version of it), Ofili's multimedia visual image and Serrano's photograph would have caused only the excitement they would have had they been regarded simply formally. But of course, these works were to be viewed within a religious context. The artists intended this, as evidenced in their choice of titles and their use of images that are iconic for practitioners of Christianity. (This first area represents an arena in which formalism may be favored over contextualism if the goal is enhancing the value of the art object as the focus of the audience member's experience.)

Second, religious identification can lead, through positive identification, to experiences that become at times massively richer, where both the artist and the audience share a common religious context and where

both seek to celebrate that context. A Roman Catholic's visit to St. Peter's Basilica, to the Sistine Chapel, and to the Vatican's art collection will most likely result in a deeper and more rewarding experience than a visit by a Hindu or a Buddhist. I talk about issues of meaningfulness, including religious or spiritual meaningfulness, in the next chapter, so I will leave this matter for now.

Third, religious identification can lead to an intensification of experiences where the religious context is shared by the audience member but where the artist is not interested in communicating anything particular about the religion itself. Here the artist merely uses the context to bolster the power of the object's effect on the audience. We see this in the use of mythic themes.

When my eleven-year-old son first saw Jackson's *Fellowship of the Ring,* the first in the trilogy, he was critical, so much so that I had to implore him to keep his views to himself until we reached the car; we were there on opening day, and the lines of enthusiasts were long and excited. One of his criticisms was that Jackson (and Tolkien) stole a lot of his material from J. K. Rowling. Art critical thinking is critical thinking and so always to be applauded, and my son was not unhappy when I pointed out that his chronology was backward. The larger point is that much of the content that Tolkien employed was not novel. He used characters, as does Rowling, that are part of the broader Western cultural playing field. Tolkien did not invent elves, dwarves, wizards, or trolls. Neither did Rowling. In fact, Rowling takes a step further than Tolkien did; she uses much of this culturally Western fantasy ontology as part of her reality backdrop. This is, I think, part of what has made the Harry Potter series so successful as both literature and film. Rowling is able to capitalize on the common context, *taking it as common context,* and so builds a story in a pre-made, yet very "other," world. This world is a world of myth, and myth and religion are clearly on a continuum. Context means everything to Rowling's work; without it, her series would have had to do a great deal more backdrop creation. This is the same with Tolkien, with Lewis Carroll, with C. S. Lewis, and with science fiction writers such as Arthur C. Clark, Madeleine L'Engle, and Frank Herbert. Science fiction and fantasy have their own conventions, ontological and mythical elements that are common and easily taken as ordinary reality in the worlds constructed by these writers.

I have saved my favorite example of religious identification for last. In 1976, *The Omen,* by David Seltzer, was published. I turned thirteen in 1976, and I remember buying a copy of this book. When I was thirteen, I was a devout Southern Baptist. This was before the takeover of the Southern Baptist Convention by the self-described fundamentalists in the mid-1980s, but even in the mid- to late 1970s, it was a conservative denomination: no drinking, no dancing. During this time, conservative Christian denominations were very interested in eschatological issues, issues having to do with the end of the world, particularly as it was forecast in the book of Revelations. So I was getting a steady diet of this. My end-of-the-world, Bible-based religious context was firmly and massively in place. This resulted in Seltzer's book robbing me of very many nights' sleep. My attitude toward *The Omen* was not distanced or disinterested. I certainly understood that it was a novel, and being an avid reader in my youth, I certainly understood the conventions of reading novels, but this did not matter. I could not read this book without taking it, to some degree (however modest), as a vision of the end of the world that could just possibly be accurate. After all, it was Biblically based, and Southern Baptists then and now, by and large, take the Bible as fully true. William Friedkin's film *The Exorcist* was released in 1973, and although I did not see it until much later, although Protestant ontology includes demons but not rituals for their exorcism, and although I had probably left being a Southern Baptist behind by that time, I am sure that my religious upbringing was nevertheless brought to bear on how that film affected me when I did see it. I love horror films. The main reason that I love horror films is that they scare me. The scarier they are, the more I like them. If I can be persuaded that the events and characters of a film are plausible, the film will be all the scarier. Horror films that are too fantastic do not scare me. "Slasher"/"splatter" films do not scare me. But films in which normal people in fairly normal circumstances undergo abnormal events—Jack and Danny Torrance in Kubrick's version of *The Shining,* Clarise Starling in Jonathan Demme's *Silence of the Lambs,* Max Cady and Sam Bowden in (either the 1962 or 1991 version of) *Cape Fear,* Marion Crane and Norman Bates in *Psycho,* Niles Perry in Robert Mulligan's *The Other*—these are great scary films filled with people not dissimilar from my friends, colleagues, and the kids my kids go to school with. My religious

sensibilities, and so my religious contexts, have evolved a bit since I was in high school, but then the scariest films for me were directly connected to what—on a weekly basis—I was being told was the real world. Seltzer's book did not have the effect of making me shy away from artworks that would result in lots of lost sleep: quite the reverse. The power of the combination of Seltzer's story and my preset religious context rendered a very rich and valuable aesthetic experience that formed a basis for my seeking out many similar experiences. If the success of a horror film is based on how frightened it makes its viewers, and the greatest aesthetic experience regarding a horror film is to feel maximally frightened, then shared context, even where the artist is merely using that context to boost the power of his or her work, can result in powerful aesthetic experiences.

All of these examples of identification—personal identification, gender and sexual identification, ethnic identification, political and national identification, class identification, and religious identification—are contexts through which a work of art may be considered, understood, and appreciated. Identification is something that happens to or in a subject in response to a work of art as that subject brings that work under a particular concept, regarded within a particular context; of course, for such a contextualization to have an effect, the work itself must speak from that context. On occasion, such identification can harm the quality of the aesthetic experience and decrease the worth of the work of art for that experiencer. On these occasions, a formalist approach (that is, an approach focused on aesthetic analysis rather than aesthetic experience, perhaps occasioned by adoption of an attitude of disinterest or psychic distance) may be warranted and even recommended. But taking a formalist approach should be considered carefully, for two reasons: first, these occasions present themselves, among all those art experiences that provide for identification, only a small minority of the time, and, second, it is unclear that undergoing some pain through identifying with characters and themes is necessarily a matter of the work of art being less valuable than it otherwise would be. Often, we endure small pains to reap greater rewards, and on occasion (as I discuss above with negative personal identification), this speaks to the greater power of the art object. In the majority of identification situations, we experience no pains to reap

rewards; in most cases, identification either with a character or with a theme allows us to learn about ourselves and those around us. Normally, identification enlivens one's experience of a work of art, and the greater that identification—the more intimate, the more emotionally moving, the more intellectually engaging, the more insightful or instructive—the greater the power of that work of art.

IMAGINATION

In chapters 1 and 3, I discuss Archibald Alison and his theory of imagination and association. Imagination, for Alison, is a matter of actively drawing out, through attentive contemplation of the object, associations in the subject. I need say little more here, then, about his theory. Its relevance is obvious.

No art object comes to us complete. It cannot. Aesthetic value, says Alan Goldman, lies in the object's "engag[ing] us so fully as to constitute another world for us, at least temporarily."[19] Aesthetic judgment, then, can be built on this model. Art objects are better to the degree to which they can engage us to this level and according to this fashion of constituting for us another world. No art object can do this completely. The world we live in is gigantic. It is composed of massive amounts of matter and space—some believe infinitely so—and time that stretches at least fourteen billion years into the past. No art object can seriously suggest a challenge to this. So for an art object to constitute another world for us, we must think of this only in abbreviated, abridged, or perhaps symbolic ways. By definition, none of these is complete. So for us to move to contemplation of the other world that the art object offers is for us to be comfortable in filling in the blanks for ourselves. Roger Scruton writes, "When I summon the image of a horse in the absence of a real horse, or invent the description of a battle which I have heard about from no other source, my image and thought go beyond what is given to me, and lie within the province of my will. Such inventive acts are paradigm cases of imagination."[20]

Filling in the blanks can take either a conscious form or a kind of implicit form. It is more common in film today to see, in a dialogue, a series of shots, first of the one conversant and then of the other. It is rare

to see both conversants in the shot for the entire dialogue. The famous balcony scene in Franco Zeffirelli's film version of *Romeo and Juliet* is a great example of this. Except for as little as 5 percent of the exchange between the two, maybe less, the screen contains only one of them at a time. These are two of Western culture's most celebrated lovers, and yet in their most thematically central of scenes, the director does not visually keep them together. Does anyone miss Juliet when Romeo is on the screen? Does anyone miss Romeo when Juliet is there? Not at all. It is because we are conscious of their intimacy, of the fact that they are talking passionately to one another, that our imagination fills in the blank of the visual presence of the other during the dialogue. When we hear the nurse call for Juliet, we do not need to see her. We do not even need to continue to hear her call as Juliet attempts to break free of Romeo's dialogical embrace for us to know that the nurse is what prompts Juliet's nervousness. We do not need to see Mercutio and his band to know that Romeo hides from them at the start of the scene. We do not need to see the Capulet family, the ones with swords, to know what sort of danger Romeo is in. We fill in the blanks. We do this consciously: not in the sense that we are conscious that we are doing this but rather that we are conscious of the fact that in the make-believe world of Romeo and Juliet all these other things exist.

We also fill in the blanks in a more subtle way. We know when Romeo scales the walls of the Capulets' garden that he could fall and be injured. We know that, in the Zeffirelli film, when he climbs the tree to get to Juliet, gravity is offering him some resistance. We know that swords can injure, and we know this well before they have drawn blood in the play. We know that fair Verona is in Italy, and we know that the play is set at a point earlier than when the Tudors left the English throne to the Stuarts. We know that everybody in the play is Roman Catholic. We know that this means that a wedding entails a priest, as does confession. We know, to make sense of part of the balcony speech, that the moon goes through phases. We fill in the blanks to create enough of a full world in which to set those objects and events that the play explicitly gives us.

Filling in the blanks is the activity of the imagination. When we read, we give the book's characters a physical visage, based on what clues the writer gives us. These clues are never complete, and so we imaginatively

fill in the blanks. We call upon associations we make between the clues the writer offers us both of the physical and of the psychological attributes of the character and our own experiences with people who are in these respects similar. Although Shakespeare does not describe their physical attributes much, I have never heard of anyone imagining either Romeo or Juliet as gawky or otherwise unattractive. We fill in the blanks: anyone who can deliver this level of verbal eloquence cannot be gawky, and anyone who, like Romeo (and at his age), attracts girls the way both Benvolio and Friar Lawrence suggests he does cannot be physically un-attractive. These things are not given to us; we create them imaginatively.

The exercise of our subjective imaginations can enhance a work of art dramatically. The lack of such an exercise can turn a work into a source of boredom. Part of this rests, of course, with how well the work itself engages us, prompting us to fill in the blanks and to fill them in richly and interestingly. But part of this rests with us, with our imaginative abilities and our level of aesthetic investment. Art objects explicitly offer us only a tiny fraction of 1 percent of a full world. This goes for Tolkien and for Dr. Seuss. For these objects to be so engaging as to constitute other worlds for us, we have many blanks to fill in. Every blank we fill in represents some relation between what the artist gives us and something that we in turn are offering back. We do a great deal more than simply offer the pure intuitions of time and space or transcendental categoriza-tion in terms of substance, causality, reciprocity, and the rest. Kant's recommendation to hold the object out of relation with history, with other objects, with our own personal associations has to be rejected. It is through bringing to the party all these relations that art objects are able to occasion great experiences for us. Loss of active imaginative contempla-tion and association, together with all the externalities we individually and relativistically contribute, means death to a rich aesthetic life.

7 Issues of Meaningfulness

I NEED TO STATE HERE AT THE OUTSET THAT MY focus in this book and in this chapter is not on the semantic content of works of art. While I certainly agree that careful interpretations of artworks can enhance the value of the experiences of those who consider these works under these interpretations, interpretation—conceived not in terms of theories of how one should go about it but simply in terms of an aesthetic activity—is principally a cognitive activity that audience members engage in. This activity may have the character of constructing an account wherein all the various aspects of a work of art—however widely or narrowly that properly should be done—are brought together coherently. And it may have a goal: to enrich the experience of the audience member.[1] Interpretation may even, as the New Critics would have it, be explicitly directed just to what is formally present in the art object or event. But despite narrow readings of New Critical approaches, the fact is that the *meanings* of works of art are not something that they contain as formal or objective elements; to have an interpretation, one must have an interpreter.[2] There is some subjectively additive cognitive work that must go on in the mind of the subject in the creation of an interpretation. If this is true, and if we take anything added to the artwork by the subject as a matter of context, then it makes interpretative activities inescapably contextualist. This is one possibility, though I am sure the issue is not settled here.

Contextual interpretation of works of art is a rich area, and perhaps some discussion of contextual interpretation is warranted in a book like this. Were I including a focus on interpretation, I would feel obliged to offer at least a full chapter on deconstructionism. Clearly, deconstruction is currently the most context-sensitive approach to considering the meaning of a work of art. Deconstructionists suggest that we cannot come to understand *the* meaning of the object, since there is no referent, standing outside the interpretation, of any given text or object. The subjectivity that informs grasping the semantic content of works of art is comprehensive on the parts of the artist and the audience. The deconstructionist, then, is obliged to say not only that at times context can be relevant but also that all there is, is context.

The focus of this chapter is narrower, focused not on interpretation and the meaning of works of art but rather on the meaningfulness of works of art. In this chapter, I discuss the meaningfulness of art objects not in terms of methods of content interpretation but rather as a fact about the impact the work has on its audience. This force of impact is the same sort of thing I was talking about in the preceding chapter, only here I focus the discussion on the power of the work for communicating. Once again, for clarification, the focus is not on how the semantic content of a work of art is discovered or established. My focus here is on the supposition that insofar as a work of art has a semantic content, that work is more valuable because of it; in addition, the very fact that a work has a semantic content is a matter of context.

Let me make one more point before going on. The semantic content of a work of art can be carried by many syntactic vehicles; the meaning of a work can be communicated through more channels than merely the narrative or strictly textual elements of that work. "Narrative fixation" is the view that works of art are best or even exclusively dependent for their meanings on their narratives. Narrative fixation is prevalent in film interpretation, yet narrative is but one of many aesthetic features of a film. Traditionally, film form, the understanding of film structure, is divided into (1) narrative aspects, (2) stylistic aspects, and (3) motifs. The critic who ignores items 2 and 3 ignores a great deal. A film's mise-en-scène—its sets, props, costumes, lighting, and the movements and gestures of the actors, the way that three-dimensional space is created—

is not film narrative. A film's cinematography—the photographic aspects of what we see on the screen, the framing, the duration of the shots—is not film narrative. Stanley Kubrick's *Eyes Wide Shut* is visually arresting. It is the most colorful of all of Kubrick's films.[3] Kubrick, for the first half of the film, keeps all the back planes of the mise-en-scène out of focus (presumably by using long lenses). These are decisions that Kubrick made that, while perhaps relevant to the film's narrative, really have little to do with film narrative per se. Consider a film's sound. Music in film is common and is usually nondiegetic. As above, though music is relevant to narrative, it is not narrative. Its purpose is frequently to focus attention on something in the film or to heighten the viewer's emotional response. In general, nondiegetic elements of a film, those things that lie outside the film's world, outside its ontology, are not narrative elements of the film. There are many directors who do not make films that have what we commonly think of as classic Hollywood narrative, a story driven by the psychology of a protagonist for whom we feel sympathy and to whom we can and want to relate. Consider the films of Ingmar Bergman, Sergei Eisenstein, Terry Gilliam, and even Spike Lee and Woody Allen. On a scale of one to ten, the levels of narrative coherence in their films would generally rate below a five. Yet many commonly believe that all five of these directors produce films of deep meaning, perhaps deeper than most directors, even other talented auteurs. Listen to two academics inside their ivy-covered walls discuss a film. The chances are fairly high that their discussion will focus on the film's narrative. Narrative, text, story is but one avenue of assessing an artwork's meaning. Semantic content can be carried by non-narrative formal elements of works, too.

POLITICAL MEANINGFULNESS

In the second half of the twentieth century, we began to take up the practice of referring to societies of indigenous peoples from this continent, of Native Americans, as nations. We speak about the Seminole nation and the Cherokee nation. Yet these nations, as political units, are geographically subnations within the United States of America. The difficulty here is not merely hierarchy but also geography. If we take a people to constitute a nation only when their sovereignty reigns fully over a geographical lo-

cation, the practice of referring to Native American nations as nations makes little sense. Neither would it make sense, on the other side of the world, to speak about the Tibetan nation, since it is the sovereignty of China that reigns there. We too often have a "map mentality" about what constitutes a nation: we look at a map or a globe, and we see that each "nation" is in a different color. There are three regions of color in North America. There is one color for the entire continent of Australia. There are many, many regions of color in Europe, as well as in Africa. We see these regions of colors as bona fide nations. We of course realize that boundaries shift, and the names that identify these geographical regions may change, but these regions of uniform color encourage us to think of nations as geographical entities. Many Americans heard the names "Kazakstan" and "Uzbekistan" for the first time only after the Soviet Union ceased to be. Why was this? Because when we (Americans) looked at a map or globe, we saw that there was one color, and only one color, signifying the geographical area of the Soviet Union. Certainly for the duration of the cold war, Americans saw the Soviet Union as one state, one "nation."

The idea that a nation is defined geographically runs counter to our actual use of the word *nation*. The same is true of the reign of sovereignty. The Tibetans share in common with one another such cultural things as values, beliefs, and language that the Chinese do not share. Certainly Tibetan culture and Chinese culture share more in common than do Tibetan culture and Mexican culture, but the matter is not one of degree. China and Tibet are different nations. However, Tibet is not a sovereign nation in the sense that it is an independent nation, in the sense that Tibet has "home rule." Are the Seminole nation and the Cherokee nation sovereign over themselves? In one sense, yes, but in a wider and perhaps deeper sense, no. The only indigenous people in the United States today who are free from the daily influence of the federal government are the Traditional Independent Seminoles living in and around the Everglades in southern Florida. Members of this group do not have social security cards; they do not have birth certificates; they do not pay taxes; they do not carry "BIA" cards. But they are the exception. Most nations of indigenous peoples living within the borders of the United States do indeed feel the daily influence of a sovereignty not their own. Are these nations properly

called nations? They share in common with one another all the cultural elements that are shared in common by all Tibetans. If the Seminole nation and the Cherokee nation are properly nations, as the Tibetan nation is properly a nation, then the ability of a people to rule itself, independent of the influence of another power, is, like geographical location, not a proper factor in determining whether a certain people constitutes a nation. Geographical location and governmental sovereignty are but two issues in the consideration of how one ought to define "nation." To be sure, there are many others. But these two demonstrate the point that defining a nation must have more to do with what we can broadly term "culture" than it does with politics or with maps.

Nothing so readily identifies a people as art and cultural artifacts. So it should come as no surprise that nationalist communication—including propaganda, general efforts at enhancing or encouraging patriotism, and political campaigns, both friendly and aggressive—makes use of art objects or objects that are at least candidates for being labeled art. Throughout this section of the chapter, I will use the following definition: nationalist art consists of artifactual objects accepted and interpreted by the art world as art that support the assertion of self-identity of a people made over and against other peoples or states as a declaration of the right to preserve and advance its own identity in an international world. I first review two theories of art that understand art functionally in terms of its support of the state. Next, I explore some examples of nationalist art and examine some of the reasons for the creation of nationalist art. Finally, I discuss how art understood from a nationalist perspective, within a nationalist context, has added and can add to its value as art.

Political Art Theory and Karl Marx

Creating, celebrating, or censoring art on the basis of its relationship with the state, society, or nation has theoretical foundations. If we take nationalist art in the broad sense to be art that is supportive of a nation's self-identity, particularly in contrast to that of other nations, then theories that offer specific reasons for connecting art and society provide us with insight into how nationalist art is meant to function in support of nationalism. Most of the examples of nationalist art that I will discuss come from the eighteenth, nineteenth, and twentieth centuries. Most of the examples

of theories that support the creation and celebration of nationalist art (or the censoring of non-nationalist art) come from these centuries, too. In chapter 4, I discuss the theories of Plato and Tolstoy, both of which have strong societal contextual aspects. Here I want to discuss two more theorists: Karl Marx and Mao Tse-tung. Their theories are explicitly and exclusively about nationalist art, and this is why they were saved for this chapter.

Karl Marx (1818–1883) was a writer, not only of political and philosophical theory but of literature as well (although he was clearly more successful in the former). He was raised in Germany, and art and aesthetic theory were part of his education. This included exposure to the aesthetic writings of Friedrich von Schiller. Schiller believed that the aesthetic is the fundamental harmonizing element of human life, and commentators on Marx believe that Marx's conception of a fully actualized life was strongly influenced by Schiller's view. Marx's political-philosophical position has come to be known as *historical* or *dialectical materialism,* and the position on art that evolved from his work has come to be known as *social realism.*[4] The relationship between these theoretical positions was at times strained—not quite inconsistent but not always entirely coherent. This is due to the fact that the relationship between the ascendancy of cultural elements in a society does not always jibe with that of the ascendancy of material elements of that society. Art can flourish in nations that are materially modest, as it can decline or devolve in nations within which the material conditions are rich. To understand all factors of a society in terms of the material conditions of that society does not easily fit with the facts about a society's cultural life and work.

However, largely because of his political-philosophical views, Marx's views about art tend to be highly contextual. Marx saw art as wrapped up with other social concerns. It does not stand alone; art is not for art's sake. It is a social institution, and so the best way to understand art is through the broader context of its creation and its trends. Certain forms of art and trends in art depend on the sorts of societies in which those art forms and trends arise. An artist's sensibilities, inspirations, and interests are tied to the social conditions that allow and inform one's life as an artist. (This connects to the discussion of Alois Riegl's views in chapter 4.) And social conditions, for Marx, are a consequent of material conditions. Marx believed that the artist's very consciousness is a matter

of the social-material context in which the artist works. This naturally binds or constrains the artist and thereby the art that is created by the artist. As a matter of determined fact, thought Marx, societies produce certain sorts of art dependent on their social conditions.

Social realism is in part a matter of offering advice and in part a matter of making a prediction about the art that a given society will produce; it is both prescriptive and descriptive. Marx's realism is not the sort of aesthetic realism that we might find Plato or Aristotle discussing. Aesthetic realism is sometimes meant as a theory concerning the existence of aesthetic properties, and it is sometimes meant as a theory concerning the precision that should be sought in the creation of works of art that seek to imitate or represent. Although Marx's realism is closer to this second sort, it goes beyond this. Marx's advice to artists is to portray as realistically or faithfully as possible the typical lives of typical members of the society. The ordinary presents the truth.

Lenin put the Marxist views to work by taking Marx's understanding of the relationship between the artist and the state and then maintaining that the art should be put to the service of the state or, to be precise, of the party. The artist should not only demonstrate the reality of the lives of those in his society but also show in his artwork the reality of the social forces that motivate and move those in that society. The artist should show the deeper reality.

Plato, Aristotle, Tolstoy, and Marx all agreed on one thing: art teaches. For Plato, it is an ineffectual teacher. For Tolstoy, the worth of any particular artwork depends on its level of teaching, on its level of communicability. For Marx (and those who followed him), art teaches by showing reality, and by showing that reality deeply, by showing the social and material conditions that make the reality of a particular society what it is. In the work of both Plato and Marx, art should support the state. It does so, for the former, by revealing the heroic, the elevated, the exemplary aspects of the state and its citizens. For the latter, art supports the state by showing reality, as typically, ordinarily, and deeply as possible.

Political Art Theory and Mao Tse-tung

Few contemporary political leaders have affected the culture and art of their nations more than Mao Tse-tung. Mao was born in 1896 to a peasant

　　　　　　　　ISSUES OF MEANINGFULNESS

family in the Hunan province. He served in the Nationalist Army from 1911 through 1912. In 1918 he graduated from a teacher training school, and in 1920 he became head of a primary school in Changsha. He left teaching for politics in 1921, and in 1923 he was working full time with the Chinese Communist Party. Mao was the first chairman of the Chinese Soviet Republic, after being elected in 1931. Over the next two decades, the Nationalist Party collapsed, and in 1949 the People's Republic of China was born, with Mao as its first president. Mao died in Beijing in September 1976.

Like Marx, Mao believed that there is no such thing as "art for art's sake"; instead, all art belongs to definite classes and is geared to definite political lines. But Mao went further than Marx (although clearly not as far as Lenin and Stalin) by not only recognizing the connection between art and class but also insisting that art should serve the proletariat revolution. "Proletarian literature and art," he said, "are part of the whole proletarian revolutionary cause."[5] Mao believed that art and literature are for the masses, "created for the workers, peasants and soldiers and are for their use." He went on, "Our literary and art workers must . . . gradually move their feet over to the side of the workers, peasants and soldiers, to the side of the proletariat, through the process of going into their very midst and into the thick of practical struggles and through the process of studying Marxism and society."

The purpose of creating and supporting art and literature for the masses was to support the revolution. Mao believed strongly in the social power of art to move the masses, to strengthen their resolve in revolution. In one sense, then, Mao was a leading proponent of propagandist art. The purpose, Mao said, is "to ensure that literature and art fit well into the whole revolutionary machine as a component part, that they operate as powerful weapons for uniting and educating the people and for attacking and destroying the enemy, and that they help the people fight the enemy with one heart and one mind. . . . Revolutionary culture is a powerful revolutionary weapon for the broad masses of the people. It prepares the ground ideologically before the revolution comes and is an important, indeed essential, fighting front in the general revolutionary front during the revolution."

But while Mao clearly believed in art as propaganda, he did not—at least originally—want art to degenerate in such a way that it lost its artistic or aesthetic quality. Mao said, "What we demand is the unity of politics

and art, the unity of content and form, the unity of revolutionary political content and the highest possible perfection of artistic form. Works of art which lack artistic quality have no force, however progressive they are politically. Therefore, we oppose both works of art with a wrong political viewpoint and the tendency toward the 'poster and slogan style' which is correct in political viewpoint but lacking in artistic power." Mao was aware that propagandist art, in its zeal to communicate a political message, can move away from its aesthetic grounding and the focus on artistic quality. He realized that art that moves in such a direction loses its power to move the hearts of those fighting in the revolution. Without culture and art, an army is "dull-witted," and such an army cannot defeat its enemy. Mao sought a balance between political communication and aesthetic merit. He realized that the former without the latter is uninspiring and ineffectual.

There is another balance in Mao's early thought. Unlike the policy of the Stalinist Soviet Union of that time, Mao's (original) policy was one of tolerating diversity of opinion. He is famous for "let[ting] a hundred flowers bloom" through allowing criticism of the government, intellectual freedom, and artistic freedom. In 1957, in his speech "On Correct Handling of Contradictions among the People," Mao rejected the Soviet denial of contradictions in socialist society, believing that conflict was both inevitable and healthy. At this time, Mao rejected the idea that art must be controlled by the state. At this time, his method of supporting revolutionary, proletariat art was by way of encouragement. Critics may say that Mao's use of force to encourage the production of one sort of art rather than another amounts to the same thing as controlling art: in both cases, art is controlled. But for Mao during these early years, there was a key difference. If art were state controlled, insofar as artistic merit cannot be commanded, the power of art to support the revolution would be placed in jeopardy. Only when art is freely created by free artists will it possess the power to move the masses. Motivation to create revolutionary art in early Maoist China therefore was internal, not external, and so art's propagandist power was safeguarded. (What happened later is discussed below.)

The theories of Marx and Mao are contemporary examples of political-aesthetic theories that support the creation and celebration of nationalist

art. While there are many other states around the world, contemporary or not, that have directed, encouraged, or forced art to serve nationalist purposes, Marx and Mao developed and articulated reasoned theories for why nationalist art should be produced. Their views may be the views of other states that have promoted nationalist art, but they are credited with articulating the reasons behind such promotion.

Nationalist Art

There are many clear cases of nationalist art. There are many that are unclear as well, cases that may fit my definition of what constitutes nationalist art but do not fit, for one reason or another, our intuitions of what nationalist art consists of. The definition of nationalist art used here is the one presented above: objects accepted by the art world as art and supporting the assertion of self-identity of a people in declaration of the right to preserve a distinctive identity. Although a vast variety of objects will fit this definition insofar as they actually do support the assertion of self-identity of a people, some objects extend this support in overt ways, while other objects extend this support in subtle ways. Some objects not only support the self-identity of a nation but also encourage others to support it. These are the clearest cases of nationalist art. Other objects support a nation's self-identity merely by being objects that are only made or only understood within one particular cultural context. These objects fulfill the formal definition of nationalist art with which we are working, but they constitute unclear cases of nationalist art. Let us begin by looking at some clear cases.

Art coming out of the early Soviet Union and out of postrevolutionary communist China constitute clear cases of nationalist art. Not only do works coming out of these contexts have a clear nationalist focus, but they also go the extra step of expressing their purpose as nationalist art. That is, these artworks not only support the nation and its unique identity but also express a recommendation to support the nation; they not only support the nation, they inspire others to do so as well. As I mention earlier, Mao's early policy was to let "a hundred flowers bloom, a hundred schools of thought contend." This freedom was very different from the Soviet experience. In early Maoist China, artistic expression was encouraged, regardless of the message. Unfortunately, this freedom

lasted only until 1957. In 1966, Mao and his supporters began the famous "Cultural Revolution." The aim of the Cultural Revolution was to wipe out the last remnants of bourgeois ideals and practices, to recapture the revolutionary zeal of early Chinese communism. The Cultural Revolution was taken up by the youth population. Zeal was spread through demonstrations, not always peaceful, by the "Red Guards," students who attacked the establishment: the bureaucrats, government and party officials, and intellectuals. The effects of the Cultural Revolution were felt not only in China but in the rest of the world, as well. In contrast with early Maoist China, the Soviet government imposed strict controls on all the arts during the late 1920s. "Unions," created for each branch of the arts, served to exercise government censorship over individual members and to regulate the course and content of each art. Works were judged on the basis of their expression of socialist realism. They had to depict the goodness of the communist society and the flourishing of citizens living in this society. An artist's expulsion from the union meant that the artist's work was banned from the Soviet Union. An excellent example of this is Nobel Laureate Aleksandr Solzhenitsyn, who was expelled in 1969 from the Soviet Writers Union for his criticism of the government's censorship policies. Solzhenitsyn was deported to West Germany and stripped of his Soviet citizenship in February 1974. Later, Solzhenitsyn moved to the United States. Eventually, Soviet officials dropped charges of treason against him (in 1991), and Solzhenitsyn returned to live in Russia in May 1994. The Soviet "nationalist" art movement (understanding that the Soviet Union described itself not as a "nation" per se but rather as a "people") was very different from the "natural" nationalist art movements occurring around the world at roughly the same time. Whereas Soviet art was externally controlled, most global moves toward nationalism over the past three centuries were simply products of artists' choices of theme and style.

The production of nationalist art around the world is frequently associated with romantic movements and realist movements occurring within the global art world of the past three centuries. In the eighteenth century, Sir Joshua Reynolds and Benjamin West produced visual works of art that celebrate and support Great Britain. Reynolds, known for his portraiture, was, in 1768, elected the first president of the Royal Academy

of Arts, the principal British art organization. West, who was born in America, succeeded Reynolds as president of the Royal Academy in 1792. Although an American, West is best known for his realist work celebrating British national life. Both Reynolds and West were associates of the king, George III. It was George III who founded the Royal Academy. He did so as a response to a memorial presented by twenty-two British artists. Today, the Royal Academy, the embodiment of the British nationalist art world, usually numbers about eighty.

In nineteenth-century America, we find the work of Winslow Homer and Thomas Eakins (and Gerald Murphy in the early twentieth) and, in the literary arts, the work of Ralph Waldo Emerson, Nathaniel Hawthorne, and Herman Melville. Eakins, whose realist work takes its themes directly from the American experience of life (especially that found in and around Philadelphia), is one of the most important American visual artists. The predominant American style of the nineteenth century was both realist and naturalist. It forthrightly celebrated the land and the people's experience with and on the land. Homer, for instance, began his work as a painter concentrating on American rural life.

Richard Wagner, perhaps Germany's greatest nationalist artist, likewise worked in the nineteenth century. Wagner held strong political views, but he is best known for his work as a musical artist, particularly as a creator of opera. His most famous work is the lengthy four-opera work known as *Der Ring des Nibelungen,* which was based on the twelfth-century German epic poem *Nibelungenlied.* Not only cannot one fail to recognize the cultural context of Wagner's work as clearly Germanic—Thomas Mann describes Wagner's "metaphysical impulse" as a decidedly German trait—but the themes of *Der Ring des Nibelungen* include conflicts between nations and the struggle for power. Wagner's work has widely been considered to be one of the greatest expressions of Germanic art (unlike that of Albrecht Dürer, who, it is said, endangered his "German-ness" because he dedicated himself to the study of correct proportions developed by the Italian renaissance).

In the early twentieth century, Mexican artists such as Diego Rivera, José Clemente Orozco, and David Alfaro Siqueiros painted murals that focused on cultural nationalism and revolutionary politics. Their murals celebrated and supported the Mexican nation, taking as themes the current

state of the Mexican citizen/worker and the history of (indigenous) Mexican culture as a context for the modern Mexican. This is especially evident in the work of Rivera.

In architecture in the early twentieth century, we find Le Corbusier (Charles Édouard Jeanneret) in Switzerland and France, Charles Rennie Mackintosh in Scotland, Walter Gropius in Germany, and Frank Lloyd Wright in America, each creating architectural styles unique to, and celebratory of, their respective nations. Mackintosh is known for the simplicity of his design, focusing on geometric shapes and unadorned surfaces, a sort of "clean" Art Nouveau style. Gropius created the Bauhaus school, which is famous for its focus on engineering and function in the designs it produced. Wright is famous for his "organic architecture," following the principle that structures should develop out of their natural surroundings. The buildings and furniture produced by these artists are highly recognizable. While each of the four artists mentioned above was a modernist, each creates a style so distinct from the others that merely on seeing a building or piece of furniture, the viewer can easily identify its creator and its creator's national context.

Another set of clear cases of nationalist art is the art produced just prior to the start of World War II in both the United States and Germany. From around 1920 through the 1940s, the production of nationalist art in the United States was at its highest point. Perhaps the rise in U.S. nationalist art was a response to having come through the First World War. Perhaps it was an effect of the country's consideration of national isolation in a world heavy with international unrest and on the brink of the Second World War. Germany, during the ascendancy of the Nazi Party and its eventual control of the nation in the late 1930s and early 1940s, produced works of art that clearly supported and recommended the identity of the majority culture of that nation. (Riefenstahl's *Triumph of the Will*, discussed elsewhere, is perhaps the best example.) Art produced in Nazi Germany, such as the architectural work of Klemens Klotz, supported this cultural ideal. And art that was considered anti-German was destroyed; indeed, huge bonfires were fueled by masses of books judged to be anti-German.

Now let us turn to some unclear cases. Consider two sorts: propagandist art and indigenous cultural artifacts.

Regarding the first, Mao spoke against the creation of "poster and slogan" art. Although, he said, it can express a forceful and correct political message, it expresses its message in a less than aesthetically meritorious manner. Propagandist posters are clearly nationalist, but are they art? Mao offers an argument against their inclusion as nationalist art. But galleries and patrons of art who collect such posters for the purpose of treating them as art—displaying them as art, writing about them as art, and so forth—present a de facto argument for including propagandist posters in the category "nationalist art." Such posters were very common in World War II: Japan made them; the United States made them; Germany made them; England made them. Many survive today. Are they nationalist art?

In the second category, consider indigenous cultural artifacts. Some examples would include historical and prehistoric cultural artifacts made by the indigenous peoples of North America, architectural objects such as tepees and chickees, functional objects such as pottery and textiles, nonfunctional objects such as pictographs and items of adornment such as jewelry. Other examples come from indigenous Mesoamerican cultures: the carvings and jade work of the Olmecs, the pyramidal temples of the Mayas, the great stone Aztec calendar. Contemporary examples would include art forms practiced today that have evolved for a vast number of years as cultural forms. Consider two from Japan: calligraphy and ikebana. Japanese calligraphy has been elevated from a cultural practice to an art form. The instruments, materials, and styles of Japanese calligraphy are the basis of serious study in Japan. The same is true of ikebana, Japanese flower arranging. Ikebana literally means "[making] flowers come alive." These two art forms, practiced and understood thoroughly only by the Japanese, surely support the national identity of the Japanese, and for many years each has been accepted as a bona fide art form. Are the products of Japanese calligraphy and ikebana nationalist art? These sorts of unclear cases demonstrate that many objects fulfill the statement "support the assertion of self-identity by a people" in only a subtle way. They do in fact support the self-identity of a nation by supporting its uniqueness.

Why is nationalist art produced? This may seem a naive question, given that nationalism is purposeful in the sense that it seeks to assert (preserve

and advance) the self-identity of one nation over others. But this pur-
pose can be carried out in overt and in subtle ways, and, in reality, some
of the objects that on reflection may be classed as nationalist art may not
be created with the intention of being classed this way. In short, there are
many art forms that are best or only understood from the perspective of
a particular culture. Is the creation of objects in these art forms the
creation of nationalist art? Each of the political art theories reviewed
above advises the creation of art that strengthens the society in which
these theories reside. In so doing, that society is better positioned for
survival and flourishing in an international world than it would other-
wise be. However, one must not lose sight of the fact that international
political survival or ascendancy was a secondary concern to the artists.
Of primary importance was the betterment of the lot of the citizens of
that particular society. If we revisit the definition of nationalism earlier
offered, there is a clear reference to a nation's position vis-à-vis the posi-
tions of other nations. International political identity is perhaps today a
more important consideration than it was at the time that the aesthetic
theories reviewed earlier were written. In the late twentieth century,
nations must maintain a global perspective. The survival and flourishing
of any individual nation on earth is tied, more and more tightly, to the
fates and actions of other nations. Contemporary nationalism cannot
be viewed only from an isolationist perspective; consideration of one's
national identity is a global issue now. Nationalist art can support a
nation's survival and political ascendancy through propagandist means,
but it can also support that nation through preservation of the history
and culture of that nation. There are many nations that are absorbed
into larger, more powerful nations. This is a political reality. However,
if an absorbed nation is able to preserve and protect its history and its
culture, then it does not have to surrender its identity along with its
sovereignty. The preservation of all those things that make up a nation's
culture—shared behaviors, beliefs, attitudes, values, institutions, sym-
bology, iconography, art, and artifactual style—can have the effect of
preserving a nation even in spite of a loss of political self-determination.
This is one of the clearest intentional reasons for producing nationalist
art, or at least art that has a very particular cultural identity. It is this
reason, the preservation of national culture, that increases the tenability

of considering cultural art objects and cultural art forms contextually as nationalist art.

As I mentioned earlier, some art objects and art forms are best understood or can only be understood from the perspective of a certain culture. Creation, celebration, and interpretation of these works, or in these art forms, are for the most part culture-bound. Only those either within a particular culture or having an appropriate understanding of that culture will normally produce works of these sorts. There are, of course, plenty of examples of those of one culture mimicking the creations of other cultures, but these imitations are usually viewed as new elements of that first culture (and so take on new meanings as parts of the adopting culture) or are seen as highly suspect. For example, some European Americans mimic the rituals of Native Americans without benefit of guidance or instruction. While their hearts may be in the right place in terms of paying homage to what was or is a part of one of the indigenous cultures of this country, their imitated ceremonies can never be taken to hold the meaning of the ceremonies practiced within the appropriate cultural context. Consider what it would look like to Christian European Americans for some culturally non-Christian group to mimic a church service, the offering of Holy Communion, or some other sacrament. Some art objects and art forms are like this; they possess their full meaning within only one culture.

Some particular art expressions are culture-bound. Mexico became the center of the Latin American art world in the first half of the twentieth century. As I mention earlier, Mexican artists such as Diego Rivera, José Clemente Orozco, and David Alfaro Siqueiros painted murals that had cultural nationalism and revolutionary politics as themes. While many cultures around the world produce murals, and many produce murals with nationalist themes, the Mexican murals produced by Rivera, Orozco, and Siqueiros are only fully meaningful from within the culture of early-twentieth-century Mexico. Another good example of this is Japanese calligraphy, likewise discussed earlier. While many cultures produce calligraphic art, to understand a work of Japanese calligraphy is to understand it from within the culture of Japanese calligraphy. Issues concerning paper, brushes, ink, technique, style, and history are relevant to understanding and appreciating Japanese calligraphy fully. Cultural context is essential to works such as these.

Some particular art forms are culture-bound. A good example is, as I mentioned earlier, Japanese flower arranging: ikebana. Ikebana is an art form. Artists study their craft for years. Flower arranging in America, the sort practiced by altar guilds before Sunday services, by florists, and by interior decorators is not (apparently) an art form. The difference between ikebana and American flower arranging is the difference between art and decoration. Ikebana, to be understood and appreciated fully, must be viewed as a culturally bound art form, one practiced nowhere outside of its culture (wherever that culture, or representatives of that culture, are found). Another good example of a culturally bound art form is Indian music. Although Ravi Shankar did a great service in terms of popularizing Indian music in America, Indian music is by and large not understood by Westerners as anything but an aesthetic novelty. Most Westerners do not understand that Indian music is based on a wider tonal scale, that the movement between tones is not of the same sort found in Western classical music, and so forth. Most Westerners are not prepared to listen to Indian music in the way that they would be prepared to go to a symphony hall and listen to Western classical or orchestral music. The famous conductor Zubin Mehta reports that the same is true in reverse: most Indians are not prepared to listen to Western (hemisphere, not cowboy) music. Indian music is a culturally bound art form. Part of the reason for this is also that Indian music utilizes culturally bound media for the creation of Indian music. A tabla and a sitar are common instruments for producing Indian music, but tablas and sitars are not widely to be found in the West. Some art media are likewise culture-bound. For example, rice paper is important for Japanese calligraphy; the koto, the *shamisen,* and the *sho* for Japanese music. Bagpipes are important for Scottish music. The *guitarron* is an important instrument in a Mexican mariachi band. The *qin* is important for traditional Chinese music. Bark-cloth and lava rocks are important in the creation of art in New Guinea, Polynesia, and Micronesia. These are simply some of the examples of art media that are to be found only in specific cultures. A Mexican would normally not know how to play a sitar. A Polynesian would normally not know how to play the bagpipes. The fact that certain media are only to be found in certain cultures limits production of arts utilizing those media only to those cultures. In a strong sense,

certain art media are nationalist insofar as they support the cultural identity of specific nations.

There are, of course, counterexamples to culture-bound art. Children in Japan learning to play Suzuki violin may play Mozart and other Western classical works. But these sorts of counterexamples are exactly what drives the contention that cultural and national identity is now a global matter. If American children begin learning to play the sitar by playing classical Indian music, then an art form and art media that are generally localized to Indian culture will lose that localization. This sort of thing is already being seen in the popularity of Scottish bagpipes in America, for instance. If some art forms and art media truly belong to one nation and support that nation's cultural identity, then as these forms and media are popularized elsewhere, the nationalist function of those formerly culture-bound items will diminish.

Political Context and the Value of Art

Again, the definition of nationalist art in this section includes art that supports the assertion of self-identity of a people in relation to other peoples or states. Some objects clearly fit this definition, whether by design or by accident. Some art forms and some art media—at least those that are culture-bound, that is, existing and being used only within the context of a single culture—clearly produce these sorts of objects.

Nationalist art, so defined, is only one sort of political communication, but it is certainly the most interesting sort. First, examples of it abound. If my thesis that a nation is best understood in terms of its cultural artifacts, including its art, is correct, then the fact that examples of nationalist art are plentiful is not a contingent claim; it is necessary. Only with an abundance of cultural artifacts can a political entity such as a state or nation maintain its own identity, especially contrasted with either that of its neighbor or that of whatever sovereign political power may control it. Second, even though certain individuals having localized—temporally or geographically—political agendas may make use of cultural artifacts to create propaganda, whether the resulting propagandist objects are really art or even additions to that nation's culture is unclear. Also, the temporal localization of the use of such objects limits them in a variety of ways, not least of which is in terms of the duration of their meaningfulness.

A political poster may be politically motivating today, but in twenty years it will be seen in a very different light. Its motivational power, its efficacy and function as political communication, will have changed—most likely having dissolved. But nationalist art endures throughout the life span of the nation that creates it. Third, nationalist art need not abandon aesthetic motives or values in favor of political ones. Lessons from the early Mao teach us that. Fourth, nationalist art communicates more broadly and deeply than does more politically localized objects. An object designed to communicate a point in a political agenda, or even recommend adoption of a particular political agenda, is limited to just that purpose. Nationalist art can serve this end, but it can also serve more general purposes, including the encouragement of patriotism, inspiring virtue in the citizenry, enhancing solidarity among the citizens, and so forth.

Nationalist art, then, is contextual in several ways. First, it may best be understood as a product of a particular culture, of particular art forms and art media, and through this understanding may achieve its greatest worth. Second, nationalist art is almost always intended by its artist to serve ends that benefit the nation or the nation's populace. And, third and most important, nationalist art is received by its audience, if that audience is of that nation, as having not only whatever artistic and aesthetic merits it may have but also as benefiting the audience individually, socially, and nationally. Such benefits enhance the value of those artworks (or cultural artifacts, to keep this inclusive). Nationalist art seen within the context of nationalist art is more valuable than it would be were its value assessed outside that context. This is clearly the case for those whose nation it is. But it is also true for those on the outside who look to understand the art coming from artists in other parts of the world, in subnations within our own, or in other times, and to understand it in its most valuable state.

RELIGIOUS MEANINGFULNESS

The points I want to make here, continuing the discussion begun in the preceding chapter, concern one sort of identification: where the artist and the audience share both the religious context and an interest in communication, in the delivery of a religious message from the artist to the audience

and perhaps, though this need not be the case, from the divine through the artist to the audience.

In 1989 I took my wife on her first trip to London. I had, in previous trips, spent a total of almost six months in London, and I felt not only that this was a city I wished to share with her but also that I was decently well prepared to serve as her tour guide. My wife and I are Anglican, and we were at the time, so some of the things I wished to share with her were of a religious nature. I wanted to show her St. Paul's Cathedral, and I wanted her to hear evensong there. I wanted to show her Westminster Abbey and to participate in a worship service there. So one day—I no longer recall whether it was a Sunday—we prepared ourselves as well as our tourist clothing would allow, and we set out for Westminster Abbey. As we made our way through the tourists, back to the area where worshipers were being admitted entrance, we found our way blocked by an official in a red robe. He told us that only worshipers were allowed further, and he gave my wife and me such a look that I realized at once that our attire (and perhaps our age) was not, in his eyes, indicative of a fervent enough desire to worship there and then. We backed off. On subsequent trips to London, my wife and I have worshiped at Westminster Abbey, but this did not happen in the summer of 1989. I regret not pushing my case then, and my revenge on that fellow in the red robe who barred my way from access to the formal worship of God is to write about him here. In retrospect, were I a fellow in a red robe charged with admitting out of a host of tourists only worshipers into a worship event, I may well have acted similarly to the way he did. His job was to separate those who wished to worship from those who wished to sightsee. His job was to assess the purposes of those who wished admission. This is a tough job, but, to bring us back to the present, it is an even tougher job for aestheticians because these two purposes—worship and sightseeing—are not mutually exclusive. My interest in worshiping at Westminster Abbey was worshiping at *Westminster Abbey*. My motives were not pure, I admit. My motives were mixed, and the reality is that the motive that drove me to Westminster was an aesthetic one, not a worshipful one. Opportunities to worship at Westminster Abbey, at St. Paul's Cathedral, at Canterbury Cathedral, at Bethesda-by-the-Sea in Palm Beach are half the reason my wife and I became Anglicans in the first place. It is the

aesthetic half. Opportunities to enhance the aesthetic dimension of worship results in my having a much richer experience. Richer aesthetic experience or richer worship experience? The answer is both.

The Anglican worship experience is guided by the Book of Common Prayer. A service begins with preparation during which one finds oneself on one's knees. Then there is a song and a processional. On good days, the processional is long, colorful, and—when incense is used—perfumed. In my experience, a verger is followed by a crucifer, followed by bearers of candles, banners, flags, and a book. These are followed by a choir, another cross-bearer, and in rank order, with vestments growing in both complexity and color, the priests. The Prayer Book comes out. Familiar words are read in a familiar cadence. Familiar chants are said or sung. This is what I would call the "first movement of the symphony" that is the Anglican or Episcopalian Sunday church worship service. The "second movement" is about reading. Lessons are read by trained readers, followed by a procession of acolytes bearing a cross, candles, and a book, and a priest to the center of the congregation of worshipers. The "third movement" is the sermon; this is my least favorite part because philosophers make lousy audience members for supernatural lectures and because the aesthetics of this movement depend entirely on the personality of the priest. Most priests I know are unprepared to keep the aesthetic level constant. The "fourth movement" is a series of familiar recitations: a creed and a set of formal, stylized prayers. This movement involves kneeling and standing. This movement ends with a familiar pronouncement made by the priest in a familiar cadence. The "fifth movement" is the Holy Communion. There are familiar words chanted back and forth in a familiar rhythm. This period culminates with a formalized walk to the altar, the ingesting of bread and wine, and a walk back. Besides this walk, time during this movement traditionally is spent on one's knees. This movement concludes with, again, familiar words spoken by the priest in a familiar cadence. The "sixth movement" is the transition from the religious to the secular. It involves a recessional, a moment of closure, and the familiar dance of trying to get out of the pew, past the priest and her waiting hand, and out the door.

I have tried to be neither glib nor precious in my description. There are various events that congregants take in different degrees of meaning-

fulness, but despite the variety, the events as events make up a regular, formal liturgy, which has elements that are decidedly meant to contribute to the having of an aesthetic experience. I have found no religious group, not even the Society of Friends, who lack some form of ritualized events. Whether the ritual character carries some supernatural or psychological significance is not at issue here. What is clear is that liturgy involves aesthetic considerations. What I wish to claim here is that the level of aesthetic engagement and the level of worshipful engagement are inextricably tied together in Christian worship services, at the very least those of the higher-liturgical denominations such as Anglicanism, Roman Catholicism, Orthodoxy, and Lutheranism. I would claim that this is the case across all worship contexts, lower-liturgical Christianity and beyond, but this would be a contingent claim, and I am not an anthropologist.

If the aesthetic and worship aspects of a church service are inextricably bound together, then they cannot help but influence one another. As the aesthetic aspects are enhanced, so it should be expected that the worshipful aspects will be enhanced. This is precisely my motivation for seeking entrance to Westminster, St. Paul's, and Canterbury. But the complement is true as well. As the worshipful aspects are enhanced, so too should we expect the aesthetic aspects to be enhanced. Let me put this another way. With the inclusion of the purposeful and functional interest of the worshiper to worship, the aesthetic aspects of the setting and the events are made richer. This enhancement occurs because there is a dimension of meaningfulness to the aesthetic experience of the worshiper that is simply not available to the aesthetic "tourist."

Suppose that I am in attendance at St. Paul's one Sunday. I aesthetically appreciate the formal qualities of the cathedral, the historical relations, the relations it bears to others of its kind (cathedrals, or cathedrals with domes, or buildings designed by Christopher Wren), and the significance, in Christendom, of St. Paul's Cathedral in particular. Now suppose that the music begins to play, I see the colorful procession, I smell the incense, I feel the cold stone and the hard chairs; soon I feel the kinesthetic sense of standing, kneeling, and sitting in unison with the rest of the congregation; then I taste the "elements." So far in my description, two things are going on: first, I am appreciating or experiencing everything from an

aesthetic point of view, I am attending to the aesthetic features of every-thing that is going on around me and with me; second, I am using all of my senses, experiencing in as full a range as possible. Now, suppose that instead of being a disinterested attender I become a participant; that is, I experience or take serious note of the *meaning* behind the ritual characteristic of the act of worship. The question now is this: If my aesthetic experience then becomes greater in the face of the addition of my interest—my "purposeful" engagement in worship—who is to say that my interest does not indeed add to my aesthetic experience? It is useless to say that these two approaches, one aesthetic, the other worshipful, are separate and distinct attitudes. The reality of my experience is that the two are not only linked, but causally linked. As I take on the context of participation, my experience becomes richer, with part of this richness actually taking an aesthetic form, a greater appreciation of the aesthetic aspects of the worship event.

From my perspective, this is my best example of the relationship be-tween the value of an aesthetic experience (which one could argue is artistic, given the purposeful design and control of the aesthetic elements) and the meaningfulness of contextualizing that experience in the func-tionality of religious worship. But I have another example, and it may be as good.

In 2004, Mel Gibson's *Passion of the Christ* was released. It is a good bet that this film had been prescreened by more people than any other film in history. Once it was released, the lines for this film were long. The two principal audiences were devout traditional Christians and those interested in what all the hubbub was about. I did not see the film until it was released on DVD, and I am afraid that I fit more into the second category than the first. My take on the film is pretty simple: Gibson's film is a generally coherent, traditional medieval Passion play, right down to the concrete personification of the devil. Viewed this way, it is not very exciting. As art it is anachronistic, like music composed today in the Baroque style. If Kendall Walton is right, this speaks negatively about its value. As a medieval Passion play created with the bells and whistles available in the early twenty-first century, however, it is interesting. If my perspective is accurate, it opens up the nature of the medieval Passion play to contemporary audiences in an accessible way. But this example

is not about my take on the film. I am sure that I am in a small minority in respect to what the film means to me.

For the vast majority of devout traditional Christians, this film portrays for them reality. The events described in the film, in the way that they are described, are for those who accept the biblical account—as expressed in the book of Luke, I think—of the last days of Jesus of Nazareth as being authoritative and accurate. This is what really happened. This is the context that such audience members bring to the film, and the result of this, for them, is a film of extraordinary power and meaning. We live in a generation accustomed to having its aesthetic objects delivered to it in THX sound and on a wraparound screen, positioned before a bank of rows upon rows of stadium seats, within a theater that is about the size of a small airplane hanger. Reading an account of torture and death, especially as this account is offered in the English of King James, is comparatively dull and, as a result, comparatively uncommunicative. Seeing that description temporalized into two hours, on the big screen, but still essentially the same as what was written in the book of Luke, is a much more communicative experience.

The Passion of the Christ was created by an artist who sought to bring the most salient parts of his own religious orientation and perspective to his artwork. The primary audience for the film shares with him this context. Moreover, the audience members are open to being favorably impressed by the content of the work. There is a message, one already known by both sides but which the audience expects and the artist intends to send. That message and the receptivity of the primary audience to receive it result in many individual experiences that are acute, exigent, and moving. More than one audience member have described the experience as life-changing. Many viewers take the content of Gibson's film to be supernatural: while the accidents of the film—the actors, lighting, sets, the mise-en-scène—are Gibson's, the message is divine. This is consistent with the view that the message is taken faithfully from text that the primary audience understands as being written by the hand of God. If God writes a movie script, isn't that one film you would want to see? If this movie script includes the most salient matters concerning the ultimate divine act by God, isn't this a movie the message of which you would want to be open to?

The Passion of the Christ, and the audience response to it, may well be the best example of the power of context in this book. I think the film is somewhat interesting despite being strongly anachronistic as a film. I think there are a few interesting artistic elements in the film, but only a very few. As art, the film is, to me, not very valuable. But change the context—or, better stated, *add* a context. With only a small shift in perspective, this film becomes life-changing, perhaps the greatest film ever made. My perspective on the film and my assessment of the quality of the film turn essentially on two things: formalist considerations and Waltonian historical/classification considerations. Judging on these grounds, I end up with less-than-enthusiastic praise for the film. But for the filmmaker and for the intended audience—who both (and perhaps jointly) bring to the film a context different from the one I bring—the film is one of extraordinary power and meaningfulness. Were I able to bring to *Passion* this alternative context, my experience might be as rich. Just as a work of nationalist art will be more valuable to those from whose nation it originates and celebrates, so too will religious works of art be more valuable to practitioners of that religion. Clearly, contexts depend on the content of the work of art—I rely on the content of an artwork to adjudicate what contexts are appropriately brought to a work—but they depend equally on the subject and what lenses she chooses to wear when experiencing that work. As we leave pure formalism behind, we leave behind the safety of the purely objective approach; contextualization necessarily includes a subjective component.

My perspective on the film is contextualized, as I say above, in terms of Waltonian considerations, but this particular context decreases the value of the art object. I am not willing to say that my contextual perspective is less worthy than the perspectives of those for whom the film is life-changing, but if, on the one hand, I were to argue that the point of contextualization *should* always be to enhance the value of works of art, then I should reject my contextualization for the alternative one. The thesis of this book is that contextualization usually *does* enhance the value of an artwork—and thus one should seek to view objects within appropriate contexts—so to adopt the position above is to radically beg the question. If, on the other hand, I were to hold the position that

the truest understanding of the value of the film is had through the most informed and broadest contextualization—assessing the value of the film formally, in terms of Waltonian considerations *and* in terms of the religious-communicative context that was not only explicitly designed by the filmmaker but also readily received by the vast majority of audience members—then support for the book's thesis, that contextualization reveals an art object's value, is intact.

RITUAL

I want to begin by saying that my intent in this section is not to define "ritual" in such a way that it absolutely excludes some events and includes other events. The lesson we learned from the antiessentialists is that to offer such a definition in absolutist or objectivist terms is to invite counterexample and the ultimate defeat of whatever definition we started with. Instead, in this section I do three things. First, I sketch out some common characteristics of rituals, including as much as possible that any competent speaker of English might label as a ritual. (Of course, the list will not be exhaustive, but this is only a sketch for the purpose of establishing a playing field with some hint of boundaries.) Second, I argue that rituals are aesthetic events and, insofar as they are designed artifacts, may constitute candidates for being art objects—perhaps performance art. Third, I argue that rituals are like architecture in the sense that they are essentially purposeful and functional. I might well have included ritual in the chapter on definition, since I claim that rituals, to be rituals, must be understood in terms of their functions. However, their functionality is not generally an objective feature of their instantiation. Generally, the function is one of manifesting some meaning. Hence the inclusion of rituals in this chapter, directly following religious communication.

I begin by offering a list of rituals, organized broadly around the purposes they serve. This is a loose arrangement, and it must be so, as many rituals serve a variety of purposes. On occasion, what one might intuitively consider to be the primary purpose of a given ritual-event is supplanted by the ritual's creators with another purpose altogether.

1. Religious Rituals

 A. Rites of Passage. These rituals are observed in religious communities in recognizing a new means of identifying the individual or group that performs them. They commonly include baptism/christening, confirmation, bat/bar mitzvah, a vision quest, marriage, ordination, and commissioning. These events will stretch no one's intuition of what counts as a ritual; they are all canonically central (forgive the pun). But it is noteworthy to repeat that these events are not restricted in purpose to religious functions. One can be married outside a religious context, of course, and a baptism can be as much a social event as a religious one.

 B. Repeated Religious Rituals. These rituals are practiced with regularity within religious communities. They commonly include Holy Communion/Eucharist/Mass/The Lord's Supper, the Shabat meal, the Seder, recitation/reading of scripture or creeds, formalized prayers, healing ceremonies, and meditation.

2. Educational Rituals: graduation/commencement, convocation, and presidential installations/inaugurations.

3. Military Rituals: induction, commissioning, formalities of discipline and respect (saluting and coming to attention, for instance), formalities of giving and receiving orders, promotion, and decoration.

4. Civic Rituals

 A. Governmental/Political Rituals: voting formalities, formal debating, office installation/inauguration, legislation formalities, judicial formalities, and the reading of Miranda rights.

 B. Rituals of Identification: marriage, taking a driving license test, and the formalities of acquiring a fishing or hunting license.

5. Employment Rituals: the formalities of application and interview/audition, formalities of discipline and "chain-of-command," formalities of office etiquette, and formalities of termination.[6]

Social Rituals

1. Parties: dinner parties, receptions, birthday parties, and anniversary parties.

2. Rituals of Loyalty, Camaraderie, and Collegiality: company picnics, pub and bar etiquette, water-cooler etiquette, and business lunches.

3. Entertainment: formalities of restaurant dining, restaurant dining etiquette, cinema etiquette, shopping etiquette, art gallery etiquette, and performance-attendance etiquette.

4. Sports and Games: rituals of sportsmanship etiquette and the formalities of following game rules. While sports is no doubt a form of entertainment, in this society its mass alone would qualify it for its own category.

Personal Rituals

1. Functional Rituals: reading a book before retiring to bed, having a martini upon arriving home from work, doing the laundry every Thursday, and so forth.

2. Inherited Rituals: making one's bed, moving the dishes from the table to the dishwasher to the cabinet to the table, eating three meals a day, and so forth.

Elements in Common

I am conscious of the fact that my list includes many events that perhaps do not warrant being called rituals. Several of the events listed above may be simply routines, and meaningless routines at that. If there are such events in this list, they will not help me establish my theses about rituals. However, the point of constructing such a list is to cast as wide a

net as possible, capturing in this sketch every sort of event that any competent speaker of English might label as a ritual. My suspicion is that there is a continuum that includes both rituals and routines, with more paradigmatic events of the two sorts lying at the extremes but with a good deal of overlap in the middle.

Speaking again in general terms, what are the common properties in the events listed above?

1. The first thing is that it seems that one necessary condition for something to be a ritual is that it is an event or a set of events. This means that it has temporal duration. An event is not simply a single state of affairs—if it were, we would call it a "state of affairs" and not an "event." Instead, an event is a movement from one state of affairs to another. In those cases in which the states of affairs are more than two, we are talking about a series or set of events. One event includes two states of affairs, moving from the first to the second. But rituals generally involve many states of affairs, so they contain sets of events. Commonly, we understand rituals to be constructed of a variety of different states of affairs, and so rituals are understood to be composed of a variety of events.

 The sequencing of the events that make up a ritual is not at all random. To kiss the bride before the pronouncement of marriage is out of order. To dress before bathing is ridiculous. To pick up the dinner fork at the salad course is obscene. The ordering of events is not at all arbitrary. Correct sequencing is essential to the ritual as a ritual.

 It is not only the ordering of the events that is important; also important is the speed at which the events are enacted or brought about. Every mainstream Christian knows that a standard church service will take between one hour and an hour and a half, and if this is a classic Sunday morning service, it will reach its conclusion at about lunchtime. This is the case for both the most liturgically rich services of high-church Anglicanism and the most liturgically modest meetings of the Society of Friends. Even those churches that profess to being liturgically

modest still have an ordering of events and a timeline for the movement of event to event that are quite regular and predictable. In this way, rituals are like songs. Each has not only a series of notes to be played in a particular order but also a tempo that must be respected if the song is to come out right. (Hence my symphony analogy above in connection with the progression of an Anglican worship service.)

2. Rituals are not usually performed, participated in, or observed for the mere sake of aesthetic experience. However, all rituals have an aesthetic aspect. They clearly have a formal rhythm that readily can be appreciated aesthetically. To justify my claim that rituals are aesthetic objects, I turn to Beardsley's rich account of the features of an aesthetic experience (see chapters 1 and 2). Although I have problems with Beardsley's account if it is used as a explanation of the value of art, it is a fine statement of the characteristics of aesthetic experience. Following are the five components of Beardsley's account as applied to ritual.

A. Object Directness. A ritual is not a ritual if its formal characteristics are not attended to. One can get married without the observation of any ritual at all. But it is easy to tell the difference between a nonritualized wedding and a ritualized form. The ordering of events and the timing of their performance are not merely matters of academic interest. For an event to be a ritual, the ordering and timing must be readily and obviously visible, so much so that for an attender to ignore such things is for the attender to be ignorant of the event as a ritual altogether.

B. Felt Freedom. Perhaps the ordering of ritualized events can be found in "nature," but the timing through which they are carried forward is anything but natural. One need only think of how much effort it takes to get the young flower girl to walk *slowly* down the aisle. Rituals create their own space, in both the physical and the temporal senses. Their events engage attention—if A is fulfilled—and this provides the attender with a world unto itself.

C. Detached Affect. This is the least best match between my account of ritual and Beardsley's account of aesthetic experience. But this has been given a full hearing earlier in the book, so we will not pause here.

D. Active Discovery. Earlier I said that rituals are commonly complexes of events, of movements from one state of affairs to another, and then to another and another. The point is the complexity. Even in those rituals for which one is clearly familiar with the ordering of the events, the timing, and even the "normal" content—as in the case of a church service or a wedding—there is still a great deal of discovery to be made. Something must motivate attention, and even if much of the ritual is familiar, the way in which the ritual's creators inform those familiarities with novelty and excitement still provides engagement. And, again, not every ritual will be as rewarding as every other one. We may say here that the greater the sense of "active discovery," the better the ritual.

E. Wholeness. Beardsley focuses on the subject, on the psychological sense of wholeness felt by a person in attention to an aesthetic object. Beardsley's fifth category has always seemed to me a consequent of one through four. If one is engaged in the first four ways that Beardsley describes, it seems to me that one cannot help but feel the sense of wholeness that he describes here.

It is perhaps important to remember that all rituals are human artifacts. Sequences of events practiced by nonhuman animals, though they may mirror human rituals in many respects, are not rituals. Such ordered events may be quite purposeful, but the purposes of nonhuman animals are not matters upon which the nonhuman animal will or can reflect. Rituals, to be rituals, must be candidates for reflection as bounded and organically unified sets of purposeful events, sequenced and timed on purpose, as well. As such, they are candidates for being recognized as works of art, works of performance art. Whether their candidacy is successful depends on the particu-

lar ritual and on—to use Danto's theory—how the work is interpreted in the context of the history and traditions of the art world.

3. Finally, rituals are always purposeful. The events that are undertaken or brought about constitute means to ends. The ends themselves—what rituals aim toward—have to do with the contents of rituals, but the purposefulness of rituals has to do with their form. The purpose of attending a house of worship is primarily to worship a deity or divine reality. While there are clearly other purposes to such attendance, the primary one, the one that most clearly may be seen as the principal motivation for attendance and participation, is worship. The point, it seems, to throwing elaborate dinner parties, complete with successive courses and a vast array of knowledge and use of etiquette, is both gastronomic (or gustatory) and social. Attention at such events is on two things: the delightfulness of the consumables and those with whom such consumables are being shared, usually with the latter taking precedence over the former. The purpose of starting each morning with "morning rituals" is living functionally. Those who practice "morning rituals" do so because, first, they require some time to wake up and such rituals provide that time without necessitating much cognitive engagement; second, they find that ritualizing—or perhaps routinizing—variously required events each morning provides for greater efficiency in meeting those requirements; or third, they find that such routinization allows them to put their cognitive energies elsewhere, say, on the morning newspapers or planning the day. It is difficult to imagine one attending a place of worship in the absence of a purpose; indeed, the perceived purposelessness of worship of the divine is exactly the reason so many people, even believers in the divine, elect to skip services. Dinner parties that did not pay due attention to their social functions would be nothing other than restaurants where the food is free; the social purpose of dinner parties is crucial in motivating those events. And, finally, in the event that someone discovers yet a better way to wake up or a more effective way of

preparing for the day, that person will almost surely adjust her morning rituals to meet her purposes more functionally.

Rituals and Function

Most of this discussion has been about the form of rituals. If we turn to the contents of rituals, we realize immediately that rituals depend entirely on their function. The purposefulness of rituals turns on their movement toward some particular ends. There is something to be accomplished in performing, participating in, or observing a ritual. To circumscribe a set of events identified as *the* ends of (all) rituals is to invite—nay, beg for—the offering of counterexamples. Even if we were able to create such a set, here and now, there is no doubt that future examples of paradigmatically central rituals will arise that fall outside such a set or that paradigmatically central examples of rituals from other cultures or subcultures would likewise fall outside.

But one thing is certain, and that is that, whatever the function, rituals are all enacted purposefully and functionally. Their meaningfulness lies in their functionality. Abstracted from their function, rituals are nothing more than abstract performance art. Given that the vast majority of rituals are most meaningful for their participants and only secondarily for their observers, ritual as abstracted and reduced to performance art thus becomes a very odd sort of aesthetic form. First, rituals are performed again and again. Although we might attend performances of Tchaikovsky's *Nutcracker* many times over the course of our lives, we would not attend the same performance weekly. Yet this is what Christians do with Sunday worship service and Jews with the Shabat meal. Second, when abstracted and reduced to performance art, rituals become massively less valuable. The value of rituals lies in their meaningfulness, in what they mean for their participants and what they mean for those who are invested in the activities of the participants. Taken as purposeless aesthetic objects—or, better put, taken as objects the purpose of which is only to occasion an appreciation of formal aesthetic properties and no more—these events would rank quite low in comparison to other events, those that promise much greater reward in attendance to their formal aesthetic properties. Architecture abstracted from function is sculpture, and one might well expect that most architecture

regarded in this way would make subpar works of art. The same is true of ritual. Ritual abstracted from function is simply performance art, the participants in ritual merely actors. Regarded in this way, it is not very valuable. The value of ritual lies in its meaningfulness, and its meaningfulness lies in its functionality.

The general point of this chapter is to point to aesthetic and/or art objects that are more valuable in terms of the level of their meaningfulness when viewed contextually, whether in political contexts, in religious contexts, or in ritualized contexts. If one attempts to abstract artworks from these contexts, one succeeds only in reducing their value. Meaningfulness enhances value, and as the sorts of objects mentioned above have their greatest significance both as objects and as art objects in light of their meaningfulness, we do not do ourselves and our aesthetic experiences any favors by separating our consideration of their formal aesthetic properties from their meaningfulness.

8

Science and Contextualist Aesthetics

IN THIS CHAPTER, I EXPLORE THE RELATIONSHIP between science and contextual aesthetics in two parts. In the first section, I explore how aesthetic properties are helpful in the pursuit of the discipline of science and scientific theory creation, development, and assessment. This exploration ends with an example from Allen Carlson's work in environmental aesthetics. The second section focuses on contextualist aesthetics and methodological choices in the social sciences. In this section, I explore a parallel between disinterested and contextualized approaches in aesthetics on the one hand and quantitative and qualitative methodologies on the other.

This chapter does not extend the book's thesis—that most works of art when viewed contextually are more valuable than when viewed from a formalist or disinterested perspective—in a direct way, in the way that the preceding three chapters do, but it supports the thesis nonetheless through demonstrating that science, as a matter of fact and as a matter of principle, makes use of contextualist aesthetics. The ways in which this is done are discussed explicitly at the end of this chapter. The claim that we are working toward here is that a formalist aesthetic will be useless to scientists, while a contextualist aesthetic not only is but also has been useful to scientific progress.

Eddy Zemach, in an article entitled "Real Beauty," offers two interesting arguments in support of aesthetic realism.[1] Zemach's first argument is based on language. To use a word correctly is first to have learned the paradigmatic instances where the word is correctly used. These paradigmatic, correct applications of the use of terms—aesthetic terms included—make up a common core of shared term applications. Without this common core, such terms would be incomprehensible. Without such a core, critics could not disagree with one another because there would be no basic shared application of aesthetic terms against which one critic argues for the application of the term and the other disagrees. It is this common core of shared applications of aesthetic terms that points to the real existence of the aesthetic properties to which those terms refer.[2] Zemach's second argument is based on scientific realism.[3] Scientists apply criteria to theories, such that those theories that best meet these criteria are judged to most closely approximate the truth. At least in part, these criteria are aesthetic: simplicity, elegance, unity, and so forth. Were it not for the real existence of such aesthetic properties, the scientific realism that holds that theories are more approximately true when they possess such aesthetic virtues could not be maintained. Scientific realists must be, if they use aesthetic criteria, aesthetic realists as well.[4]

Aesthetic versus Epistemic Considerations

Zemach's second argument, of course, is the one I focus on here. The argument turns on an empirical premise, that scientists actually use criteria in the adjudication of theory that have a pronounced or genuine aesthetic character, or to put it more forcefully, that scientists actually cite aesthetic properties in their cases for and against theories. If they do, the second question has to be, should they? E. O. Wilson, probably the most famous sociobiologist living today, writes,

> To a considerable degree science consists in originating the maximum amount of information with the minimum expenditure of energy. Beauty is the cleanness of line in such formulations, along with symmetry, surprise, and congruence with other prevailing

beliefs. [This is why] Dirac . . . could say that physical theories with some physical beauty are also the ones most likely to be correct, and why Herman Weyl, the perfecter of quantum and relativity theory, made an even franker confession: "My work always tried to unite the true with the beautiful; but when I had to choose one or the other, I usually chose the beautiful."[5]

Wilson's report of Weyl's confession may give one pause. What many of us expect out of our scientific theories is a reliable description of the way the world is, with the consequent being a set of predictions about the future and about how we can negotiate or manipulate it. We, at least those who are realists, expect that scientific theories make true statements about the world, and much of the time we expect that there will be some instrumental value, some practical utilitarian value, that will come from understanding the world more deeply. It must be granted that the sort of science that Dirac and Weyl are engaged in is not the sort that easily translates into inventions and technology, and so the instrumental expectations here are not as pronounced as they are in other scientific endeavors. Abstract physics is done mostly if not exclusively from other motivations. If we take Dirac and Weyl at their words, then part of that motivation lies with aesthetic concerns. But what does it mean to place aesthetic concerns, the search for beauty in the development of scientific theory, over and above the true? To the extent that we who listen to the theorists are interested in learning more about the world, having scientists engaged in exercises where the motivation is predominantly aesthetic rather than epistemic certainly may give us pause. If the scientist's first concern is an aesthetic one, a search for beauty in the description of the world or in the development of theory, then how is the scientist different from the artist? If not different, then are scientists simply artists who create art objects (scientific theories) that are to be appreciated aesthetically, artistically, by those capable of such appreciation? That is, are these scientists simply hyperelite artists? If they are, then it is unclear what the vast majority of nonscientists will find in them of value.

Most of us are happy when scientists cite aesthetic properties as they describe theories. We appreciate that they have such an appreciation. We appreciate that as we find nature beautiful in scientifically naive ways,

those who describe nature in more profound, detailed, or systematic ways create theories that also portray nature as beautiful; we appreciate that our observations of nature are in this respect like the observations of scientists. We appreciate that such aesthetic considerations make the scientists' theories more accessible to the lay audience. I may not understand the actual mathematics involved, but I can understand to some degree what the scientist means when she says that formulae or subatomic particles (or waves) are symmetrical, balanced, or elegant. This gives me an entree that I would not otherwise have had. So we appreciate the accessibility that a shared aesthetic vocabulary offers. But although we appreciate all these things, we tend to do so from a secondary perspective. We tend to see aesthetic considerations as gravy or icing; they come after the substance is set down. They are ways of appreciating a theory after that theory has gone through all the important and serious matters, matters concerning how true it is, how predictive it is, how comprehensively it addresses all the empirical data.[6] The idea of privileging aesthetic considerations over truth considerations, in the way that Weyl confesses, is worrisome. This is not a scientist who is doing the work of a scientist, one may think.

Surely scientists seek truth first, and if there is any aesthetic appraisal, this is an afterthought. This premise seems to fit with the movements in physics from Newton through Einstein and Bohr, down through Heisenberg, Feynman, and physicists working today. Newton's system was beautiful. Events were predictable according to an unchanging, finite slate of laws, codified in mathematical precision. Newton revealed the simple set of nature's fundamental principles and with that, the mind of the Creator. As God made man in his own image, complete with grand and subtle aesthetic sensibilities, so also does God's architectural plan as manifested in the natural world demonstrate those same aesthetic sensibilities. Einstein's theories have been called beautiful and elegant, but both the simplicity and accessibility of earlier Newtonian mechanics was sacrificed. Einstein's theories are beautiful to other physicists, perhaps, but they are largely inaccessible to the general populace. Quantum mechanics, as these theories were being developed by the Copenhagen physicists, were more complicated. The quantum world is confusingly baroque. Worse still, its descriptions of the natural world do not

translate into metaphors. Perhaps one can appreciate the beauty of the math, but when one attempts to map quantum descriptions onto the human imagination, nothing but paradox results. Without metaphor, we have nothing that we can sense with our mind's eye. Without this, there is no physical aesthetic appreciation. The only thing left to appreciate is the math (and perhaps the paradoxes themselves). The same sort of thing was true with the shift from a geocentric universe to a heliocentric solar system. Aristotle's and Ptolemy's astronomical systems were beautiful, clean, and simple, and they cohered with theological and metaphysical data (about the place of humans in creation) as well. To take another early cosmological paradigm to its extreme, the emperor of China sat in the middle of the Forbidden City in the middle of the capital of the Middle Kingdom in the middle of the entire universe. That is impressive. Unfortunately, Kepler, Copernicus, and Galileo took that sort of geocentrism away from us. We now have no center to the universe but a metaphorical one; we are on a planet shuffled together with other planets, circling an ordinary star in the outer-middle fringes of a pretty ordinary galaxy. No impressiveness here. We even lost the clear circular orbits of Aristotle and Ptolemy and gained in return only various sorts of ellipses, not all of which are even in the same general plane. If aesthetic considerations should predominate, it is difficult to see from a layperson's perspective why science has gone the direction it has. Yet most of us, at least those who do not have a diehard obsession with the concerns of theological and metaphysical data, are entirely comfortable with the progress of science, even at the expense of our aesthetic appreciation of it. We want our science to describe the world in truth. We are pleased that quantum mechanics has more predictions coming to pass than earlier systems did, and we take this as a sign that we are still on the right path, converging on a true and accurate account of the natural world.

Are aesthetic considerations in the development and evaluation of scientific theories really secondary matters, important only as an afterthought for scientists and as a means through which people who can only grasp science metaphorically can have some access? Perhaps there is more to this. In the same journal in which Zemach's article appears, Peter Kivy's "Science and Aesthetic Appreciation" appears.[7] In this essay, Kivy exam-

ines the use of aesthetic consideration in scientific theory creation and evaluation. Kivy constructs his essay around two earlier figures debating the importance of aesthetics to science, J. W. N. Sullivan[8] and Roger Fry.[9] Sullivan offers forceful rhetoric in support of aesthetic consideration in scientific theory development and evaluation. Fry offers reasons, along the lines of the ones I offer above, for rejecting Sullivan's claim that aesthetic considerations should be superior to epistemic ones. There are many beautiful systems, Fry says, in theology and in metaphysics that have aesthetic value, but only aesthetic value. These systems, of course, are not science, because scientific theories first and foremost should agree with facts.

Kivy's essay takes up three central questions. First, do we really appreciate or evaluate science aesthetically, in the literal sense of the term? Second, are scientists really motivated by an aesthetic appreciation of their theories? In other words, are aesthetic concerns really important to why and how they do science? And third, are aesthetic considerations really employed by scientists in judging the worth of a theory?

On the first question, he writes, "The criteria that scientists customarily cite in support of their apparent aesthetic judgments are certainly the kind that we tend to cite in [other], and uncontroversial, cases of the aesthetic: symmetry, simplicity, order, unity, coherence, elegance, harmony. . . . I take it . . . that if we cite aesthetic criteria in support of a judgment, we hardly need any more proof that the judgment is an aesthetic one."[10] Kivy softens this a bit by pointing out that the aesthetic properties that scientists tend to invoke are what he calls "classical" ones, ones that are "beauty-making." Scientists do not celebrate aesthetic properties such as ambiguity or "sublime disorder." Nonetheless, Kivy remains with his initial take: even if scientists limit their aesthetic citations, there is no reason to believe that their application of these terms is not genuine or literal. Kivy also takes up the problem of mixed postures, that is, how the attitude of the scientist can be both epistemic and aesthetic at the same time, as I discuss in chapter 3. Kivy does not see the disjunct as an exclusionary matter, either.

On the second question, Kivy lays out three possible motives for why people practice science: practical instrumentality, intellectual curiosity, and aesthetic appreciation. He dismisses the first of these almost imme-

diately, citing Richard Feynman, who said that "the work he was doing in theoretical physics was not merely of no practical utility in the foreseeable future but, as far as he was concerned, of no conceivable practical utility—ever."[11] Kivy says of the second and third that they are bound together: "The answers one seeks at such a theoretical level are ones that must satisfy the investigator's aesthetic sense if they are to satisfy his or her intellectual curiosity."[12] The data that are involved in the sort of work that Feynman did are not empirically accessible in the way that the biologist's or sociologist's data are. Theory creation at the level of the deeply subatomic, to achieve anything worth considering, involves more than the prediction of interaction of observables. Scientists such as Wilson, Dirac, Weyl, and Poincaré (whom Kivy quotes) report the inclusion of aesthetic considerations in theory creation. One scientist who does this quite systematically is Maura Flannery, biology professor at New York's St. John's University. She writes in an article entitled "Using Science's Aesthetic Dimension in Teaching Science,"

> One approach that is still neglected is to stress the aesthetic dimensions of science. . . . All of science is permeated with the aesthetic. . . . It is amazing how many of the central concepts in science—order, symmetry, unity—are also important aesthetic qualities. . . . While aesthetic qualities abound in the processes and products of science, it could be argued that order is science's central aesthetic quality because to find order in nature is a key aim of sciences. . . . Form, rhythm, and pattern can also be seen as manifestations of order and thus of beauty in nature. . . . One type of pattern that is particularly attractive is rhythm: ordered or balanced change. . . . The attraction of symmetry relates to the quest for order: symmetry represents stability and permanence. . . . Finding the unity that underlies the diversity of life is one of the major themes in biology. . . . Related to unity is the concept of simplicity. It may be said that unity is a property of nature and simplicity a property of the processes we use to understand nature. . . . Taste, which is based on sensitivity to aesthetic qualities, determines style of research, how science is done.[13]

On the third question, Kivy writes, "This brings me to the final question that I wanted to consider here. That is the question of whether aesthetic considerations are ever conclusive, in themselves, in the acceptance of a theory. Well, it ought to be fairly apparent by now that this question as stated only makes sense under a formalist account of the aesthetic. . . . One cannot intelligibly ask whether aesthetic criteria are ever decisive in themselves in deciding for the truth of a scientific theory, unless one has severed the aesthetic from the true in formalist fashion."[14] Kivy says that the reason Fry was able to so quickly reject Sullivan's claims about the importance of aesthetics to science is that Fry was working with a strictly formalist approach. Sullivan was not, and so Fry's criticisms of Sullivan, Kivy writes, do not have the effect that Fry would have wished for them. Kivy says that "Sullivan, however, is under no such formalist constraints. His notion of aesthetic evaluation and appreciation includes both the formal and the representational; aesthetic success for him is a complex function of formal beauty and truth, both in science and in art."[15] If one considers aesthetic criteria to consist only of formal features, then Fry's complaint that a beautiful-and-false theory will trump an ugly-and-true theory is a good complaint. This is, of course, the picture I was painting above. But to take an aesthetic approach to creating and evaluating theories, say both Sullivan and Kivy, need not exclude what Kivy calls the representational, that is, how well the scientific theory represents the world it purports to describe. Kivy says that "the beauty of a scientific theory, like the overall artistic success of a realistic painting, is a function also of its representational success, which is to say, its truth. . . . Once formalism is given up, the claim that, in theoretical sciences, the beautiful can never prevail over the true loses all appeal, if not all sense, for, of course, there never is a contest between beauty and truth in theoretical science, understood as the attempt to represent nature. It cannot represent nature beautifully, in the fullest sense, without representing it truthfully."[16] Weyl's comment about truth and beauty in his work must be reread in a different way. In light of Kivy's argument for rejecting the bifurcation or juxtapositioning of truth and beauty in science, which accords well with the first part of Weyl's confession (about uniting truth and beauty), the second part of the confession (about choosing beauty over truth) must be read as a methodological

orientation, a way to press through during the discovery phase to the creation of a theory that then can be jointly viewed from the aesthetic and epistemic perspectives.

This brings us back to Zemach's argument. The questions concerning his pivotal premise—whether scientists cite aesthetic properties in their theory creation and adjudication, and whether they should do so—can be answered now in the affirmative. Surely scientists do employ aesthetic considerations. This is clear. That they should is a conclusion that can be drawn from Kivy's arguments. Scientists should employ aesthetic considerations, but with one caveat: their approach must not be exclusively formalist, setting up a division between beauty and truth, between formal aesthetic features and representational ones—"representational" as a species of contextuality. Scientists who support the division do so poetically, metaphorically, that is, in the sense that I attribute to the second reading of Weyl's confession. Any scientist who relegates truth to a position lower than beauty is not a scientist. But there are few scientists (if any) who do this. Most do employ aesthetic considerations, and most do so nonformalistically.

Positive Environmental Aesthetics

I continue this section by looking at an ingenious means of employing aesthetic considerations in scientific theory construction that results in a very interesting aesthetic claim about the nature of nature, or the character of aesthetic assessment of nature. Allen Carlson (see chapter 4), one of the foremost environmental aestheticians today, states that "frequently the appreciation of nature is assimilated to the appreciation of art. Such an assimilation is both a theoretical mistake and appreciative pity."[17] Carlson offers several arguments for his view, three of which I will note here.

First, nature appreciation differs from art appreciation by incorporating the viewer within a living, dynamic context that changes as the viewer moves through it, whereas the aesthetic object in the case of art is separate from the viewer and localized. Nature appreciation thus serves as foreground rather than background.[18] Furthermore, nature appreciation is not like art appreciation in the engagement of sensory modalities.[19] Rather than relying on only one or two senses for appreciation of the object, as

is the norm in art appreciation, nature appreciation creates an entire sensory envelope around us.

Second, whereas we typically focus our attention and base our judgments on formal qualities in art appreciation, we cannot do the same in nature appreciation. The very indeterminacy of the natural environment requires that it be framed artificially, making it, as Carlson writes, "an unlikely place to find formal qualities."[20]

Third, in attending to art we typically appreciate both (1) the design of the artist along with how well that design was executed and (2) the order and organization of the work itself.[21] But it is far from clear that in aesthetic attention to nature there is any correlate to design appreciation. Unless one were to bring a divine Creator into the picture, (virginal) nature does not have a designer.[22] These arguments and others are advanced by Carlson to demonstrate that art appreciation and nature appreciation are, in terms of those items relevant to suggesting that the environment can be aesthetically approached as one would approach an art object, dissimilar.

On the matter of the second point—whether nature can be aesthetically evaluated—Carlson advances the consideration that the only appropriate environmental aesthetic is exclusively a positive one.[23] His argument for this rests on his construction of and commitment to a cognitive model of natural appreciation that emphasizes scientific knowledge as the means through which to appropriately understand the correct classification of the natural aesthetic object.[24] Carlson writes,

> A more correct categorization in science is one that over time makes the natural world seem more intelligible, more comprehensive to those whose science it is. Science appeals to certain kinds of qualities to accomplish this . . . ones such as order, regularity, harmony, balance, tension, resolution, and so forth. . . . These qualities that make the world seem comprehensible to us are also those that we find aesthetically good. . . . The determination of categories of art and of their correctness are in general prior to and independent of aesthetic considerations, while the determinations of categories of nature and of their correctness are in an important sense dependent upon aesthetic

considerations. . . . These categories not only make the natural world appear aesthetically good, but in virtue of being correct determine that it is aesthetically good.[25]

To complete the point, Carlson writes, "If all nature 'is equal in beauty and importance,' this is a significant difference not simply between nature appreciation and the order appreciation of some works of art and anti-art but between nature appreciation and art appreciation in general."[26] Carlson's argument for positive aesthetics turns on the nature of scientific theories. Like Zemach, he assumes (rightly, as we have seen) that when scientists create and develop their theories describing nature, they employ aesthetic considerations. We find aesthetic properties in those theories that are advanced and endure. These theories render the natural world intelligible to us—this is the truth bit—but to do this, they incorporate qualities that are essentially aesthetic—this is the beauty bit. They do not do the one without the other, because a reduction in employment of aesthetic qualities will result in theories that are less intelligible and comprehensive. Such theories would restrict our access to understanding the natural world. As the beauty bit goes down, so too does the truth bit goes down. The result is that those objects and events that are described by the theory are imbued and informed with the aesthetic character of descriptive theories. We may find nature beautiful to the uninformed eye, but the informed eye, the eye educated by science, will find nature all the more beautiful. This is for two reasons. First, it is more intelligible. Second, scientific theoretical descriptions have built into them positive aesthetic features. The conclusion is that if science is the proper approach to take through which to appreciate nature—and this is Carlson's greatest legacy—then the judgments available to us about the natural world will all necessarily be aesthetically positive.

There may be reasons for rejecting positive aesthetics in nature appreciation. I have suggested that if we are going to construct a practical agenda in which we set conservation priorities, we must be able to make assessments of natural areas that are comparative in the sense that not all areas will be of equal aesthetic value. This may require negative aesthetic judgments; it would certainly require less than perfectly positive judg-

ments. But this is not at issue here. The use of aesthetic criteria in scientific theory formation and evaluation is the point, and Carlson's argument for positive aesthetics demonstrates in concrete form the conclusions that Kivy reaches about the importance of rejecting a formalist approach here. Marry Carlson's argument for positive aesthetics with his broader denial that formal properties are available to us in nature appreciation, and the point is made even more forcefully.

AESTHETIC APPROACHES IN SOCIAL-SCIENTIFIC RESEARCH

In this section, I focus on contextualist aesthetics and methodological choices in the social sciences. I believe that there is a parallel between disinterested, formal aesthetic approaches and engaged, contextualized approaches in aesthetics on the one hand and quantitative and qualitative scientific research methodologies on the other.

Qualitative and Quantitative Methodologies

Of course, there are many varieties of quantitative calculuses, just as there are many approaches to qualitative research; however, despite the diversity of approaches covered by both types of research methodology, the use of the terms *quantitative* and *qualitative* is warranted because despite the differences, the similarities among the various approaches in the quantitative camp and those in the qualitative camp are sufficiently great to label them either quantitative or qualitative. Furthermore, these two approaches generally stand in opposition to one another. Although they are not, in the Aristotelian sense, "contradictories"—which is to say, they are not logically incompatible—and although mixed approaches to research are not remarkably uncommon, the differences between quantitative and qualitative research are generally easy to see, so much so that it is generally possible, in a mixed-research approach, to pick out which parts of the study are quantitative and which qualitative. The two approaches, it is fair to say, are opposites—"contraries" in the Aristotelian sense.

Although recent history—and perhaps this is the case still—may favor the quantitative approach, there is in still-more-recent history a strong interest in the qualitative approach. This is because, over the preceding

century, our interest as inquirers has become as much for meaningfulness as for straightforward instrumental predictability.[27] We are as interested in the "whys," relationships, and contexts as we are in the facts that certain effects will follow certain causes a certain amount of the time.[28] I do not mean to suggest that qualitative research is superior to quantitative; I mean to say that the aims of each are somewhat different and, moreover, that the theoretical commitments and frameworks informing the beliefs of those who favor or practice one approach over the other are different.

Elliot Eisner is a social scientific methodologist working in the area of educational research. Based on work like Eisner's, one gets the sense that those who use qualitative methodologies have over the past several years felt a greater need to offer an apologetic, a justification for the truth-capturing capacity of the qualitative methodology, than those using a quantitative methodology. This stands to reason; the justification for using a quantitative methodology goes back to Sir Francis Bacon and to Aristotle before him. It has the strength of the entire Enlightenment behind it. But the qualitative methodology does not share in this history. Although both programs are inductive in nature, the one that purposefully amasses the greater amount of data from which to extract a pattern, explanation, or prediction is the historically favored. Aristotle's use of induction, when he settled for single or small sets of data, proved to render faulty conclusions ("fish deriving from mud" is the classic example of Aristotle as a less-than-consummate inductivist). So, prima facie, the more data, the better. Prima facie, the greater the population, that is, the greater the N, the stronger the hypothesis. But, of course, this is not the case in qualitative studies. Sometimes the opposite is the case; too large a collection of data can impede the depth of the analysis, and meaningfulness can be lost, not to mention any sense of the voice of the participants (in the event that the study is social scientific).

In offering an apologetic, Eisner invokes aesthetics and aesthetic theory to describe—and to defend—qualitative research:

> The roots of [qualitative inquiry and qualitative thinking] can
> be found in one of John Dewey's last major works . . . *Art as
> Experience* . . . [which] provides a view of mind, meaning, and

method that could serve well those interested . . . in broadening the ways in which we think about inquiry.[29]

In *Art as Experience,* John Dewey writes, "The aim of criticism is the re-education of the perception of the work of art."[30]

We need to achieve a critic's level of educational connoisseurship to recognize what counts, and we need to create a form of educational criticism to make what we see clear to those who have a stake in our schools.[31]

Qualitative studies tend to provide [the flavor of the particular situation]. This is done, first of all, by sensitivity to what might legitimately be called the aesthetic features of the case.[32]

As we see in the earlier confessions by Weyl, Flannery, and Wilson, the citation of aesthetic properties can and does play a role in the evaluation of scientific—and, as Eisner shows, social scientific—theories, in adjudicating between competing theories, and in defending theories themselves. If proponents of qualitative research turn to aesthetic considerations in constructing apologetics,[33] then the aesthetic characteristics involved in theory adjudication are not only relevant but also in some sense centrally integral to the justification not merely of which theory to embrace but of which methodology to employ and, more basically, whether there ought to be more than one. If theories that incorporate more or higher levels of certain aesthetic properties are the ones that we generally believe, on balance, to more closely approximate the truth, then surely the presence and levels of the aesthetic properties present in the means by which we develop these theories play at least as great a role.

Aesthetic considerations are relevant to quantitative researchers, as well. This is a point made in the first section of this chapter. But the approach that quantitative researchers employ may be seen, in general terms, to favor more-detached, disinterested approaches. Each of the disinterest theories reviewed in chapter 3 emphasizes, first, an absence of personal interest in the possession of the aesthetic object or in any advantage or benefit the (instrumental) use of the object may afford the viewer, and second,

an emotional detachment. Those theories that focus not on aesthetic experience per se but on aesthetic judgment, on the conditions for correct aesthetic judgment, emphasize that the posture of disinterest affords the judge that view which, in being devoid of any personal considerations, will be universal. In short, what one seeks in adopting the posture of disinterest is a loss of the personal or individual. This is essential, or so proponents of disinterest believe, for a purity of judgment, and it is that purity which leads to the universality that lies at the heart of correct judgment. This is, I think, clearly parallel to what the quantitative researcher wants, too. The quantitative researcher means to be as careful in the practice of science as she can be. She wants to fashion her problem in as value-neutral a way as possible; she wants to collect her data in an entirely uniform way; she wants to create, dispassionately and "objectively," a hypothesis to explain the pattern of the data; and then, as a good scientist, a good practitioner of the most rigorous inductive methods, she wants to frame out ways to test her hypothesis, essentially looking for ways to show that she is wrong, that her hypothesis is incorrect. This requires a strong emotional detachment on the part of the researcher. She must not invest anything of herself in the interpretation of her data or the construction of her hypothesis, else the objectivity of her investigation is in danger.

Detachment of the researcher from the object of her research is crucial in utilizing a quantitative research methodology in order to avoid tainting the data through the potential inclusion of the researcher's biases. There is a paradox that must be kept in mind when working through the details of the background theoretical commitments of any researcher. That paradox is a psychological one: the researcher must be interested enough in the topic of her research to sustain her motivation to create, instantiate, and stick with her study through to the end. This interest is frequently exposed, and appropriately so, when researchers present their findings and their theories with enormous enthusiasm. But the other side of this paradox is that the researcher must at the same time be dutifully careful to keep her own biases, explicit and hidden, from intruding into the research itself. This is a balancing act, but most scientific researchers are masters of it.

What quantitative researchers seek is objectivity, both in terms of the results of their work and in terms of the process of that work. For the

latter, the value of procedural objectivity is borne on the acquisition of the former: objectivity in the results. The value of the objectivity of the results is found in the claim to instrumentality. Researchers want to discover truths about the world—at least, the realists among the researchers want to do this. At a minimum, researchers by and large want to frame out hypotheses that consistently and trustworthily make predictions about patterns. This allows for telling the future, and telling the future is exactly what the instrumentality of science is all about. We want to say that given certain conditions and certain antecedent events, particular conclusions can well be expected to obtain. Whether the researchers ultimately think that they have discovered something essential and universal about the fabric of reality or whether they think merely that they have found a useful tool, objectivity in both process and results is key.

However, the engaged, contextual approach—the sort of approach endorsed by George Santayana, Dewey, and Arnold Berleant—emphasizes real-world, real-psychology, felt experience. It does not seek a gulf between the viewer and the viewed; it instead celebrates an intimacy between the two. The greater the intimacy, the greater the experience. The more the viewer is able to invest herself in the viewed—both qualitatively in terms of the richness of the experience and quantitatively in terms of the amount of time she can rewardingly spend with the viewed, the number of sensory modalities engaged, and the intensity of that engagement—the greater will be her aesthetic experience. The subject's involvement in the object of her experience is key here. If the subject attempts to maintain a distance from the object, her experience of it will fade.

This is the sort of claim that Eisner makes about qualitative research in education. He praises the introduction of the researcher as part of the phenomenon under research. The subject is the instrument through which the research is done; the researcher is the lens, the filter, the microscope through which the data—the experiential data—are sifted and thematized, informed and explained, to the end that the results of the research are rich with meaning. In describing the qualitative researcher, Eisner speaks of "connoisseurship," defining it as "the means through which we come to know the complexities, nuances, and subtleties of aspects of the world in which we have a special interest,"[34] and provides

as an example the "ability to make fine-grained discriminations among complex and subtle qualities."[35] The subjective is not only something to be embraced but also the cornerstone upon which deep qualitative research is built. It is the engaged involvement of the researcher, conversant with her subjectivity and understanding her subjectivity to be a research tool,[36] that produces good qualitative research. Disinterest is anathema here; it shuts down the acquisition of insight and perception. Eisner writes, "The kind of detachment that some journals prize—the neutralization of voice, the aversion to metaphor and adjectives, the absence of the first-person singular—is seldom a feature of qualitative studies."[37]

Making a Methodological Choice

There are several ways in which aesthetic considerations are relevant to the researcher in deciding which of the two methodologies to employ. The first way that I explore here focuses on the researcher's prior commitments: philosophical and methodological commitments that the researcher brings with her to the decision. The second way focuses on a difference in the goals of the study; different goals lead to different means to achieve them, and this frequently comes down to a methodological choice. The third way is straightforwardly aesthetic: some researchers, on the aesthetic virtues or characteristics of one of the methodologies, choose that one. But we will start with a discussion of prior commitments.

It is not too difficult, as I do in chapters 3 and 4, to separate aestheticians into those who favor the disinterested, formal approach and those who favor an engaged, contextual approach. While there may be some who fall close to the line, most do not; most are clearly in one camp or the other. Part of the reason for this is historical. The disinterest approach commanded the entire "market" during the eighteenth and early nineteenth centuries. Not until late in the nineteenth century do we see an engagement approach. Even into the twentieth century—Jerome Stolnitz is the clearest example of this—we continue to see proponents of disinterest. So another part of the story goes beyond the historical.

Lord Shaftesbury was a Platonist. He believed in essences, and he believed that the correct means to reach those essences was through disinterest. Arthur Schopenhauer's case is virtually the same as Shaftes-

bury's, the only differences being the focus on the person and what we might anachronistically call the psychological elements in Schopenhauer's account. Immanuel Kant accepted David Hume's emphasis on the sovereignty of the individual subject when it came to aesthetic judgment, but Kant saw, in his attempt to work through the relativistic stumbling blocks in Hume's theory, the importance for uniformity in aesthetic judgment of putting each judge on an absolutely equal footing. This is accomplished through disinterest. In these cases, the approach is dictated in some measure by prior commitments: Platonism and aesthetic realism, in these cases.

Prior commitments have the same sort of influence when the social scientist must choose a methodological approach. If a researcher has a strong commitment to the view that there is really no such thing are pure, objective research—or Truth with a capital T—or a description of reality that rises above the dense, tangled, and complex, then that researcher's commitment may entail that she approaches all of her research qualitatively. We are in the midst, and have been for a number of years, of a period—sometimes called postmodernism—that views the Enlightenment (or Platonic) attempt at securing pure knowledge, pure truth, and the understanding of pure essences as hubristic, without merit, and ultimately futile.[38] This is certainly true in the philosophical disciplines, and my impression is that it has even greater strength in the social scientific disciplines. Whenever there is a revolution, there is almost sure to follow a counterrevolution, and we have seen this, too, in philosophers and scientists alike working toward constructing theories, the promise of which is knowledge and truth, in the old sense (what some postmodernists refer to as "positivism"). Researchers who find allegiance with the counterrevolution will prefer quantitative approaches. These researchers boast that they are discovering truths, truths tested by their value as predictive devices. Science that has proceeded on this "positivistic" tack—science that has given us such advances as heart surgery, space travel, and television—has proven itself through concrete, practical results. Whatever the philosophical commitment, such commitments tend to move their adherents toward favoring certain methodological approaches.

A second consideration, when making the methodological decision, focuses on the goal of the given study being conducted. The qualitative

approach is purposefully designed to provide us with greater insight into the explanatory, into not only that event B always follows event A, but also why it does, and why it does in some circumstances but not in others—or why more in some rather than others.[39] The qualitative approach is meant to supply us with insight and with meaning. In contrast, the quantitative approach is designed to offer us regularity, reliability, and straightforward generalizability. It seeks not so much to explain why a thing happens but rather to show that it will, time and again, happen. The quantitative approach offers us a view of a pattern, and although both approaches seek, as does all good science, to offer us predictive devices, the quantitative approach holds predictability to be the primary goal. This is not always the case with a qualitative approach: while predictability is a goal, it is not an exclusive one.[40] Depth of explanatory insight is every bit as much of an aim.

The differences in the goals of each research methodology are a second ground upon which rests the decision of which to use in a given study. Sometimes examining the statistical significance of the correlation between two events is all that is needed, and so the goal is to achieve this in as simple, direct, and secure a way as possible. In that case, the quantitative approach may be used. Sometimes the factors affecting a given phenomenon are so dense and tangled that generalizability can be thought only an ideal, and the goal is to explore the factors as they manifest themselves. The goal is understanding and sorting. This is frequently the case when dealing with human beings and phenomena that flow from the subjective, psychological aspects of humans. In this case, a qualitative approach may be preferred. Methodological preference follows the goals of the study. If one is looking for one kind of answer, one approach will be used; if one is looking for another kind of answer, another approach is preferred.

How are aesthetic considerations relevant here? One need only consider the detail of the parallel laid out earlier. If the goal is discovery of the significance of event correlation, then the crucial point is that interfering influences be minimized, that to whatever extent possible the two events (given that sort of study) be isolated from external intrusion. One minimizes researcher intrusion—especially where expectations are present (and they almost always are)—through a posture of scientific disin-

SCIENCE AND CONTEXTUALIST AESTHETICS

terest. If, however, the goal is explanatory depth, then the researcher will have to use her expertise in the subject matter, as well as her expertise as a human being, to work through the tangle of factors and the importance her subjects place in these factors. Engagement must be the model here, and connoisseurship of subjectivity and complexity may be judged to be the best means to achieve the goal. I want to say, at the close of this point, that my characterization of the goals of these two research methodologies may border on the extreme. I describe polar views. In spite of this, I continue to believe that while all methodologies seek both to predict and to explain, quantitative approaches tend toward the former and qualitative tend toward the latter.

Both of these first two considerations can and sometimes do involve concern for, or at least reflection on, the aesthetic features of the two methodologies. This is clearly the case in qualitative research. Eisner writes,

> In the context of qualitative inquiry, the term *interpretative* has two meanings. First, it means that inquirers try to account for what they have given an account of. . . . A second meaning of interpretation . . . is concerned with matters of meaning.[41]

> If description can be thought of as giving an account of, interpretation can be regarded as accounting for.[42]

> [Clifford] Geertz' "thick description" focused on the nature of method and the aims of ethnography. Geertz himself has been influenced by aestheticians such as Suzanne Langer and calls into question the tidy positivism that has significantly influenced his own field. Thick description is aimed at interpretation, at getting below the surface to that most enigmatic aspect of the human condition: the construction of meaning.[43]

While Eisner understands Geertz to have been influenced by the aesthetic views of Langer,[44] he understands qualitative methodology, as we saw earlier in this section, to rest on the shoulders of Dewey's work in aesthetics. If qualitative studies intimately involve researcher sensitivity

to "the aesthetic features of the case," then any researcher who has a prior commitment to, or has the goal of, uncovering such features in his work will tend toward qualitative methods. As this influences in a direct fashion the decision to pursue a qualitative study, so too does it, at least indirectly, impact the decision concerning pursuit of a quantitative study—given that the quantitative methodology is passed over. I grant that such aesthetic considerations may not be centrally focal, but given the fact that Eisner and others invoke aesthetic talk in developing their descriptions of, and cases for, qualitative methods, such considerations are relevant in making methodological choices.

Finally, a third consideration concerning the methodological decision is simply and straightforwardly aesthetic. The nineteenth-century metaphysician Alexius Meinong had an extremely robust sense of ontology. His world was thickly and densely populated. At the other extreme, W. V. O. Quine had a very modest ontology; some even say barren. Quine is reputed to have said that he appreciated desert landscapes. In contrast, more than a few teachers of Meinong's views have described them as "baroque." If approaches to ontology can be described—and, more to the point, preferred (at least by the likes of Quine)—in reference to their aesthetic features, then research methodologies can as well. The disinterested approach leads to simplicity, to the researcher's having a sense of control and, at the conclusion of the study, a sense of closure, that something—however modest, however grand—was discovered. The engaged approach is messy. The researcher may well end the study with more questions than those with which she started. She will have to employ her own creativity and plumb her own subjectivity to make anything approximating a discovery. Some people like desert landscapes, and the chances are good that if they are social scientific researchers, they will prefer, all other things being equal, quantitative approaches. Some people like the baroque, the rococo, the rich and complex; researchers such as these we might well find tending toward more-qualitative approaches.

CONTEXTUALISM IN SOCIAL-SCIENTIFIC RESEARCH

The parallel between social-scientific research methodologies and aesthetic-approach orientations seems obvious to me. If this parallel indeed

makes sense, then we can advance a few claims, some old, some new. Among these are the following:

1. Scientists employ aesthetic consideration (seeking out the incorporation of aesthetic properties) in the discovery phase of their work, in which they begin to formulate and construct theories to describe the natural world.

2. Scientists employ aesthetic consideration in adjudicating between competing theories, in evaluating theories, and in supporting theories.

3. Scientists who engage in the approaches numbered 1 and 2 above cannot do so essentially from a formalist perspective. An approach that ignores the contextual aspect of the theory's representation of the natural world is useless.

4. Scientists who engage in qualitative research methodologies go one step further. These scientists actively embrace subjective engagement with the objects of their study. They not only reject a nonrepresentational formalism but also reject even the motivations of a formalist approach. They reject the detached, disinterested approach that traditionally has been held to constitute the best chance of securing objectivity. But as we see in number 3 above, even scientists who work in this tradition, generally those employing orthodox quantitative methodologies, cannot be true formalists or disinterest theorists. Kant's approach is useless in reference to the (active and vital) relationship between aesthetics and science.

5. Earlier I brought up Eddy Zemach's argument for aesthetic realism that is based on the citing of aesthetic virtues in theory adjudication. I extend this point further now by saying that if one social-scientific research methodology is preferred over the other and this preference is both made, to some degree, through consideration of aesthetic features of the case and shown on other grounds to be the correct methodological choice (because the study revealed more, however that is cashed

out, than it would have were it based on the alternative methodology), then this is good evidence that consideration of aesthetic properties in methodological adjudication picks out properties that contribute—*really* contribute (to make the point)—to the knowledge-acquisition of the results of that methodological choice. This is not different from Zemach's point but merely amplifies it.

The function of this chapter, as we have seen, differs from that of the preceding chapters. Chapters 5–7 are about offering concrete evidence for the theoretical claims in support of contextualist aesthetics. This chapter, in contrast, is about advancing the theoretical arguments. Unlike the work reviewed in chapter 4, the arguments here have a specific and concrete context: the creation and evaluation of scientific theory.

A Review of the Arguments and Evidence

THIS CHAPTER SERVES AS A REVIEW OF WHERE we are so far, both in terms of offering argumentation for the thesis that in many cases consideration of context increases the value of art objects and in terms of offering empirical evidence for this claim. It may be important to recall that this book's core argument is advanced through offering empirical evidence to concretely and experientially demonstrate the enhancement of an art object's value when viewed contextually. The argument structure of the case that I offer in this book is simple:

P1 *A work of art is valuable if and only if it is (does, has) X.*

P2 *In many cases, X is enhanced if the subject who is experiencing the artwork takes into consideration appropriate contextual features related to the work.*

C *In many cases, the value of a work of art is enhanced if the subject who is experiencing the artwork takes into consideration appropriate contextual features related to the work.*

The logic is elementary, so anyone who is out of agreement with my case will probably look to the truth of the premises, explored in the later sections of this chapter. Before turning to an examination of the core

argument, I take some time to review briefly the many supporting arguments mentioned throughout the book in support of contextualism.

SUPPORTING ARGUMENTS

The Nature of Aesthetic Attention

It is wrong to assume or claim a priori that aesthetic attention, for the purposes of either aesthetic experience or aesthetic judgment, is characterized by disinterest.

Aesthetic matters are not automatically matters of merely considering formal properties of objects and events from a detached and decontextualized perspective. This is so for the following reasons:

- Aesthetic experience is the basic building block, the bedrock, of aesthetic inquiry. Some experiences are apportioned off from others, with the former labeled "aesthetic," the latter not. This is a matter of description, not ontology. Aesthetic experiences are private, yet we all can describe examples of aesthetic experiences and nonaesthetic ones in ways that resonate with the experiential descriptions of others.

- To understand the nature of aesthetic experience—again, from a descriptive point of view, not necessarily an ontological one— without prejudice is to adopt an inductivist approach. The principal reason that this is the correct approach is that the raw data that we are attempting to understand in all this is actual lived aesthetic experiences. To attempt to do this in anything but an inductivist manner is to invite the inevitable counterexample. We are not, in trying to explain the nature of aesthetic experience, in the business of saying to people under what conditions they will and will not have aesthetic experiences. Rather, we must take the plethora of data with which we are faced and try to find some pattern or patterns to it.

- To claim that the very meaning of aesthetic consideration is necessarily conjoined with an posture of disinterest is to miss the

A REVIEW OF THE ARGUMENTS AND EVIDENCE

point of open philosophical inquiry into the nature of aes-
thetic experience. It may be that the best means of achieving the
greatest reward in those experiences that humans decide to call
"aesthetic" can be had through a disinterested disposition. But
I think that this purely empirical claim is, in many instances,
false. Connecting the meaning of aesthetic appreciation with
disinterested appreciation cuts off inquiry, rendering further
philosophical challenge useless.

To use "aesthetic consideration" as an abbreviation for "con-
sideration of the formal properties of an aesthetic object" is to
cut ourselves off from value, and it goes against the inductivist
program outlined in chapter 1 in terms of understanding aes-
thetic experience. If what we are after is a means of understand-
ing aesthetic experience and, subsequently, understanding how
to enhance it, we do well not to limit ourselves by adopting this
abbreviation uncritically or axiomatically. Marcia Eaton writes,
"What is wrong is the claim that when one looks, reads, or listens
to works of art (or other 'aesthetic objects'), the only genuine aes-
thetic experiences are those solely or exclusively directed at in-
trinsic features."[1] If the motivation for adopting a decontextual
approach is to provide a mechanism for aesthetic realism, then
the cart is put before the horse. Quality aesthetic judgment serves
the goal of aesthetic experience, not vice versa. Rarifying the con-
ditions for quality aesthetic judgment without a purpose is non-
sense. The purpose should be to understand and enhance human
experience. Decontextual approaches work at odds with this.

Revisionist Art Evaluation

*The correctness of a revisionist approach to the evaluation of art
implies the correctness of contextualism.*

Anita Silvers introduces the difference between a traditionalist view of
the value of works of art and a revisionist view. The traditionalist holds
that the value of works of art depends on the features they had at the
point of their creation. The revisionist holds that their value can vary
depending on future events. Silvers, in defending a revisionist view, talks

about how objects are added to the canon in one of three ways: through the acquisition of qualifying properties, by notice being taken of existing qualifying properties, or through the absence of disqualifying properties after careful scrutiny (see chapter 2).[2]

Incorporating both linear time and statistical time in her analysis, Silvers does not consider either to be sufficient in the "test of time" as applied to works of art, for an improvement in art valuation does not directly correlate with the discovery of positive properties in works that had originally been rejected, nor does a decrease in art valuation occur with the discovery of negative properties in works that had previously enjoyed admiration.[3] The two rejected premises are traditionalist. With their rejection, only the first is left, and it is revisionist: the future history of a work counts in its assessment and its candidacy for canonization.

Feminist Aesthetics

Feminist aesthetics is inherently and essentially contextual.

The employment of disinterest and universal intersubjectivity derives from the work of male theorists who share an ethnicity primarily focused on eighteenth-century Europe. Such a shared perspective is not the same as universality, nor does it reflect a neutral set of views. Indeed, the fact that modern women and members of particular ethnic groups, classes, and nationalities (see chapter 5) frequently have differing perspectives leads directly to the conclusion that disinterest theory and formalism are themselves matters of perspective and are thus to be understood contextually.

Aesthetic Experience

It is a contextual project to claim that aesthetic experience—and/or aesthetic evaluation—necessarily includes a subjective aspect in either of the following senses: (1) that what is going on in the subject is more than simply ontologically actualizing objective aesthetic properties, that it is "additive," or (2) that this aspect is a psychological one, amenable to empirical exploration.

George Santayana, Roger Scruton, John Dewey, Anita Silvers, Monroe Beardsley, Frank Sibley, Arnold Berleant, Allen Carlson, and Alan Goldman are all theorists who recommend including the subject, her per-

spective and her psychology, in approaching objects aesthetically. The inclusion of the subject (as we see in the work of David Hume, Sibley, Beardsley, and Goldman) removes the possibility of creating an objective, nonaesthetic formula for the presence of some aesthetic property such as beauty. The subject is necessarily a part of the equation. This would not have been a problem for disinterest theory unless and until a focus on the subject began to mean a focus on the subject's psychology. As psychological science grew, so did the aesthetician's interest in using it to understand the nature of the (or an) aesthetic experience. This movement toward greater empirical investigation of the subject and aesthetic experience meant that the context of the subjective state became even more important; given that new means of investigation, disinterest has been shoved over to the side. The degree to which disinterest gets pushed aside depends on the degree to which the theorist in question believes that empirical inquiry is important to determining the character of those experiences we label as "aesthetic."

The Nature of Art and Artworks

Incorporating historical, sociological, or anthropological features in projects of defining "art," understanding the nature of art, or correctly classifying works of art are all contextualist projects; the correctness of such approaches implies the correctness of contextualism.

Morris Weitz, Arthur Danto, Jerrold Levinson, Kendall Walton, and Stephen Davies all incorporate empirical and contingent features from history in their theories of what makes something a work of art or what goes into appropriately understanding a given work of art. To the extent that these approaches are warranted, so too is contextualism.

Moral, Ethical, Social, and Political Considerations

Considering the moral/ethical, social, or political features of a work of art is a contextualist project; the correctness of such consideration implies the correctness of contextualism.

Plato, Leo Tolstoy, Karl Marx, Mao Tse-tung, Noël Carroll, Berys Gaut, Marcia Mueateder Eaton, and Mary Devereaux are all examples of theorists who include moral/ethical, social, and/or political considerations when

assessing the value of works of art or, in some cases, in framing a theory of the value of art. If their arguments are good, especially those concerned recently with positions of moralism or ethicism, then contextualism, to that extent, is also correct.

The Unnaturalness of Disinterest

Adoption of a posture of disinterest is unnatural in aesthetic attention.

When people attend to works of art, they seek out some sort of rewarding experience. Different people seek out different things, and no one theory captures this adequately (see chapter 1). But what they all have in common is that every art viewer who wants to be in the gallery, museum, auditorium, and so forth is there to get something out of being there. The viewer is looking to get a return on her investment of time, energy, and attention. To the extent that she is seeking such a reward, she is actively engaged in finding value. This is the natural approach. Although some of us attend to art objects purely as an intellectual exercise—for the purpose of understanding the nature of art, art creation, art viewing, art classifying, or for the purpose of art criticism and the evaluation of the work under consideration—these purposes are had by the minority of art viewers. The natural approach holds as the purpose of art viewing to come away with something—some experience, insight, mood, emotion—of value. As it is natural for people to hold a perspecte, as it is natural for viewers to consider works as they "immediately" find them, as it is natural to find works in psychological, social, political contexts—with the most "immediate" approach being one that brings with it context, and thus the "immediate" approach being one that is essentially mediated—so too will it be natural for viewers to seek their rewards as broadly and widely as they will.

The decontextualist, certainly the proponent of disinterest, will disallow this, considering it an improper approach. The Kantian variety of theorist will object that, given this "natural approach," true judgment is impossible. This does not imply that my complaint is wrong; it only implies that Kant's relevance is relegated only to those whose sole purpose is evaluation. The Stolnitzean variety of disinterest theorist is in more trouble, because such a theorist will have to create a case that says that the reward the viewer finds in attendance to the works she consid-

ers is not an aesthetic interest—aesthetic interest being reserved for properly disinterested viewers—but some other kind. This is a tough case to make if we take the subject's report as bedrock and if the subject professes that her experience, which was at its core focused on an art object, was rewarding. To suggest that her experience was not an aesthetic one— or, more precisely, to suggest that her experience was not an art-aesthetic one—requires either that we find something more basic than subjective experience and subjective testimony or that we reclassify the world such that "aesthetic" becomes a label incorrectly applied by the "natural" viewer. Attention, as Stolnitz says, is selective; one focuses, consciously or not, on different aspects of what one senses, and one dismisses, again, consciously or not, those aspects or properties that are not relevant to one's viewing. The selectivity of attention implies that, when this selectivity is conscious, the viewing is inherently purposeful. There is a purpose to viewing art, and apart from the unnaturalness of saying that the purpose is to achieve purposeless viewing, the real unnaturalness is to say that there is some circumscribed and restricted set of purposes (actually, only one) that the viewer may bring with her to her consideration of art objects. This is unnatural.

Decontextualism and Elitism

Decontextual approaches are elitist, and elitism is to be avoided.

Those accounts—and this is the majority of the "taste theory" accounts— that construct a set of parameters that only limited numbers of viewers can meet will result in elitism. "Limited" is the only way to describe the number of those who have access. Accounts that require that an individual have certain traits will exclude potentially large numbers of viewers from the achievement of the proper disposition, and accounts that require the adoption of an unnatural posture with which a possible viewer has no experience will do the same. Attending in the absence of purpose may be so alien to some people that they are de facto prevented from achieving what we are told by disinterest theorists is the proper posture for aesthetic appreciation. If the correct posture is not available—and this cannot be a theoretical point; it must be a practical one— then those for whom it is unavailable are cut off, not able to have true aesthetic experiences. Exclusion from sources of pleasure on grounds

that are out of the (de facto) control of the agent is discriminatory. Elitism breeds discrimination, and to the extent that decontextual approaches to art appreciation limit access to the conditions for proper disposition, they are to be held suspect (see chapter 4).

The Internal and External Logics of Artworks

Works of art have sets of internal rules, knowable by considering the work alone, but implicit in understanding how this set of internal rules functions in the object is knowing another set of rules, a set of external rules that are at the same time inherent in the work and still contextual.

Frank Sibley argues that the citation of aesthetic properties requires more than seeing whether certain objective properties fit certain contextual definitions; it also requires the exercise of taste. While exercising taste, the critic works out the internal logic of a particular work of art, seeing through to the internal structure of the work and then articulating that logic as the basis for the evaluation of the piece, thereby understanding not merely the meaning but also the value of a work of art. Thus, both the internal logic and the external set of rules to which a particular work's internal logic is related are important in valuing that artwork (see chapter 4). As with the internal logic, the external rules are only knowable in the particularity of a given work.

Appreciating Aesthetic Properties

Appreciating aesthetic properties as individual properties requires differentiation, and differentiation requires a context of normalcy, of ordinariness, against which these noteworthy properties stand out.

Non-art aesthetic objects are regarded in one of two ways: as objects to be experienced on the basis of their internal logic or as objects to be appreciated in the absence of their internal logic. Kant's description of the subjective maxim of looking for purposiveness in all objects under our taste consideration leads us to regard non-art aesthetic objects as art, as having an internal logic. Beardsley goes further in saying that art appreciation comes logically prior to aesthetic appreciation. If we regard non-art aesthetic objects in this way, then we are obliged to recognize

that they have inherent contexts as well. But what of a non-art aesthetic object that is appreciated both in the absence of considering its logic and in the absence of engaging our cognitive faculties? Even here, I think that context is inevitable. In those instances in which we experience the object separate from its logic, its structure, we are really experiencing the object not as a whole but as a set of aesthetic properties. Appreciating aesthetic properties, when not a cognitive affair, is straightforwardly psychological. This means that appreciating these qualities will most likely take the form of appreciating them as distinct, special, or unique.

The Relativity of Taste

The fact that different aesthetic subjects have different tastes makes taste a contextual matter with regard to the evaluation of artworks.

Sibley talks about the importance of engaging taste in ascribing to objects aesthetic properties. I think we can take one step out from this and, starting from his work, consider other taste contexts that seem very relevant to assessing the value of art objects. Sibley holds that to engage in any critical activity, any aesthetic evaluation, requires the involvement of a subjective context, the engagement of a set of skills on the part of the audience member. If aesthetic evaluative activity is subjectively additive, then aesthetic judgment is in its very nature a contextual matter, and formalism here is dead. If there is no subjectively additive component to the exercise of taste (including "good taste," "my taste," and "your taste") in simple and straightforward aesthetic evaluation, then the formalist project is still viable (see chapter 4). The likelihood that two individuals equally well disposed toward and qualified to judge a given aesthetic object will disagree about its merits, often attributed to a difference in taste, constitutes a challenge to formalism.

PREMISE ONE: THE THEORETICAL, MAJOR PREMISE

A work of art is valuable if and only if it is (does, has) X.

In chapter 2, I outline a set of six possibilities that might fill the variable. There I reject the intrinsic account of the value of artworks for an assortment of reasons (some of which I do not explore there, as these are very

familiar in the literature). My case against intrinsic value accounts rests on the following two reasons. First, if certain modern artworks are valuable as works of art—objects such as readymades, certain Pop Art objects, and, for good measure, certain of John Cage's musical works—then their value cannot be intrinsic, because they are essentially not different from other objects possessing precisely the same objective features but lacking the value that these art objects have. Any position that attempts to account for the intrinsic value allegedly possessed by these objects in the reclassification or renaming of the object is flawed, because any event that happens after the object is created is an aspect of context rather than intrinsic to the object itself. If these certain modern artworks are valuable, therefore, it is because of something going on subjectively; intrinsic value accounts fail to cleanly or adequately account for this. The second reason for rejecting intrinsic value accounts is based on Anita Silvers's revisionism. If works of art can acquire value during the course of their existence after the point of creation, then the value of these objects is not fully explained through intrinsic value accounts focused on the work's objective (nonaesthetic) properties.

Of the six accounts I outline in chapter 2, I accept five. All of these are extrinsic, and the first four (an aesthetic production account, a cognitivist production account, an affective production account, and an amalgam account) are instrumental. The remaining account, a noninstrumental extrinsic account, is a sort of economical expressivist account, in which the value is located subjectively in the respect that the audience member has for the work of the artist. I say this is an economical account, because I do not posit the existence of "an expression" that is separable from the range of things that could characterize the artist's work. This sixth account, although it has some instrumental features, is not a production account in the straightforward way the previous four are.

I believe that it does not matter which of the five acceptable accounts a reviewer of this argument accepts—and I think it is a virtue to have a plurality of choices so that the overall argument does not collapse if the value account being relied upon collapses—but different commitments come with different accounts. For instance, the degree to which the subject enters into the equation changes. Some accounts, such as Goldman's, are more subjectivist; some, such as Beardsley's, describe the location of

the value not exclusively in a subjective state but rather in a relation between the subject and the object. (This is captured nicely in Hume's account, in which the object "is such as" to prompt in true judges a state of approbation.) The degree of subjectivity in the equation may imply differences in the degree to which the various accounts surrender aesthetic realism in favor of relativism. Goldman, for example, is known to be an aesthetic nonrealist.[4] He has argued that there is no means through which one can solve the problem of two aesthetic evaluators of equal ability differing on the value of an aesthetic object. Taste is ultimately a matter that does not accede to adjudication.

It may well be that contextualism is inherently and inescapably relativist in the sense that there is no way to circumscribe exactly which contextual matters are subjectively taken into account or the strength of the subject's consideration of them. Although contexts should be appropriate—by which I mean to limit the range of lenses to those for which some good justification based in the work of art itself may be found—which exact contexts an aesthetic attender brings to her perspective is an open, subjective, and experiential matter. Religious contextual cases are great examples of this, as different subjects will very likely have different religious commitments both in content and in force. And while I suggest in chapter 7 that the greater the range of contexts that a subject brings to her consideration of an object, the truer—more articulable and defensible—her assessment of the object's value will be, it may be, nonetheless, necessary that the contextualist accept that the value of an art object is relative, and pretenses to aesthetic absolutism or full-blown realism must be abandoned.

Formalist and disinterest accounts were originally built, or so one may argue, in the service of aesthetic realism. And so it may be that a reviewer of this argument who insists on aesthetic absolutism will only find it in intrinsic value accounts and formalist means of accessing the value of art. I think, however, that this is less of a problem than it might appear. I have never claimed—though I have been persistently tempted to—that in all cases, at all times, contextualism (that is, consideration of relevant contextual features of a work of art) raises the value of a particular artwork. I think that there are occasions when contextual considerations actually diminish an object's value. This is to say that the relativism that

may be implied by, or simply connected with, the more subjectivist accounts of value is, in my treatment of the matter, avoidable in a narrow range of possible cases.

For me, I have no problem sacrificing aesthetic absolutism for the sake of contextualism. The latter seems more honest to actual lived experience. If aesthetic experience as commonly lived and commonly identified is our bedrock, and we have the added commitment of doing what we can to foster, nurture, promote, and enhance the quality and value of such experiences for their subjects, then it seems the wiser course of action to embrace contextualism and abandon absolutism. Dewey writes, "It is mere ignorance that leads then to the supposition that connection of art and esthetic perception with experience signified a lowering of their significance and dignity. Experience in the degree in which it *is* experience is heightened vitality. . . . Because experience is the fulfillment of an organism in its struggles and achievements in a world of things, it is art in germ."[5]

However, a theorist who wants both contextualism and aesthetic realism need do little more than build in stronger conditions for what counts as appropriate in circumscribing the range of contexts that should be brought to a consideration of an artwork. This book's thesis is a modestly sufficient one: in most cases, if contextual considerations are brought to bear, then the objects' value is enhanced. But it is not a necessary one: bringing contextual considerations to bear is not necessary to aesthetically experience a work of art and, more to the point, to find value in the work. I shy away from the necessity case primarily because, first, I believe that there are (rare) occasions when a formalist consideration is preferable to a contextualist one, and second, I have no problem jettisoning realism in favor of an account that locates, situation by situation, the value of the artwork in the experience of the subject relativistically. Aesthetic realism is primarily motivated by a call or expectation of universality among aesthetic judgments. I believe that if the point of universal aesthetic judgment is a point about identifying the value of artworks—and not about actually increasing the value of artworks (presumably in the experiences of subjects)—then establishing aesthetic realism is of secondary importance to constructing means of increasing the wealth of the aesthetic realm. The contextualist, to secure aesthetic realism, need do

nothing more, it seems to me, than specify when, where, how, and which contexts are necessarily brought to bear in the subject's consideration of a particular work of art in order to assert the claim that there is one and only one correct judgment of the value of each work of art. This seems tricky to me, but it is certainly a logical possibility.

Apart from concerns about the legitimacy of intrinsic value accounts and about aesthetic absolutism and relativism, the first premise of my deductive argument is not very controversial at all. And given that both of these sorts of concerns only apply to *potential* values for the variable in the premise, the premise is even less controversial.

PREMISE TWO: THE EMPIRICAL, EVIDENTIARY PREMISE

In many cases, X is enhanced if the subject who is experiencing the artwork takes into consideration appropriate contextual features related to the work.

Chapters 4–8 are devoted to delivering the evidence for this claim. Each argument presented in those chapters is, by and large, one datum in the inductive case for this second premise. These data are meant to be taken from intuitively attractive art-historical and art-theoretical discussions of particular works and common experiences of those works. As inductive evidence is never absolute, the strength of this second premise rests on the persuasiveness of each argument, each evidentiary datum, offered in these chapters, all taken together as a whole.

The caveats built into the claim are "in many cases" and "appropriate." The "in many cases" phrasing I discuss above. "Appropriate," also discussed above, is meant to limit the range of contexts under which a work may be considered to those that have some ground in the object itself. I have attempted in building my case to focus on the value of art objects rather than the enhancement of particular experiences qua experiences, because, given the messiness of aesthetic experience, whatever strength the book's thesis has would be diminished as the thesis is rendered automatically true and pretty trivial. My caveats are a reminder that that is not the road I mean to travel. The road I mean to travel in this book is laid out below, mapped by sixteen evidence sets.

Evidence Set One: Defining Modern Art

The value of works of modern art can only be assessed appropriately when context is taken into account; a strictly formal assessment will on many occasions render a work of modern art as possessing little if any artistic value.

In chapter 2, I discuss Marcel Duchamp's *In Advance of a Broken Arm* and his *L.H.O.O.Q.*, as well as works by Damien Hirst, Jasper Johns, Mark Rothko, Robert Rauschenberg, and Willem de Kooning. In this context, I also mention the work of Claes Oldenburg, Andy Warhol, Richard Serra, Christo, Ingmar Bergman, John Cage, Tom Stoppard, and Martha Graham. All of these twentieth-century artists have created works of art that challenge our ideas, our approach to art, or our very definition of art. Modern art generally requires audiences to move beyond what is presented to the senses and what information may be available about the origins of the work, its position in history, and how it relates to other works. Without cognitive and imaginative work on the part of the subject, such works either are of very little value or have a reduced value. Modern art thus requires one to understand the place of a modern work in the history of art, to understand that a challenge is being offered, and to understand that some reflection is necessary. The very fact that modern art requires such value-enhancing interpretation is a contextual matter.

Evidence Set Two: Defining Architecture

Defining an object as architecture necessarily involves reference to the object's function; assessment of its value is inexorably tied to consideration of its functional aspects.

Gordon Graham defines architecture as essentially functional and considers that any building that fails "in the purpose for which it is built is an architectural failure" despite any aesthetic merits it might have.[6] If one wishes to consider works of architecture as architecture, therefore, one is bound to consider their functions. Consideration of works of architecture from noncontextual perspectives, purely formal ones, or ones where function is discounted, would both reduce to considerations of the object as a work of sculpture and also, in most cases, leave the attender unengaged and with a flat experience. Conversely, those works of

architecture that exhibit greater functionality are better, as architectural and art objects, than works that exhibit less.

Evidence Set Three: Defining Dance

Defining an event as dance, given the nature of modern dance, requires reference beyond the event's formal properties. A member of a modern dance audience will find a work of greater value if he rejects a purely formalist consideration and adopts a view informed by an appreciation of the sort of dance he watches.

The premiere of *Still/Here* at the Brooklyn Academy of Music in 1994 (see chapter 5 discussion) led to a discussion of the definition of "dance" by notable dance critic Arlene Croce, who decided not to review *Still/Here*, calling it "victim art" and stating that there might be dancing within the performance but that she could not approach it as dance theatre.[7] Croce's position implies that if an object cannot be attended to with emotional detachment, then it cannot be criticized and therefore lacks the accessibility by the disinterested viewer that renders it capable of producing an aesthetic experience. If a dance performance does not, because of its content, permit this, then it cannot, for the formalist, constitute a work of art.

Evidence Set Four: Emotion and Inspiration

Works of art that inspire us—patriotically or otherwise—are, when viewed in terms of this functional feature, more powerful works than they would otherwise be.

Films such as *Braveheart, Joan of Arc,* and *Young Mr. Lincoln*—along with many other artworks from a range of art forms—arouse a deep emotional engagement with the object represented and thereby create the conditions for audience members to be inspired. Art that achieves inspiration is valuable to the extent that it does this; moreover, the value of inspirational works of art increases as the level of inspiration rises. *Henry V,* for example, is a better play than it would otherwise be because of its inspirational efficacy, specifically in a patriotic dimension. Yet there is also a functional element to such a play if a work of art is intended to inspire patriotism (or inspire anything) and the artist takes pains to

construct the artwork to achieve this. To the disinterest theorist, who says that emotional connection is appropriate but consideration of function is not, such a functional element of the work is off-limits.

Evidence Set Five: Emotion and Catharsis

Works of art that present us with opportunities for psychological and emotional catharsis are, when viewed in terms of this functional feature, more powerful works than they would otherwise be.

Catharsis is commonly thought to be the purging of emotions through attention to some art object that arouses these specific emotions. The mystery of why one would choose to attend to art objects that prompt negative emotions can be partly answered by the common subjective testimony that through catharsis, particularly the creation of cathartic experiences through aesthetic attention, one can gain pleasure. Additionally, catharsis is perhaps the most intuitively comfortable explanation of why it is that we seek out and return to experiencing art objects which involve and arouse decidedly negative emotions in us.

Evidence Set Six: Emotion and Humor

Works of art that present us with opportunities for humor are, when viewed in terms of this functional feature, more powerful works than they would otherwise be. Moreover, humor is not a mere manifestation of being sympathetic to the emotional spirit of a work; it requires an external context of subjective preparation and subjective engagement.

Humor requires that the audience "get it." We take pleasure in working through a joke, in "getting it." This requires subjective preparation. Preparation can involve being open to the presentation of a joke, being prepared for the intellectual challenge of it, knowing the background information that forms its context, and in all cases, seeing the incongruity and unexpected nature of the joke. Humor is only humorous when it is "gotten," and being "gotten" is a matter of subjective context.

Evidence Set Seven: Personal Identification

A work of art is more powerful if the work provides an occasion for personal identification with a character in that work and the audience member adopts the personally engaged perspective permitting the iden-

A REVIEW OF THE ARGUMENTS AND EVIDENCE

tification to be made; such a perspective is at odds with a disinterested, detached, or distanced point of view.

Classic Hollywood cinema is characterized by a focus on individual characters who advance the story through seeking out the satisfaction of their desires. As the characters realize, will, or pursue something, the story moves along. Audiences are thereby afforded plenty of opportunities to identify in a personal way with the characters it puts on the screen, whether the protagonists, antagonists, or supporting players. Personal identification is also common in literature and opera. A well-crafted character capable of inspiring sincere empathy makes an artwork containing such a character more valuable than it would be if such identifications were not readily available as in the formalist, noncontextual approach.

Evidence Set Eight: Identification, Gender, and Sex

A work of art is more powerful if the work provides an occasion for identification with themes of gender and/or sexual identity and the audience member adopts the nonformalist, contextual perspective receptive to this identification.

Through the illumination of aspects of gender and sexual identity in art (particularly in paintings, in books, on the stage, and on the screen), the viewer can identify with these aspects as portrayed and developed in characters. Such aspects give works a greater significance than they would have as particular stories about particular people and events. Their power lies in part in the greater stories they tell, stories accessible only through a contextualized appreciation of the work.

Evidence Set Nine: Identification and Ethnicity

A work of art is more powerful if the work provides an occasion for identification with themes of ethnicity and/or race and the audience member adopts the nonformalist, contextual perspective receptive to this identification.

Evidence Set Ten: Identification, Nationality, and Politics

A work of art is more powerful if the work provides an occasion for identification with nationalistic themes and the audience member

adopts the nonformalist, contextual perspective receptive to this identification.

Evidence Set Eleven: Identification and Class

A work of art is more powerful if the work provides an occasion for identification with themes of class and the audience member adopts the nonformalist, contextual perspective receptive to this identification.

Evidence Set Twelve: Religious Identification

A work of art is more powerful if the work provides an occasion for identification with the religious character of that work and the audience member adopts the nonformalist, contextual perspective receptive to this identification.

Evidence Set Thirteen: Imagination

For a work of art to constitute a world unto itself, the imagination of the audience member must be engaged to fill in the blanks; by definition, "filling in the blanks" involves bringing the work under a subjective context, subjectively adding to what is present objectively.

No art object comes to us complete. Alan Goldman says that art objects are better to the degree to which they can engage us deeply, to the point of constituting for us another world. No art object can do this completely, so for an art object to constitute another world for us, we must be comfortable doing some of the creative work ourselves: this is the activity of the imagination. When we read, we imagine the physical form of the book's characters, following clues given to us by the writer. But because these clues are incomplete, we must complete them through our own imaginative power. To do so, we call upon our own experiences with people who have physical and psychological attributes that are similar to the ones we associate with the character. Part of our ability to exercise our subjective imaginations rests with how well the work functions in engaging us, but part of it rests with us, with our imaginative abilities and level of aesthetic investment.

Evidence Set Fourteen: Political Meaningfulness

Art objects that are understood in their political or national contexts are more valuable objects, in terms of being more meaningful, than they would otherwise be.

Because art and cultural artifacts serve masterfully to identify a people, art objects have long been used to enhance or encourage patriotism, political identification, and national identity. Nationalist art, although only one type of political communication, is for my purposes the most interesting, for it is contextual in several ways: as a product of a particular culture, it is most valuable when understood as such; as a product of a particular artist, it is intended to serve ends that benefit the nation or the people; and as viewed by an audience that is of that same nation, it is received as beneficial for them individually, socially, and nationally. Such benefits enhance the value of those artworks. Because of this, nationalist art seen within such a context is more valuable, not only for those whose nation it is but also for those who wish to understand the art from other contexts (other nations, cultures, peoples) in its most valuable state.

Evidence Set Fifteen: Religious Meaningfulness

Art objects that are understood in their religious contexts are more valuable objects, in terms of being more meaningful, than they would otherwise be.

The point here concerns identification where both the religious context and an interest in communication are shared by the artist and the audience. The context brought by devout traditional Christians to films such as Mel Gibson's *Passion of the Christ*, for example (see discussion in chapter 7), creates a film that has extraordinary power and meaning for them. *The Passion of the Christ* was created by a filmmaker who sought to bring to his artwork his own religious orientation and perspective, a context shared by the primary audience for the film.

Evidence Set Sixteen: The Nature of Ritual

Ritual necessarily involves reference to function; rituals are only truly meaningful when their functions are taken into account. If rituals are

an art form, then their value is inexorably tied to an appreciation of their functions.

Rituals, of whatever kind, have three things in common. First, rituals are events or sets of events sequenced meaningfully and enacted at a meaningful pace. Second, all rituals have an aesthetic aspect, a formal rhythm that can be appreciated aesthetically. Third, rituals are always purposeful, undertaken as means to some end. The contents of a ritual depend entirely on the ritual's function. Ritual abstracted from function, that is, taken out of context, is lessened in value.

FINAL REMARKS

It is entirely possible that there are *reductios* out there that would speak against my case, but in closing let me address just one. For those who celebrate the independence of art from the influences and constraints of social, moral, political, religious viewpoints, and so forth, for those who celebrate art's autonomy and worry that embracing contextualism threatens to make art the slave of nonaesthetic values, who worry that contextualism means a return to medievalism or a subservience to "political correctness," I can only respond by repeating that insulation against such perceived threats (that is, taking the art-for-art's-sake retreat) only succeeds in removing aesthetics from the real world, limiting aesthetic experience or the full quality of it, and fostering exclusion and the elitism and marginalization that exclusion breeds. Both on the grounds of all those other values that art may serve and on the grounds that real, felt, lived aesthetic experience may be heightened through a removal of the artificial barriers of formalism and disinterest theory—and their art-historical correlates aestheticism and New Criticism—we do well to embrace contextualism. Marcia Eaton writes,

> To a great extent, Kant more than Tolstoy influenced twentieth-century aesthetics in Eurocentric cultures. Formalist theorists insisted that disinterested appreciation of directly perceivable properties (color, rhythm, meter, balance, proportion, etc.) distinguished aesthetic experiences from all others. Kant never won the day in many non-Eurocentric cultures, however. Native

Americans, for example, continued to connect aesthetic activity directly to "interested" and functional objects and events. Descriptions of objects or events as "beautiful" in most African cultures never required distinguishing "What is it for?" from "How does it look?" . . . So was Kant wrong to insist that when someone judges something to be beautiful it is independent of interests or purposes? My own experience . . . leads me to think, with Tolstoy, that Kant was mistaken. . . . I do think these "pure," conceptless, valueless uses of "beauty" are rare. It certainly has been a mistake for aestheticians to take this sense of beauty as the paradigmatic aesthetic concept. . . . I do not see how that kind of beauty can matter—at least in the way I think beauty can and should. The formalists thought beauty could matter only if it were given its own niche. But, made pure, given its own niche, beauty stops mattering.[8]

NOTES

INTRODUCTION

1. Thanks to my colleague, art historian Debra Murphy, for this reference.

2. Harold Osborne writes that "the modern conception of a museum or gallery devoted to the assembly and preservation of famous works of the past and intended primarily for the edification and delectation of the general public was foreign to antiquity." "Museums and Their Functions," *Journal of Aesthetic Education* 19 (1985): 42.

3. Nelson Goodman writes that "by overwhelming popular opinion supported by a distressing number of official statements, a primary function of the museum is to provide the opportunity for a few moments of inconsequent pleasure. . . . If you thought my comparison of a museum to a home for the mentally deranged far-fetched, where except in these two institutions do you expect to find anyone standing stock-still staring at a wall where nothing is going on?" "The End of the Museum?" *Journal of Aesthetic Education* 19 (1985): 53 and 58.

4. "Museums make aesthetic choices in everything they do, from the arrangement of spaces, the choice of exhibitions, the arrangement and lighting of the work of art, to the design of furnishings and brochures." Kathleen Walsh-Piper, "Museum Education and the Aesthetic Experience," *Journal of Aesthetic Education* 28, no. 3 (1994): 107–8.

5. Francis Sparshott, "Showing and Saying, Looking and Learning: An Outsider's View of Art Museums," *Journal of Aesthetic Education* 19 (1985): 72.

6. Walsh-Piper, 106.

7. On page 42 of "Museums and Their Functions," Osborne writes, "The public collections of today are a result of the spread of democratic ideas which followed the French Revolution. Gradually the products of the fine arts came to be thought of as a public heritage by right rather than an aristocratic privilege: many Church collections were secularized, and treasures of dispossessed royal houses and aristocratic families were transferred to public ownership."

8. Jerome Stolnitz, "On the Origins of 'Aesthetic Disinterestedness,'" *Journal of Aesthetics and Art Criticism* 20 (Winter 1961): 132. On page 134, Stolnitz remarks that Shaftesbury opposes disinterestedness to the desire to possess or use the object: "The aesthetic spectator does not relate the object to any purposes

that outrun the act of perception itself"; "A man is disinterested when he takes no thought for any consequence whatever."

9. Sparshott, *Showing and Saying,* 68.

10. Sparshott, *Showing and Saying,* 76.

11. Annie V. F. Storr, "Shock of Tradition: Museum Education and Humanism's Moral Test of Artistic Experience," *Journal of Aesthetic Education* 28, no. 1 (Spring 1994): 2. The emphasis in this quote is mine.

12. Osborne, "Museums and Their Functions," 45–49. One who agrees with Osborne, and perhaps takes the point further, is Mark Lilla ("The Museum in the City," *Journal of Aesthetic Education* 19 [1985]: 79–92).

13. Hilde Hein, "Institutional Blessing: Museum as Canon Maker," *Monist* 76, no. 4 (1993): 556–57.

14. Lydia Goehr, *The Imaginary Museum of Musical Works: Essays in the Philosophy of Music* (Oxford: Clarendon, 1992), 173. This quote was included in an article by David Carrier ("Art Museums, Old Paintings, and Our Knowledge of the Past," *History and Theory* 40, no. 2 [May 2001]: 170–89) focused on whether works of art that are removed from their original sites, their original contexts, retain their identities. On pages 180–81, Carrier writes, "Maybe the work of art exists as such only in relation to its local, historical, worldly, or human origins. Perhaps when these origins are stripped away, nothing remains of the original work of art. . . . A museum is a place for displaying objects that have lost their original function. Turning sculptures, carpets, and paintings into objects we appreciate aesthetically, the museum might preserve the physical artifacts, but doing this, the Skeptic would assert, 'does not preserve the works of art.'" In the end, Carrier believes that the skeptic's case is overstated, that there is sufficient overlap between the museum experience and the original-site experience to warrant a continuity of identity of the artwork in the two sites.

15. George Dickie, "The New Institutional Theory of Art," in *Aesthetics: A Critical Anthology,* ed. G. Dickie, R. Sclafani, and R. Roblin (New York: St. Martin's, 1989; 2nd ed.), 204.

16. George Dickie, *Art and the Aesthetic: An Institutional Analysis* (Ithaca: Cornell University Press, 1974), 34.

17. I regret using the wonky term *art-aesthetic,* but I cannot think of a better one. To refer to the purpose that an artist might have or a viewer might have in considering a work simply as "aesthetic" seems to do one of two things: it either imports a Beardsleyan notion of the value of art resting in the instrumental production of a certain experiential state, or it begs the question in favor of those views, such as those of Kant and Stolnitz, that true and real aesthetic attention directed to a work of art is characterized in one particular way (regardless of how a subject might describe her own experience). The latter I obviously want to avoid, but for the sake of the content of chapter 2, I would avoid the former, too; artists' purposes certainly go beyond the creation of

vehicles for the production of aesthetic experiences. *Art-aesthetic* is meant to capture a certain intuition about such experiences having a particular nature or a particular "feel" but to do so without bringing a lot of baggage along, without slipping in some theory of what that nature is or even whether that nature is singular or describable.

18. "Few observers today would deny that the many painters and sculptors who design work with the museum in mind are freed from the constraints which controlled the creative ambitions of earlier artists, who were often told the subject, the size, the number of figures, sometimes even the style, of their proposed product." Francis Haskell, "Museums and Their Enemies," *Journal of Aesthetic Education* 19 (1985): 18.

19. John Dewey, *Art as Experience* (New York: Perigee, 1934), 8–9.

20. Danielle Rice, "The Art Idea in the Museum Setting," *Journal of Aesthetic Education* 25, no. 4 (1991): 129–35.

21. Albert William Levi, "The Art Museum as an Agency of Culture," *Journal of Aesthetic Education* 19 (1985): 29 and 33.

22. Nick Zangwill, on page 610 of in "Feasible Aesthetic Formalism" (*Nous* 33, no. 4 [1999]: 610–29), writes, "Aesthetic Formalism has fallen on hard times. At best it receives unsympathetic discussion and swift rejection. At worse it is the object of abuse and derision."

23. Mary Devereaux, "Beauty and Evil: The Case of Leni Riefenstahl's *Triumph of the Will,*" in *Aesthetics and Ethics: Essays at the Intersection,* ed. Jerrold Levinson (Cambridge: Cambridge University Press, 1998), 252.

CHAPTER 1: THEORY OF THE AESTHETIC

1. This chapter is taken largely from my article "Defining the Aesthetic," *Journal of Comparative Literature and Aesthetics* 23, no. 1–2 (2000): 101–17.

2. Frank N. Sibley, "Aesthetic Concepts," *Philosophical Review* 68 (October 1959): 421–50.

3. Monroe C. Beardsley, "What Is an Aesthetic Quality?" *Theoria* 39 (1973): 61 and 65.

4. "Aesthetic properties are those which contribute to the aesthetic values of artworks (or, in some cases, to the aesthetic values of natural objects of scenes). . . . We might conclude that works of art are objects created and perceived for their aesthetic values, and that aesthetic properties are those which contribute to such values." Alan H. Goldman, "Properties, Aesthetic," in *A Companion to Aesthetics,* ed. David Cooper (Oxford: Blackwell Publishers, 1995).

5. Alan H. Goldman, "Interpreting Art and Literature," *Journal of Aesthetics and Art Criticism* 48, no. 3 (Summer 1990): 205–14.

6. Monroe C. Beardsley, *The Aesthetic Point of View* (New York: Cornell University Press, 1982), 63, 68, 80.

7. Michael Mitias, "Locus of Aesthetic Quality," in his *Aesthetic Quality and Aesthetic Experience* (Amsterdam: Rodopi, 1988), 36. Mitias makes this point even more eloquently, though somewhat less briefly, in describing how the lines and colors in Vermeer's *Kitchen Maid* give rise in the viewer to a sense of a flood of light; this is discussed at various points, starting on page 76, in his *What Makes an Experience Aesthetic?* (Amsterdam: Rodopi, 1988). On page 77, Mitias writes of the latter work, "So when I perceive it as light I move to a higher level of perception, or apprehension, in which I *actualize* (realize, concretize) a feature potential in the configuration I perceive." On page 151, he writes, "Here I should stress once more that in perceiving the art work *aesthetically* . . . we do not literally transcend or surpass the physical reality of the work. For the qualities which we intuit become actual only in perceiving definite aspects of the sensuous form."

8. This section is taken largely from my "Aesthetic Experience and Aesthetic Analysis," *Journal of Aesthetic Education* 37, no. 1 (Spring 2003): 40–53.

9. Edward Bullough, "'Psychical Distance' as a Factor in Art and as an Aesthetic Principle," *British Journal of Psychology* 5 (1912): 87–98.

10. Suzanne Langer, *Feeling and Form* (New York: Scribner, 1953), 318.

11. Archibald Alison, *Essays on the Nature and Principles of Taste* (Boston: Cummings and Hilliard, 1812). See also Dabney Townsend's treatment of Alison in "Archibald Alison: Aesthetic Experience and Emotion," *British Journal of Aesthetics*, 28 (Spring 1988): 132–44.

12. Alison, 114.

13. Richard Shusterman, "Aesthetic Censorship: Censoring Art for Art's Sake," *Journal of Aesthetics and Art Criticism* 43, no. 2 (Winter 1984): 171–80.

14. John Dewey, "Having an Experience," in his *Art as Experience* (New York: Perigee, 1934).

15. Beardsley, *Aesthetic Point of View*, 286, 288.

16. Morris Weitz, "The Role of Theory in Aesthetics," *Journal of Aesthetics and Art Criticism*, 15 (1956): 27–35.

17. Mitias, *What Makes an Experience Aesthetic?* 8.

CHAPTER 2: THE VALUE OF ART

1. This section is derived largely from my "Artistic Value," *Journal of Value Inquiry* 37, no. 4 (2003): 555–63, and from my "Production Theories and Artistic Value," *Contemporary Aesthetics* 3 (2005) (http://www.contempaesthetics.org/pages/journal.php).

2. Where the value lies in the properties of the object in a potential form, where some subjective state is involved in actualizing that value, I would call that account inherent. To cleanly differentiate inherent accounts from instrumental (or other sorts of extrinsic) accounts, I would say that the work the

subject does in an inherent account is not additive at all; the subject adds nothing to the value that is in the object in a potential form. All that the subject does is ontologically trigger and actualize the value that is already there. If this is an acceptable description of inherent accounts, then they suffer from the same complaints I make against intrinsic accounts.

3. Anita Silvers, "The Story of Art Is the Test of Time," *Journal of Aesthetics and Art Criticism* 49, no. 3 (Summer 1991): 211–24.

4. Silvers, "Story of Art," 211.

5. Silvers, "Story of Art," 212.

6. Silvers, "Story of Art," 213.

7. Monroe C. Beardsley, *Aesthetics: Problems in the Philosophy of Criticism* (Indianapolis: Hackett, 1981; orig. pub. 1958).

8. Beardsley, *Aesthetics,* 462.

9. Beardsley, *Aesthetics,* 527–29; emphasis in original.

10. Beardsley, *Aesthetic Point of View,* 288. This list of aesthetic experiential qualities was first presented in Monroe C. Beardsley, "In Defense of Aesthetic Value," in *Proceedings and Addresses of the American Philosophical Association* (Newark, DE: American Philosophical Association, 1979), 723–49.

11. Beardsley, *Aesthetics,* 531.

12. Beardsley, "In Defense," 729.

13. This is from a review by Sky Dorey for *Viewzone Magazine,* which I found on the Internet.

14. Sr. Wendy Beckett, *The Story of Painting* (London: British Broadcasting Corporation, 1996).

15. There may be an additional difficulty. Some have charged that Beardsley's account is relativistic; different subjects may have experiences of different magnitudes, thereby rendering the value of the artwork different for different people. One might also find Beardsley's account relativistic because he follows Dewey's lead in not settling on some identified or settled intrinsic value as the ultimate goal of "artistic experience." Dickie discusses this a bit on page 74 of *Evaluating Art* (Philadelphia: Temple University Press, 1988); I personally do not find it enough of a problem to care much.

16. This is a very interesting phenomenon, since Augustine was not, as far as we know, familiar with Aristotle's work. To have constructed such an empiricistic formula, when his chief philosophic influence was Plato, is remarkable.

17. Anthony Shaftesbury, *Characteristics of Men, Manners, Opinions, Times* (New York: Bobbs-Merrill, 1964).

18. Francis Hutcheson, *An Inquiry into the Original of Our Ideas of Beauty and Virtue* (New York: Garland, 1971).

19. Joseph Addison, "On the Pleasures of the Imagination," nos. 411–21 in *Selections from* The Tatler *and* The Spectator, ed. Robert Allen (New York: Holt, Rinehart and Winston, 1957). My inclusion of Addison here is a bit of

a cheat. Addison included among his criteria for the aesthetic merit of an object these three: greatness, uncommonness, and beauty. Thus, although Addison was a formalist with regard to aesthetic judgment, he did not so clearly offer a formal criterion for a thing's being beautiful as the others I am citing in this list.

20. G. E. Moore, *Principia Ethica* (Cambridge: Cambridge University Press, 1903).

21. Clive Bell, *Art* (London: Chatto and Windus, 1914).

22. Beardsley, *Aesthetics,* 527.

23. Nelson Goodman, *Languages of Art: An Approach to a Theory of Symbols* (Indianapolis: Hackett, 1976; orig. pub. 1968).

24. Goodman describes these in chapter 4 of *Languages of Art,* "The Theory of Notation," 127–73. Dickie reviews these in *Evaluating Art,* 102–4.

25. Goodman, *Languages of Art,* 5.

26. Goodman, *Languages of Art,* 14.

27. Goodman, *Languages of Art,* 8.

28. Goodman, *Languages of Art,* 10.

29. Goodman, *Languages of Art,* 36–37.

30. Goodman, *Languages of Art,* 39.

31. W. K. Wimsatt and Monroe C. Beardsley, "The Intentional Fallacy," *Sewanee Review* 54 (1946): 3–23.

32. Brooks is mentioned throughout Beardsley's *Aesthetics.*

33. Goodman, *Languages of Art,* 259.

34. Goodman, *Languages of Art,* 258.

35. Goodman discusses his theory of exemplification on pages 52–57 of *Languages of Art.*

36. Dickie, *Evaluating Art,* 111.

37. Beardsley, *Aesthetics,* 527.

38. The work's creator is Mary Jo Maraldo; it was gifted to me in 1993.

39. Monroe C. Beardsley, "The Philosophy of Literature," in *Aesthetics: A Critical Anthology,* ed. G. Dickie, R. Sclafani, and R. Roblin (New York: St. Martin's, 1989; 2nd ed.), 428.

40. Beardsley, "Philosophy of Literature," 427.

41. Beardsley, "Philosophy of Literature," 430.

42. Leo Tolstoy, *What Is Art?* trans. A. Maude (Indianapolis: Hackett, 1960).

43. Tolstoy, *What Is Art?* 140.

44. Beckett, *Story of Painting.*

45. Edward Bullough, "'Psychical Distance' as a Factor in Art and as an Aesthetic Principle," *British Journal of Psychology* 5 (1912): 87–98.

46. Alan H. Goldman, *Aesthetic Value* (Boulder, CO: Westview, 1995), 152.

47. Goldman, *Aesthetic Value,* 150.

48. Goldman, *Aesthetic Value,* 150–51.

49. James O. Young, "A Defense of Colourization," *British Journal of Aesthetics* 28, no. 4 (Autumn 1988): 368–72.

50. Mark Sagoff, "On Restoring and Reproducing Art," *Journal of Philosophy* 75, no. 9 (September 1978): 453–70.

CHAPTER 3: DISINTEREST THEORY AND FORMALIST THEORY

1. Melvin Rader refers to decontextualist theories as "isolationist theories," which he says "insist that art is distinct and separate from the rest of life." "Isolationist and Contextualist Esthetics," *Journal of Philosophy* 44 (1947): 393.

2. Lord Shaftesbury, *Characteristics of Men, Manners, Opinions, Times* (New York: Bobbs-Merrill, 1964).

3. Shaftesbury, 216–18.

4. Jerome Stolnitz, "On the Origins of 'Aesthetic Disinterestedness,'" *Journal of Aesthetics and Art Criticism* 20 (Winter 1961): 131–44.

5. Dabney Townsend, "Shaftesbury's Aesthetic Theory," *Journal of Aesthetics and Art Criticism* 41 (Winter 1982): 211. Townsend also discusses the point in "From Shaftesbury to Kant: The Development of the Concept of Aesthetic Experience," *Journal of the History of Ideas* 48 (April–June 1987): 287–305.

6. Townsend, "Shaftesbury's Aesthetic Theory," 212: "Disinterest is a result of proper interest in the first place."

7. Stolnitz remarks on page 133 of "On the Origins" that for Shaftesbury, "the virtuous man is like nothing so much as the art-lover, from whom he differs only in the objects which he apprehends. . . . Virtue is itself no other than the love of order and beauty."

8. Shaftesbury, 257.

9. Stolnitz, "On the Significance of Lord Shaftesbury in Modern Aesthetic Theory," *Philosophical Quarterly* 11 (April 1961): 101.

10. Francis Hutcheson, *An Inquiry into the Original of Our Ideas of Beauty and Virtue* (New York: Garland, 1971), reprinted in part in G. Dickie, R. Sclafani, and R. Roblin, eds., *Aesthetics: A Critical Anthology* (New York: St. Martin's, 1989; 2nd ed.).

11. Hutcheson, 224; emphasis in original.

12. Hutcheson, 225.

13. Hutcheson, 227.

14. The word *triggers* may express a causal relation. Peter Kivy, however, suggests in "Recent Scholarship and the British Tradition" (in Dickie, Sclafani, and Roblin, *Aesthetics)* that the relationship may not be causal but only explanatory. Since I merely want to lay out the British Tradition as a historical backdrop, I will not debate points such as this one.

15. On page 227, Hutcheson says that "the Word beauty is taken for the Idea Rais'd in us"; on page 229, that "Beauty has always relations to the Sense

of some Mind"; on page 234, that "all Beauty has a relation to some perceiving Power."

16. Joseph Addison, "On the Pleasures of the Imagination," nos. 411–21 in *Selections from* The Tatler *and* The Spectator, ed. Robert Allen (New York: Holt, Rinehart and Winston, 1957).

17. No. 412 (page 209) in Addison's "On the Pleasures."

18. The test of time, Kivy (in "Recent Scholarship") suggests, is a regress to the question of authority, but it can be made into an ideal observer theory.

19. No. 409 (pages 202–3) of Addison's "On the Pleasures."

20. Kivy asks this question in "Recent Scholarship."

21. No. 411 (page 207) from Addison's "On the Pleasures."

22. This discussion is based on Archibald Alison's *Essays on the Nature and Principles of Taste* (Boston: Cummings and Hilliard, 1812) and from Dabney Townsend's "Archibald Alison: Aesthetic Experience and Emotion," *British Journal of Aesthetics* 28 (Spring 1988): 132–44.

23. Alison, *Essays on the Nature,* 114.

24. Dickie thinks that of the British Taste Theorists, Alison has the most developed concept of disinterest (in Dickie, Sclafani, and Roblin, *Aesthetics,* 20).

25. Alison, *Essays on the Nature,* 5, 7.

26. Stolnitz (quoting Alison), "On the Origins," 137–38.

27. David Hume, "Of the Standard of Taste," reprinted in Dickie, Sclafani, and Roblin, *Aesthetics,* 245–46.

28. Hume, "Of the Standard of Taste."

29. Hume, excerpt from his *Four Dissertations,* reprinted in Dickie, Sclafani, and Roblin, *Aesthetics,* 250.

30. Hume, "Of the Standard of Taste."

31. There is a nice discussion of the test of time (conceptually divided into a statistical test and a linear test) in Anita Silvers, "The Story of Art Is the Test of Time," *Journal of Aesthetics and Art Criticism* 49, no. 3 (Summer 1991): 211–24. Another is in Anthony Savile's "On Passing the Test of Time," *British Journal of Aesthetics* 17 (Summer 1977): 195–209. Savile divides his discussion between autographic and allographic works. Unlike Silvers (and me), he credits the version of the test of time he discusses to Samuel Johnson.

32. Hume, "Of the Standard of Taste," 245.

33. Immanuel Kant, *Critique of Judgment* (Indianapolis: Hackett, 1987), 45.

34. George Dickie presents a very clear and concise explanation of this in his *Evaluating Art* (Philadelphia: Temple University Press, 1988), 27–34.

35. All of the quotations are taken from Kant's *Critique of Judgment,* Book One; emphasis in original.

36. Israel Knox, *The Aesthetic Theories of Kant, Hegel and Schopenhauer* (New York: Columbia University, 1958), 24.

37. Arthur Schopenhauer, *The World as Will and Idea* (London: Routledge and Kegan Paul, 1896), 220, 222.

38. On page 232, Schopenhauer writes that "when an individual knower has raised himself [to view will-lessly], [he] at the same time has raised the observed object to the Platonic Idea." Schopenhauer thought that music, especially the more formal compositions, was able to best raise us above the Will and the phenomenal world.

39. Schopenhauer, 241.

40. Schopenhauer, 231.

41. Schopenhauer, 405.

42. Schopenhauer, 230–31.

43. This is supported by both Dickie and Stolnitz: Stolnitz, "'The Aesthetic Attitude' in the Rise of Modern Aesthetics," *Journal of Aesthetics and Art Criticism* 36 (Summer 1978): 410.

44. Knox, 172.

45. Edward Bullough, "'Psychical Distance' as a Factor in Art and as an Aesthetic Principle," *British Journal of Psychology* 5 (1912): 87–98, reprinted in Dickie, Sclafani, and Roblin's *Aesthetics: A Critical Anthology* (page numbers for additional citations of this Bullough article come from the anthology), 320–23.

46. "Distance" can best be seen as a voluntary action on the part of the agent; as voluntary, the action is thus conscious. G. M. Bolton (in "Psychical Distance and Acting," *British Journal of Aesthetics* 17 [Winter 1977]: 63–67) says, "Not only must the viewer be fooled, he must know that he has been fooled. Without this, illusion would be lost.... The delight, Aristotle says, is not in the object but in the recognition of the object as presented." In distancing, we understand that we put ourselves out of "affect" with the object.

47. Dickie apparently agrees: "Psychical distance is supposed to be a psychical component of a specific kind of consciousness which when 'inserted' between a subject and his affections is productive of aesthetic experience." George Dickie, *Art and the Aesthetic: An Institutional Analysis* (Ithaca: Cornell University Press, 1974), 91.

48. Unfortunately, my "detached affect" definition is not universally shared. Kingsley Price (in "The Truth about Psychical Distance," *Journal of Aesthetics and Art Criticism* 35 [Summer 1977]: 411–23) believes that psychical distance is nothing more than a metaphor, without any coherent meaning. But Price appears to miss the point altogether. It is exactly because as a metaphor it cannot be cashed coherently that we should reject cashing the notion metaphorically. Better to cash the term in the empirical terms that I have attempted to articulate and defend.

49. Bullough, "Psychical Distance," 324.

50. Bullough, "Psychical Distance," 324.

51. Suzanne Langer, *Feeling and Form* (New York: Scribner, 1953), 318.

52. Dickie, "The Myth of the Aesthetic Attitude," reprinted in Dickie, Sclafani, and Roblin's *Aesthetics,* 344.

53. Peter Weiss, *Marat/Sade* (New York: Athenaeum, 1967), 21.

54. Henry Fielding, *Tom Jones* (New York: Random House, 1945), pages 10 and 819, respectively.

55. Jerome Stolnitz, *Aesthetics and Philosophy of Art Criticism* (New York: Houghton Mifflin, 1960), 32–33.

56. Stolnitz, *Aesthetics,* 35.

57. Stolnitz, *Aesthetics,* 35. In another work ("Some Questions Concerning Aesthetic Perception," *Philosophy and Phenomenological Research* 22 [1961]: 69–87), Stolnitz invokes the notion of thinking of a judge as the paradigm of disinterest. This is the classic example, but it is not particularly illuminating.

58. Stolnitz, *Aesthetics,* 36.

59. Stolnitz, *Aesthetics,* 53. In another work ("The Artistic Values in Aesthetic Experience," *Journal of Aesthetics and Art Criticism* 32 [Fall 1973]: 5–15), Stolnitz argues that "anti-geneticism," or discounting the origins of the object in the interpretation of it (as Beardsley would have it), is too strong.

60. While not directly relevant to this work, the following insight by Stolnitz is interesting: "The director of a leading American art gallery made a study of the amount of time spent by visitors in looking at paintings. It came to an average of three seconds per painting. Yet the same people will doubtless spend hours on works of music or literature" (*Aesthetics,* 70).

61. See Stolnitz, "On the Significance," 100: "Under such names as 'psychical distance' disinterest has become a commonplace in our time."

62. John Rawls, *A Theory of Justice* (Cambridge, MA: Harvard University Press, 1971), 136–42.

63. Melvin Rader, "Isolationist and Contextualist Esthetics," 397.

64. Noël Carroll, "Formalism," in *The Routledge Companion to Aesthetics,* ed. Berys Gaut and Dominic McIver Lopes (London: Routledge, 2002), 90.

65. Aristotle said that the most important elements in a consideration of whether something is beautiful are order, symmetry, and definiteness.

66. St. Augustine said that for an object to be beautiful is for it to exhibit unity, number, equality, proportion, and order, with unity as the most basic notion.

67. Following Aristotle, St. Thomas Aquinas offered a formula for beauty, which rests on three conditions: integrity or perfection, due proportion or harmony, and brightness or clarity (as light is a symbol of divine beauty and truth).

68. Frank Sibley, "Aesthetic Concepts," *Philosophical Review* 68 (October 1959): 421–50.

69. Clive Bell, *Art* (London: Chatto and Windus, 1914).

70. Bell, 266–67.

71. G. E. Moore, *Principia Ethica* (Cambridge: Cambridge University Press, 1903).

72. Eduard Hanslick, *On the Musically Beautiful*, trans. Geoffrey Payzant (Indianapolis: Hackett, 1986).

73. "The new art . . . will not tolerate a confusion of frontiers. The desire to see frontiers between things sharply defined is a symptom of mental health. Life is one thing and poetry is another thing." José Ortega y Gassett, *The Dehumanization of Art* (Princeton: Princeton University Press, 1968; orig. pub. 1925), 47.

74. Roger Fry, *Vision and Design* (New York: Brentano's, 1924).

75. Stuart Hampshire, "Logic and Appreciation," *World Review* (October 1952), reprinted in *Problems in Aesthetics*, ed. Morris Weitz (London: MacMillan, 1970; 2nd ed.), 818–25.

76. I say that Beardsley was *a kind of* formalist, because although he adopted a New Critical approach to interpreting works of art and advanced a theory of aesthetic (and artistic) value based on finding formal properties in both works of art and, jointly, experiences of them, he was not a full-fledged formalist. This is evidenced clearly in his chapter "The Arts in the Life of Man" in *Aesthetics: Problems in the Philosophy of Criticism* (Indianapolis: Hackett, 1981), 557–91, where he rejects both aestheticism and a reductive moralism as sufficient for characterizing proper aesthetic judgment.

77. William Wimsatt and Monroe C. Beardsley, "The Intentional Fallacy," *Sewanee Review* 54 (1946): 3–23.

78. Jenefer Robinson, "Style and Personality in the Literary Work," *Philosophical Review* 94 (1985): 227–48.

79. Fry, 302.

80. Fry, 20, 29–30.

81. Hampshire, 822.

82. Hampshire, 819–20 and 823–24.

83. Nick Zangwill, "Defusing Anti-Formalism Arguments," *British Journal of Aesthetics* 40, no. 3 (July 2000): 376–83; "Feasible Aesthetic Formalism," *Nous* 33, no. 4 (1999): 610–29; and "In Defence of Moderate Aesthetic Formalism," *Philosophical Quarterly* 50 (October 2000): 476–93.

84. Zangwill, "Feasible Aesthetic Formalism," 611.

85. Zangwill, "Feasible Aesthetic Formalism," 611.

86. Zangwill, "Feasible Aesthetic Formalism," 611.

87. Zangwill, "Feasible Aesthetic Formalism," 610; emphasis in original.

88. Zangwill, "Feasible Aesthetic Formalism," 613–14; emphasis in original.

89. Zangwill, "Feasible Aesthetic Formalism," 618.

90. Zangwill, "Feasible Aesthetic Formalism," 619.

91. Zangwill, "Feasible Aesthetic Formalism," 623.

CHAPTER 4: CONTEXTUALIST THEORY

1. Carolyn Korsmeyer, *Gender and Aesthetics* (New York: Routledge, 2004); Carolyn Korsmeyer and Peggy Zeglin Brand, eds., *Feminism and Tradition in Aesthetics* (University Park: Pennsylvania State University Press, 1995); Carolyn Korsmeyer and Hilde Hein, *Aesthetics in Feminist Perspective* (Bloomington: Indiana University Press, 1993).

2. Sarah Worth, "Feminist Aesthetics," in *The Routledge Companion to Aesthetics*, ed. Berys Gaut and Dominic McIver Lopes (London: Routledge, 2002), 439.

3. Worth, 440–46.

4. Edward Sankowski, "Art Museums, Autonomy, and Canons," *Monist* 76, no. 4 (1993): 535.

5. Stephen Davies, "John Cage's *4'33"*: Is It Music." *Australasian Journal of Philosophy* 75, no. 4 (1997): 462.

6. Francis Haskell writes, "The case against public art museums . . . argued that museums destroyed the very purpose of the art which they had been called upon to house and to preserve. . . . [E]ach [painting] lost its true function once it had been moved from bedroom or chapel to the bare walls of a building which was necessarily devoid of any of the associations of bedroom or chapel. . . . [However,] the main function of the art museum [is] what can for the moment be loosely described as the improvement of public taste." "Museums and Their Enemies," *Journal of Aesthetic Education* 19 (1985): 13 and 18.

7. George Santayana, *The Sense of Beauty* (New York: Collier, 1961).

8. Santayana, 43.

9. Marcia Muelder Eaton discusses this systematically in "A Strange Kind of Sadness," *Journal of Aesthetics and Art Criticism* 41 (Fall 1982): 51–63.

10. Roger Scruton, *Art and Imagination* (London: Methuen, 1974).

11. Scruton, *Art and Imagination*, 134–35.

12. Scruton, *Art and Imagination*, 154.

13. John Fisher, "Evaluation without Enjoyment," *Journal of Aesthetics and Art Criticism* 7 (Winter 1968): 135–39; Christopher New, "Scruton on the Aesthetic Attitude," *British Journal of Aesthetics* 19 (Fall 1979): 320–30.

14. Scruton, *Art and Imagination*, 136. Both Bernard Bosanquet and Harold Lee support Scruton's point. Bosanquet, *Three Lectures on Aesthetics* (New York: Bobbs-Merrill, 1963), 21: "The aesthetic attitude may fairly be described in some such words as these: the pleasant awareness of a feeling embodied in an appearance presented to imagination or imaginative perception." Lee, *Perception and Aesthetic Value* (New York: Prentice-Hall, 1938), 79–80: "The aesthetic attitude is contemplative or absorbed; but unpleasantness is the affective sign of the tendency to avoid. Unpleasantness calls to practical activity—to avoidance. . . . Aesthetic value in the broadest sense is a property

attributed to an object by virtue of the fact that it may be perceptually appre-hended with pleasure or displeasure. If it is apprehended with pleasure, the value is positive; if with displeasure, the value is negative." For a more recent consideration of the place of pleasure in aesthetic discourse, see Jerrold Levin-son, "Pleasure and the Value of Works of Art," *British Journal of Aesthetics* 32 (1992): 295–306.

15. John Dewey, *Art as Experience* (New York: Perigee, 1934).

16. Dewey, 3, 4, 8, 13, 25, and 40; emphasis in original.

17. Stephen Pepper (in "The Development of a Contextualistic Aesthetics," *Antioch Review* 28 [1968]: 169–85) writes, "Let me list the features of a contex-tualistic aesthetics Dewey has brought out: . . . (1) The felt quality of the expe-rience unifying it as a whole; (2) The intuition of this quality as an immediate awareness of "what experience itself is"; (3) The fusion and funding of quali-tative details or strands within the whole to yield the quality of the whole; (4) The vividness of the experience as intuited in its quality; (5) The uniqueness of every such experience; (6) The novelty of it; (7) The consummatory char-acter of it in the context of the continuity of experience" (181).

18. Anita Silvers, "Vincent's Story: The Importance of Contextualism for Art Education," *Journal of Aesthetic Education* 28, no. 3 (1994): 47–62.

19. Frank Sibley, "Aesthetic Concepts," *Philosophical Review* 68 (October 1959): 421, 424, 426, 433.

20. Richard Shusterman, "Aesthetic Censorship: Censoring Art for Art's Sake," *Journal of Aesthetics and Art Criticism* 43, no. 2 (Winter 1984): 171–80.

21. Arnold Berleant, *The Aesthetics of Environment* (Philadelphia: Temple University Press, 1992), 28.

22. Berleant, *Aesthetics of Environment*, 131.

23. Berleant, *Aesthetics of Environment*, 159.

24. Allen Carlson, *Aesthetics and the Environment* (New York: Routledge, 2000), 48. This account is in his chapter entitled "Appreciation and the Natural Environment" (originally published in the *Journal of Aesthetics and Art Criticism* 37 [1979]: 267–75). Earlier in the book, in a chapter entitled "Formal Qualities in the Natural Environment" (originally published in the *Journal of Aesthetic Education* 19 [1979]: 99–114), Carlson writes, "It is being in the environment, being a part of the environment, and reacting to it as a part of it. It is such active, involved appreciation, rather than the formal mode of appreciation nurtured by the scenery cult and encouraged by photographs, that is appro-priate to the natural environment" (35).

25. Carlson, "Appreciating Art and Appreciating Nature," in *Landscape, Natural Beauty and the Arts,* ed. Salim Kemal and Ivan Gaskell (Cambridge: Cambridge University Press, 1993), 117.

26. Carlson, *Aesthetics and the Environment*, 37. On page 38, he writes that "the assumption that formal qualities have the same place and importance in

the aesthetic appreciation and evaluation of the natural environment as they do in the appreciation and evaluation of art must be abandoned."

27. Glenn Parsons and Allen Carlson, "New Formalism and the Aesthetic Appreciation of Nature," *Journal of Aesthetics and Art Criticism* 62, no. 4 (Fall 2004): 363–76.

28. Jerrold Levinson, "Defining Art Historically," *British Journal of Aesthetics* 19 (1979): 232–50. This article was followed by "Extending Art Historically," *Journal of Aesthetics and Art Criticism* 51, no. 3 (Summer 1993): 411–23; "Refining Art Historically," *Journal of Aesthetics and Art Criticism* 47, no. 1 (1989): 21–33; and "The Irreducible Historicality of the Concept of Art," *British Journal of Aesthetics* 42, no. 2 (2002): 367–79.

29. Kendall L. Walton, "Categories of Art," *Philosophical Review* 79 (1970): 334–67.

30. William K. Wimsatt and Monroe C. Beardsley, "The Intentional Fallacy," *Sewanee Review* 54 (1946): 3–23.

31. In a recent article ("In Defence of Moderate Aesthetic Formalism," *Philosophical Quarterly* 50 [October 2000]: 476–93), Nick Zangwill argues that Walton's claims are not comprehensive; on this ground, and perhaps others, Zangwill believes that a limited or modest formalism may survive. This seems to me a matter of perspective. Zangwill might argue that because contextualism cannot account for all cases, formalism survives, while I would argue that because formalism cannot account for all cases, contextualism is the answer. It seems to me a half-full glass kind of thing. Melvin Rader casts some light on this in his "Isolationist and Contextualist Esthetics," *Journal of Philosophy* 44 (1947): 393–406.

32. Stephen Davies, "Musical Understanding and Musical Kinds," *Journal of Aesthetics and Art Criticism* 52, no. 1 (Winter 1994): 70.

33. Davies, "Musical Understanding," 80.

34. Davies, "John Cage's *4'33"*."

35. The last two examples come from my "In Celebration of Imperfection," *Journal of Aesthetic Education* 38, no. 2 (Summer 2004): 67–79.

36. Noël Carroll, "Moderate Moralism," *British Journal of Aesthetics* 36, no. 3 (July 1996): 223–38; "Moderate Moralism versus Moderate Autonomism," *British Journal of Aesthetics* 38, no. 4 (1998): 419–24; "Art, Narrative, and Moral Understanding," in *Aesthetics and Ethics: Essays at the Intersection,* ed. Jerrold Levinson (New York: Cambridge University Press, 1998), 126–60; "Art and Ethical Criticism: An Overview of Recent Directions of Research," *Ethics* 110, no. 2 (January 2000): 350–87; "The Wheel of Virtue: Art, Literature, and Moral Knowledge," *Journal of Aesthetics and Art Criticism* 60, no. 1 (Winter 2002): 3–26; and "Art and the Moral Realm," in *The Blackwell Guide to Aesthetics,* ed. Peter Kivy (Malden, MA: Blackwell, 2004), 126–51.

37. Carroll, "Art, Narrative, and Moral Understanding," 143–44.

38. Berys Gaut, "The Ethical Criticism of Art," in *Aesthetics and Ethics: Essays at the Intersection,* ed. Jerrold Levinson (Cambridge: Cambridge University Press, 1998), 182–203.

39. Gaut, 182.

40. Gaut, 185–86.

41. Marcia Muelder Eaton, *Aesthetics and the Good Life* (Cranbury, NJ: Associated University Presses, 1989).

42. Eaton, *Aesthetics and the Good Life,* 178–79.

43. Eaton, *Aesthetics and the Good Life,* 154.

44. Marcia Muelder Eaton, "Serious Problems, Serious Values: Are There Aesthetic Dilemmas?" in *Ethics and the Arts: An Anthology,* ed. David Fenner (New York: Garland, 1995), 279–91.

45. Marcia Muelder Eaton, "Aesthetics: The Mother of Ethics?" *Journal of Aesthetics and Art Criticism* 55, no. 4 (Fall 1997): 356. The article to which she refers is Carroll's "Moderate Moralism."

46. Marcia Muelder Eaton, "Kantian and Contextual Beauty," *Journal of Aesthetics and Art* 57, no. 1 (Winter 1999): 13.

47. Marcia Muelder Eaton, "Integrating the Aesthetic and the Moral," *Philosophical Studies* 67, no. 3 (1992): 226; emphasis in original.

48. Mary Devereaux, "Beauty and Evil: The Case of Leni Riefenstahl's *Triumph of the Will,*" in *Aesthetics and Ethics: Essays at the Intersection,* ed. Jerrold Levinson (Cambridge: Cambridge University Press, 1998), 227–56.

49. Devereaux, 244.

50. Devereaux, 246–47.

CHAPTER 5: ISSUES OF DEFINITION

1. Jenefer Robinson disagrees with me in detail but not in substance: "Rothko's huge canvasses are not particularly interesting formally; they are not particularly beautiful; and they have no figurative content. But they are enormously powerful because they can directly induce a quasi-mystical state of serene contemplation." "The Emotions in Art," in *The Blackwell Guide to Aesthetics,* ed. Peter Kivy (Oxford: Blackwell, 2004), 189.

2. Is a cognitivist approach to considering the value of a work of art compatible with a formalist approach to this same purpose? The devil will surely be in the details, but to the extent to which the cognitivist requires either the addition of certain psychological elements to the agent's consideration of the work or certain facts about the world (histories, representational connections, etc.), this seems at odds with any formalist approach.

3. The lessons here concerning Readymade Art and Pop Art can easily be applied to such things as "found art" and "outsider art." Without understanding the contexts—historical and taxonomical—of objects labeled "found art"

and "outsider art," there can be no serious entree to understanding the worth of these objects. Found objects are very similar to readymades; their creation did not undergo the normal creative design process that most art objects undergo; they have to be adopted as art. This historical information is crucial to understanding their identities but just as crucial to understanding their value. "Outsider art" is similar in the sense that, absent the genetic conditions under which it was made, the object's value remains hidden. The formalist is free to exclude all these objects from consideration or to claim that these contextual matters are not relevant to the value of the object as an aesthetic (or even art) object, but once again this view would be in contrast to common critical practice and to the current traditions of the art world as a whole.

4. John Harris, "Oral and Olfactory Art," *Journal of Aesthetic Education* 13 (1979): 5–15; Marienne Quinet, "Food as Art: The Problem of Function," *British Journal of Aesthetics* 21 (Spring 1981): 159–71; Elizabeth Tefler, "Food as Art," in *Arguing about Art,* ed. Alex Neill and Aaron Ridley (London: Routledge, 2002; 2nd ed.), 9–27; Carolyn Korsmeyer, "The Meaning of Taste and the Taste of Meaning," in Neill and Ridley, *Arguing about Art,* 28–49; Carolyn Korsmeyer, *Making Sense of Taste: Food and Philosophy* (Ithaca: Cornell University Press, 1999).

5. This complaint goes as far back as Hegel.

6. These sorts of claims are attributed to Monroe Beardsley (*Aesthetics: Problems in the Philosophy of Criticism* [Indianapolis: Hackett, 1981], 98–99) and to Harold Osborne ("Odors and Appreciation," *British Journal of Aesthetics* 17, no. 1 [Winter 1977]): 37–48. Both of these theorists come from a formalist background.

7. The temporality or ephemeral nature of food used as an argument against food being art strikes me as very shortsighted. All the performing arts are temporal; just as we have scripts, scores, and choreographers with memories, so too do we have recipes that are designed to re-create the food and its original taste. Of course, the re-created work of food will not be exactly the same as before, but this is in close parallel to the performing arts. As different dancers dance a dance differently, as different orchestra members and conductors perform a musical work differently, so different chefs will create different works of food even when following the same recipe (or the same virtual recipe—such as coq au vin—virtual recipes are like dances in that way; there is no firm record of what was done before, just principles and memories).

8. Tefler raises this objection in "Food as Art." In the same volume, Korsmeyer ("The Meaning of Taste") addresses and apparently defeats it.

9. This is the focus of Quinet's "Food as Art."

10. Quinet is one; see pages 168–70 of her article.

11. The part of this chapter dealing with architecture is derived largely from my "Pure Architecture," in *Architecture and Civilization,* ed. Michael H. Mitias (Amsterdam: Rodopi, 1999), 43–57.

12. Gordon Graham, "Art and Architecture," *British Journal of Aesthetics* 29, no. 3 (Summer 1989): 248–49.

13. Francis Sparshott, "Architecture and Space," in *Philosophy and Architecture,* ed. Michael Mitias (Amsterdam: Rodopi, 1984), 7.

14. Sparshott, "Architecture and Space," 8.

15. Arnold Berleant, "Architecture and the Aesthetics of Continuity," in Mitias, *Philosophy and Architecture,* 21.

16. Stephen Davies, "Is Architecture Art?" in Mitias, *Philosophy and Architecture,* 38.

17. Richard Serra discussed the removal of *Tilted Arc* in a speech given in Des Moines, Iowa, on October 25, 1989. A transcript of the speech appeared in "Tilted Arc," *Critical Inquiry* 17 (Spring 1991): 574–81.

18. See, for instance, B. R. Tilghman, "Architecture, Expression, and the Understanding of Culture"; David Novitz, "Architectural Brilliance and the Constraints of Time"; and Allen Carlson, "Existence, Location, and Function: The Appreciation of Architecture," all in Mitias, *Philosophy and Architecture.* Also see Roger Scruton, *The Aesthetics of Architecture* (London: Methuen, 1979).

19. Tilghman, 64.

20. Berleant, "Architecture," 24.

21. Berleant, "Architecture," 29–30.

22. Tilghman, 60.

23. Alan H. Goldman, *Aesthetic Value* (Boulder, CO: Westview, 1995).

24. This section of the chapter devoted to dance was inspired by a presentation by philosopher and dance critic Kenton Harris.

25. John Coulbourn, "A Dance for Life," *Toronto Sun* (http://www.canoe.ca/TheatreReviewsS/stillhere.html).

26. Ramsey Burt, "Social Memory and the Theatre of Bill T. Jones," June 15, 2004, Sadler's Wells, London (http://www.ballet-dance.com/200407/articles/Jones20040615b.html).

27. These biographical notes come from Roanne Edwards, writing for *Africana* (http://www.africana.com/research/encarta/tt_795.asp).

28. All of the quotations from Arlene Croce come from "Discussing the Undiscussable," *Dance Connection* (http://www.canuck.com/Esalon/dance/Croce.html).

29. Jowitt's response is recorded on the same web site as Croce's (http://www.canuck.com/Esalon/dance/Response.html). Also included there is a lengthy exchange concerning "victim art" between Joyce Carol Oates ("Confronting Head On the Face of the Afflicted," *New York Times,* February 19, 1995) and Susan Sontag (March 5, 1995, letter to the *New York Times*).

30. Croce's work as a critic coincided with the period when George Balanchine was choreographing strongly formalist works for the New York City

Ballet. Balanchine was the most celebrated choreographer and dance teacher of his day, and no doubt this had a strong impact on Croce's work as a dance critic and her approach to it.

CHAPTER 6: ISSUES CONCERNING THE POWER OF ART

1. Noël Carroll, *The Philosophy of Horror or Paradoxes of the Heart* (London: Routledge, 1990).

2. To the extent that the feeling of emotion requires inclusion of psychological and associational aspects, it will be at odds with disinterest theory. The inclusion of emotion is not, however, at odds with formalist theory as described by Nick Zangwill, as long as the emotion is understood to be derived from the features of the object.

3. Jenefer Robinson, "The Emotions in Art," in *The Blackwell Guide to Aesthetics,* ed. Peter Kivy (Oxford: Blackwell, 2004), 174–92.

4. Robinson, "Emotions in Art," 175–76.

5. Robinson, "Emotions in Art," 177.

6. Arthur Child, "The Social-Historical Relativity of Esthetic Value," *Philosophical Review* 53 (January 1944): 1–22. This articles takes as its focus emotion in an aesthetic context.

7. Marcia Muelder Eaton, "The Social Construction of Aesthetic Response," *British Journal of Aesthetics* 35, no. 2 (April 1995): 95–107.

8. Eaton, "Social Construction," 96.

9. Robinson, "Emotions in Art," 186–88; emphasis in original.

10. In "The Development of a Contextualist Aesthetics," *Antioch Review* 28 (1968): 169–85, Stephen Pepper describes Croce as a central player in contextualism: "So much there is in Croce's *Aesthetic* that is authentic contextualism. He focuses on the immediate qualitative experience. He notices the action of psychological fusion in unifying the experience. He stresses its individuality and uniqueness. He recognizes it as a central mode of knowledge, an intuition of fundamental reality, and contrasts it with conceptual cognition."

11. Aristotle, *The Poetics,* trans. Richard Janko (Indianapolis: Hackett, 1987), 59, in a section on "The Fragments of the *On Poets.*"

12. For an excellent account of a related phenomenon, one could read Marcia Muelder Eaton, "A Strange Kind of Sadness," *Journal of Aesthetics and Art Criticism* 41 (Fall 1982): 51–63.

13. When studying for my doctoral qualifying examinations and when reaching tense moments in writing my dissertation, I would put a horror film or a tearjerker in the VCR. It did not matter whether the film was sophisticated (Hitchcock or Shakespeare) or manipulative. The emotional release this provided would help me regain my concentration when I returned to my work. My best explanation for this lies in catharsis.

14. A more elaborate treatment of the contextuality of emotional aesthetic response would include discussions of both sexual content/response and violent content/response. Certainly the degree to which a work incorporates sexual or violent themes or images (coupled with the degree to which an audience member is sensitive to, or even offended by, these sorts of things) is a central issue in debates between contextualists and those who say that aesthetic values trump concerns over sexuality and violence in artworks. These same sorts of considerations apply when art objects incorporate themes or images that are racist, sexist, or otherwise stereotyping. Perhaps this fuller treatment is warranted; however, I have made a choice to stick generally with more-positive themes in building my evidentiary case for contextualism, so I will leave these other aspects for others to discuss.

15. This is only one of many theories of humor, but historically it is the most popular. It owes its academic origins to Kant and Schopenhauer. Theories that focus on the felt superiority of the "laugh-er" over the subjects of laughter go back to Hobbes and Henri Bergson, and theories of humor that focus on psychic, emotional, or physical relief or release go back to Shaftesbury, Sigmund Freud, and Herbert Spencer. For more on theories of laughter and humor, see John Morreall, *Taking Laughter Seriously* (Albany: SUNY Press, 1983); John Morreall, ed., *The Philosophy of Laughter and Humor* (Albany: SUNY Press, 1987); John Morreall, *Humor Works* (Amherst: HRD, 1997); Ted Cohen, "Humor," in *The Routledge Companion to Aesthetics,* ed. Berys Gaut and Dominic McIver Lopes (London: Routledge, 2002), 375–81; Ted Cohen, *Jokes: Philosophical Thoughts on Joking Matters* (Chicago: University of Chicago Press, 1999); and David Carrier, *The Aesthetics of Comics* (University Park: Pennsylvania State University Press, 2000).

16. Morreall, *Taking Laughter Seriously,* 62.

17. On page 185 of "Emotions in Art," Robinson writes, "How can . . . we feel some powerful emotion for a fictional character, while knowing full well that the character is fictional? . . . [E]motions are ongoing interactions between an individual and the environment, and 'the environment' includes not only the world present to our senses but the world as it appears to us in our thoughts and imaginings. This 'inner environment' is peopled with events and situations and people who may or may not exist in reality, but I can have emotional reaction to the contents of my thoughts and imaginings just as I can to the objects of perception."

18. Andre Bazin, "Theatre and Cinema," from *What Is Cinema?* (Berkeley: University of California Press, 1967), reprinted in *Film Theory and Criticism,* ed. Leo Braudy and Marshall Cohen (New York: Oxford University Press, 1999), 410.

19. Goldman, 150–51.

20. Roger Scruton, "Imagination," in *A Companion to Aesthetics,* ed. David Cooper (Oxford: Blackwell, 1995), 214.

CHAPTER 7: ISSUES OF MEANINGFULNESS

1. This is Alan Goldman's position. Alan H. Goldman, "Interpreting Art and Literature," *Journal of Aesthetics and Art Criticism* 48, no. 3 (Summer 1990): 205–14.

2. I deal with the problem of art evaluation being essentially "subjectively additive" in chapter 4.

3. Colorful, that is, if the whole film is taken into account. Nothing is more colorful in Kubrick's oeuvre than the penultimate scenes in *2001*.

4. Karl Marx, *Grundrisse* (London: Penguin Books, 1859).

5. All of these quotes are taken from "Talks at the Yenan Forum on Art and Literature" and "On the Correct Handling of Contradictions among the People," in *Mao Tse-tung: An Anthology of His Writings* (New York: International Publishers, 1962).

6. For the perfect example, one need only think of the stylized termination of Mr. Banks in Disney's film *Mary Poppins*. Upon his being fired from the bank, Mr. Banks's lapel carnation is thrown away, his bowler hat is destroyed, and his umbrella is turned inside out. This is a wonderful dig at the stereotype of the British middle class and the perfect example of an employment ritual.

CHAPTER 8: SCIENCE AND CONTEXTUALIST AESTHETICS

1. Eddy Zemach, "Real Beauty," *Midwest Studies in Philosophy* 16 (1991): 249–65. Zemach has a book by this same name: *Real Beauty* (University Park: Pennsylvania State University Press, 1997).

2. Zemach, "Real Beauty," 252.

3. In this chapter I work from a scientifically realist perspective, although from the vantage point of the instrumentalist, the case I make here is an even easier and clearer one.

4. Zemach, "Real Beauty," 260–61.

5. Edward O. Wilson, *Biophilia* (Cambridge, MA: Harvard University Press, 1984), 60–61. Paul Dirac writes something very similar to what Wilson attributes to Weyl: Dirac, "The Evolution of the Physicist's Picture of Nature," *Scientific American* 208 (1963): 45–53.

6. The secondary importance of the aesthetic features of scientific theories is illustrated in Thomas Kuhn's use of aesthetic considerations as evidence of a-rational or nonrational elements in scientific thinking. Tibor Machan (in "Kuhn, Paradigm Choice, and the Arbitrariness of Aesthetic Criteria in Science," *Theory and Decision* 8 [October 1977]: 361–62) takes Kuhn to task for failing to advance an argument for the a-rational or nonrational nature of aesthetic considerations in scientific theory adjudication or selection.

7. Peter Kivy, "Science and Aesthetic Appreciation," *Midwest Studies in Philosophy* 16 (1991): 180–95.

8. J. W. N. Sullivan, "The Place of Science," *Athenaeum,* April 11, 1919.

9. Roger Fry, "Art and Science," reprinted in his *Vision and Design* (New York: Brentano's, 1924).

10. Kivy, "Science and Aesthetic Appreciation," 185.

11. Kivy, "Science and Aesthetic Appreciation," 188.

12. Kivy, "Science and Aesthetic Appreciation," 189.

13. Maura Flannery, "Using Science's Aesthetic Dimension in Teaching Science," *Journal of Aesthetic Education* 26, no. 1 (1992): 1–15. Quotations taken from pages 1–9.

14. Kivy, "Science and Aesthetic Appreciation," 190.

15. Kivy, "Science and Aesthetic Appreciation," 183.

16. Kivy, "Science and Aesthetic Appreciation," 192–93.

17. Allen Carlson, "Appreciating Art and Appreciating Nature," in *Landscape, Natural Beauty and the Arts,* ed. Salim Kemal and Ivan Gaskell (Cambridge: Cambridge University Press, 1993), 213.

18. Allen Carlson, *Aesthetics and the Environment* (New York: Routledge, 2000), 48. Earlier in this book, in a chapter entitled "Formal Qualities in the Natural Environment" (originally published in the *Journal of Aesthetic Education* 19 [1979]: 99–114), Carlson writes, "[T]hus aesthetic appreciation of the natural environment is not simply a matter of looking at objects or 'views' from a specific point. Rather, it is being 'in the midst' of them, moving in regard to them, looking at them from any and every point and distance, and, of course, not only looking, but also smelling, hearing, touching, feeling" (35).

19. "Certain complexities make it even more difficult to develop an aesthetics of environment than of art. For one thing, environment involves perceptual categories that are wider and more numerous than those usually recognized in the arts. No single sense dominates the situation; rather, all the modes of sensibility are involved." Carlson, "Appreciating Art and Appreciating Nature," 117.

20. Carlson, *Aesthetics and the Environment,* 37. On page 38, he writes that "the assumption that formal qualities have the same place and importance in the aesthetic appreciation and evaluation of the natural environment as they do in the appreciation and evaluation of art must be abandoned."

21. This distinction echoes the division that was a hallmark of New Criticism—or any art critical view that seeks to separate the artist, or the artist's intentions, from the object itself.

22. Carlson, "Appreciating Art and Appreciating Nature."

23. On page 4 of *Aesthetics and the Environment,* Carlson writes, "John Muir saw all nature and especially wild nature as aesthetically beautiful and found ugliness only where nature was subject to human intervention." In his chapter "Nature and Positive Aesthetics" (originally published in *Environmental Values* 6

[1984]: 5–34), Carlson writes, "All virgin nature is essentially aesthetically good. The appropriate or correct aesthetic appreciating of the natural world is basically positive[,] and negative aesthetic judgments have little or no place" (72).

24. On page 85 of *Aesthetics and the Environment,* Carlson writes that "consideration of science suggests a more plausible justification for positive aesthetics than any of those examined in the last three sections." His case for relying on science and scientific classification is constructed in "Nature, Aesthetic Judgment, and Objectivity," which is chapter 5 of his *Aesthetics and the Environment.* That article was originally published in the *Journal of Aesthetics and Art Criticism* 40 (1981): 15–28.

25. Carlson, *Aesthetics and the Environment,* 93–94. On pages 221–22 of "Appreciating Art and Appreciating Nature," he writes, "All of nature necessarily reveals the natural order. Although it may be easier to perceive and understand in some cases more than in others, it is yet present in every case and can be appreciated once our awareness and understanding of the forces which produce it and the story which illuminates it are adequately developed. In this sense all nature is equally appreciable. . . . In this way the stories that play a role in the order appreciation of nature work toward making natural objects all seem equally aesthetically appealing."

26. Carlson, "Appreciating Art and Appreciating Nature," 221.

27. "Believing, with Max Weber, that man is an animal suspended in webs of significance he himself has spun, I take culture to be those webs, and the analysis of it to be therefore not an experimental science in search of law but an interpretative one in search of meaning." Clifford Geertz, "Thick Description: Toward an Interpretative Theory of Culture," in his *Interpretation of Cultures* (New York: Basic Books, 1973), 5. On page 29, he writes, "Meaning, that elusive and ill-defined pseudoentity we were once more than content to leave philosophers and literary critics to fumble with, has now come back into the heart of our discipline."

28. "It is not against a body of uninterpreted data, radically thinned descriptions, that we must measure the cogency of our explications, but against the power of the scientific imagination to bring us into touch with the lives of strangers" (Geertz, 16).

29. Elliot Eisner, *The Enlightened Eye: Qualitative Inquiry and the Enhancement of Educational Practice* (Englewood Cliffs, NJ: Prentice Hall, 1998), 16.

30. Eisner, 85, quoting Dewey, *Art as Experience,* 324.

31. Eisner, 22.

32. Eisner, 38.

33. "There is no reason why the conceptual structures of a cultural interpretation should be any less formulable, and thus less susceptible to explicit canons of appraisal, than that of, say, a biological observation or a physical experiment" (Geertz, 24).

34. Eisner, 68.

35. Eisner, 63.

36. Eisner, 34.

37. Eisner, 36.

38. Eisner is certainly in this camp. See pages 43–47 in his *Enlightened Eye*.

39. "Anthropology, or at least interpretative anthropology, is a science whose progress is marked less by a perfection of consensus than by a refinement of debate" (Geertz, 29).

40. Geertz writes, "Thus we are led to the second condition of culture theory: it is not . . . predictive. The diagnostician doesn't predict measles; he decides that someone has them, or at the very most *anticipates* that someone is rather likely shortly to get them. But this limitation, which is real enough, has commonly been both misunderstood and exaggerated, because it has been taken to mean that cultural interpretation is merely post facto" (26; emphasis in original).

41. Eisner, 35.

42. Eisner, 95.

43. Eisner, 15.

44. The first sentence of Geertz's landmark essay, "Thick Description," is about Langer.

CHAPTER 9: REVIEW OF THE ARGUMENTS AND EVIDENCE

1. Marcia Muelder Eaton, "Integrating the Aesthetic and the Moral," *Philosophical Studies* 67, no. 3 (1992): 228.

2. Silvers, "The Story of Art Is the Test of Time," *Journal of Aesthetics and Art Criticism* 49, no. 3 (Summer 1991): 212.

3. Silvers, "Story of Art," 213.

4. Alan H. Goldman, "Realism about Aesthetic Properties," *Journal of Aesthetics and Art Criticism* 51, no. 1 (1993): 31–37.

5. John Dewey, *Art as Experience* (New York: Perigee, 1934), 19; emphasis in original.

6. Gordon Graham, "Art and Architecture," *British Journal of Aesthetics* 29, no. 3 (Summer 1989): 248–49.

7. Arlene Croce, "Discussing the Undiscussable," *Dance Connection* (http://www.canuck.com/Esalon/dance/Croce.html).

8. Marcia Muelder Eaton, "Kantian and Contextual Beauty," *Journal of Aesthetics and Art* 57, no. 1 (Winter 1999): 12–14.

BIBLIOGRAPHY

Addison, Joseph. "On the Pleasures of the Imagination." Nos. 411–21 in *Selections from* The Tatler *and* The Spectator. New York: Holt, Rinehart and Winston, edited by Robert Allen, 1957.

Aldrich, Virgil C. "Aesthetic Perception and Objectivity." *British Journal of Aesthetics* 18 (Summer 1978): 209–16.

———. "Back to Aesthetic Experience." *Journal of Aesthetics and Art Criticism* 24 (Spring 1966): 365–72.

———. *Philosophy of Art.* Englewood Cliffs, NJ: Prentice-Hall, 1963.

Alexander, Charles. *Here the Country Lies: Nationalism and the Arts in Twentieth-Century America.* Bloomington: Indiana University Press, 1980.

Alison, Archibald. *Essays on the Nature and Principles of Taste.* Boston: Cummings and Hilliard, 1812.

Aristotle, *The Poetics.* Trans. Richard Janko. Indianapolis: Hackett, 1987.

Bazin, Andre. "Theatre and Cinema." In *What Is Cinema?* Berkeley: University of California Press, 1967. Reprinted as pp. 408–18 in *Film Theory and Criticism,* edited by Leo Braudy and Marshall Cohen. New York: Oxford University Press, 1999.

Beardsley, Monroe C. *The Aesthetic Point of View.* New York: Cornell University Press, 1982.

———. *Aesthetics: Problems in the Philosophy of Criticism.* Indianapolis: Hackett, 1981.

———. "In Defense of Aesthetic Value." In *Proceedings and Addresses of the American Philosophical Association,* 723–49. Newark, DE: American Philosophical Association, 1979.

———. "The Philosophy of Literature." In *Aesthetics: A Critical Anthology,* 2nd ed., edited by George Dickie, Richard Sclafani, and Ronald Roblin, 420–30. New York: St. Martin's, 1989.

———. "What Is an Aesthetic Quality?" *Theoria* 39 (1973): 61, 65.

Beckett, Sr. Wendy. *The Story of Painting.* London: British Broadcasting Corporation, 1996.

Bell, Clive, *Art.* London: Chatto and Windus, 1914.

Belting, Hans. *The Germans and Their Art: A Troublesome Relationship.* New Haven: Yale University Press, 1998.

Berleant, Arnold. *The Aesthetics of Environment.* Philadelphia: Temple University Press, 1992.

———. "Architecture and the Aesthetics of Continuity." In *Philosophy and Architecture,* edited by Michael H. Mitias, 21–30. Amsterdam: Rodopi, 1984.

Blocker, H. G. "A New Look at Aesthetic Distance." *British Journal of Aesthetics* 77 (Summer 1977): 219–29.

Bohn, John W. "Museums and the Culture of Autography." *Journal of Aesthetics and Art Criticism* 57, no. 1 (1999): 55–65.

Bolton, G. M. "Psychical Distance and Acting." *British Journal of Aesthetics* 17 (Winter 1977): 63–67.

Bosanquet, Bernard. *Three Lectures on Aesthetics.* New York: Bobbs-Merrill, 1963.

Bourassa, Steven. *The Aesthetics of Landscape.* London: Belhaven, 1991.

Bullough, Edward. *Aesthetics: Lectures and Essays.* Stanford: Stanford University Press, 1957.

———. "'Psychical Distance' as a Factor in Art and as an Aesthetic Principle." *British Journal of Psychology* 5 (1912): 87–98.

Burt, Ramsey. "Social Memory and the Theatre of Bill T. Jones." June 15, 2004, Sadler's Wells, London. http://www.ballet-dance.com/200407/articles/Jones20040615b.html.

Carlson, Allen. *Aesthetics and the Environment.* New York: Routledge, 2000.

———. "Appreciating Art and Appreciating Nature." In *Landscape, Natural Beauty and the Arts,* edited by Salim Kemal and Ivan Gaskell, 199–227. Cambridge: Cambridge University Press, 1993.

———. "Existence, Location, and Function: The Appreciation of Architecture." In *Philosophy and Architecture,* edited by Michael H. Mitias, 141–64. Amsterdam: Rodopi, 1984.

Carrier, David. *The Aesthetics of Comics.* University Park: Pennsylvania State University Press, 2000.

———. "Art Museums, Old Paintings, and Our Knowledge of the Past." *History and Theory* 40, no. 2 (May 2001): 170–89.

Carroll, Noël. "Aesthetic Experience Revisited." *British Journal of Aesthetics* 42, no. 2 (April 2002): 145–68.

———. "Art and Ethical Criticism: An Overview of Recent Directions of Research." *Ethics* 110, no. 2 (January 2000): 350–87.

———. "Art and Human Nature." *Journal of Aesthetics and Art Criticism* 62, no. 2 (Spring 2004): 95–107.

———. "Art and the Domain of the Aesthetic." *British Journal of Aesthetics* 40, no. 2 (April 2000): 191–208.

———. "Art and the Moral Realm." In *The Blackwell Guide to Aesthetics,* edited by Peter Kivy, 126–51. Malden, MA: Blackwell, 2004.

————. "Art, Narrative, and Moral Understanding." In *Aesthetics and Ethics: Essays at the Intersection,* edited by Jerrold Levinson, 126–60. New York: Cambridge University Press, 1998.

————. "Clive Bell's Aesthetic Hypothesis." In *Aesthetics: A Critical Anthology,* 2nd ed., edited by George Dickie, Richard Sclafani, and Ronald Roblin, 84–95 New York: St. Martin's, 1989.

————. *Engaging the Moving Image.* New Haven: Yale University Press, 2003.

————. "Formalism." In *The Routledge Companion to Aesthetics,* edited by Berys Gaut and Dominic McIver Lopes, 87–96. London: Routledge, 2002.

————. "Historical Narratives and the Philosophy of Art." *Journal of Aesthetics and Art Criticism* 51, no. 3 (Summer 1993): 313–26.

————. "Moderate Moralism." *British Journal of Aesthetics* 36, no. 3 (July 1996): 223–38.

————. "Moderate Moralism versus Moderate Autonomism." *British Journal of Aesthetics* 38, no. 4 (1998): 419–24.

————. *The Philosophy of Horror or Paradoxes of the Heart.* London: Routledge, 1990.

————. "The Wheel of Virtue: Art, Literature, and Moral Knowledge." *Journal of Aesthetics and Art Criticism* 60, no. 1 (Winter 2002): 3–26.

Casebier, Allan. "The Concept of Aesthetic Distance." *Personalist* 52 (Winter 1971): 70–91.

Child, Arthur. "The Social-Historical Relativity of Esthetic Value." *Philosophical Review* 53 (January 1944): 1–22.

Cohen, Marshall. "Appearance and the Aesthetic Attitude." *Journal of Philosophy* 56 (November 1959): 915–25.

Cohen, Ted. "Humor." In *The Routledge Companion to Aesthetics,* edited by Berys Gaut and Dominic McIver Lopes, 375–81. London: Routledge, 2002.

————. *Jokes: Philosophical Thoughts on Joking Matters.* Chicago: University of Chicago Press, 1999.

Collingwood, R. G. *The Principles of Art.* Oxford: Clarendon, 1938.

Coulbourn, John. "A Dance for Life." *Toronto Sun,* http://www.canoe.ca/TheatreReviewsS/stillhere.html.

Crane, Susan A. "Memory, Distortion, and History in the Museum." *History and Theory* 36, no. 4 (1997): 44–63.

Crawford, Donald. *Kant's Aesthetic Theory.* Madison: University of Wisconsin Press, 1980.

Croce, Arlene. "Discussing the Undiscussable." *Dance Connection,* http://www.canuck.com/Esalon/dance/Croce.html.

Croce, Benedetto. *Aesthetic.* London: Heinemann, 1921.

Danto, Arthur. *After the End of Art: Contemporary Art and the Pale of History.* Princeton: Princeton University Press, 1997.

————. *The Philosophical Disenfranchisement of Art.* New York: Columbia University Press, 1986.

————. *Transfiguration of the Commonplace.* Cambridge, MA: Harvard University Press, 1981.

Davies, Stephen. "Definitions of Art." In *The Routledge Companion to Aesthetics,* edited by Berys Gaut, 169–79. New York: Routledge, 2001.

————. "First Art and Art's Definition." *Southern Journal of Philosophy* 35, no. 1 (Spring 1997): 19–34.

————. "Interpreting Contextualities." *Philosophy and Literature* 20, no. 1 (April 1996): 20–38.

————. "Is Architecture Art?" In *Philosophy and Architecture,* edited by Michael H. Mitias, 31–47. Amsterdam: Rodopi, 1984.

————. "John Cage's *4'33 ":* Is It Music?" *Australasian Journal of Philosophy* 75, no. 4 (1997): 448–62.

————. "Musical Understanding and Musical Kinds." *Journal of Aesthetics and Art Criticism* 52, no. 1 (Winter 1994): 69–82.

Dawson, Sheila. "'Distancing' as an Aesthetic Principle." *Australasian Journal of Philosophy* 39 (August 1961): 155–74.

Devereaux, Mary. "Beauty and Evil: The Case of Leni Riefenstahl's *Triumph of the Will.*" In *Aesthetics and Ethics: Essays at the Intersection,* edited by Jerrold Levinson, 227–56. Cambridge: Cambridge University Press, 1998.

Dewey, John. *Art as Experience.* New York: Perigee, 1934.

Dickie, George. *Art and the Aesthetic: An Institutional Analysis.* Ithaca: Cornell University Press, 1974.

————. "Attitude and Object: Aldrich on the Aesthetic." *Journal of Aesthetics and Art Criticism* 25 (Fall 1966): 89–92.

————. "Beardsley's Phantom Aesthetic Experience." *Journal of Philosophy* 62 (March 1965): 129–35.

————. "Beardsley's Theory of Aesthetic Experience." *Journal of Aesthetic Education* 8 (April 1984): 13–23.

————. "Bullough and the Concept of Psychical Distance." *Philosophy and Phenomenological Research* 22 (December 1961): 233–38.

————. *Evaluating Art.* Philadelphia: Temple University Press, 1988.

————. "Is Psychology Relevant to Aesthetics?" *Philosophical Review* 71 (July 1962): 285–302.

————. "The New Institutional Theory of Art." In *Aesthetics: A Critical Anthology,* 2nd ed., edited by George Dickie, Richard Sclafani, and Ronald Roblin, 196–205. New York: St. Martin's, 1989.

————. "Psychical Distance: In a Fog at Sea." *British Journal of Aesthetics* 13 (Winter 1973): 17–29.

————. "Stolnitz' Attitude: Taste and Perception." *Journal of Aesthetics and Art Criticism* 43 (Winter 1984): 195–204.

————. "Taste and Attitude: The Origin of the Aesthetic." *Theoria* 39 (1973): 153–70.

Dickie, George, Richard Sclafani, and Ronald Roblin, eds. *Aesthetics: A Critical Anthology.* 2nd ed. New York: St. Martin's, 1989.

Dirac, Paul. "The Evolution of the Physicist's Picture of Nature." *Scientific American* 208 (1963): 45–53.

Duncan, Carol. *Civilizing Rituals: Inside Public Art Museums.* New York: Routledge, 1995.

Eagleton, Terry. *The Ideology of the Aesthetic.* Oxford: Basil Blackwell, 1990.

Eaton, Marcia Mueder. "Aesthetics: The Mother of Ethics?" *Journal of Aesthetics and Art Criticism* 55, no. 4 (Fall 1997): 355–64.

————. *Aesthetics and the Good Life.* Cranbury, NJ: Associated University Presses, 1989.

————. "Art and the Aesthetic." In *The Blackwell Guide to Aesthetics,* edited by Peter Kivy, 63–77. Malden, MA: Blackwell, 2004.

————. "Dangerous Beauties." *Philosophic Exchange* 30 (1999–2000): 35–52.

————. "Fact and Fiction in the Aesthetic Appreciation of Nature." *Journal of Aesthetics and Art Criticism* 56, no. 2 (1998): 149–56.

————. "Integrating the Aesthetic and the Moral." *Philosophical Studies* 67, no. 3 (1992): 219–40.

————. "Kantian and Contextual Beauty." *Journal of Aesthetics and Art* 57, no. 1 (Winter 1999): 11–15.

————. "Response to Robert Fudge." *Journal of Aesthetics and Art Criticism* 61, no. 1 (2003): 70–71.

————. "Serious Problems, Serious Values: Are There Aesthetic Dilemmas?" In *Ethics and the Arts: An Anthology,* edited by David Fenner, 279–91. New York: Garland, 1995.

————. "The Social Construction of Aesthetic Response." *British Journal of Aesthetics* 35, no. 2 (April 1995): 95–107.

————. "A Strange Kind of Sadness." *Journal of Aesthetics and Art Criticism* 41 (Fall 1982): 51–63.

Edwards, Roanne. http://www.africana.com/research/encarta/tt_795.asp.

Eisner, Eliot. *The Enlightened Eye: Qualitative Inquiry and the Enhancement of Educational Practice.* Englewood Cliffs, NJ: Prentice Hall, 1998.

Etlin, Richard A., ed. *Nationalism in the Visual Arts.* Hanover, NH: University Press of New England, 1991.

Fenner, David. "Aesthetic Appreciation in the Artworld and in the Natural World." *Environmental Values* 12, no. 1 (2003): 3–28.

————. *The Aesthetic Attitude.* New Jersey: Humanities, 1996.

————. "The Aesthetic Attitude." In *Encyclopedia of Aesthetics,* edited by Michael Kelly, 150–53. Oxford: Oxford University Press, 1998.

————. "Aesthetic Experience and Aesthetic Analysis." *Journal of Aesthetic Education* 37, no. 1 (Spring 2003): 40–53.

————. "Art and Culture." In *Encyclopedia of Nationalism,* edited by Alexander Motyl, 39–54. San Diego: Academic, 2001.

————. "Artistic Value." *Journal of Value Inquiry* 37, no. 4 (2003): 555–63.

————. "Defining the Aesthetic." *Journal of Comparative Literature and Aesthetics* 23, no. 1–2 (2000): 101–17.

————, ed. *Ethics and the Arts: An Anthology.* New York: Garland, 1995.

————. "In Celebration of Imperfection." *Journal of Aesthetic Education* 38, no. 2 (Summer 2004): 67–79.

————. "Production Theories and Artistic Value." *Contemporary Aesthetics* 3 (2005): http://www.contempaesthetics.org/pages/journal.php.

————. "Pure Architecture." In *Architecture and Civilization,* edited by Michael H. Mitias, 43–57. Amsterdam: Rodopi, 1999.

————. "Virtues and Vices in Film Criticism." *International Journal of Applied Philosophy* 15, no. 2 (Fall 2001): 309–22.

Fielding, Henry. *Tom Jones.* New York: Random House, 1945.

Fisher, John. "Evaluation without Enjoyment." *Journal of Aesthetics and Art Criticism* 7 (Winter 1968): 135–39.

Flannery, Maura. "Using Science's Aesthetic Dimension in Teaching Science." *Journal of Aesthetic Education* 26, no. 1 (Spring 1992): 1–15.

Forbes, John D. "The Art Museum and the American Scene." *Journal of Aesthetics and Art Criticism* 1 (1942): 3–11.

Free, William J. "Structuralism, Literature, and Tacit Knowledge." *Journal of Aesthetic Education* 8 (1974): 65–74.

Fry, Roger. *Vision and Design.* New York: Brentano's, 1924.

Fudge, Robert. "Problems with Contextualizing Aesthetic Properties." *Journal of Aesthetics and Art Criticism* 61, no. 1 (2003): 67–70.

Gaut, Berys. "The Ethical Criticism of Art." In *Aesthetics and Ethics: Essays at the Intersection,* edited by Jerrold Levinson, 182–203. Cambridge: Cambridge University Press, 1998.

Geertz, Clifford. *The Interpretation of Cultures.* New York: Basic Books, 1973.

Gilbert, Paul. "Applied Aesthetics?" *Journal of Applied Philosophy* 15, no. 1 (1998): 105–7.

Goehr, Lydia. *The Imaginary Museum of Musical Works: Essays in the Philosophy of Music.* Oxford: Clarendon, 1992.

Goldman, Alan H. *Aesthetic Value.* Boulder, CO: Westview, 1995.

————. "Aesthetic versus Moral Evaluations." *Philosophy and Phenomenological Research* 50, no. 4 (June 1990): 715–30.

————. "Art Historical Value." *British Journal of Aesthetics* 33, no. 1 (January 1993): 17–28.

———. "Interpreting Art and Literature." *Journal of Aesthetics and Art Criticism* 48, no. 3 (Summer 1990): 205–14.

———. "Properties, Aesthetic." In *A Companion to Aesthetics,* edited by David Cooper, 342–47. Oxford: Blackwell, 1995.

———. "Realism about Aesthetic Properties." *Journal of Aesthetics and Art Criticism* 51, no. 1 (1993): 31–37.

———. "Response to Stecker's 'Goldman on Interpreting Art and Literature.'" *Journal of Aesthetics and Art Criticism* 49, no. 3 (Summer 1991): 246–47.

Goodman, Nelson. "The End of the Museum?" *Journal of Aesthetic Education* 19 (1985): 53–62.

———. *Languages of Art: An Approach to a Theory of Symbols.* Indianapolis: Hackett, 1976. Originally published 1968.

Graham, Gordon. "Art and Architecture." *British Journal of Aesthetics* 29, no. 3 (Summer 1989): 248–49.

Guyer, Paul. *Kant and the Claims of Taste.* Cambridge, MA: Harvard University Press, 1979.

Hampshire, Stuart. "Logic and Appreciation." *World Review* (October 1952). Reprinted in *Problems in Aesthetics,* 2nd ed., edited by Morris Weitz, 818–25 London: MacMillan, 1970.

Hanslick, Eduard. *On the Musically Beautiful.* Trans. Geoffrey Payzant. Indianapolis: Hackett, 1986.

Harris, John. "Oral and Olfactory Art." *Journal of Aesthetic Education* 13 (1979): 5–15.

Haskell, Francis. "Museums and Their Enemies." *Journal of Aesthetic Education* 19 (1985): 13–22.

Hayry, Matti, and Heta Hayry. "Artistic Value as an Excuse for Spreading Cinematographic Filth." *Journal of Value Inquiry* 29, no. 4 (December 1995): 469–83.

Hein, Hilde. "Institutional Blessing: Museum as Canon Maker." *Monist* 76, no. 4 (1993): 556–73.

Hume, David. "Of the Standard of Taste." In Hume, *Four Dissertations.* New York: Garland, 1970.

Hutcheson, Francis. *An Inquiry into the Original of Our Ideas of Beauty and Virtue.* New York: Garland, 1971.

Hyman, Lawrence W. "Autonomy and Distance in a Literary Work: A New Approach to Contextualism." *Journal of Aesthetics and Art Criticism* 31 (1973): 467–71.

———. "Moral Values and the Literary Experience." *Journal of Aesthetics and Art Criticism* 24 (1966): 539–48.

Kant, Immanuel. *Critique of Judgment.* Indianapolis: Hackett, 1987.

Kasprisin, Lorraine. "The Concept of Distance: A Conceptual Problem in the Study of Literature." *Journal of Aesthetic Education* 18 (Fall 1984): 55–68.

Kivy, Peter. *Francis Hutcheson: An Inquiry Concerning Beauty, Order, Harmony and Design*. The Hague: Martinus Nijhoff, 1973.

————. "Recent Scholarship and the British Tradition." In *Aesthetics: A Critical Anthology*, 2nd ed., edited by George Dickie, Richard Sclafani, and Ronald Roblin, 254–68. New York: St. Martin's, 1989.

————. "Science and Aesthetic Appreciation." *Midwest Studies in Philosophy* 16 (1991): 180–95.

————. *The Seventh Sense: Francis Hutcheson and Eighteenth-Century British Aesthetics*. Oxford: Clarendon, 2003.

Knox, Israel. *The Aesthetic Theories of Kant, Hegel and Schopenhauer*. New York: Columbia University Press, 1958.

Korsmeyer, Carolyn. *Gender and Aesthetics*. New York: Routledge, 2004.

————. *Making Sense of Taste: Food and Philosophy*. Ithaca: Cornell University Press, 1999.

————. "The Meaning of Taste and the Taste of Meaning." In *Arguing about Art*, 2nd ed., edited by Alex Neill and Aaron Ridley, 28–49. London: Routledge, 2002.

————. "Relativism and Hutcheson's Aesthetic Theory." *Journal of the History of Ideas* 36 (April–June 1975): 319–30.

Korsmeyer, Carolyn, and Peggy Zeglin Brand, eds. *Feminism and Tradition in Aesthetics*. University Park: Pennsylvania State University Press, 1995.

Korsmeyer, Carolyn, and Hilde Hein. *Aesthetics in Feminist Perspective*. Bloomington: Indiana University Press, 1993.

Krieger, Murray. "Contextualism Was Ambitious." *Journal of Aesthetics and Art Criticism* 21 (1962): 81–88.

Langer, Suzanne. *Feeling and Form*. New York: Scribner, 1953.

Lee, Harold. *Perception and Aesthetic Value*. New York: Prentice-Hall, 1938.

Levi, Albert W. "The Art Museum as an Agency of Culture." *Journal of Aesthetic Education* 19 (1985): 23–40.

Levinson, Jerrold, ed. *Aesthetics and Ethics: Essays at the Intersection*. Cambridge: Cambridge University Press, 1998.

————. "Defining Art Historically." *British Journal of Aesthetics* 19 (1979): 232–50.

————. "Extending Art Historically." *Journal of Aesthetics and Art Criticism* 51, no. 3 (Summer 1993): 411–23.

————. "Intrinsic Value and the Notion of a Life." *Journal of Aesthetics and Art Criticism* 62, no. 4 (Fall 2004): 319–29.

————. "The Irreducible Historicality of the Concept of Art." *British Journal of Aesthetics* 42, no. 2 (2002): 367–79.

————. "Pleasure and the Value of Works of Art." *British Journal of Aesthetics* 32 (1992): 295–306.

————. "Refining Art Historically." *Journal of Aesthetics and Art Criticism* 47, no. 1 (1989): 21–33.

Levinson, Jerrold, and Philip Alperson. "What Is a Temporal Art?" *Midwest Studies in Philosophy* 16 (1991): 439–50.

Lilla, Mark. "The Museum in the City." *Journal of Aesthetic Education* 19 (1985): 79–92.

Loftin, Robert. "Psychical Distance and the Aesthetic Appreciation of Wilderness." *International Journal of Applied Philosophy* 3 (Spring 1986): 15–19.

Longman, Lester. "The Concept of Psychical Distance." *Journal of Aesthetics and Art Criticism* 6 (1947): 31–35.

Machan, Tibor. "Kuhn, Paradigm Choice and the Arbitrariness of Aesthetic Criteria in Science." *Theory and Decision* 8 (October 1977): 361–62.

Mao Tse-tung. "On the Correct Handling of Contradictions among the People." In *Mao Tse-Tung: An Anthology of His Writings.* New York: International Publishers, 1962.

———. "Talks at the Yenan Forum on Art and Literature." In *Mao Tse-Tung: An Anthology of His Writings.* New York: International Publishers, 1962.

Marcuse, Herbert. *The Aesthetic Dimension: Towards a Critique of Marxist Aesthetics.* Boston: Beacon, 1978.

Marx, Karl. *Grundrisse.* London: Penguin Books, 1859.

McCloskey, Mary. *Kant's Aesthetic.* Albany: State University of New York Press, 1987.

Michael, Emily. "Francis Hutcheson on Aesthetic Perception and Aesthetic Pleasure." *British Journal of Aesthetics* 24 (Summer 1984): 241–55.

Mitias, Michael H. "Locus of Aesthetic Quality." In Mitias, *Aesthetic Quality and Aesthetic Experience,* 25–44. Amsterdam: Rodopi, 1988.

———, ed. *Philosophy and Architecture.* Amsterdam: Rodopi, 1984.

———. *What Makes an Experience Aesthetic?* Amsterdam: Rodopi, 1988.

Moore, G. E. *Principia Ethica.* Cambridge: Cambridge University Press, 1903.

Morreall, John. *Humor Works.* Amherst, MA: HRD, 1997.

———, ed. *The Philosophy of Laughter and Humor.* Albany: SUNY Press, 1987.

———. *Taking Laughter Seriously.* Albany: SUNY Press, 1983.

Mothersill, Mary. *Beauty Restored.* Oxford: Clarendon, 1984.

Munro, Thomas. *Toward Science in Aesthetics.* New York: Liberal Arts, 1956.

Neill, Alex, and Aaron Ridley. *Arguing about Art: Contemporary Philosophical Debates.* 2nd ed. New York: Routledge, 2002.

New, Christopher. "Scruton on the Aesthetic Attitude." *British Journal of Aesthetics* 19 (Fall 1979): 320–30.

Novitz, David. "Architectural Brilliance and the Constraints of Time." In *Philosophy and Architecture,* edited by Michael H. Mitias, 67–86. Amsterdam: Rodopi, 1984.

Oates, Joyce Carol. "Confronting Head On the Face of the Afflicted." *New York Times,* February 19, 1995.

Ortega y Gassett, José. *The Dehumanization of Art.* Princeton: Princeton University Press, 1968. Originally published 1925.

Osborne, Harold. "Museums and Their Functions." *Journal of Aesthetic Education* 19 (1985): 41–52.

———. "Odors and Appreciation." *British Journal of Aesthetics* 17, no. 1 (Winter 1977): 37–48.

Parsons, Glenn, and Allen Carlson. "New Formalism and the Aesthetic Appreciation of Nature." *Journal of Aesthetics and Art Criticism* 62, no. 4 (Fall 2004): 363–76.

Pepper, Stephen C. "The Development of a Contextualist Aesthetics." *Antioch Review* 28 (1968): 169–85.

Price, Kingsley. "The Truth about Psychical Distance." *Journal of Aesthetics and Art Criticism* 35 (Summer 1977): 411–23.

Quinet, Marienne. "Food as Art: The Problem of Function." *British Journal of Aesthetics* 21 (Spring 1981): 159–71.

Rader, Melvin. "Isolationist and Contextualist Esthetics." *Journal of Philosophy* 44 (1947): 393–406.

Ramachandran, V. S., and William Hirstein. "The Science of Art: A Neurological Theory of Aesthetic Experience." *Journal of Consciousness Studies* 6 (1999): 15–51.

Rawls, John. *A Theory of Justice.* Cambridge, MA: Harvard University Press, 1971.

Rice, Danielle. "The Art Idea in the Museum Setting." *Journal of Aesthetic Education* 25, no. 4 (1991): 127–36.

Robinson, Jenefer. "The Emotions in Art." In *The Blackwell Guide to Aesthetics,* edited by Peter Kivy, 174–92. Oxford: Blackwell, 2004.

———. "Style and Personality in the Literary Work." *Philosophical Review* 94 (1985): 227–48.

Rogerson, Kenneth. "Dickie's Disinterest." *Philosophia* 17 (March 1987): 149–60.

Rowe, M. W. "The Definition of 'Art.'" *Philosophical Quarterly* (July 1991): 271–86.

Rudinow, Joel. "Race, Ethnicity, Expressive Authenticity: Can White People Sing the Blues?" *Journal of Aesthetics and Art Criticism* 52, no. 1 (Winter 1994): 127–38.

Sagoff, Mark. "On Restoring and Reproducing Art." *Journal of Philosophy* 75, no. 9 (September 1978): 453–70.

Sankowski, Edward. "Art Museums, Autonomy, and Canons." *Monist* 76, no. 4 (1993): 535–55.

———. "Ethics, Art, and Museums." *Journal of Aesthetic Education* 26, no. 3 (1992): 1–13.

Santayana, George. *The Sense of Beauty.* New York: Collier Publishing, 1961.

Savile, Anthony. "On Passing the Test of Time." *British Journal of Aesthetics* 17 (Summer 1977): 195–209.

Schopenhauer, Arthur. *The World as Will and Idea.* Translated by R. B. Haldane and John Kemp. London: Routledge and Kegan Paul, 1896.

Scruton, Roger. *The Aesthetics of Architecture.* London: Methuen, 1979.

———. *Art and Imagination.* London: Methuen, 1974.

———. "Imagination." In *A Companion to Aesthetics,* edited by David Cooper, 212–17. Oxford: Blackwell, 1995.

Serra, Richard. "Tilted Arc." *Critical Inquiry* 17 (Spring 1991): 274–81.

Shaftesbury, Anthony. *Characteristics of Men, Manners, Opinions, Times.* New York: Bobbs-Merrill, 1964.

Sharpe, R. A. *Contemporary Aesthetics.* New York: St. Martin's, 1983.

Shusterman, Richard. "Aesthetic Censorship: Censoring Art for Art's Sake." *Journal of Aesthetics and Art Criticism* 43, no. 2 (Winter 1984): 171–80.

Sibley, Frank N. "Aesthetic Concepts." *Philosophical Review* 68 (October 1959): 421–50.

Silvers, Anita. "The Story of Art Is the Test of Time." *Journal of Aesthetics and Art Criticism* 49, no. 3 (Summer 1991): 211–24.

———. "Vincent's Story: The Importance of Contextualism for Art Education." *Journal of Aesthetic Education* 28, no. 3 (1994): 47–62.

Sontag, Susan. March 5, 1995, letter to the *New York Times.*

Sparshott, Francis. "Architecture and Space." In *Philosophy and Architecture,* edited by Michael H. Mitias, 3–20. Amsterdam: Rodopi, 1984.

———. "Showing and Saying, Looking and Learning: An Outsider's View of Art Museums." *Journal of Aesthetic Education* 19 (1985): 63–78.

Stecker, Robert. "Goldman on Interpreting Art and Literature." *Journal of Aesthetics and Art Criticism* 49, no. 3 (Summer 1991): 243–46.

Steiner, Wendy. "Practice without Principle." *American Scholar* 68 (Summer 1999): 77–87.

Stolnitz, Jerome. "'The Aesthetic Attitude' in the Rise of Modern Aesthetics." *Journal of Aesthetics and Art Criticism* 36 (Summer 1978): 409–22.

———. *Aesthetics and Philosophy of Art Criticism.* New York: Houghton Mifflin, 1960.

———. "Afterwords: 'The Aesthetic Attitude' in the Rise of Modern Aesthetics—Again." *Journal of Aesthetics and Art Criticism* 43 (Winter 1984): 205–8.

———. "The Artistic Values in Aesthetic Experience." *Journal of Aesthetics and Art Criticism* 32 (Fall 1973): 5–15.

———. "On the Origins of 'Aesthetic Disinterestedness.'" *Journal of Aesthetics and Art Criticism* 20 (Winter 1961): 131–44.

———. "On the Significance of Lord Shaftesbury in Modern Aesthetic Theory." *Philosophical Quarterly* 11 (April 1961): 97–113.

———. "Some Questions Concerning Aesthetic Perception." *Philosophy and Phenomenological Research* 22 (1961): 69–87.

————. "A Third Note on Eighteenth-Century 'Disinterestedness.'" *Journal of Aesthetics and Art Criticism* 22 (Fall 1963): 69–70.

Storr, Annie V. F. "Shock of Tradition: Museum Education and Humanism's Moral Test of Artistic Experience." *Journal of Aesthetic Education* 28, no. 1 (Spring 1994): 1–12.

Sullivan, J. W. N. "The Place of Science." *Athenaeum,* April 11, 1919.

Sutton, Walter. "The Contextualist Dilemma or Fallacy?" *Journal of Aesthetics and Art Criticism* 17 (1958): 219–29.

————. "Contextualist Theory and Criticism as a Social Act." *Journal of Aesthetics and Art Criticism* 19 (1961): 317–26.

Tefler, Elizabeth. "Food as Art." In *Arguing about Art,* 2nd ed., edited by Alex Neill and Aaron Ridley, 9–27. London: Routledge, 2002.

Tilghman, B. R. "Architecture, Expression, and the Understanding of Culture." In *Philosophy and Architecture,* edited by Michael H. Mitias, 51–66. Amsterdam: Rodopi, 1984.

Tolstoy, Leo. *What is Art?* Translated by A. Maude. Indianapolis: Hackett, 1960.

Tomas, Vincent. "Aesthetic Vision." *Philosophical Review* 68 (January 1959): 52–67.

————. "Mr. Stolnitz's Questions Concerning Aesthetic Vision." *Philosophy and Phenomenological Research* 22 (1961): 88–91.

Townsend, Dabney. "Archibald Alison: Aesthetic Experience and Emotion." *British Journal of Aesthetics* 28 (Spring 1988): 132–44.

————. "From Shaftesbury to Kant: The Development of the Concept of Aesthetic Experience." *Journal of the History of Ideas* 48 (April–June 1987): 287–305.

————. "Shaftesbury's Aesthetic Theory." *Journal of Aesthetics and Art Criticism* 41 (Winter 1982): 205–13.

Vivas, Eliseo. "Contextualism Reconsidered." *Journal of Aesthetics and Art Criticism* 18 (1959): 222–40.

Walsh-Piper, Kathleen. "Museum Education and the Aesthetic Experience." *Journal of Aesthetic Education* 28, no. 3 (1994): 105–15.

Walton, Kendall L. "Categories of Art." *Philosophical Review* 79 (1970): 334–67.

Weiss, Peter. *Marat/Sade.* New York: Athenaeum, 1967.

Weitz, Morris, ed. *Problems in Aesthetics.* 2nd ed. London: MacMillan, 1970.

————. "The Role of Theory in Aesthetics." *Journal of Aesthetics and Art Criticism* 15 (1956): 27–35.

Williams, Patterson B. "Educational Excellence in Art Museums: An Agenda for Reform." *Journal of Aesthetic Education* 19 (1985): 105–24.

Wilson, Edward O. *Biophilia.* Cambridge, MA: Harvard University Press, 1984.

Wimsatt, William K.. "Art for Art's Sake." In *Literary Criticism: A Short History,* edited by William K. Wimsatt and Cleanth Brooks, 475–98. New York: Alfred A. Knopf, 1969.

Wimsatt, William K., and Monroe C. Beardsley. "The Intentional Fallacy." *Sewanee Review* 54 (1946): 3–23.

Worth, Sarah. "Feminist Aesthetics." In *The Routledge Companion to Aesthetics,* edited by Berys Gaut and Dominic McIver Lopes, 437–46. London: Routledge, 2002.

Young, James O. "A Defense of Colourization." *British Journal of Aesthetics* 28, no. 4 (Autumn 1988): 368–72.

Zangwill, Nick. "Defusing Anti-Formalism Arguments." *British Journal of Aesthetics* 40, no. 3 (July 2000): 376–83.

———. "Feasible Aesthetic Formalism." *Nous* 33, no. 4 (1999): 610–29.

———. "In Defence of Moderate Aesthetic Formalism." *Philosophical Quarterly* 50 (October 2000): 476–93.

Zemach, Eddy. "Aesthetic Properties, Aesthetic Laws, and Aesthetic Principles." *Journal of Aesthetics and Art Criticism* 46 (Fall 1987): 67–73.

———. "Emotion and Fictional Beings." *Journal of Aesthetics and Art Criticism* 54, no. 1 (Winter 1996): 41–48.

———. *Real Beauty.* University Park: Pennsylvania State University Press, 1997.

———. "Real Beauty." *Midwest Studies in Philosophy* 16 (1991): 249–65.

INDEX

Abstract Expressionism, 169
Addison, Joseph, xiv, 54, 81, 86–88, 108, 111
aesthetic analysis, 25–27, 224
aesthetic attitude, 9, 18–19, 104–7, 115, 130, 132–33, 181
aesthetic evaluation, 9, 14, 19, 23, 27, 41, 44, 47, 49, 79, 81, 109, 136–37, 140, 143, 150–52, 160, 162, 164, 182, 188, 269, 287, 288, 290, 292, 293. *See also* aesthetic judgment
aesthetic experience, xiii, xiv, xv, 2, 11, 15, 17–42, 43, 51–54, 59, 61, 67, 70, 77, 82, 86, 88, 95–108, 109, 118, 120–21, 124, 126, 131–44, 164, 166, 167, 178, 179, 182, 184, 192, 224, 248–50, 257–58, 261, 276, 277, 286–89, 296–97, 299, 304
aesthetic judgment, 8–9, 11, 12, 17, 18, 19–21, 24, 26–27, 36, 43, 49, 53, 54, 80, 81–95, 99, 108–9, 111, 115–19, 126, 134–35, 137, 139–40, 142, 166, 178, 225, 267, 271–72, 276, 279, 286, 287, 290, 293, 296–97. *See also* aesthetic evaluation
aesthetic object, xiv, 19, 21, 22, 25–27, 29, 30, 32–33, 36, 41, 50, 54, 65, 77, 80, 84, 86, 87–89, 93, 96–99, 102, 104, 106, 109, 111, 116, 118, 120, 132–35, 138, 139, 140, 142, 143, 165, 177, 181–82, 184, 192–94, 205–6, 251, 257, 260, 270, 271, 275, 287, 292–93, 295
aesthetic property, 19–20, 24, 118, 289
aestheticism, 7–8, 10, 80, 111, 113, 120, 121, 158, 304
affective value accounts, 7, 23, 50, 58, 62–66, 294
Alison, Archibald, xiv, 30–31, 81, 87–89, 108, 225
Allen, Woody, 69, 230

American naturalism. *See* naturalism
an experience, 37, 134–35
Anglicanism, Episcopalianism, 247–49, 256–57
antiessentialism, antiessentialist, 144–45, 169, 253
antinomy of distance, 100–101, 198
Aquinas, Thomas, 53, 101, 139
architecture, 82, 119, 173–85, 193, 240, 253, 260, 298–99
Aristotle, 89, 111, 139, 205–8, 234, 266, 274
art criticism, 136, 150, 290
art for art's sake, 7, 11, 35, 80, 113, 120, 135, 189, 235,
art world, xv, 1–2, 8, 32, 45–47, 53, 71–72, 107, 121, 145–47, 158, 169, 171, 172, 191, 213, 232, 259
asceticism, ascetic, 81, 97
Ashby, Hal, 211
Ashmolean Museum of Art and Archaeology, 3–4
Augustine, 53, 111, 139
Aztec, 128, 173, 241

Bach, J. S., 148, 221,
Barbican Theatre, 180
Baroque, 148, 250
Baumgarten, Alexander, 18
Bazin, Andre, 215
Beardsley, Monroe C., xiv, 21, 23, 38–41, 49, 50–54, 56, 58, 59, 61, 67, 70, 113, 114–15, 123, 137–39, 148, 151, 192, 257–58, 288–89, 292, 294
beauty, 30, 54, 83, 84–95, 98, 106, 111, 112, 119, 124, 131–33, 163–64, 170, 173, 178, 184, 188, 218, 263, 264, 266–70, 272, 289, 305
Becket, Sister Wendy, 52–53, 63–64

Siqueros, David Alfaro, 34, 239, 243
Solzhenitsyn, Aleksandr, 238
Sparshott, Francis, 5, 10, 178
Steinbeck, John, 217
Still/Here, 185–95, 299
Stolnitz, Jerome, xiv, 10, 19, 24, 80, 82,
 88, 96, 103–8, 109, 116, 137, 143, 177,
 198, 205, 278, 290, 291
Stoppard, Tom, 102, 169, 298
subjective, subjectivism, subjectivist, 7,
 19, 23, 24, 27, 28, 29, 30, 36, 37, 44,
 45, 49, 51, 52, 53, 54, 60, 66, 67, 76,
 77, 78, 79, 80, 81, 84, 87, 88, 89, 90,
 92, 93, 98, 108, 110, 112, 113, 117, 120,
 123, 127, 131, 133, 134, 137, 138, 140,
 150, 165, 166, 172, 177, 194, 208,
 209–13, 228, 229, 252, 278, 280–83,
 288, 290, 291, 292, 293, 294, 295, 296,
 300, 302
sublime, sublimity, 101, 267
Surrealism, 169
sushi, 173–74
symbol, symbolic, symbolism, 54–61,
 66, 168, 216, 219, 225, 242
sympathy, 103, 105, 107, 109, 110, 143,
 165, 198, 230
synaesthesia, 141

Tarzan, 215
taste, 6, 9, 11, 12, 14, 24, 30, 35, 36, 54, 82,
 83, 85, 86, 88, 90, 91, 93–95, 108, 109,
 111, 112, 125, 129, 131, 140, 152, 268,
 292, 293, 295
taste theorists, 9, 24, 81, 86, 96, 130,
 140, 291
tearjerkers, 197
Tibet, Tibetan, 231–32
Tilghman, B. R., 183, 184
Tolkien, J. R. R., 67, 196, 197, 214, 222,
 227
Tolstoy, Leo, xiv, 49, 50, 62–66, 124,
 156–58, 165, 200, 233–34, 289, 304
tragedy, 200, 205
Triumph of the Will, 163–64, 218, 240

true judge, 90–92, 295
truth, 8, 117, 129, 156, 204, 234, 263, 265,
 266, 269, 270, 272, 274, 275, 279

Uelsmann, Jerry, 48
Uffizi Palace, 3–4
unity, unified, 11, 37, 38, 50, 53, 54, 84,
 134, 138, 141, 258, 263, 267, 268
universal, universality, 62, 84–85, 86,
 89, 91, 92, 98, 99, 109, 118, 125, 127,
 129, 133, 135, 156, 171, 276–77, 296

Van Gogh, Vincent, 52, 137
Vatican Museum, 3, 222
violence, 35

Wagner, Richard, 34, 203, 239
Walton, Kendall L., xiv, 114, 123, 148–49,
 151, 154, 165, 194, 250, 252, 253, 289
Warhol, Andy, 32, 38, 146, 168, 169, 194,
 298
Weiss, Peter, 102
Weitz, Morris, xiv, 40, 123, 145–47, 169,
 171, 289
West, Benjamin, 33, 238
Westminster Abbey, 247, 249
Weyl, Herman, 264, 265, 268, 269, 270,
 275
Whistler, James, 7, 8, 113
Wilde, Oscar, 7, 8, 113, 192
Wilson, Edward O., 263, 264, 268, 275
Wimsatt, William K., 56, 113, 114, 115, 148
Wittgenstein, Ludwig, 144, 169
Woolf, Virginia, 217
Worth, Sarah, 125
Wright, Frank Lloyd, 176, 178, 182,
 183, 240

Young British Artists, 52, 157, 219

Zangwill, Nick, 118–20
Zeffirelli, Franco, 226
Zemach, Eddy, 263, 266, 270, 272, 283,
 284